SLIM AARONS · ONCE UPON A TIME

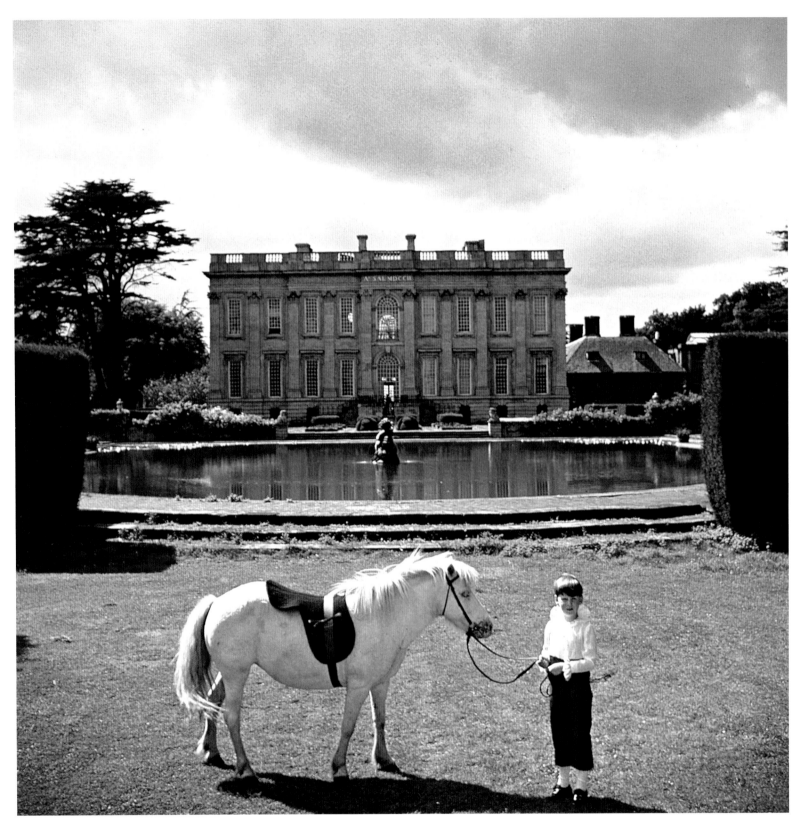

The youngest peer in England, seven-year-old Thomas Alexander Fermor-Hesketh, 3rd Baron and 10th Baronet Hesketh, in front of his ancestral home, Easton Neston House in Northhamptonshire, 1957.

SLIM AARONS · ONCE UPON A TIME

INTRODUCTION BY FRANK ZACHARY

Getty Images

Harry N. Abrams, Inc., Publishers

To Frank Zachary, art director and editor-in-chief of *Holiday* magazine and editor-in-chief of *Town & Country* magazine, who never once told me how to take a picture. He said, "How can I tell Slim what to do in Rome or Hong Kong . . . he's lived there."

To Buz Wyeth, who was the editor of my first book and lives in back of me up the hill. Having seen my photographs and heard the stories of my travels over the years, Buz said to me, just like in the old Mickey Rooney/Judy Garland movies, "Let's do a book!"

To Melissa Tardiff and her daughter Rose; Rose took the digital photos that Melissa used to design this book. Melissa worked with me for twelve years laying out my pictures at *Town & Country*. I insisted that she be the art director on this book and I'm so glad that Abrams agreed.

To Laura Hawk Cushing, the coolest cat that there ever was. Her words faithfully accompanied my pictures for six years and she helped me a great deal with the text of this book.

To Cary Ohler, who is my left arm and my right arm. Whenever I've lost anything, she found it. Every time Buz Wyeth comes to my house, he asks, "Can't we clone her?"

To Christopher Sweet, the man who flicks the whip for the publishers. I spent more weekends getting things together that he needed by Monday. I wanted to put every picture I've ever taken in this book, but, of course, that's impossible. Chris brought to the editing process common sense, at the same time pleasing me with what he picked. I know he was right. He is so good at what he does that in the end he earns his name: *tout de* sweet.

The Publishers wish to thank Eric Rachlis of Getty Images for developing this book and bringing it to Abrams.

Editor: Christopher Sweet
Designer: Melissa Tardiff
Production Manager: Maria Pia Gramaglia

Library of Congress Cataloging-in-Publication Data
Aarons, Slim.
 Slim Aarons : once upon a time / photographs by Slim Aarons;
 introduction by Frank Zachary.
 p. cm.
 ISBN 0-8109-4603-3 (hardcover)
 1. Portrait photography. 2. Rich people–Portraits. 3. Leisure class–
 Pictorial works. 4. Aarons, Slim. I. Title: Once upon a time. II. Title.
TR681.L44A23 2003
779'.2'092–dc21
2003008685

Harry N. Abrams, Inc.
100 Fifth Avenue
New York, N.Y. 10011
www.abramsbooks.com

Abrams is a subsidiary of

ACKNOWLEDGMENTS

For every photographer out shooting, there are many people back home doing the dull, necessary things that make it possible for a photojournalist to work and exist. My thanks go to many—specifically to:

Holiday magazine under the editorship of Ted Patrick and Caskie Stinnett, a great experience with good editors; picture editor Lou Mercier, a proper Bostonian—all he'd say was "Bring back the snaps"; Tony Mazzola and Jerry Smokler, editor and art director of *Town & Country*, who later became editor and art director of *Harper's Bazaar* when Frank Zachary became the editor of *Town & Country* —Tony always gave me the pages he promised; we went through a lot together, and always had fun; Marty Forscher and Willi of Professional Camera Repair, who kept my equipment working (not one of the pictures you see in this book was done with a digital or automatic camera—in my career, you couldn't use a point-and-shoot camera, you had to be an experienced photographer); Mary and Mike Gallagher, who kindly allowed me to kidnap from their vast archives the *Holiday* and *Town & Country* magazines I needed to research this book; the Getty Images people in London for finding the images we needed from my archives of nearly one million photos; Eric Rachlis, Director of Licensing Services, and Valerie Zars, Special Collections & Publishing, both in the New York office of Getty Images; Tommy and Joseph Kiley of Katonah Image—they are the whiz kids of modern photography (I don't know anything about what they do; I tell them my problem and they fix it); Michael Hoppen, whose inquiry about my photograph *Kings of Hollywood* for his London gallery led to the sale of my archives to Getty Images (—Michael flew in from London and bought two copies of *Kings of Hollywood*; upon returning to London he told Mark Getty what he'd seen in my attic. The next thing I knew, there was a knock at my door, and standing there in a windbreaker was a young, good-looking guy I assumed to be a landscaper looking for a job. It was Mark Getty, owner of Getty Images, and he told me he'd been advised by his people that I had something he should see. We climbed the stairs to the attic and he saw my hundreds of boxes marked in bold letters with the names of places on which I'd done stories: London, Paris, Rome, Gstaad, Cortina, North Africa, Singapore, Bora Bora. He walked around the attic surveying the scene. "Can we look at this one," he asked, pointing to a box that read "Rome/Black Aristocracy." He picked up a 120 transparency and held it up to the skylight. "My God," he exclaimed, "That's where we held our wedding reception!" He had married a Roman countess and the first slide he picked up was a shot of the palazzo where they were married. He put the slide back and politely asked me what price I was asking for my archives. I told him. We shook hands and the deal was done); the girls that worked with me: Linda Ashland, Laura Hawk Cushing, Meg O'Neil, Janet Carlson, Beth Heilman, Crary Pullen, and Pauline Mellon Stephaitch; Grace Mirabella, the editor of *Vogue* after Diana Vreeland, whom I knew when she worked in Rome learning the trade; Hank Carter (a.k.a. Henri Cartier-Bresson);

Gjon Mili, my daughter's godfather who never let me get too cocky; Stanley Haber, who had been with me at *Yank* magazine, an honest lawyer and a trustworthy friend, and his protégé Leonard Hocheiser, who is just as trustworthy; Sheila Berger, who designed my first book— I liked it; Harper & Row, first class all the way; Carmel Snow, Diana Vreeland, Mary Phillips and Alexey Brodovich of *Harper's Bazaar*, who encouraged me; Alex Liberman at *Vogue* and Allen Hurlburt at *Look*, who helped when I needed help; Henry Sell at *Town & Country*, a gentleman and a fine editor; George Moore, Walter Wriston, Bill Spencer, and T. J. Henry of Citibank, who trusted my judgment when I did their ads—for fifteen years they were number one in bank ads; Frank Hall of Albert Frank-Guenther Law, who proves that advertising can be a business of gentlemen; the secretaries, art department people, associate editors, and researchers who have worked with me all these years and whose book this is also; the older photographers for all the tips; those whom I photographed—my sincerest thanks; the many great writers I have worked with and whose work I am honored to have illustrated: Irwin Shaw, Cleveland Amory, Steve Birmingham, Bill Manchester, Richard Bissell, Sean O'Faolain, Niven Busch, Freddie Morton, Carleton Mitchell, Peter Benchley, Ogden Nash, Carl Carmer, Eugene Burdick, Roger Angell, Shirley Ann Grau, Ben Thielen, Budd Schulberg, Irving Stone, Joe Bryan III, Lucius Beebe, and Linda Ashland; the makers of cameras before the digital age: Leica, Nikon, Rolleiflex, and Hasselblad—there is no substitute for quality; Gloria Sidnam, who, when she read my first book, told me, "It sounds like you," and nagged me to do another; Jock and Ellie Elliott; my wife Rita; and my daughter Mary, who came through when I needed her.

Without the help and cooperation and efforts of all the people mentioned above, there would be no book. Thank you.

CONTENTS

INTRODUCTION

BY FRANK ZACHARY

Once upon a time, Slim Aarons was a combat photographer for *Yank* and *Stars and Stripes*. For three years during World War II he saw action on the battlefields of Western Europe and Africa, witnessed the fall of Tobruk and Tunis, the invasion of Anzio, the agonizing siege of Monte Cassino. Honorably discharged, he returned to civilian life and proceeded to transform himself from combat cameraman into his present eminence—photo laureate of the upper classes. A bizarre change of identity one might think, but the metamorphosis was premeditated. As Slim explains: "What the hell did we fight in the war for if it wasn't to make the world a better place to live in and even occasionally enjoy. I was honorably discharged with a Purple Heart and I'd had a bellyful of the horrors of war. From now on, I'm going to walk on the sunny side of the street. I'm going to have fun photographing attractive people, doing attractive things in attractive places and maybe take some attractive photographs as well."

And this he has done with superlative skill and grace, as you can judge from the pictures in the book you are holding. Slim is a straightforward fellow and his pictures reflect his uncompromising personality. Unembellished and directly observed, they allow the subject to speak for itself in the great tradition of the old master portrait painters (think Gainsborough and Reynolds). On assignment for various magazines (*Life, Holiday, Travel & Leisure*, and *Town & Country*), Slim has documented the life of the wealthy, the privileged, and the leisured for fifty years. Without animus or adulation, he has mirrored the changing countenance of society—face lifts and all. His sustained focus on this historically inaccessible segment of society is without parallel in the annals of photography and possibly even literature. Other photographers have recorded the manners and mores of the social classes: August Sanders's monumental album of the German Volk shot between the two wars 1918–1938; Eugène Atget's magisterial panorama of turn-of-the-century Parisian street life; Jacob Riis's heartbreaking exposé of immigrant life in New York City before World War I. But Slim's achievement stands alone. It is the only visual chronicle (and in living color, too) of the privileged class in our time; the way they lived, dressed, furnished their homes, where they played in summer and winter, and otherwise enjoyed the power of their status in the last half of the twentieth century.

The genesis of Slim's straightforward style lies in his Yankee roots. Slim is a New Hampshire man, and a New Hampshire man is a frugal man, and frugality in the composition of a photographic image is an aesthetic virtue. Frugality discourages excess and Slim's photographs are singularly free from needless ornamentation. His pictures are lean and clean and as refreshing as a glass of spring water. They are the work of a consummate artist in the guise of a photojournalist. His pictures are carefully crafted, articulated images shaped by a keen sense of form and design. It is their impeccable and seemingly artless composition that makes Slim's photographs so easy

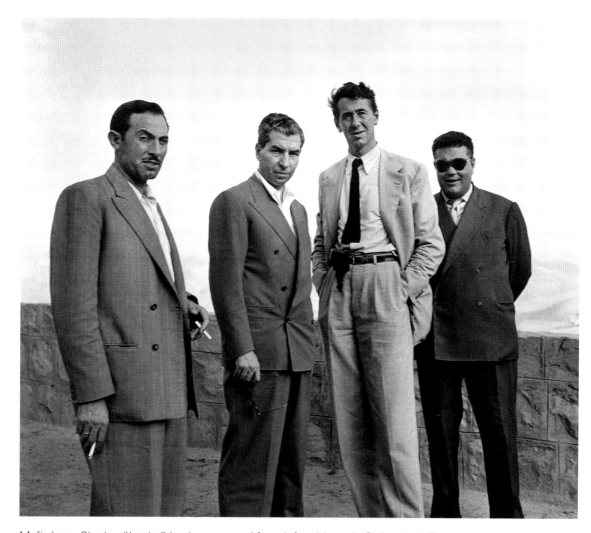

Mafia boss Charles "Lucky" Luciano, second from left, with me in Sicily, 1949. This photograph was taken near the hometown of the famous gangster. Lucky called the other guys in the picture his *cugini* or cousins. He didn't want to be photographed smoking, so he handed his cigarette to one of them. The biggest mistake I made was opening my jacket for this shot, because when the picture ran everyone thought my light meter, attached to my belt, was a Beretta.

to enjoy and appreciate. They are without equivocation. They say what they mean and mean what they say. Over and above their technical virtuosity, Slim's photographs are profoundly human. It is their content as well as their style that engage the viewer; his burnished ladies and polished gents—chic, groomed, and self-assured—compel the eye and command our respect, attention, and even envy. For every one of us is a social climber at heart, aspiring to better oneself. What young girl has not wanted to look like a beautiful princess and live in a beautiful palazzo like the Princess Colonna (page 206)? And what acne-ridden boy has not wanted to acquire the insouciant composure and casual elegance of Palm Beach's leading bachelor Peter Pulitzer (page 77)? And I'm sure every red-blooded guy would like to share a drink at Romanoff's with the Kings of Hollywood—Clark Gable, Gary Cooper, Van Heflin, and Jimmy Stewart (page 118–119). His images have the glamour and appeal of the movies but with a vital difference; he projects fantasy that is based on reality—the good life that exists beyond the foxhole and the battlefield.

ONCE UPON A TIME

BY SLIM AARONS

I believe in fairy tales. For six decades I have concentrated on photographing attractive people who were doing attractive things in attractive places. Many of these elegant people were princes and princesses and others were just ladies and gentlemen. Some lived in marble palaces and Camelot castles, and others lived in magnificent contemporary estates. I traveled all over the world to photograph them; found them in London and New York, Gstaad and Newport, Palm Beach and St. Tropez, and Lake Forest and Rome.

During World War II, I was a combat photographer for *Yank* magazine, and having survived that experience a little battered but all in one piece, I felt I owed myself some easy, luxurious living to make up for the years I had spent sleeping on the ground in the mud, being shot at and bombed. The war was over; I was eager to put all that misery behind me.

There were still a lot of problems in the world, and while many of my colleagues focused on these postwar headaches, on cold wars and little hot wars, on the social troubles in a devastated Europe and in America itself, I decided I had had my fill of photographing human suffering and despair. So when I was asked to hotfoot it to Korea to cover the war there, I let it be known that the only beach I was interested in landing on was one decorated with beautiful girls tanning in a tranquil sun. Beaches were made for strolling and lying on, not for invading.

These were the years before television had brought a certain kind of familiarity with the world into everyone's home, and the great picture magazines *Look, Life*, and *Holiday* were doing a tremendous job covering the Who, What, When, and Where of the world. There was more than enough work. And many of the friends I had made during the war were now editors of those magazines.

One of my first beats was Hollywood, dream capital of the world, as far from reality as I could have imagined getting. Freelancing for *Life* magazine, I found the transition was easily made from war combat to combating starlets. I have never forgotten the advice Clarence Bull, chief of still photography at MGM, gave me while he photographed stars like Lana Turner, Clark Gable, and Robert Taylor: Glamour was essential, illusion must be maintained. Louis B. Mayer's edict prevailed: The women must be beautiful, the men handsome. They were the princes and princesses of Dream World and Clark Gable was "The King."

After Hollywood, I decided to head for Europe, and as *Life* was just opening a bureau in Rome, I checked in there, settling down at the Excelsior Hotel on the Via Veneto, where my bill was a little over ninety dollars a month. The Excelsior had special rates for actors, newspapermen, and

EASTER CHURCHGOERS OF BACK BAY ENJOY FIRST TASTE OF SPRING

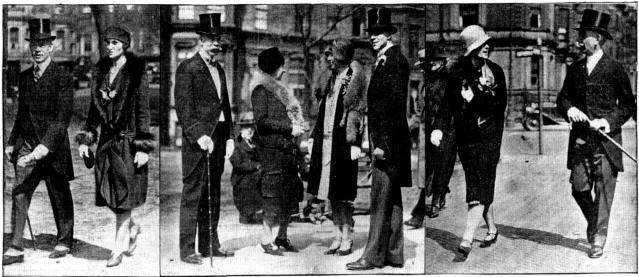

Mr. and Mrs. R. H. Stevenson of 76 Beacon street.　　Mr. and Mrs. Charles Stewart of 225 Beacon street talking to Miss Priscilla Rhodes and Philip Coburn.　　J. Lothrop Motley of 151 Beacon street greeting a friend.

Hundreds of early risers attend sunrise services at Parkman bandstand, Boston Common.　　Mr. and Mrs. W. Bradlee Smith.　　Harvard students and their friends in Easter throng. Left to right, Helen Slausen, David M. Proudfoot, Jane Douglas, Paul E. Hord.

Mr. and Mrs. Gordon Dewart of 370 Longwood avenue.　　John Donnelly, Hugh Bancroft, Jr., and E. C. Donnelly.　　Miss Marion Clair accompanied by J. A. Ryan of New York.　　Mr. and Mrs. Franklin T. Pfaelzer, Jr., of Brookline walking with Mr. Pfaelzer, Sr.

A trip to Boston was the outer limit of my imagination when I was growing up in New Hampshire. As a kid, I did not foresee that one day I would circle the world many times, using my camera as a passport to its many wonders. But there is no city in the world like Boston, and there is nobody quite like a Bostonian. I ought to know—I married one. My wife's parents, the Gordon Dewarts, are in the picture in the lower left corner. This page from the *Boston Herald* sums up for me that feeling of "once upon a time."

courtesans. The reasons were obvious, the manager told me: actors and actresses decorated the lobby; newsmen might be working on a book (remember *Grand Hotel*?), and beautiful courtesans always demanded the biggest and the best suites from their current lovers. All the great continental hotels operated that way in those days.

It was a wonderful place to begin my quest for the beautiful and the elegant. Rome offered its palaces and ancient ruins as suitable backgrounds for the galaxy of stars suddenly descending on the Eternal City. Life there was rewarding: the dollar was strong, the wine *dolce,* and the girls fantastic. Entertaining in their exquisite drawing rooms and frescoed galleries, the "Black Aristocracy," in combination with the superstars at play, gave rise to the legend of the "Beautiful People."

From Rome I returned to the States and proceeded to photograph people in elegant surroundings all over the world. *A Wonderful Time*, my first book, came about when the attic of my home could hold no more of the photographs deposited there at the end of each assignment, and something had to be done. How about organizing them into a book? I thought; and so it began. The problem that soon became apparent was that there was enough material for a dozen books, and the decision had to be made to narrow the focus to the Western Hemisphere—at least for a start.

A Wonderful Time was a personal and pictorial record of the great American cities, choice residential areas, and fashionable summer and winter resorts during the post-World War II years. It is also a glimpse of the first families of America, photographed in their elegant homes and exclusive clubs. It was made during those years when I was on assignment for a number of magazines that depicted for readers a style of living known only to the favored few. I chose to call my second book *Once Upon A Time* not only in reference to the fairy-tale world I photographed, but also because I couldn't think of a better title to show how times have changed in the six decades I've been taking photographs. What was a very simple life when I was in my twenties has become something unbelievably complex.

I can remember when I first came to New York after my formative years in New England. On hot summer days you could sleep in Central Park. Try that today! Now there are so many cars in New York that living there is a continual traffic jam. When I first began at *Life* magazine, I was paid $25 a day and I lived beautifully. At Maria's Restaurant on 52nd Street you could have a delicious lunch for $1.25 or a dinner of the finest food in New York for $2.50. When I lived in Rome,

you could fill a girl's room with flowers for $10. I still wear suits I had made to order at Brioni for less than $100, and the shoes I had made of kangaroo leather in Hong Kong were two pairs for $120. You could walk onto an airplane five minutes before the flight took off and the only time you had to go through security was at customs in a foreign country.

By the time I reached thirty, I had nearly been blown up in Anzio, I had photographed the top movie stars, stage stars, and society's stars and I had shot three *Life* covers. I paid $32 a month for an atelier on 57th Street just off Park Avenue; for $63, I got the whole floor with a terrace. I could park right in front of the door of my building, or if I wanted to garage my car, the price was 50 cents. A dime was considered a reasonable tip—it was good enough for Rockefeller! It is no wonder that people need huge salaries today just to afford a decent life.

Today I live in the country outside of New York, where I've lived for the past fifty years. I cut my own grass, not only for the enjoyment of the experience, but for the exercise as well. I even keep a hand mower in case there is no gasoline. I particularly enjoy being able to walk barefoot outside, surrounded by flowers and two-hundred-year-old trees. My water comes from my own well, and if the heat goes out, the great old fireplace in my 1782 colonial can heat the entire house. The town I live in is so concerned about maintaining open space that we pay extra taxes to buy parcels of land to leave undeveloped. I learned one lesson after being a combat photographer: if a war is coming, get out of the cities. If a million-dollar bomb is going to be dropped, it will be dropped where it can cause the most damage, not on a farmhouse in the country.

How did things become the way they are today? We have every conceivable device and more to make our lives smooth, efficient, and modern. I marvel at the wonders that we live with—satellites, digital television and cameras, cell phones, the internet. Yet I fondly remember the times when a Coke cost a nickel, when a kid could buy a piece of candy for a penny, when the computer wasn't down, and when there was something to watch on television though there were only three or four channels to choose from.

Many of those shown in this book have changed their names, and others have passed on, but as the camera has recorded, so they were, and there they were. I have tried to include images of an era that was fairy-tale-like and much simpler, such as children playing on a lawn or a horse-drawn sleigh in New Hampshire taking skiers to lifts that were never crowded. Now ask yourself, dear reader, even with all the amazing things that we have in our lives today, are we better off, or were things simpler Once Upon A Time?

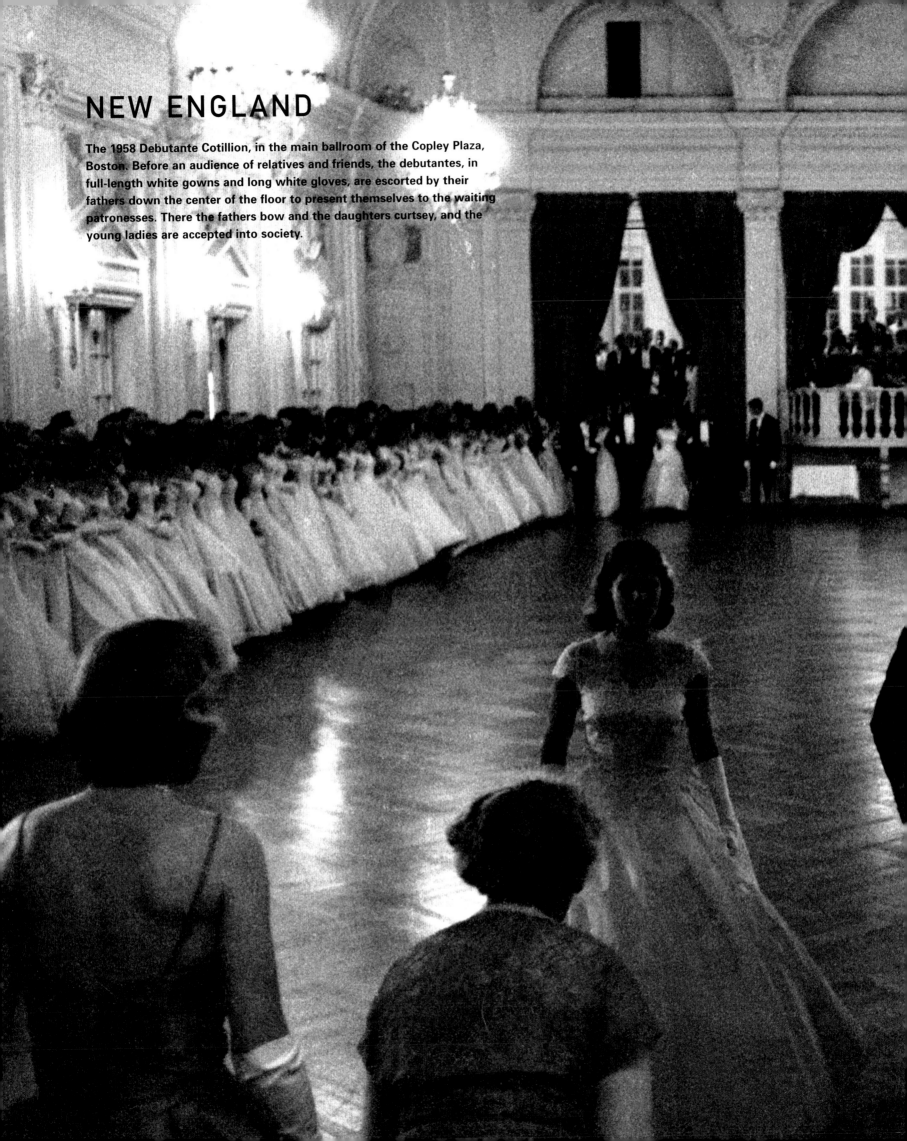

NEW ENGLAND

The 1958 Debutante Cotillion, in the main ballroom of the Copley Plaza, Boston. Before an audience of relatives and friends, the debutantes, in full-length white gowns and long white gloves, are escorted by their fathers down the center of the floor to present themselves to the waiting patronesses. There the fathers bow and the daughters curtsey, and the young ladies are accepted into society.

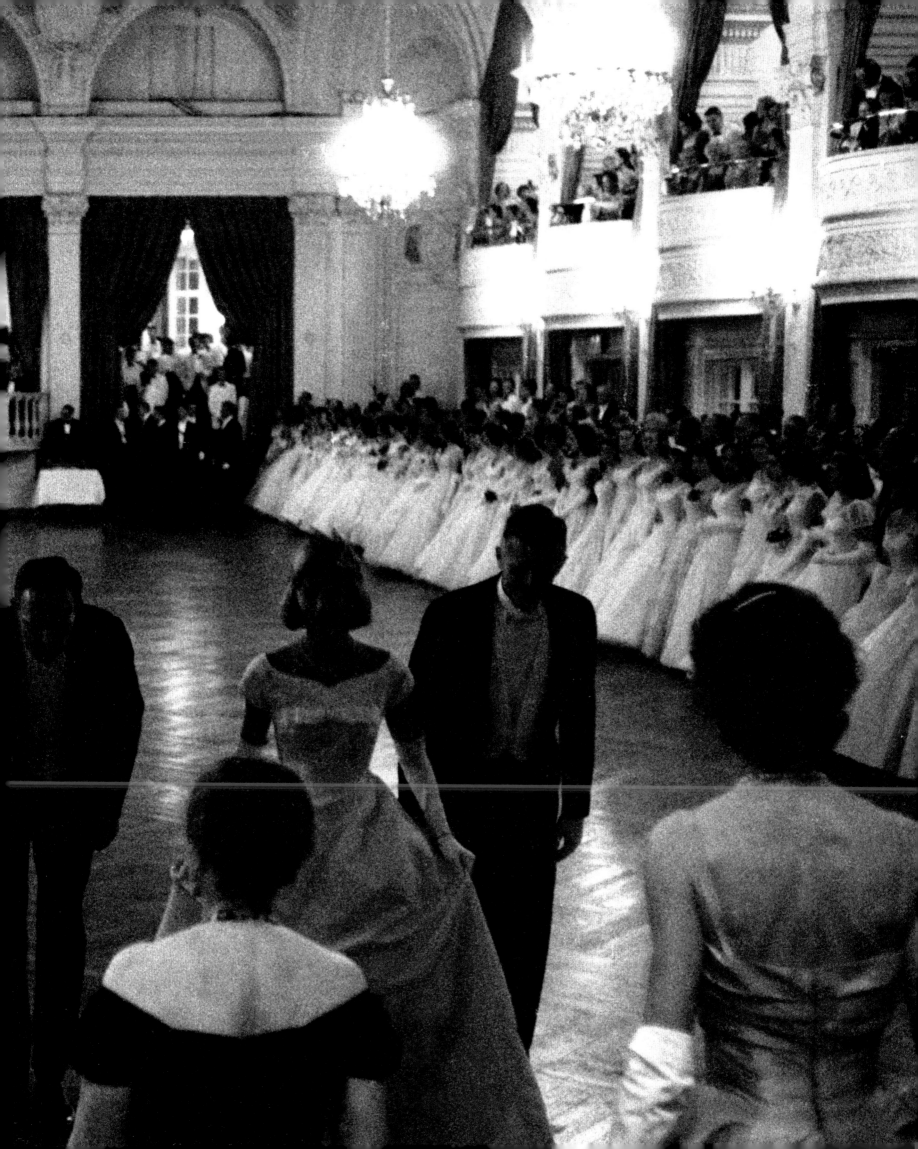

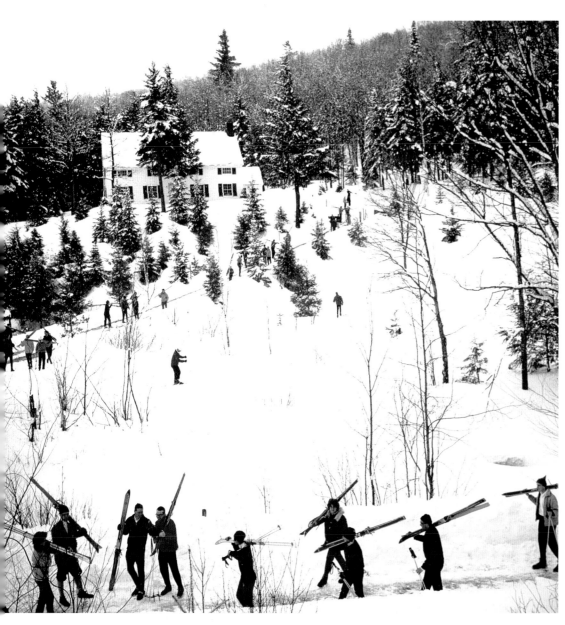

ABOVE: Students from Stowe Preparatory School in Vermont track through deep snow near Mount Mansfield and Spruce Peak, c. 1960. In the background is Ski Inn.

OPPOSITE: On the way to Cranmore Mountain, New Hampshire, 1950s. Oh, what fun it was to ride in a one-horse, open sleigh.

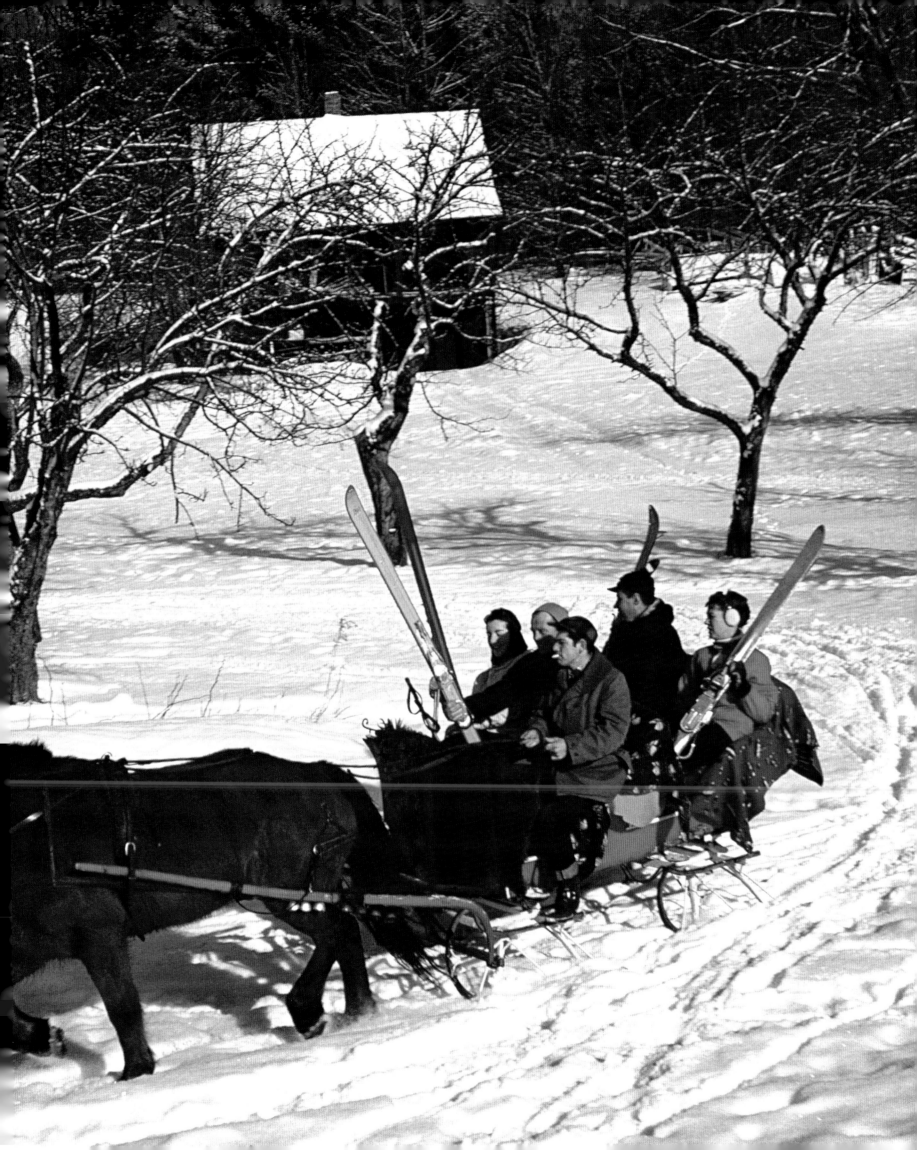

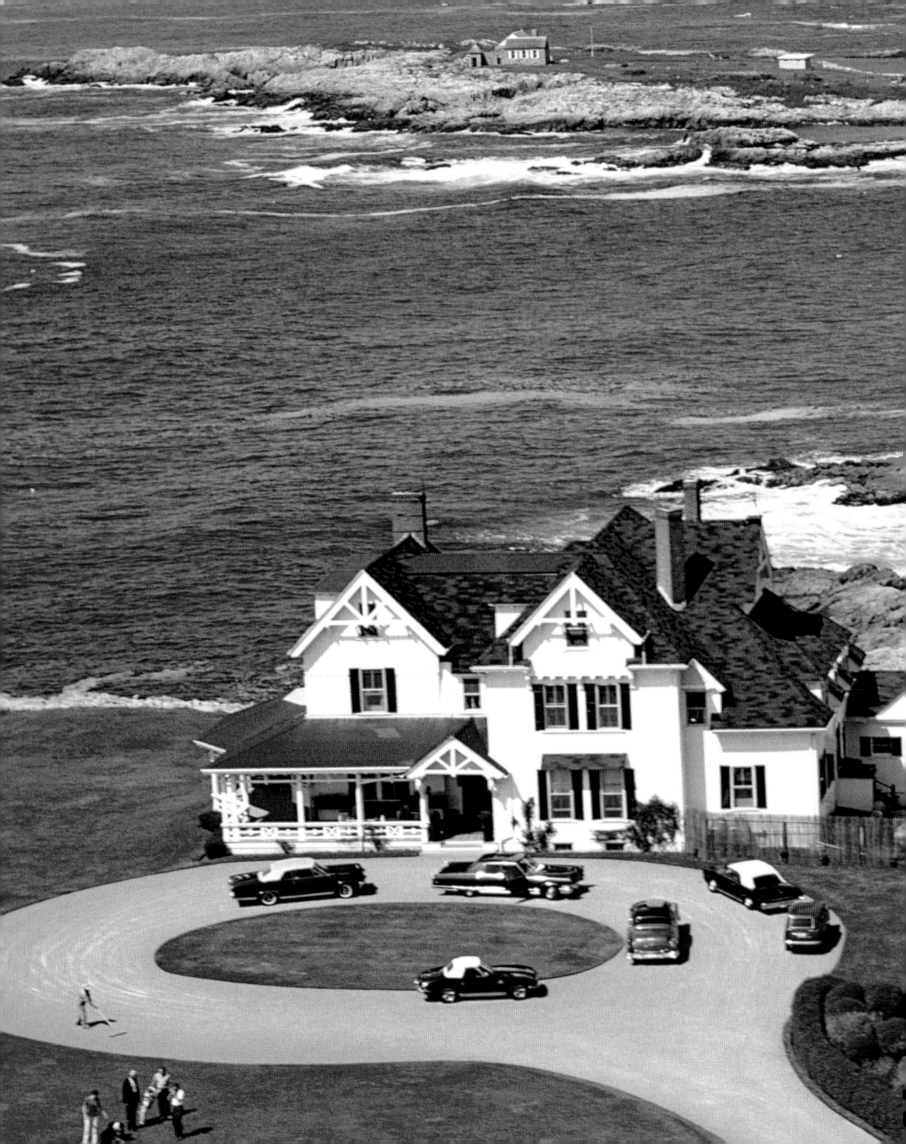

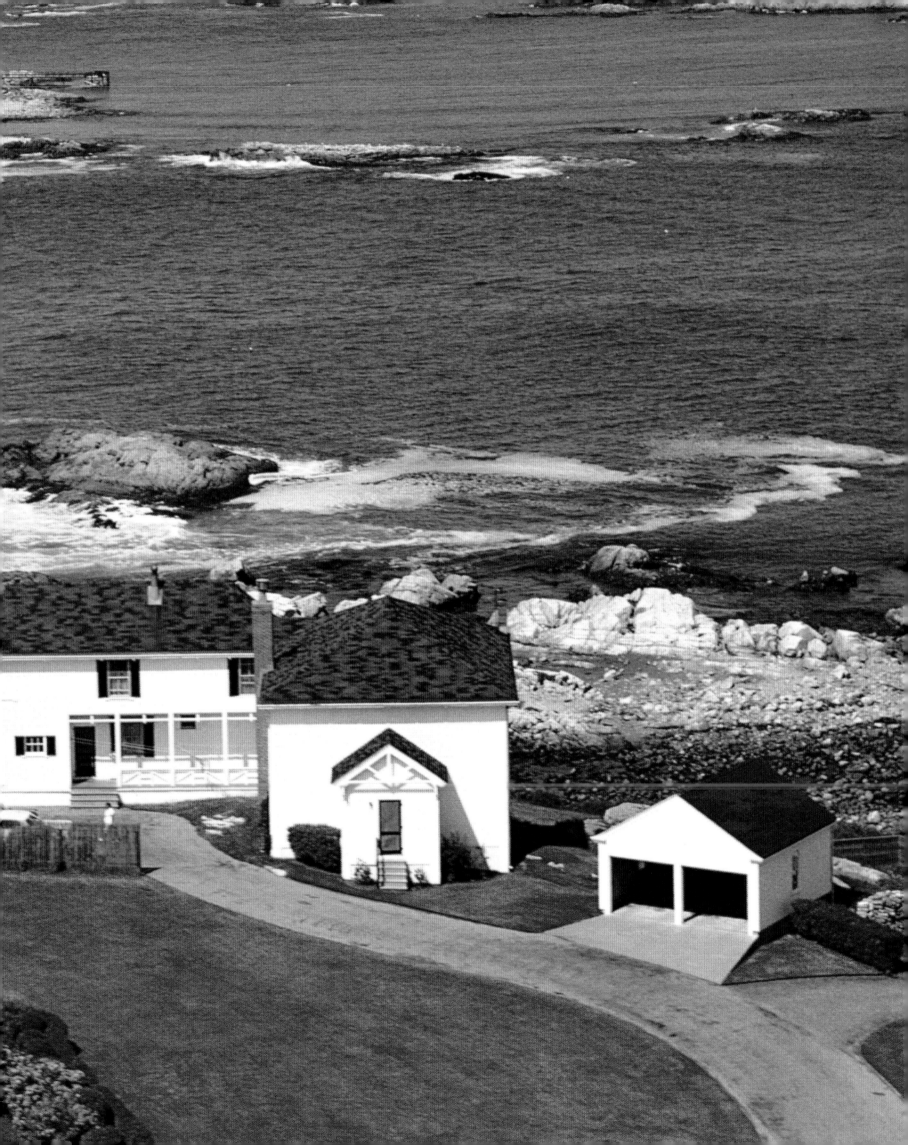

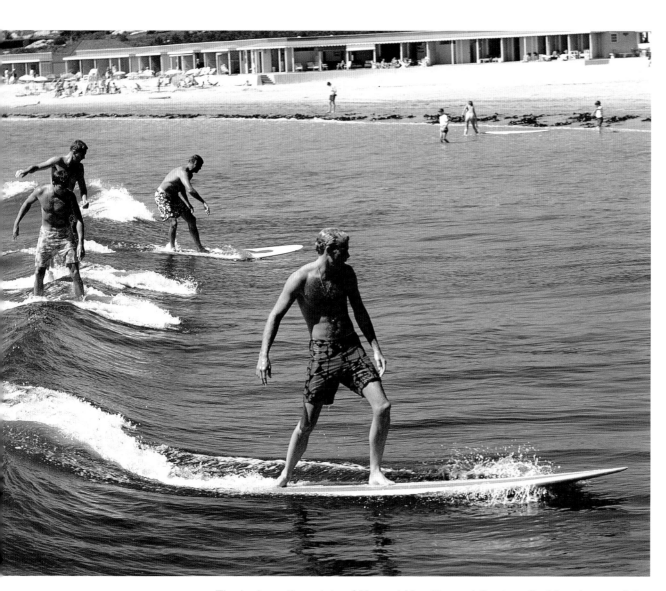

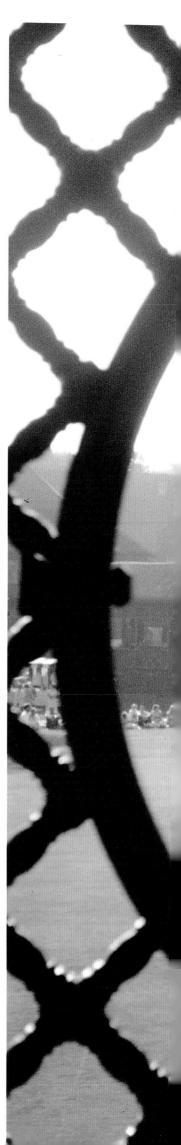

PREVIOUS PAGE: The Ledges, the estate of Mr. and Mrs. Howard Gardner Cushing, is one of the smaller of the old mansions in Newport. It was built by Robert Maynard Cushing in the 1860s as a summer retreat from the heat of Boston. In contrast to the Newport palaces that followed, this was a simple Victorian house of the period. It was only in later years that the wings and studios were added to accommodate the new generations of Cushing children and grandchildren. 1966.

ABOVE: Brothers Freddie and Howard Cushing surfing with friends at Bailey's Beach, Newport, c. 1965.

RIGHT: The Newport Casino is one of the biggest attractions in the community, offering lawn-tennis courts and lawn bowling. The Casino became the site of some legendary tennis matches over many decades during the annual August Tennis Week, c.1955.

ABOVE: Mr. Harvey Firestone, Jr., Newport, 1950s.

OPPOSITE: Mrs. Henry B. Cabot, Jr., and her children, Henry Bromfield Cabot III, Camilla Foote Cabot, and Andrew Hull Cabot, in the driveway of the Cabot home, Rollingstones, in Newport, 1960.

OVERLEAF: Players in the Fairfield County Hunt Club's croquet tournament spend an afternoon knocking out their opponents. It began years ago as a lark and has become a wildly competitive annual event. I was photographing in another part of the club and had finished by late afternoon. As I was leaving I saw this scene, just as the tournament was drawing to a close, and had to shoot it.

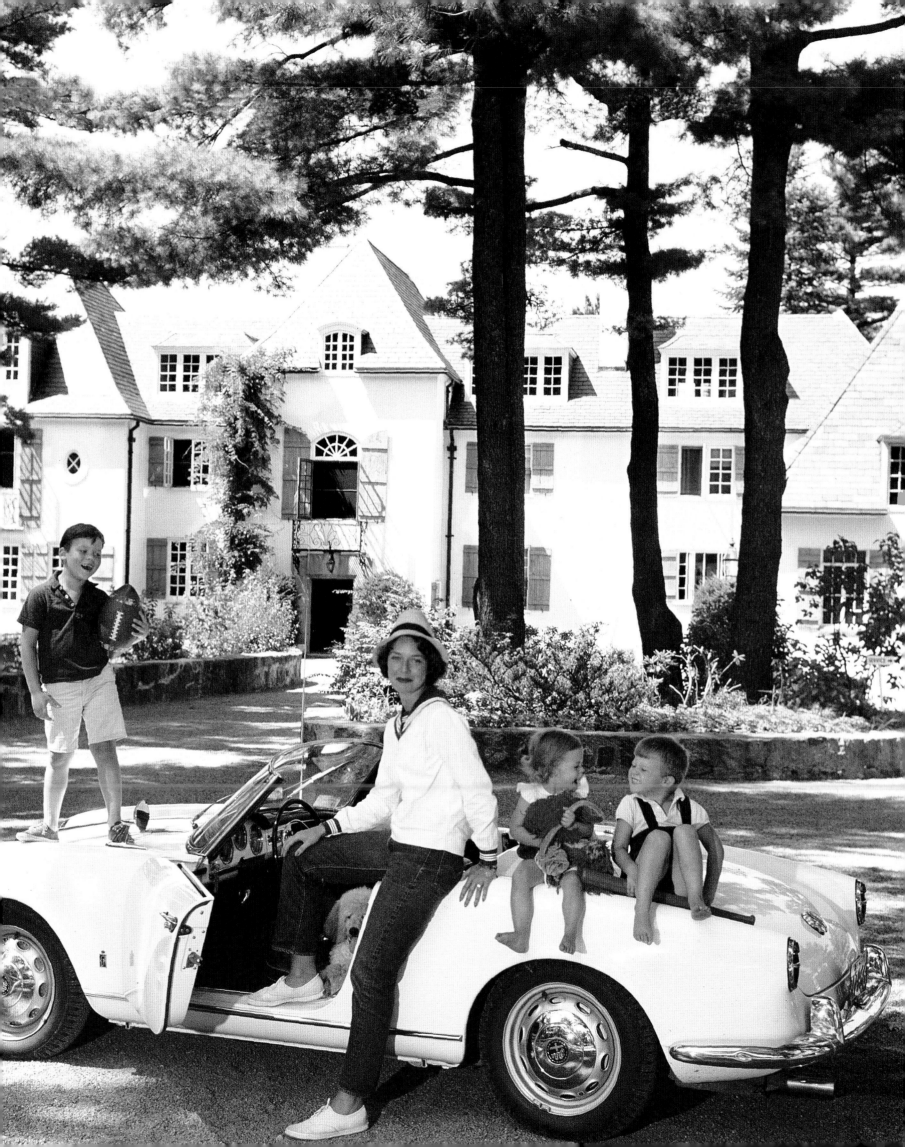

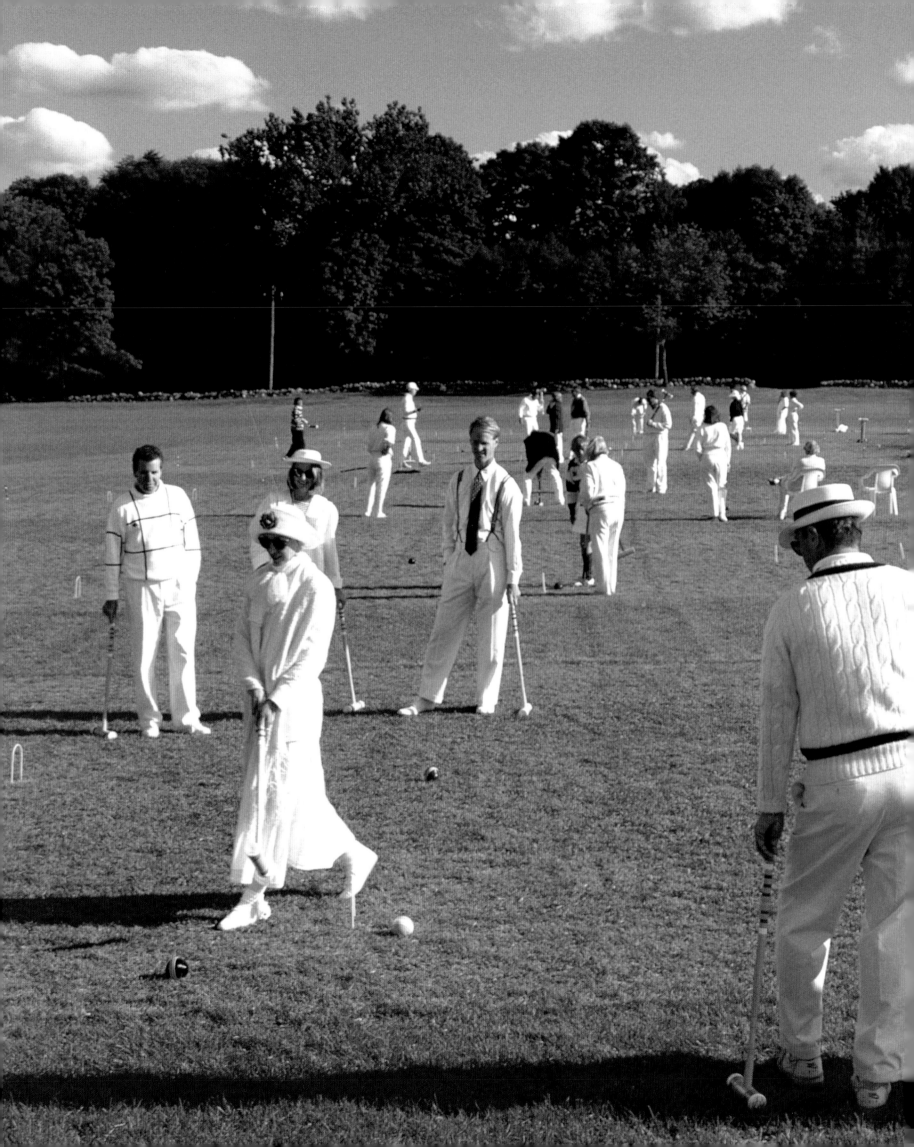

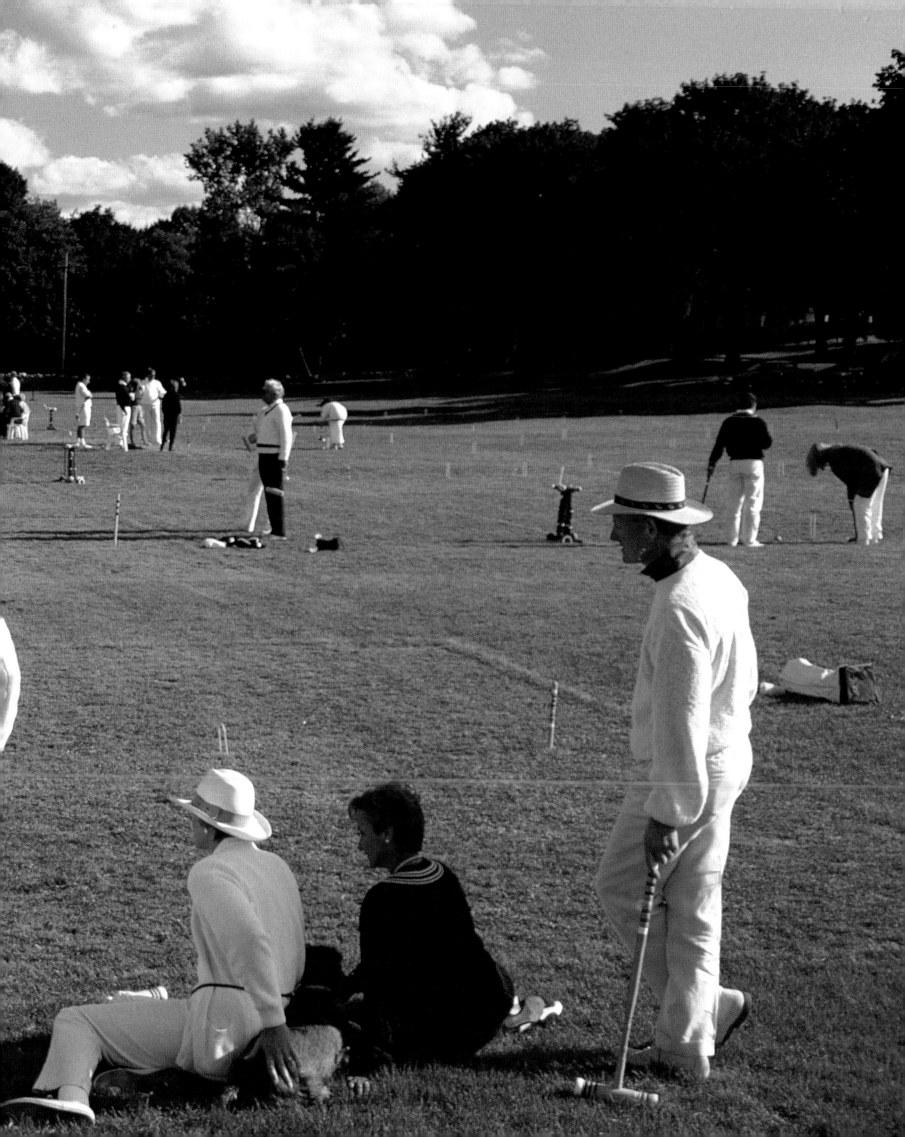

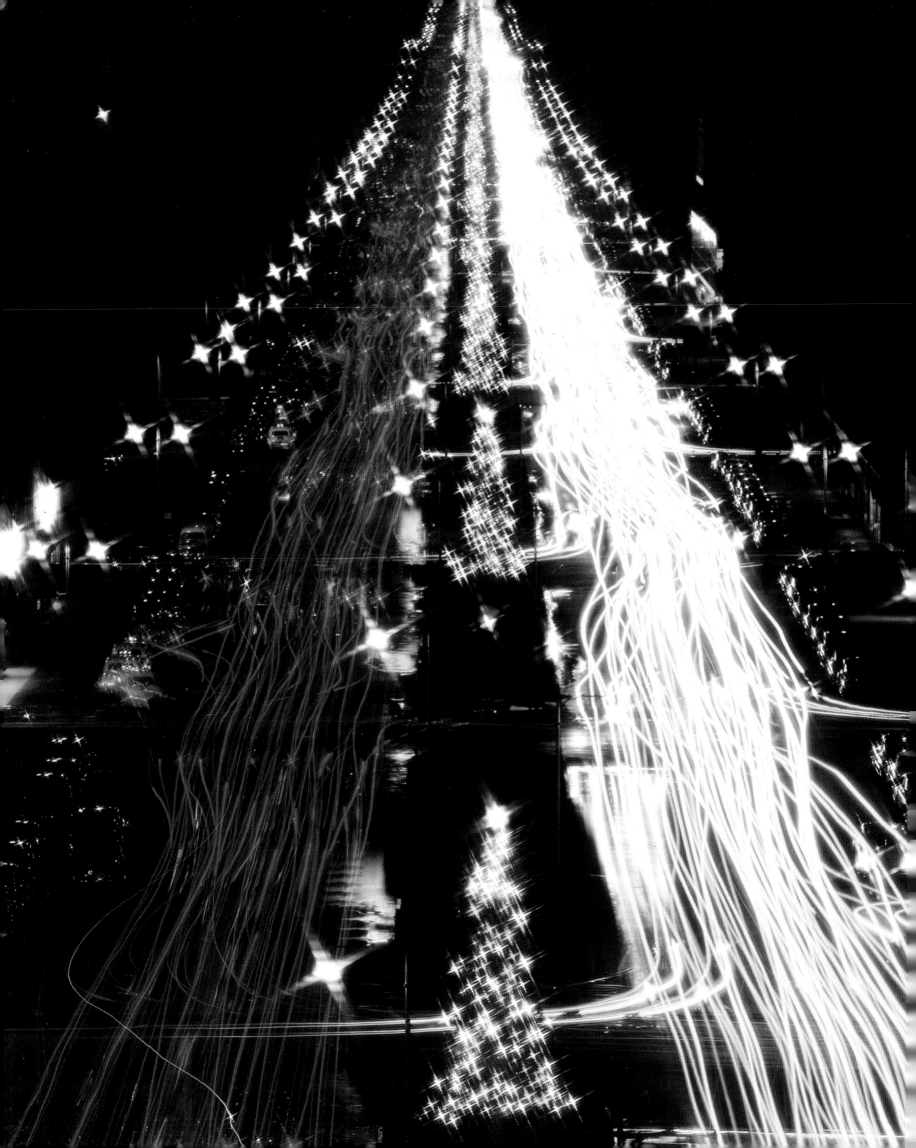

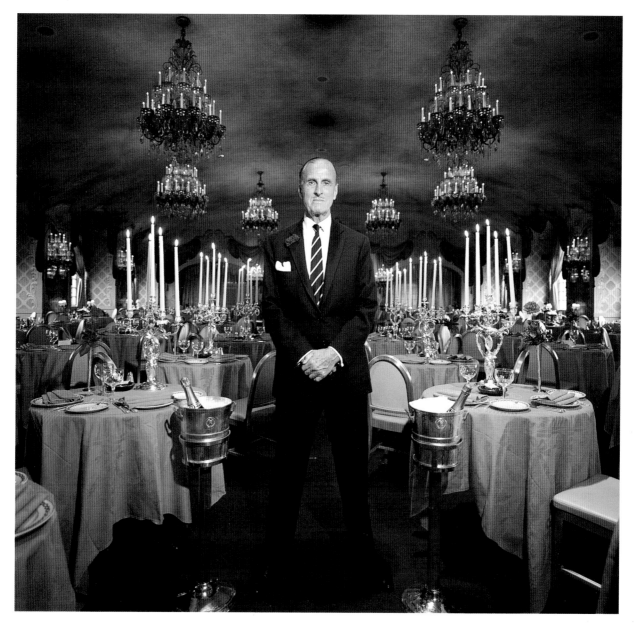

OPPOSITE: Christmas is a wonderful time of the year in New York, a time when the city proudly puts on its most glittering jewels. I was shooting a Park Avenue story for *Holiday* magazine, which took me to the seventeenth floor of the Helmsley Building with my camera, tripod, some ordinary wire screening, and a telephoto lens. The screen created the starlike effect on the lights.

ABOVE: Colonel Serge Obolensky in his creation, the St. Regis Roof, 1964. It was one of the great supper clubs of New York. Serge, often called a bridge between European aristocracy and the American elite, was born a Russian prince, fought the Bolsheviks in 1917, and in 1944 was parachuted behind German lines in France.

OVERLEAF: The Ladies of the Eighties. Sirio Maccioni in 1981, owner of famed Le Cirque restaurant, with a group of lunching ladies, from left to right, Kathryn Penske, Ivana Trump, Muffie Bancroft, Anne Arledge, Anna Moffo Sarnoff, Christina Delorean, Marie Kimberly, and Patricia Kluge. This is Sirio's old restaurant off Park Avenue. I wanted to do a picture of Sirio's place and asked if he could round up a few of the ladies who lunched there regularly. There was only room for eight ladies, but word got around and everyone in New York wanted to be in the picture. Fourteen women showed up. I did the shot with all of them, but three on each side got cut off!

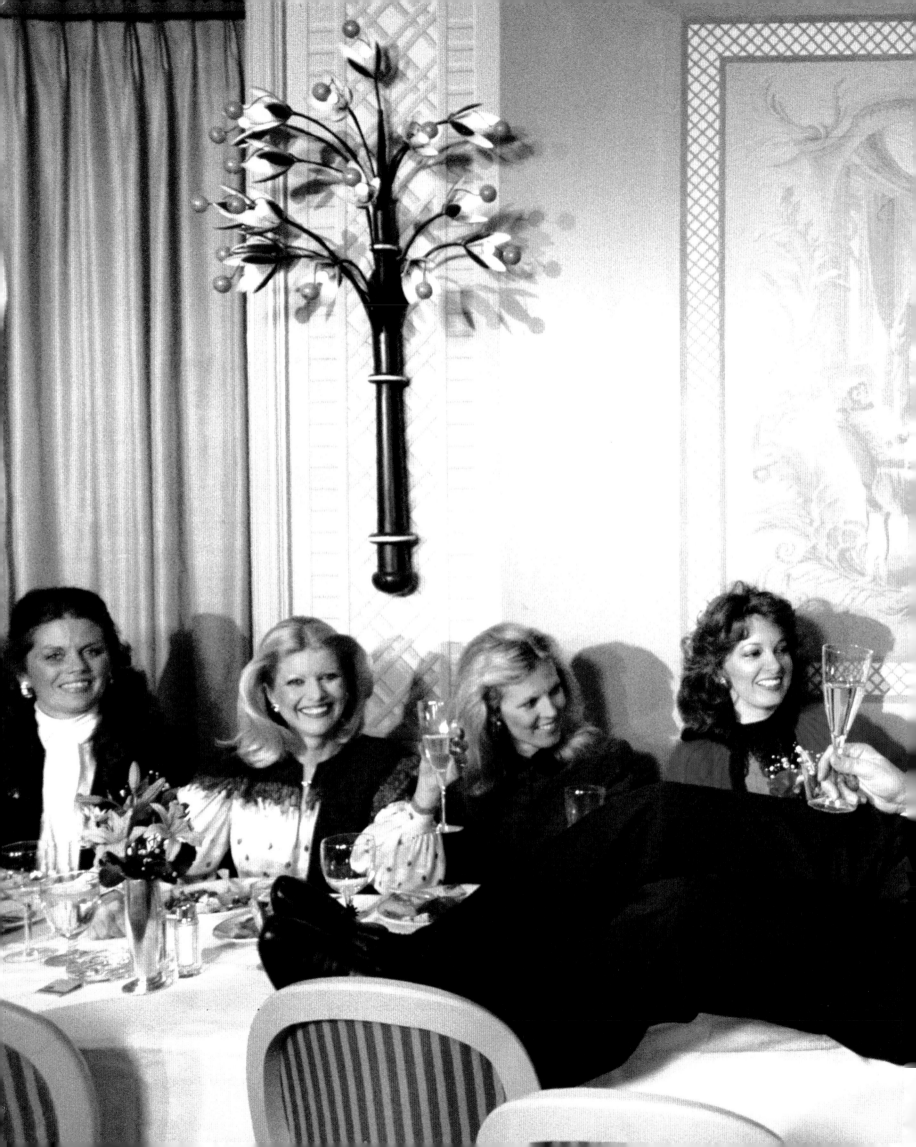

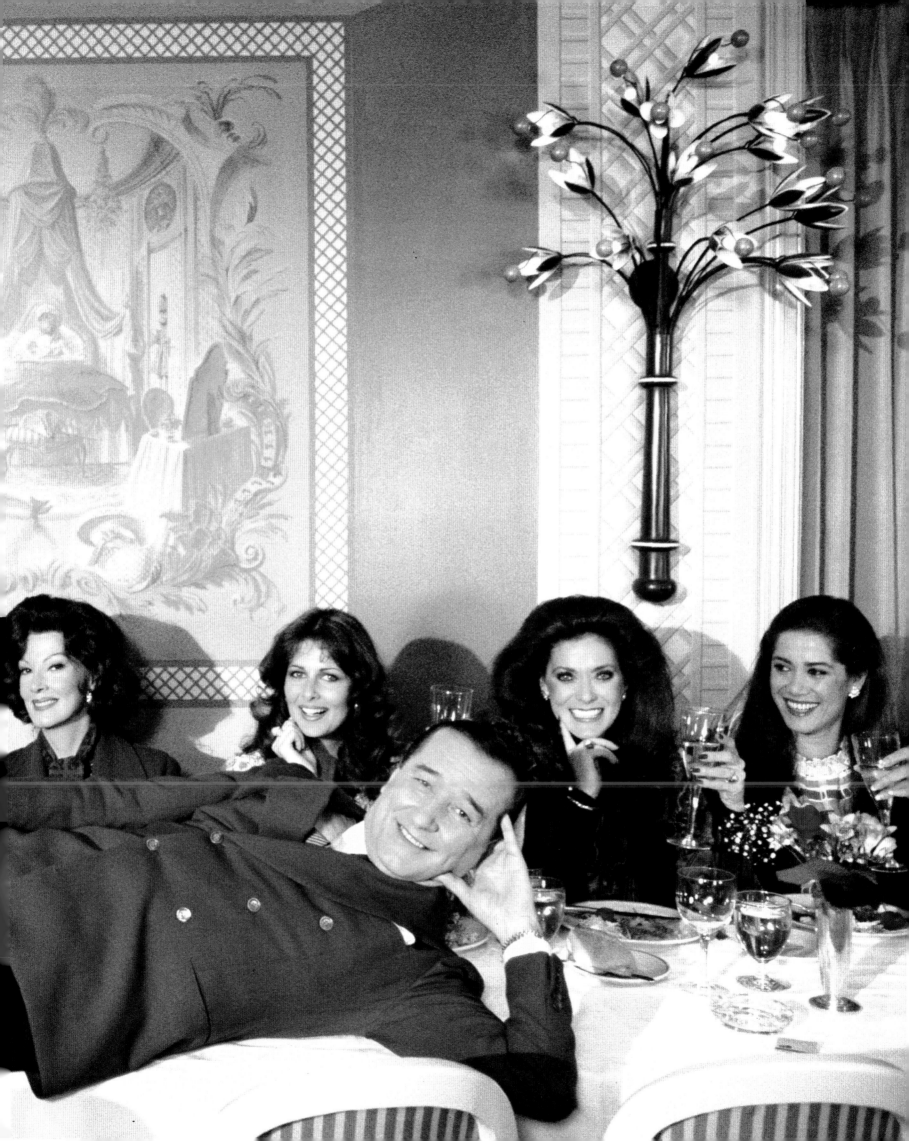

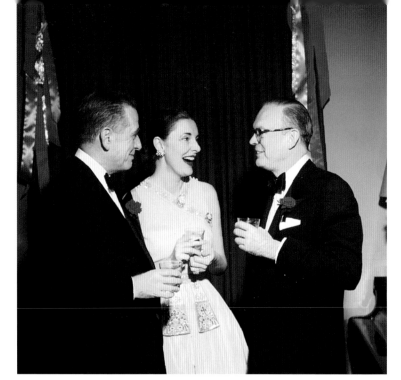

There was a great party that Gilbert and Kitty Miller gave every year on New Year's Eve. What a mix of socialites, songwriters, editors, princesses, and the like, all in the same room. 1953.

ABOVE: Producer Leland Hayward and his wife Slim with Mike Cowles.

LEFT: Princess Natasha Paley and Cole Porter.

BELOW: Cecil Beaton and Fleur Cowles.

OPPOSITE: Slim Hayward, Diana Vreeland, and her husband Reed.

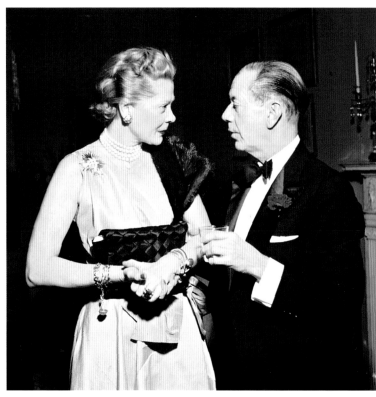

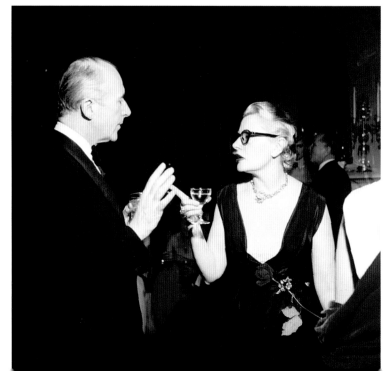

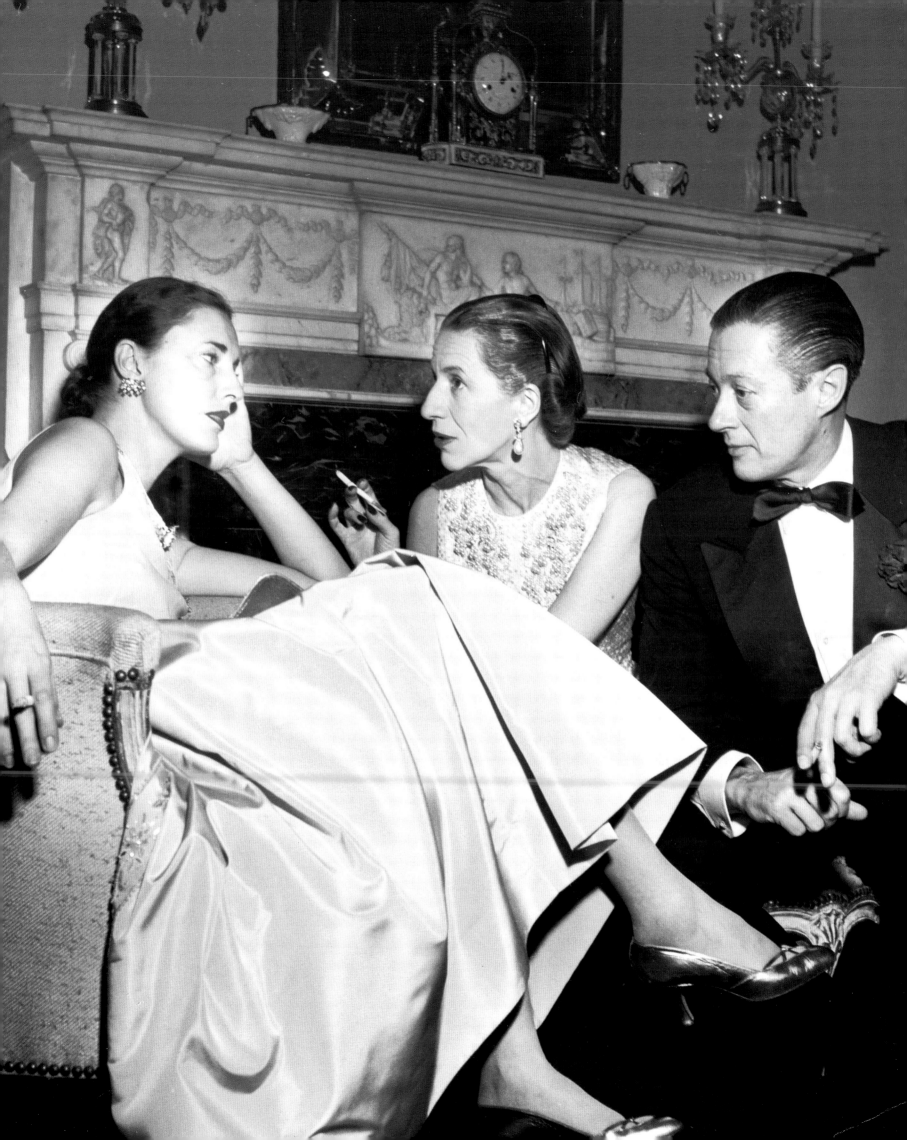

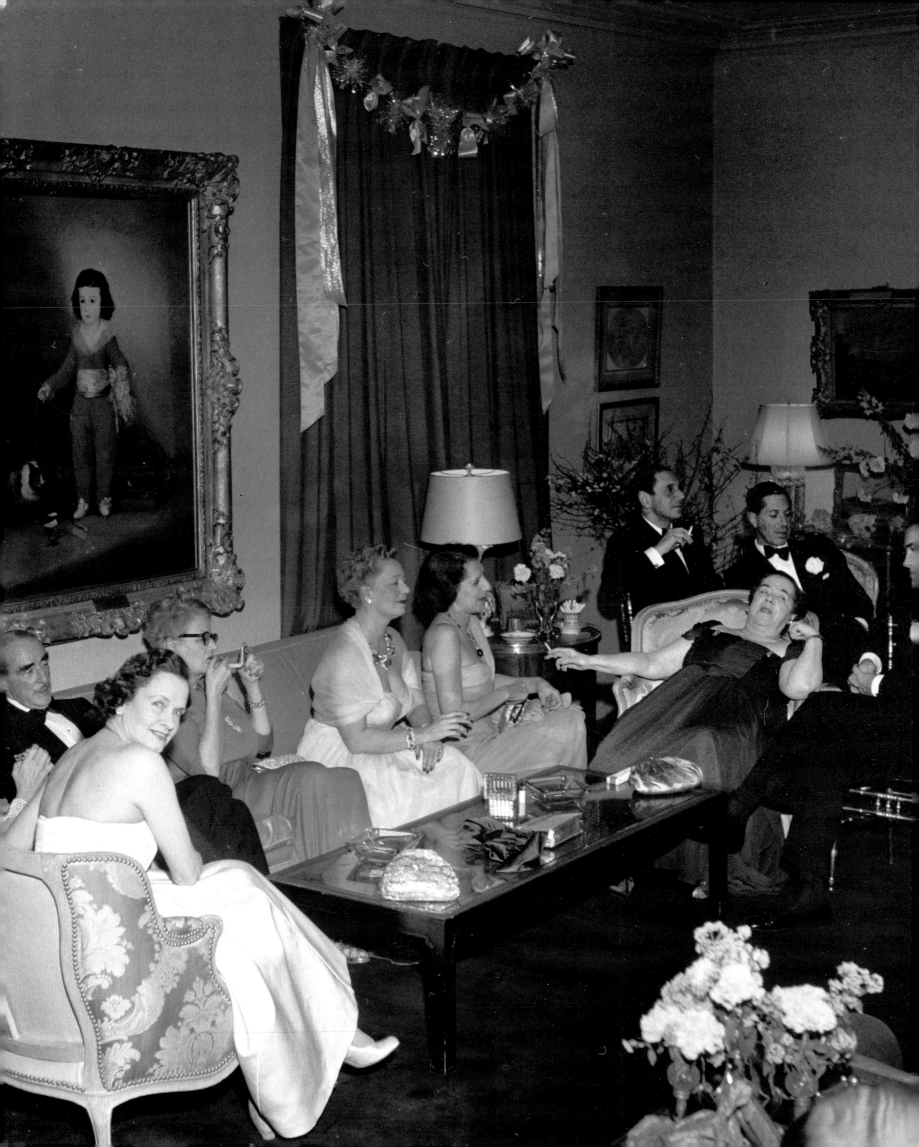

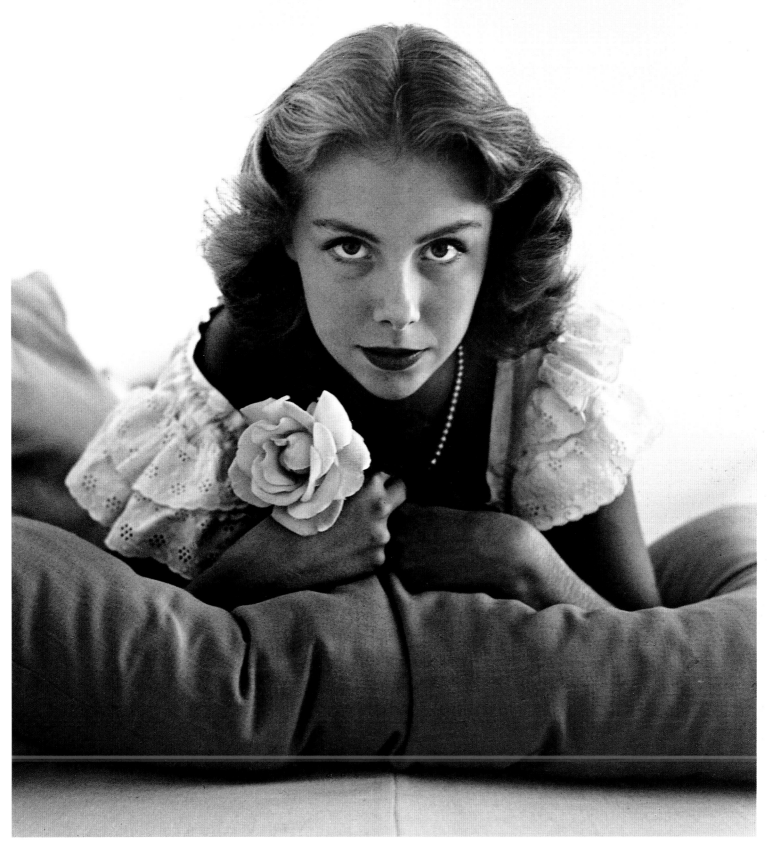

OPPOSITE: Same evening, same soirée as on previous two pages. Its guest list aglitter, this fête includes Mrs. William Randolph Hearst with friends under Goya's portrait of Don Manuel Osorio Manrique de Zuñiga, now in the Metropolitan Museum of Art. In the background, Elsa Maxwell in what her friends describe as her standard pose, with jeweler Duke Fulco di Verdura, editor Baron Nicholas de Gunzburg, and socialite Charles Amory.

ABOVE: The American Furstenberg, Countess Elizabeth Caroline von Furstenberg-Hedringen, more casually known as Betsy von Furstenberg or "Madcap Betsy," a stage and screen actress, c. 1951. This was my first *Life* cover. She was a young actress, only sixteen years old, a great beauty. And talk about Small World Department—now she lives up the road from me.

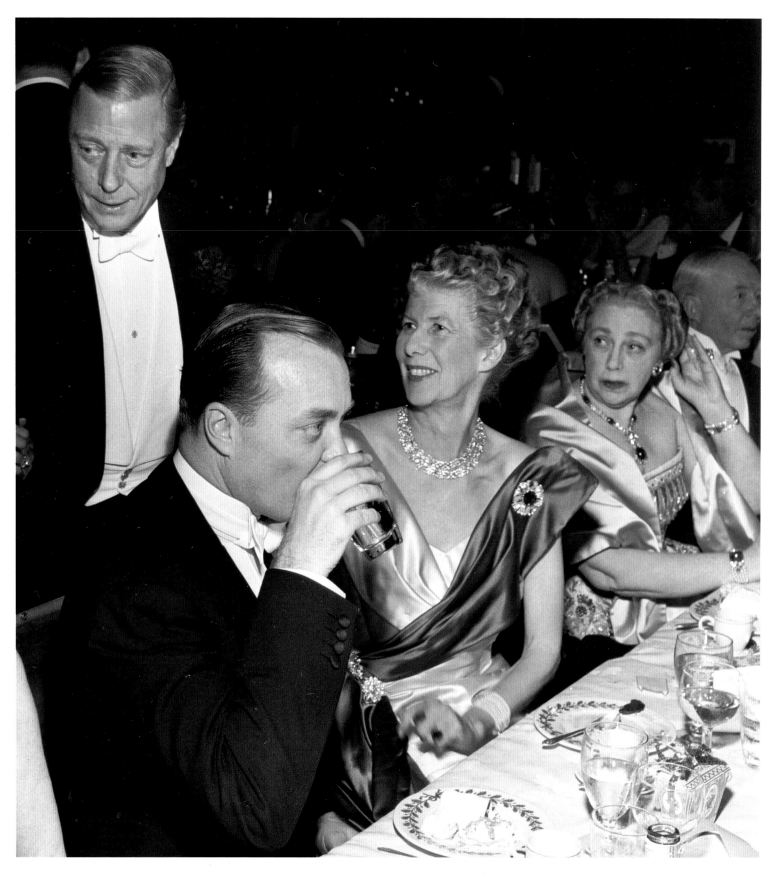

ABOVE: A party at the Waldorf-Astoria in honor of the Duke and Duchess of Windsor, c. 1955. The Duke, Woolworth Donohue, Mrs. Lytle Hull, Mrs. Jessie Woolworth Donohue, and Robert R. Young.

OPPOSITE: The Duke and Duchess, Constance Carpenter, and Milton "Doc" Holden.

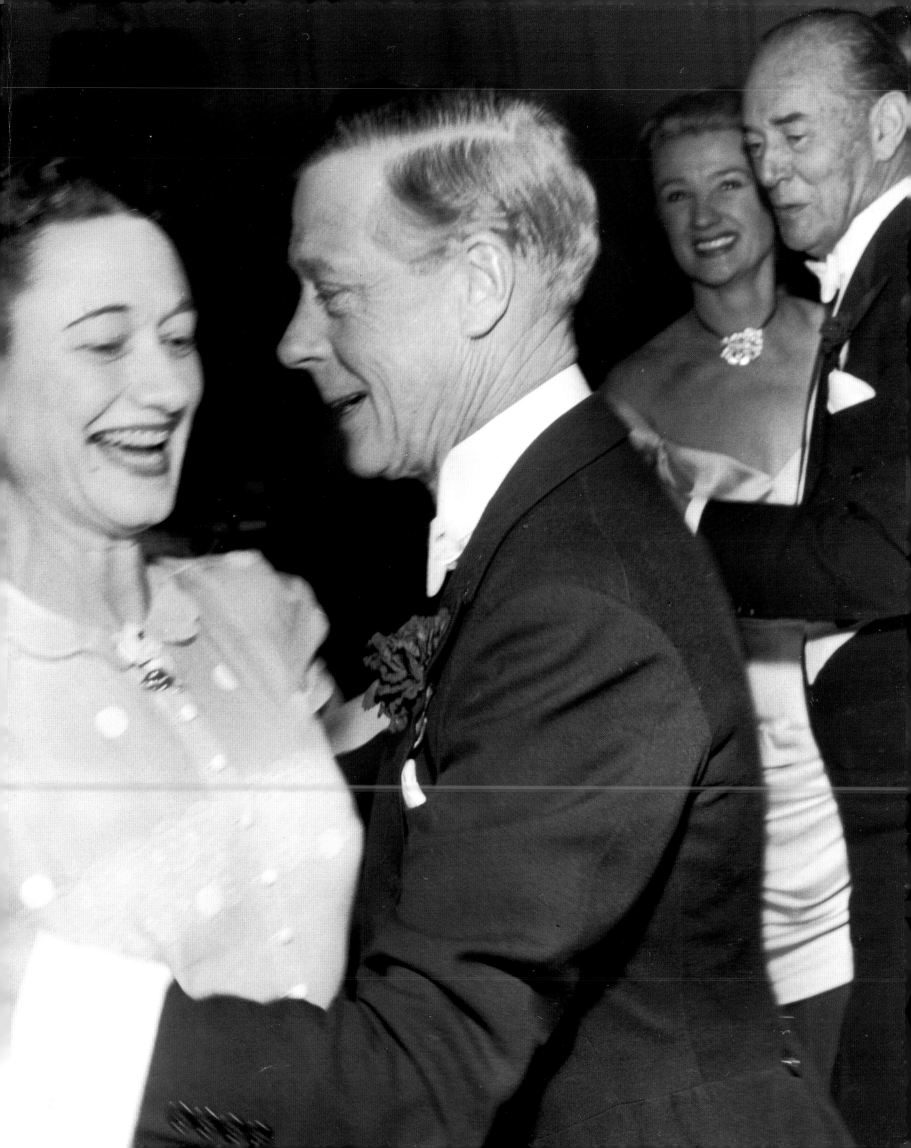

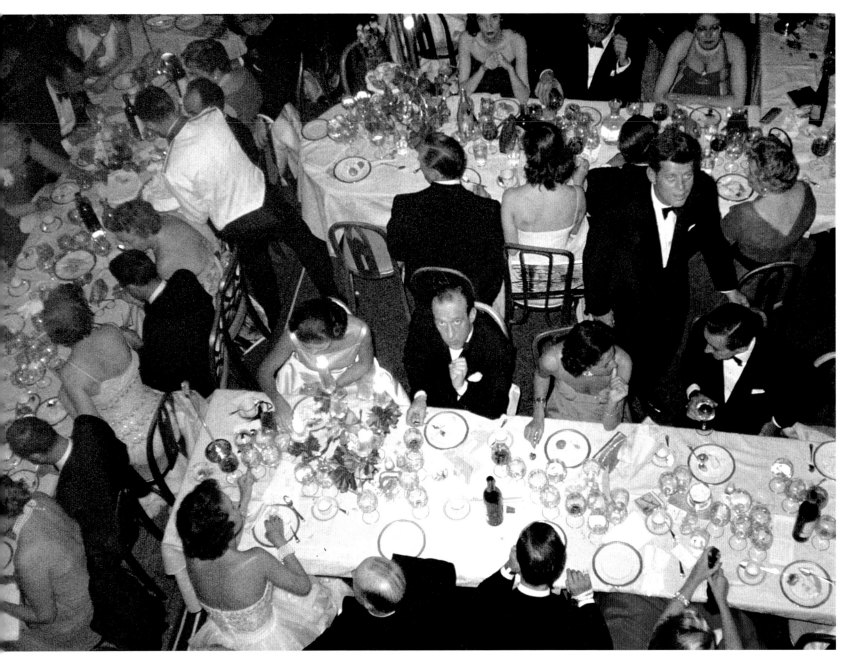

One of the big affairs of the time was the April in Paris Ball, a renowned benefit that originated in the fertile mind of Claude Philipe of the Waldorf-Astoria. At the 1959 ball, I ran into the young senator from Massachusetts and his wife, whom I'd already met. Later, I went up on a balcony, scouting for an overall shot of the Grand Ballroom. Jack Kennedy was talking to a tableful of buddies, including Charlene Wrightsman of Texas and Palm Beach and Flo Smith, a next-door neighbor of the Kennedys in Palm Beach. Later I joined him at his table, where I got a shot of Jackie, always friendly to another photographer, looking very pretty.

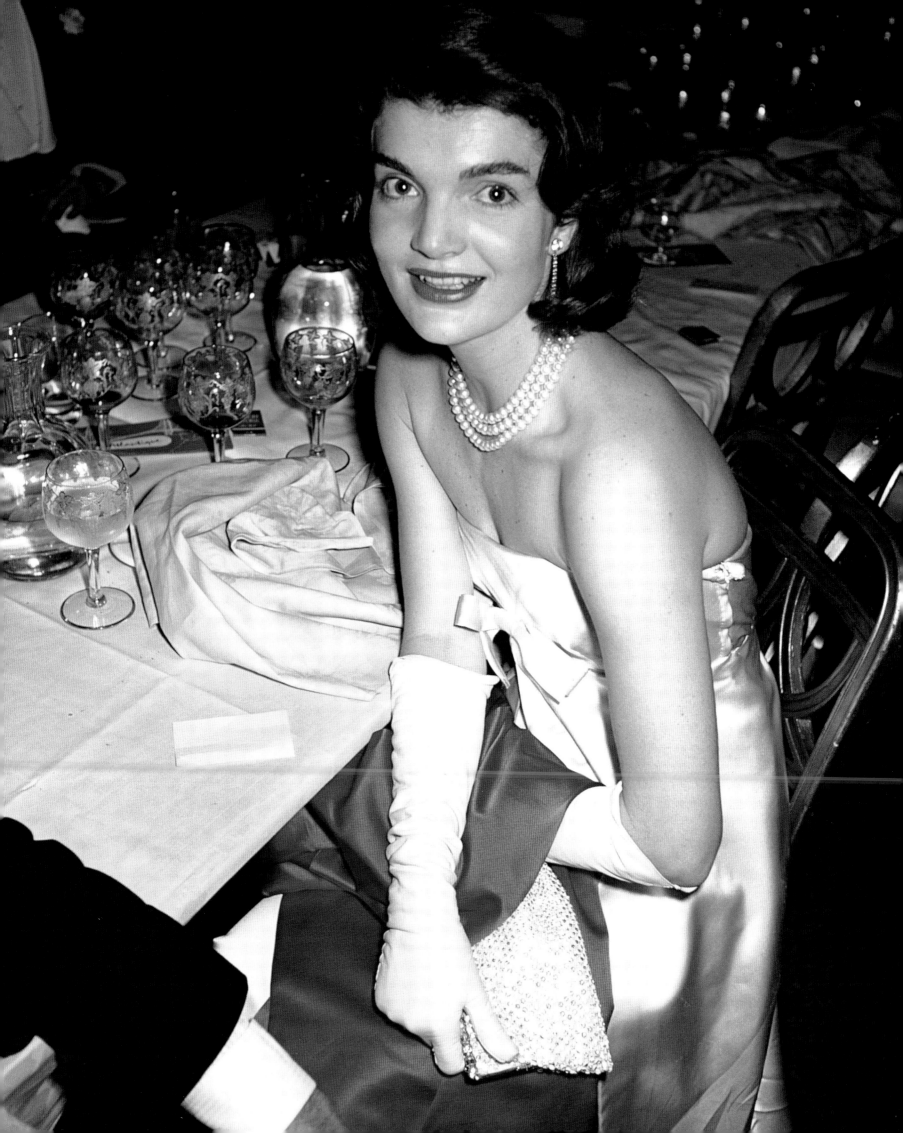

OPPOSITE: I was doing a lot of private parties in those years, including one at the Fifth Avenue home of Robert David Lion Gardiner, sixteenth lord of the manor of Gardiners Island. He is seated at the left before a Gobelins tapestry designed by Joseph Vernet. 1959.

ABOVE: Taking tea in a private suite at the St. Regis Hotel, 1956. From left to right: Baroness Daubeck, Mrs. Frederick B. Payne, Mrs. Vincent Astor, and Mrs. Cornelius Vanderbilt Whitney. Vincent Astor owned the St. Regis at that time.

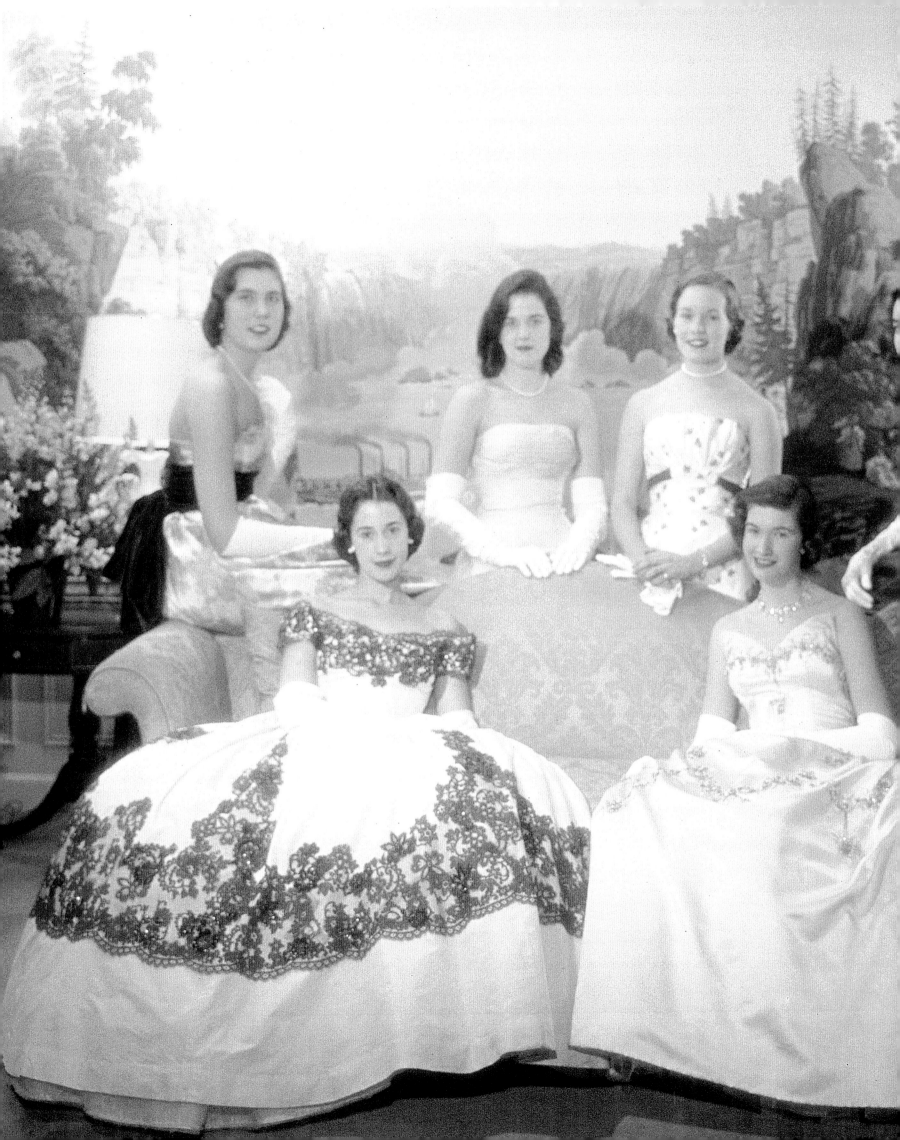

OPPOSITE: The leading New York debutantes of 1958. Left to right, standing: Linda McKay Stevenson, Sandra Emerson Topping, Elizabeth Sandra Lipson Huntington, Wendy Maria Vanderbilt; seated: Judith Allen Thompson and Alexandra Creel.

ABOVE: Brenda Diana Duff Frazier Kelly Chatfield-Taylor, a prominent member of New York society, 1955. When she made her debut as Diana Frazier in 1938, she was the most famous of all "Glamour Debutantes."

ABOVE: Philip Van Rensselaer in his pied-à-terre in New York City, c. 1960. When I wasn't covering New York parties, I had plenty of other assignments, including an article on New York's "glittering socialites," and I found myself stalking descendants of some of the oldest families in the land. One of them was Philip Van Rensselaer, whose ancestors were among the original Dutch patroons who settled in upstate New York.

OPPOSITE: Truman Capote in his Brooklyn Heights apartment with his souvenirs from all over the world, 1958. I was shooting a story at the time called the "Effete East."

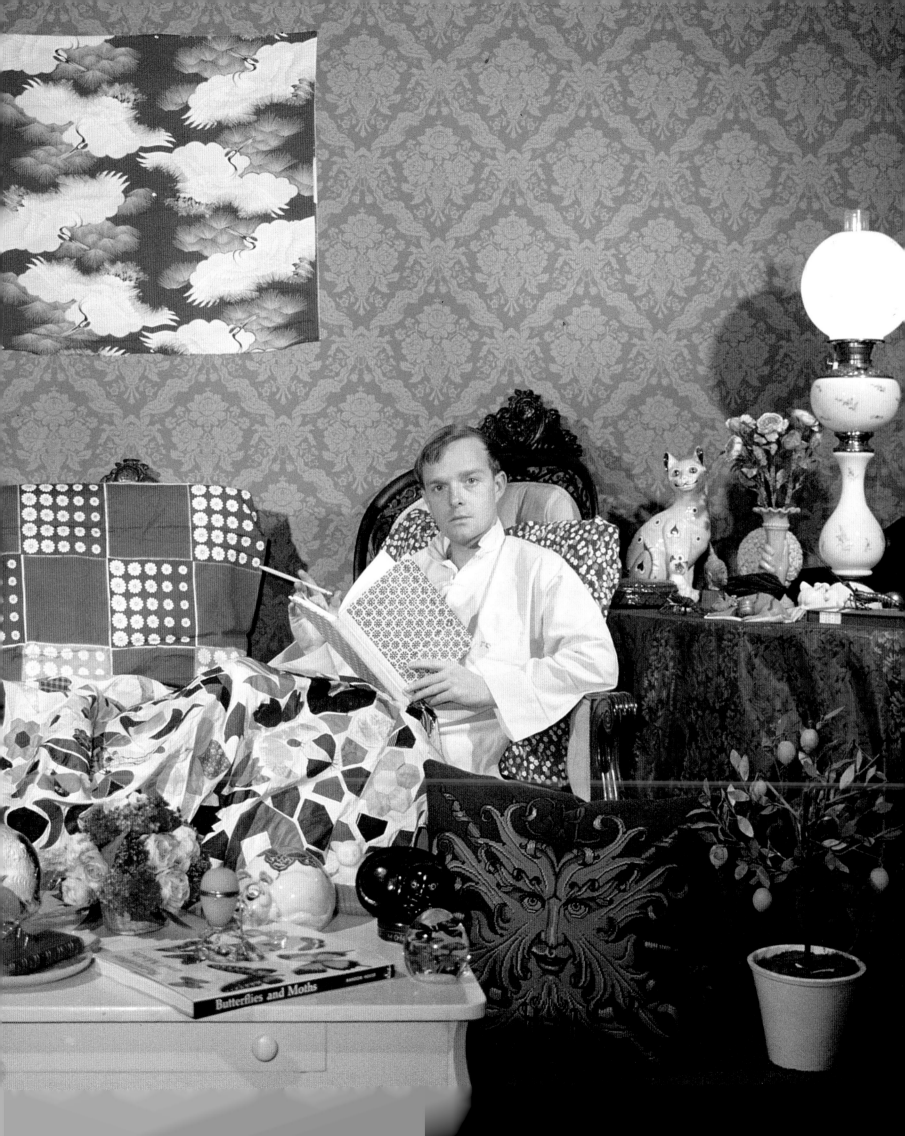

OPPOSITE: Of all the photographs I took of the Rockefellers, my favorite is the one of David in the excavation for Chase Manhattan Plaza. He never liked this photo, but he was a very good sport about it. To me it's a picture that really tells a story. One of the city's most powerful men, and the driving force behind the rebuilding (in another era) of the Financial District, shown on the site of his creation, c. 1955.

ABOVE: Nelson Rockefeller, later to become a four-term Republican Governor of New York and also Vice President of the United States, 1955.

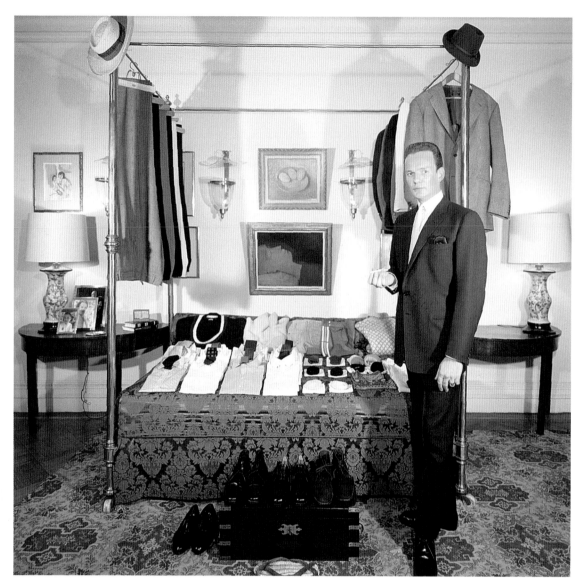

ABOVE: Patrick O'Higgins, a former British infantry captain in the Irish Guards, strikes a military pose before his complete all-season wardrobe in his New York apartment, late 1950s. O'Higgins was the aide-de-camp to Mme. Helena Rubinstein and traveled the world with her. He was also a terrific writer who seemed to always know who was doing what and to whom. His biography of Rubinstein was a bestseller. This shot shows what a man about town should have in his wardrobe.

OPPOSITE: On another assignment I was really bowled over by the apartment of Prince and Princess Archil Gourielli on Park Avenue. It spread over three floors and contained twenty-six rooms and ten baths. It also exhibited a fantastic collection of Impressionist and modern art, including Picasso's tapestry *Women*, flanked left and right by two paintings by Georges Rouault, *Fleur du Mal* and *Clown*. The Prince was a White Russian by birth; the Princess is better known as the incomparable Helena Rubinstein, founder of the cosmetics company. Here they are in their living room, c. 1955

OVERLEAF: Mrs. William de Rham's dancing class at the River Club, 1959. Left to right: unidentified, Arturo Ramos, Jr., Constance Rogers, Stephen C. Sherrill, Nedenia Rumbough, Michael Lotsch, Georgiana Berryman de Rham, Floyd Jefferson, Lorian Ramos, Austin Hearst, and two unidentified. Mrs. de Rham's class was one of those institutions, a rite of passage perhaps, for New York aristocrats. It was for many years a training ground in the gentle arts of poise, manners, and dancing, and was held once a week in the ballroom of the River Club. I dutifully went over one day to record the antics of the young, getting some great shots. Kids are always fun to work with, though results can be unpredictable.

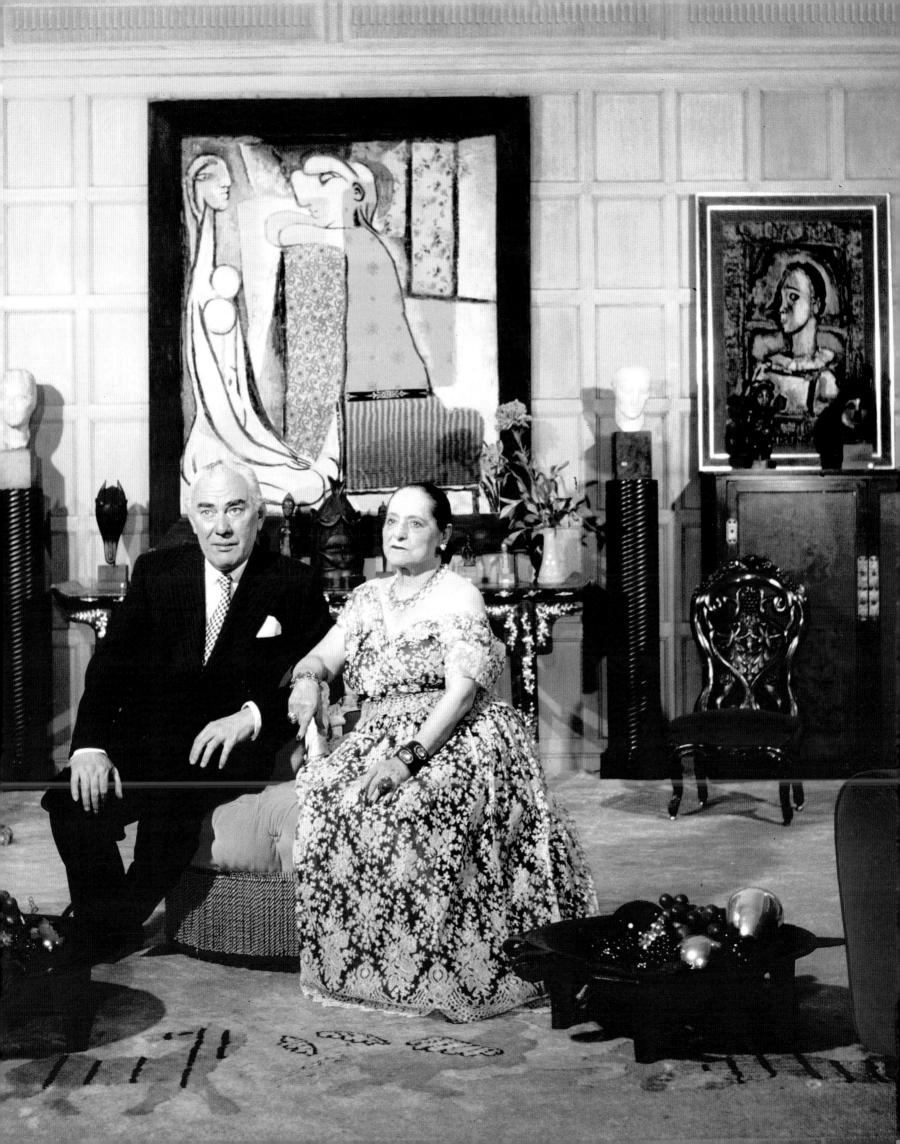

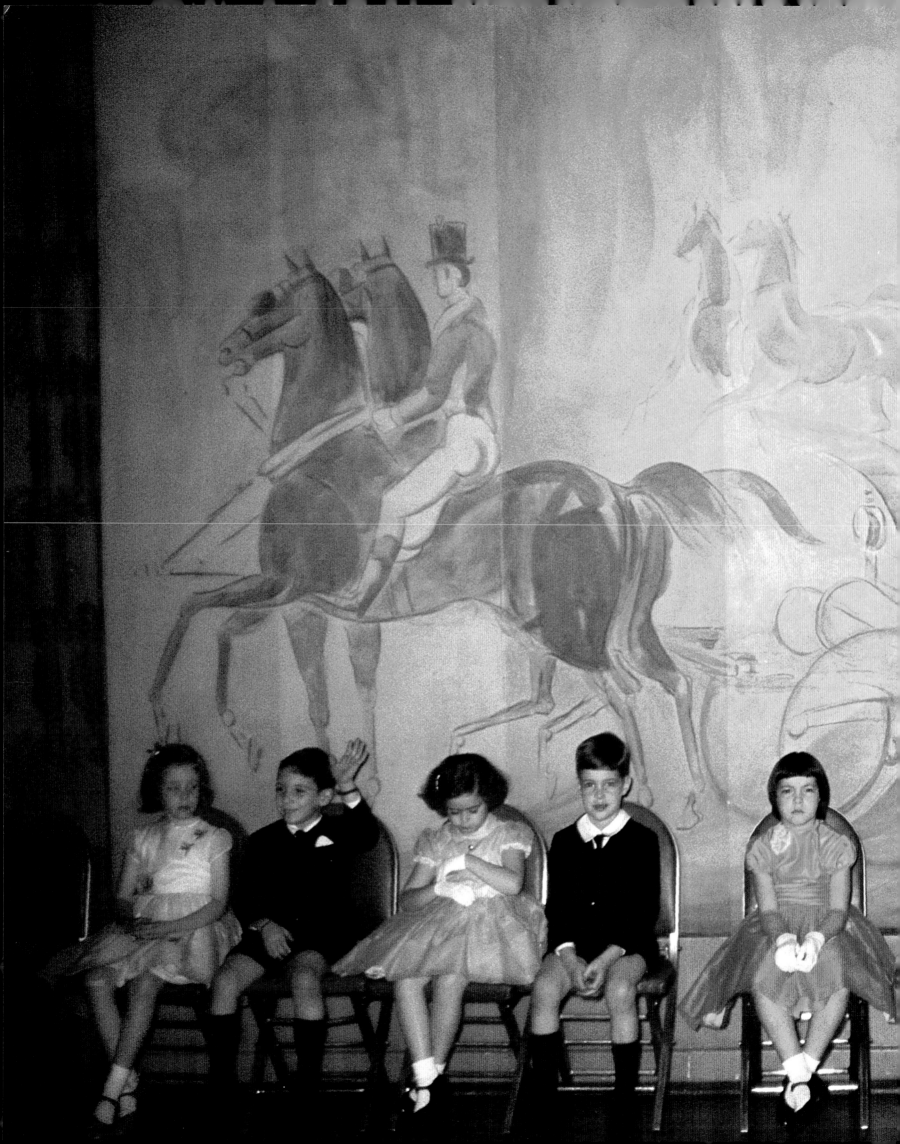

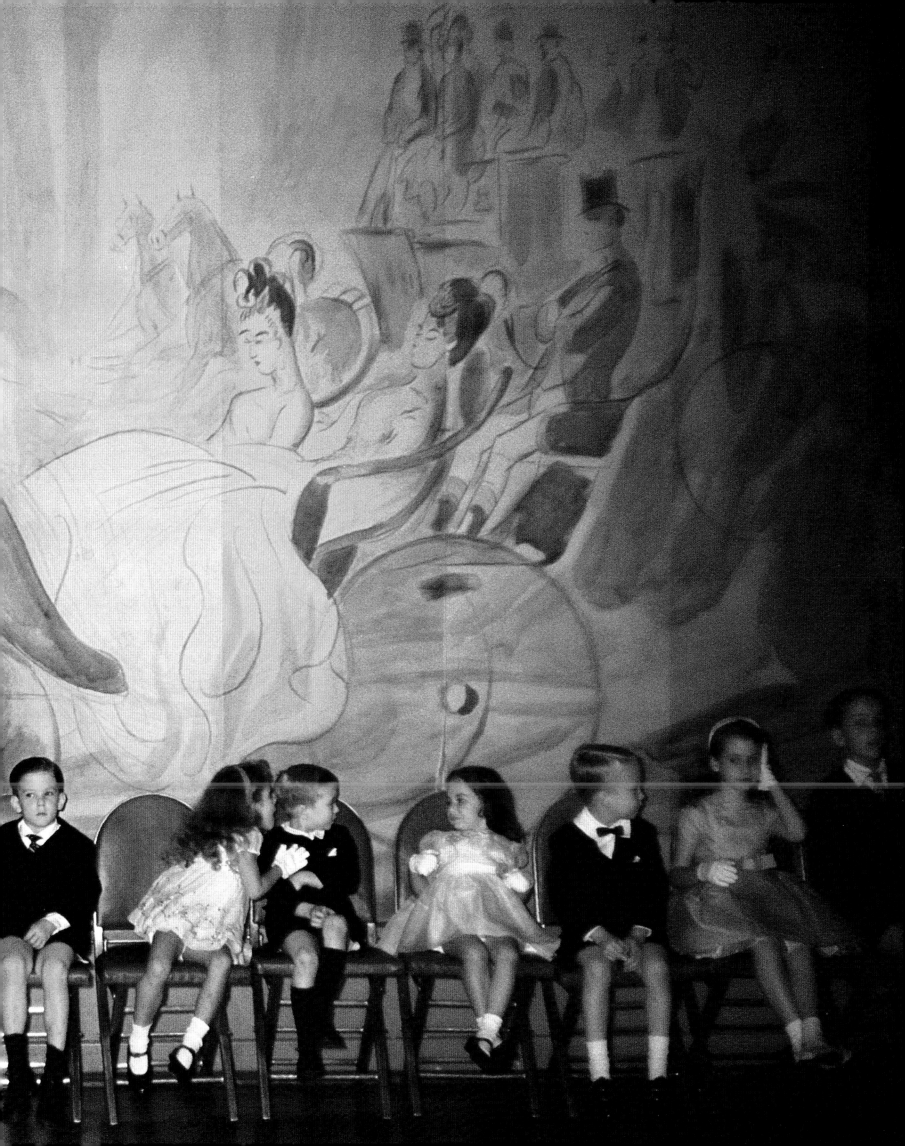

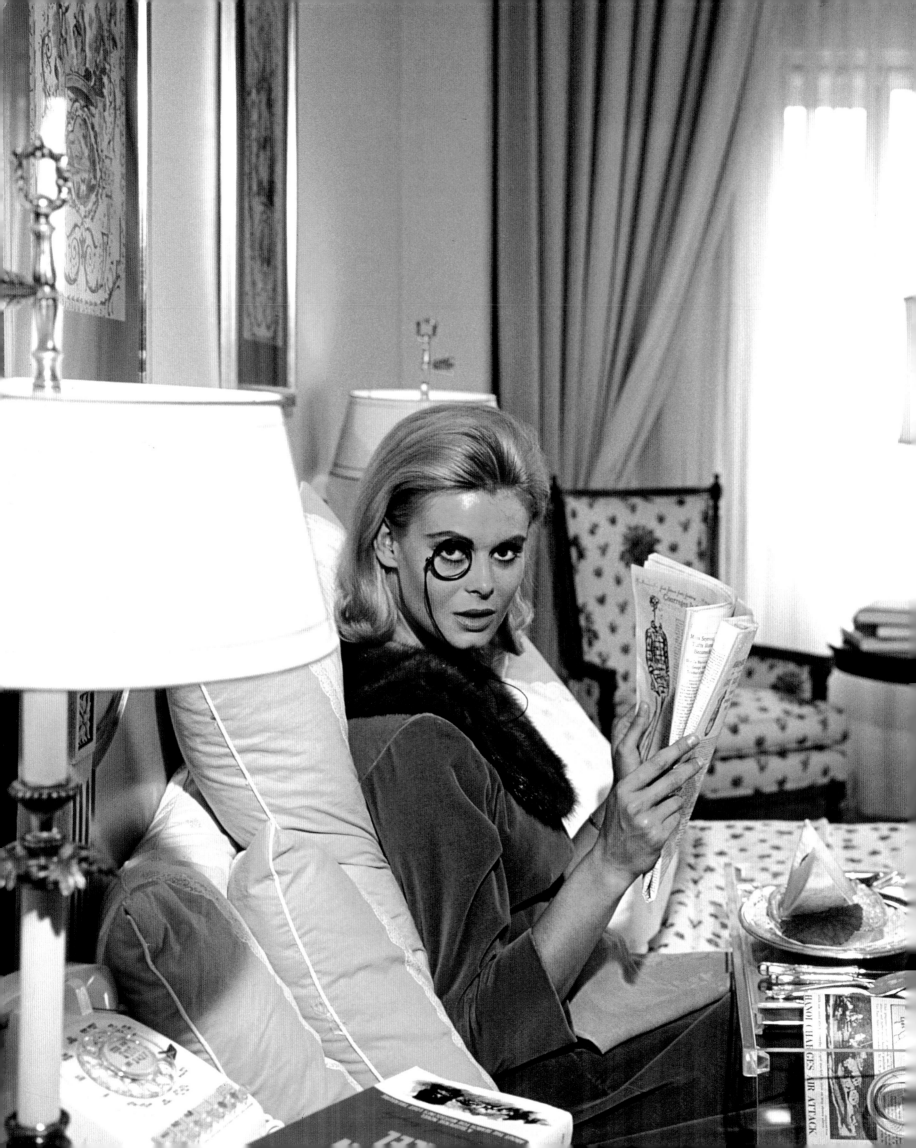

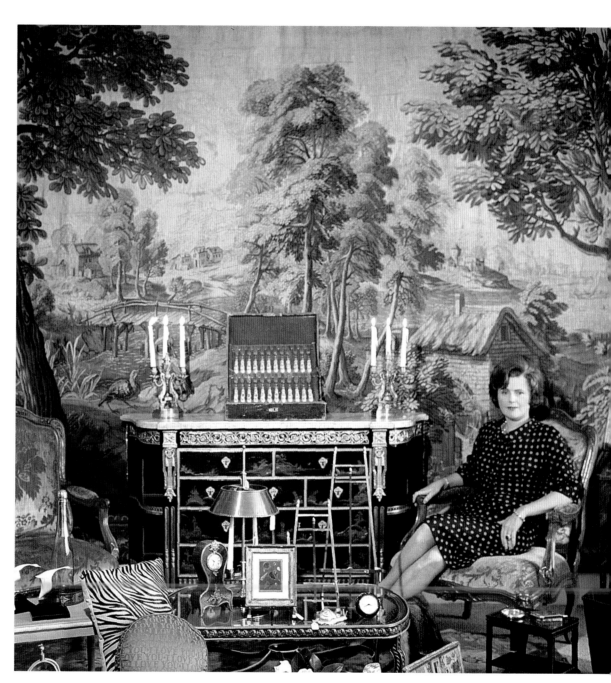

OPPOSITE: German actress and model Renata Boeck of James Bond fame breakfasts in a suite at the Regency Hotel in New York, 1964. The only thing I had to go by was that she was a German actress, so I got a monocle and had her reading *The Times*. It made the picture.

ABOVE: Mrs. Leland Hayward, better known as Pamela Churchill Harriman, who later became U.S. Ambassador to France, in a moment of repose at her New York City antiques shop, the Jansen Shop, 1964.

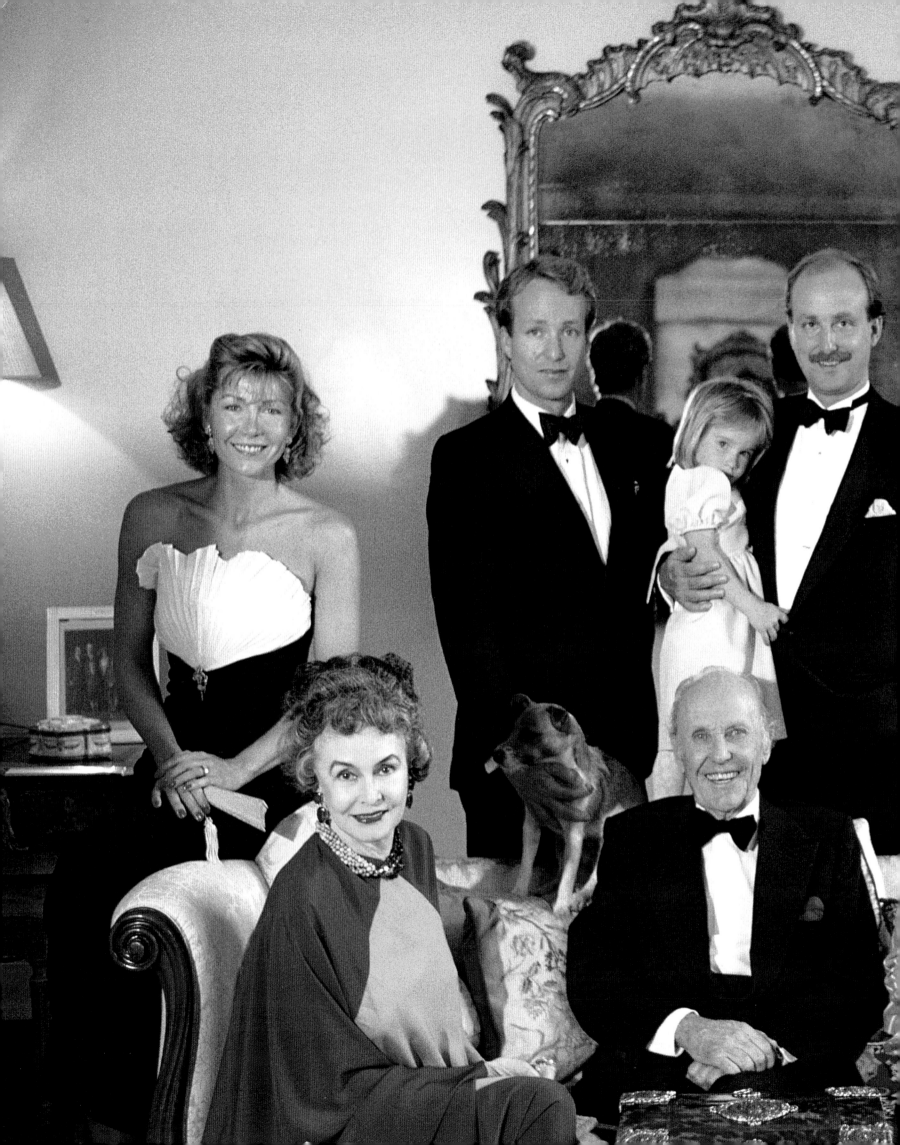

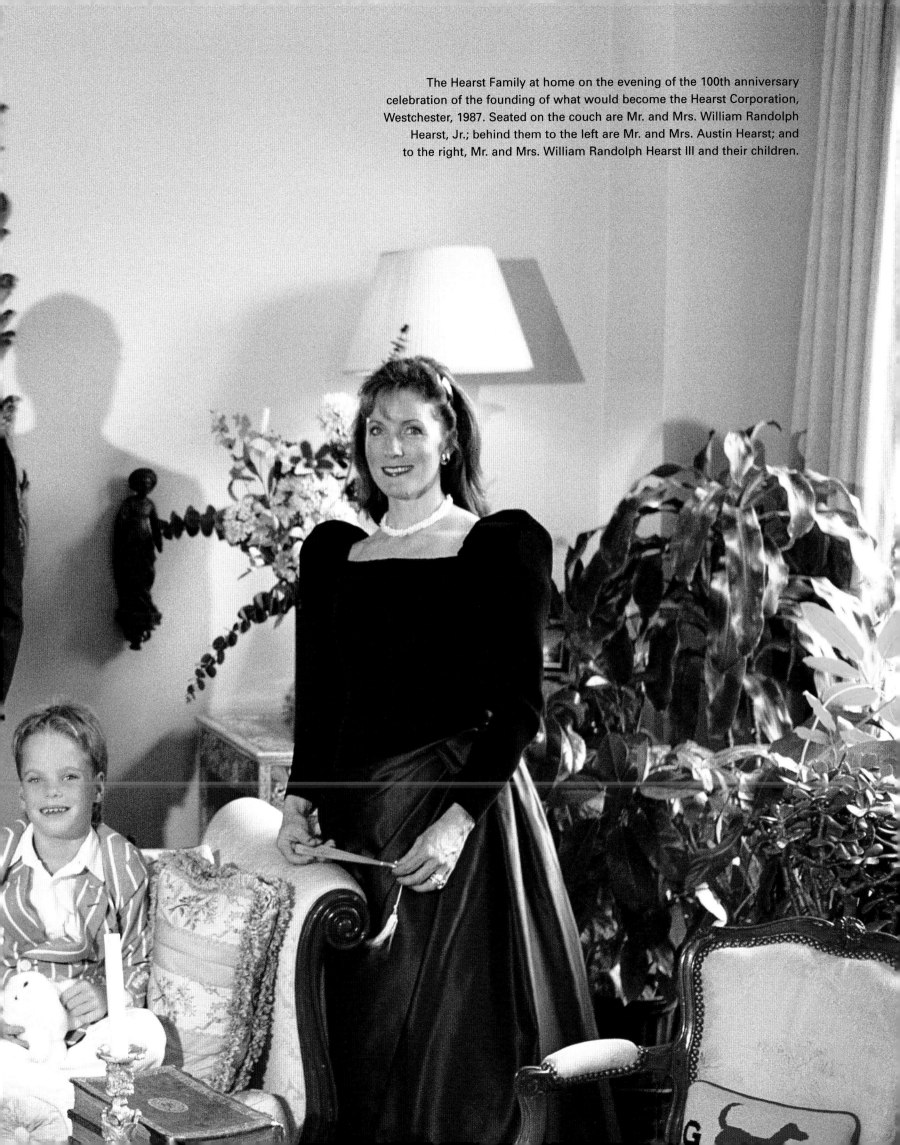

The Hearst Family at home on the evening of the 100th anniversary celebration of the founding of what would become the Hearst Corporation, Westchester, 1987. Seated on the couch are Mr. and Mrs. William Randolph Hearst, Jr.; behind them to the left are Mr. and Mrs. Austin Hearst; and to the right, Mr. and Mrs. William Randolph Hearst III and their children.

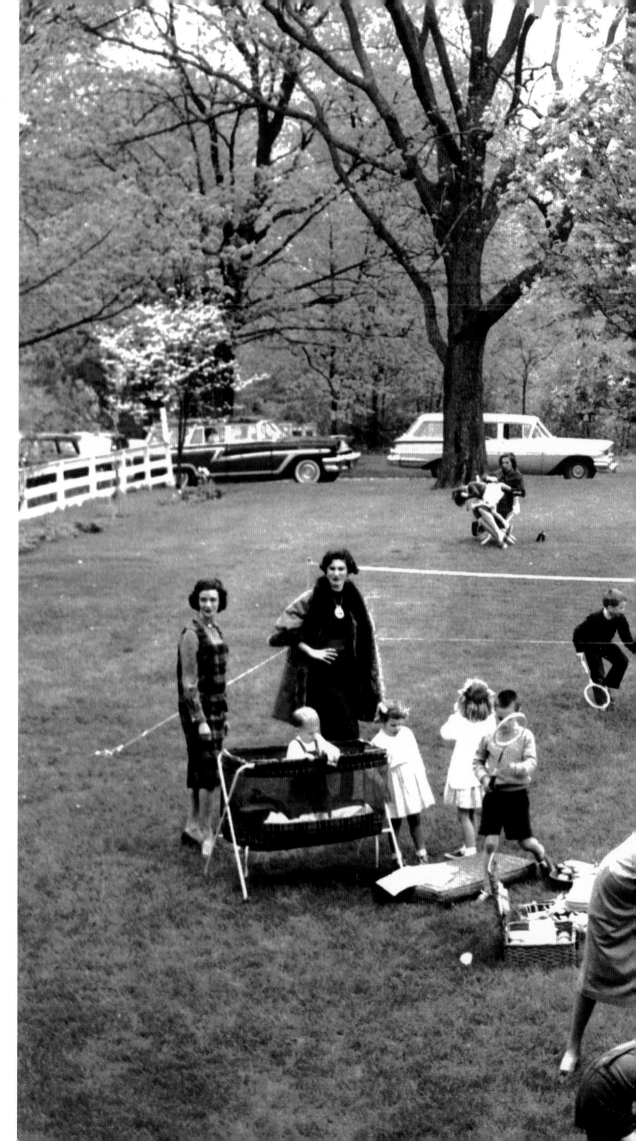

In the town of Bedford, New York, 1960. I shot this photograph for *Holiday* magazine for an article on New York's bedroom communities. I had my wife round up all her friends and their kids on our lawn and this is what happened. That little girl on the cellar door being chased by a boy is Cary Ohler, the daughter of Carol Hardenberg. My wife grew up with Carol. Little Cary Ohler, who is now grown and works for me as my partner, is being chased by young Bill Mayo-Smith. Liz Renshaw is seated in the background holding her new baby who grew up to become Nina Griscom. The rest includes the Wyeth, Evert, Davis, and Gwynne families.

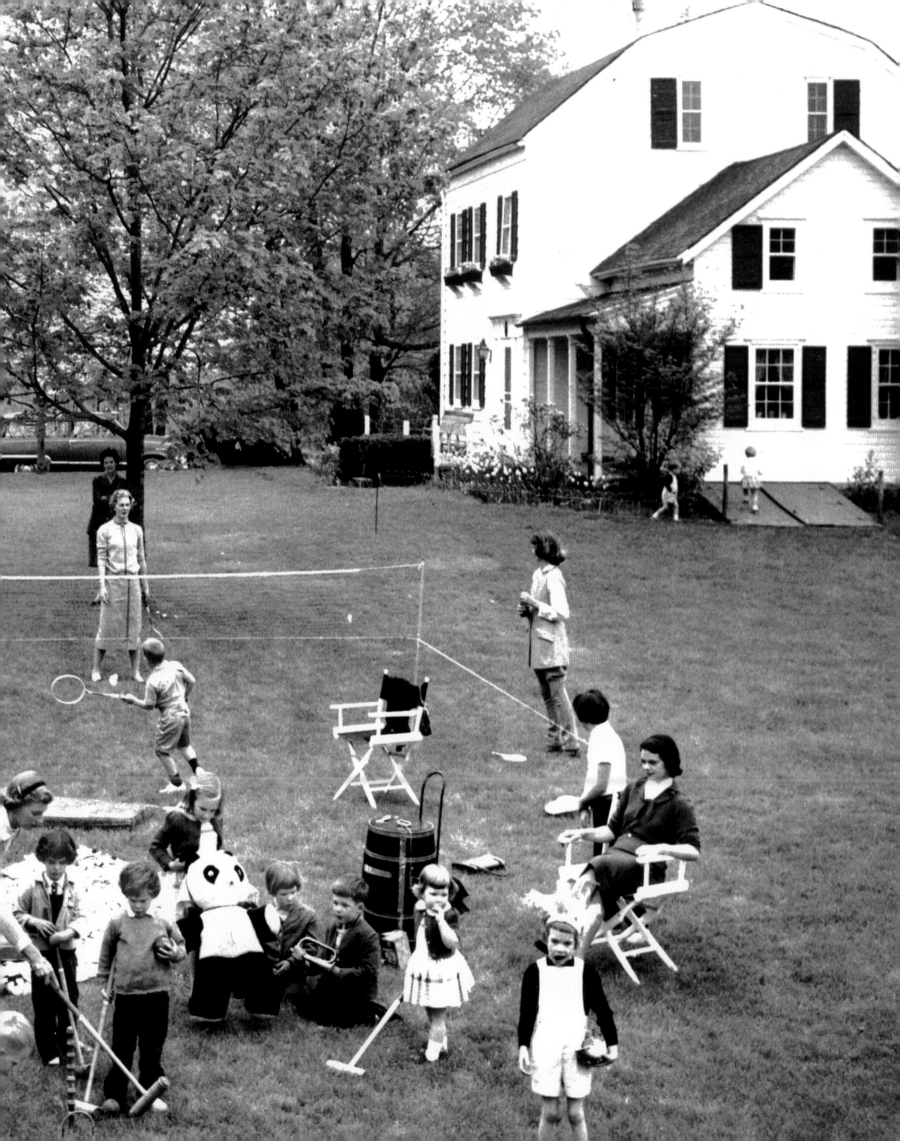

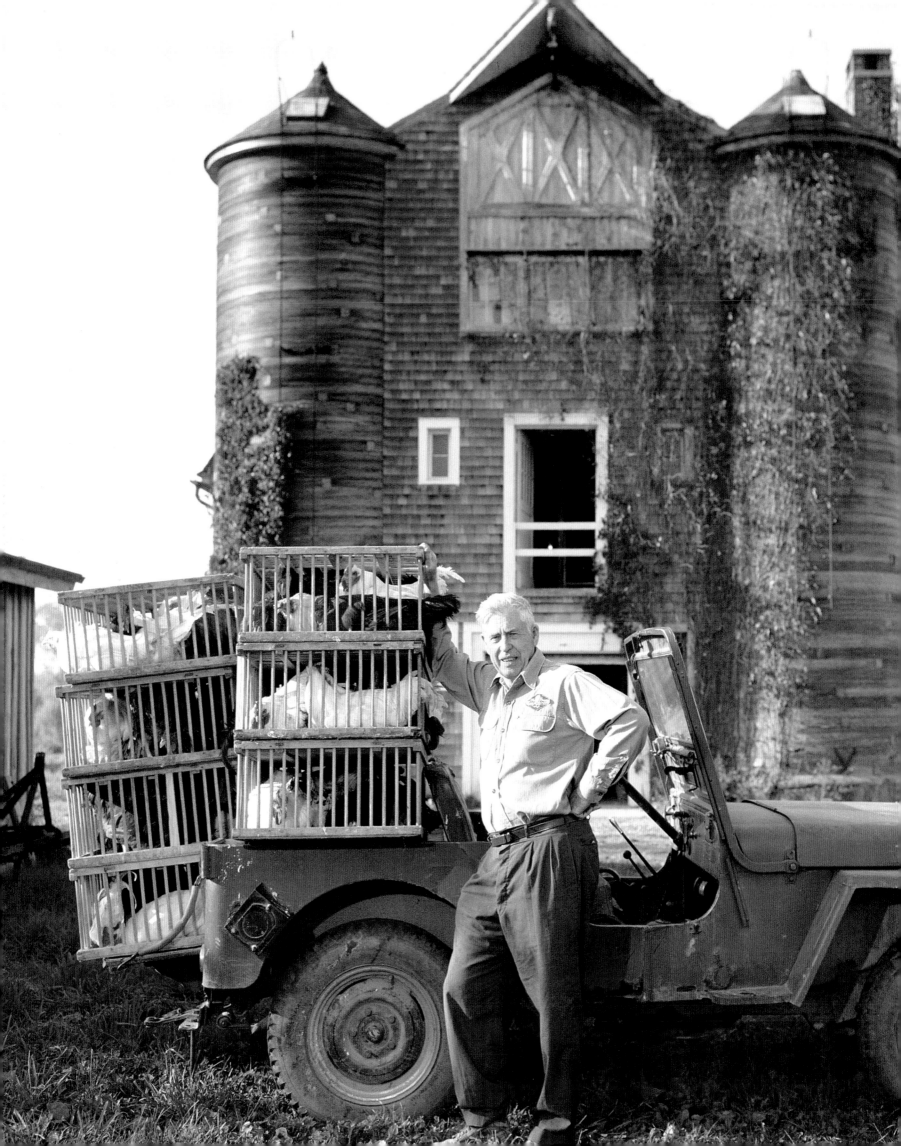

OPPOSITE: Henry Wallace, former Secretary of Agriculture, Vice President under Harry S. Truman, and presidential candidate, raised vegetables, flowers, and several breeds of chicken on his 115-acre South Salem farm in Westchester County, 1962. My daughter loved going up to his farm because he would always give her eggs. It was like Easter all year round.

BELOW: Cass Canfield, distinguished book editor and publisher, outside his home, Crowfields, in Bedford, New York, 1960.

OVERLEAF: Mr. and Mrs. John M. Seabrook at the Seabrook estate and farm in Seabrook, New Jersey, 1958. Jack Seabrook's American roots go back three hundred years, to when the Seabrook family first cultivated their fifty-thousand-acre tract of land in Seabrook. Among other activities, Jack Seabrook was raising purebred Morgan horses on his beautiful ancestral estate.

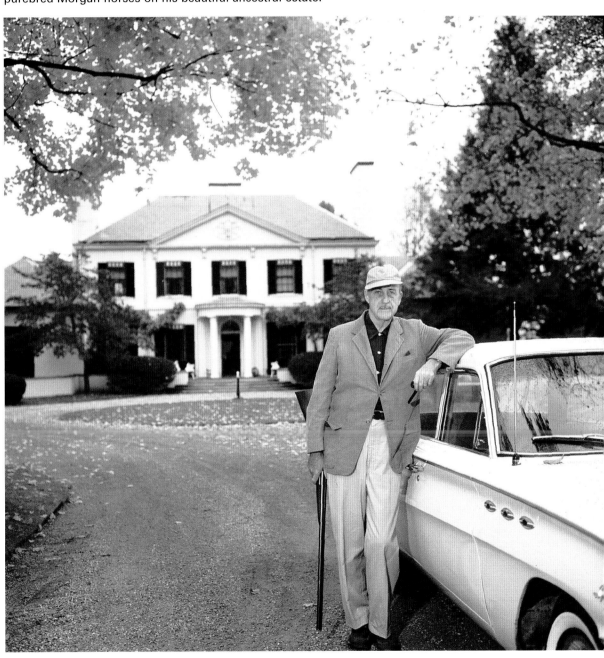

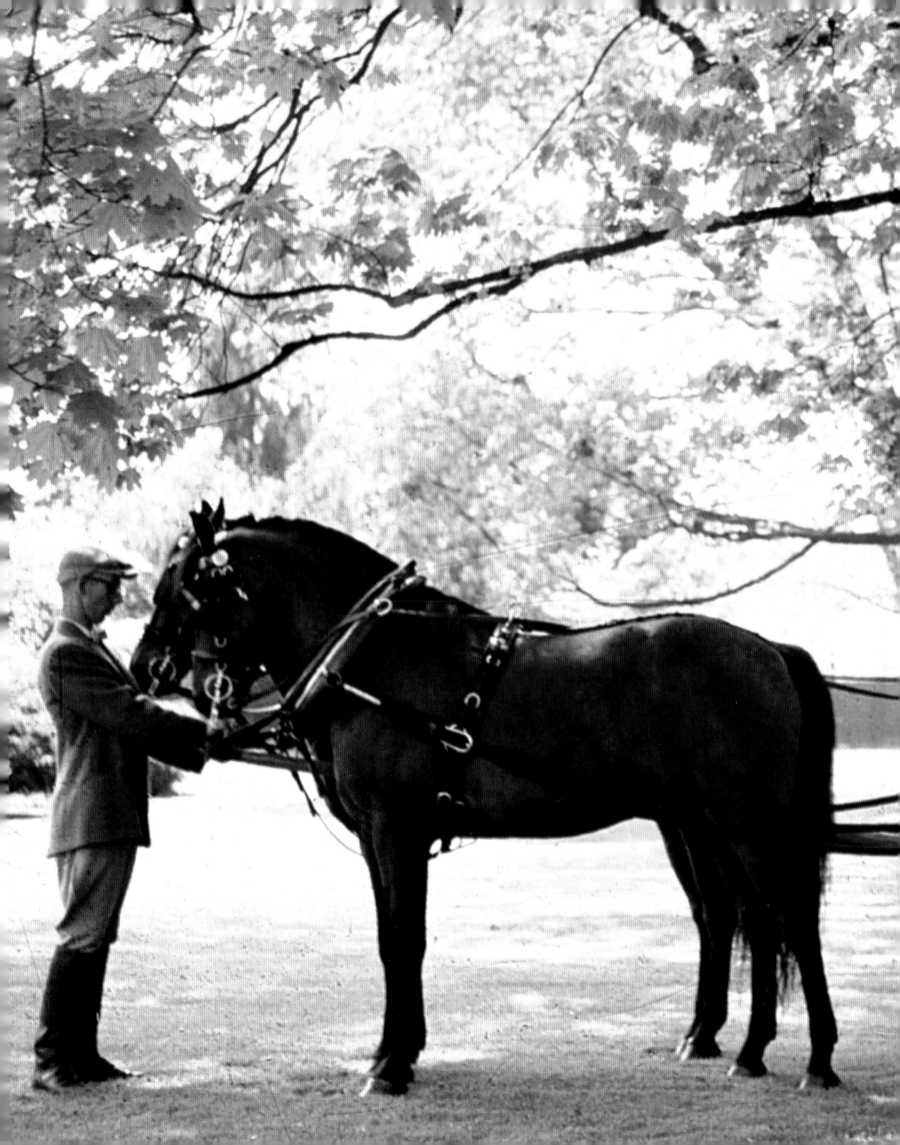

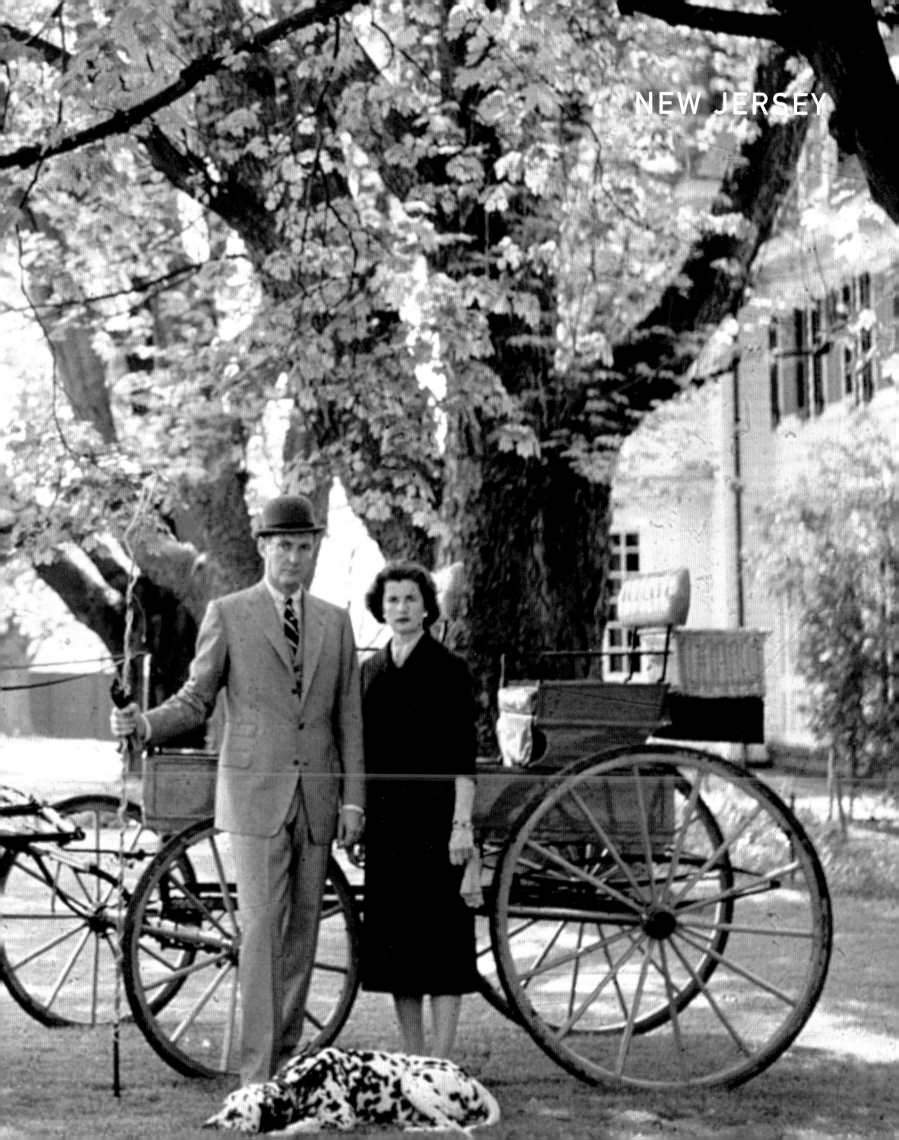

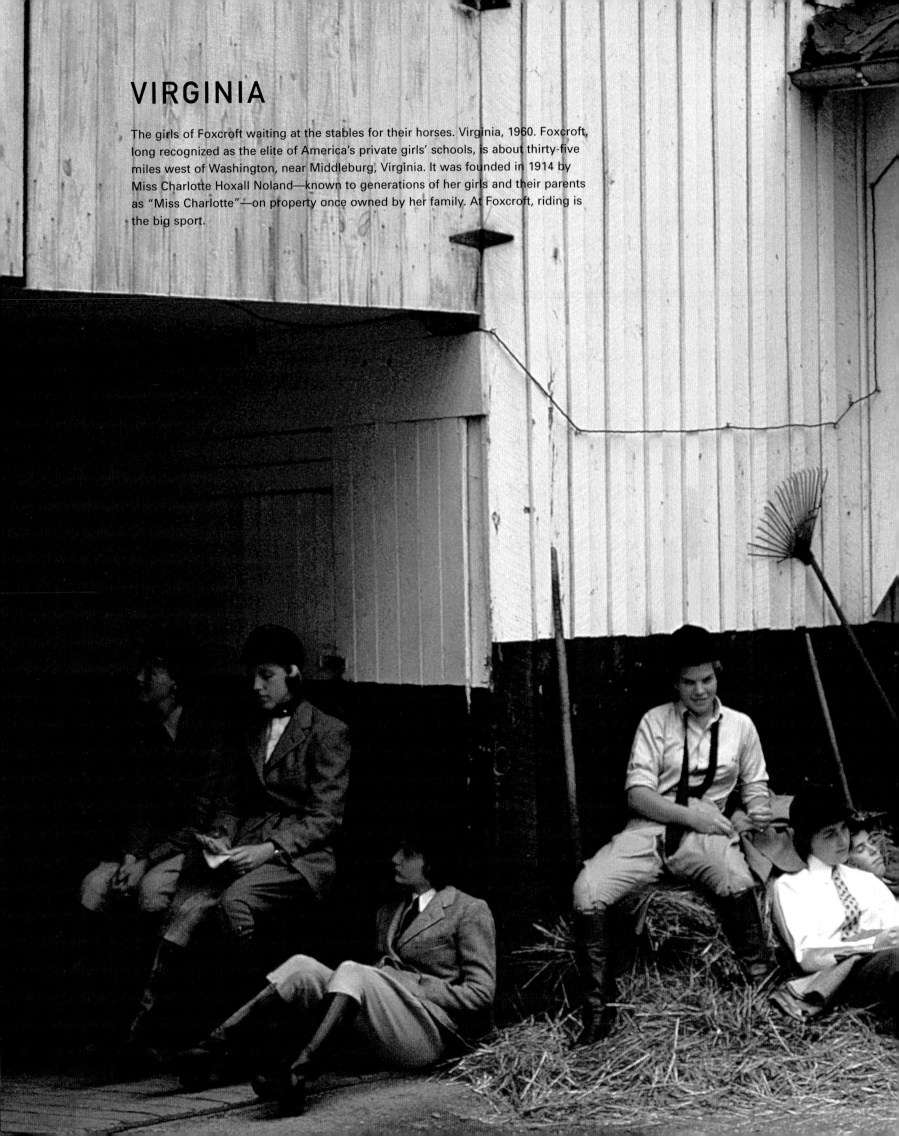

VIRGINIA

The girls of Foxcroft waiting at the stables for their horses. Virginia, 1960. Foxcroft, long recognized as the elite of America's private girls' schools, is about thirty-five miles west of Washington, near Middleburg, Virginia. It was founded in 1914 by Miss Charlotte Hoxall Noland—known to generations of her girls and their parents as "Miss Charlotte"—on property once owned by her family. At Foxcroft, riding is the big sport.

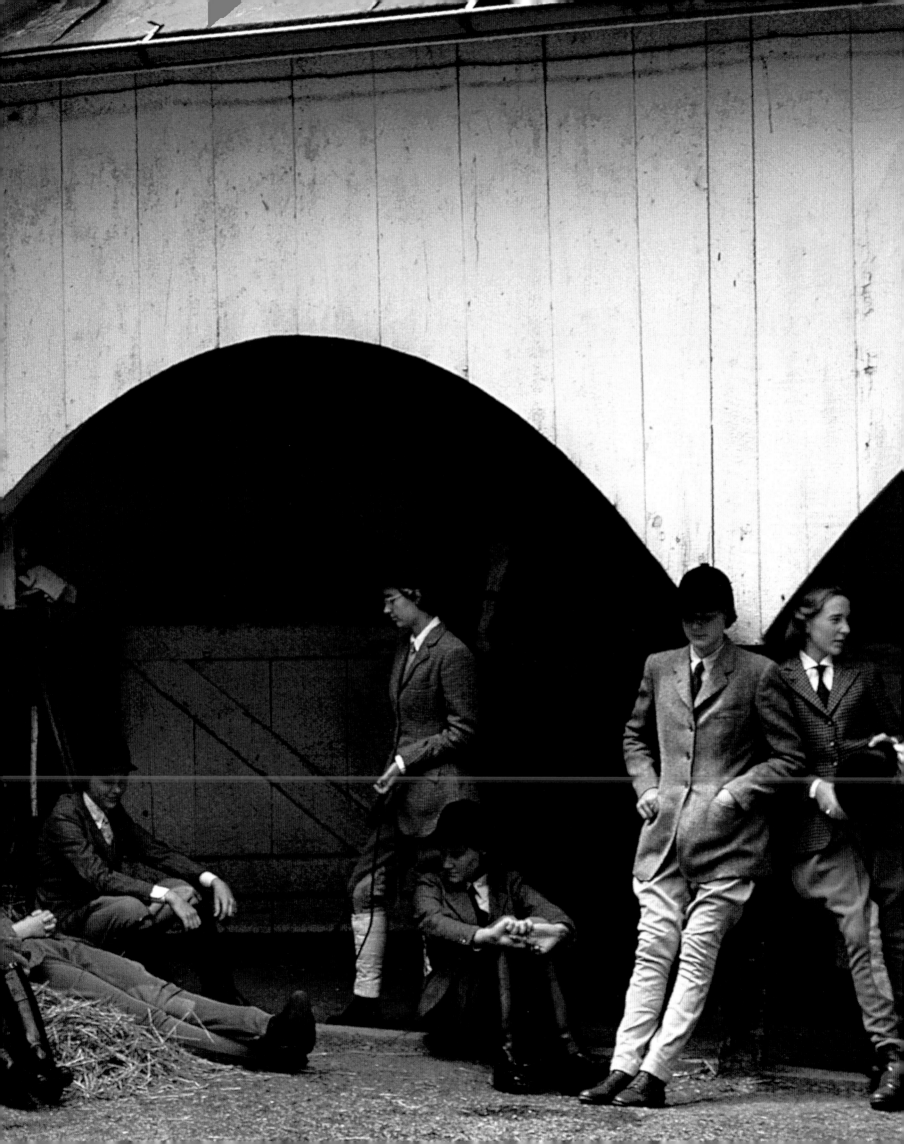

BERMUDA

BELOW: The view from the Bermudiana Hotel looking toward Paget, where the exclusive homes are, 1957. In the foreground is the Royal Bermuda Yacht Club, the patriarch of Bermuda racing, founded in 1844. On Thursday afternoons the stores close for no better reason than that the fathers and grandfathers of the owners did it, usually to go sailing. Sailing is an essential part of the lifestyle of most Bermudians, and most of those who sail belong to the Royal Bermuda Yacht Club, the patriarch of Bermuda racing and by far the most exclusive club in the colony.

OPPOSITE: Polly Trott Hornburg in front of her father's very Bermudian house, 1957. She wears her own designs—Thaibok slacks and shirt. Bermuda is the oldest English-speaking community in the western hemisphere and it is dominated by a close-knit hierarchy of families that date back to the founding of the colony in 1612.

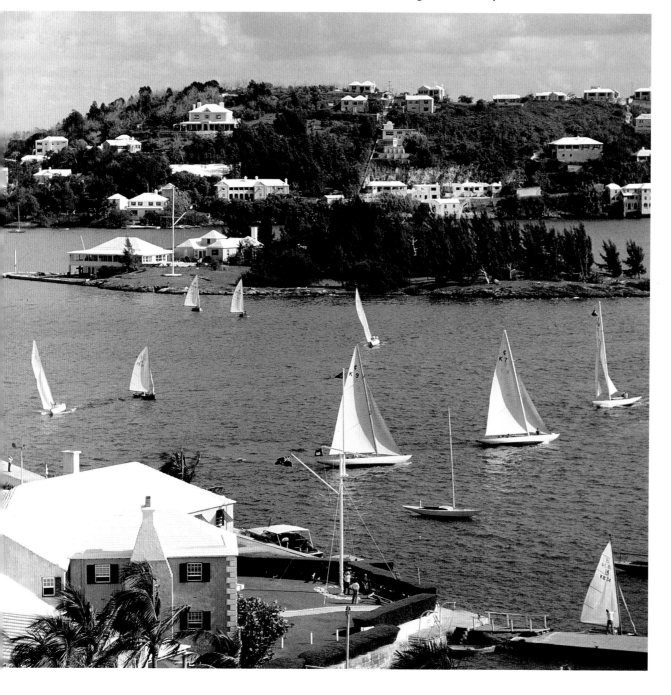

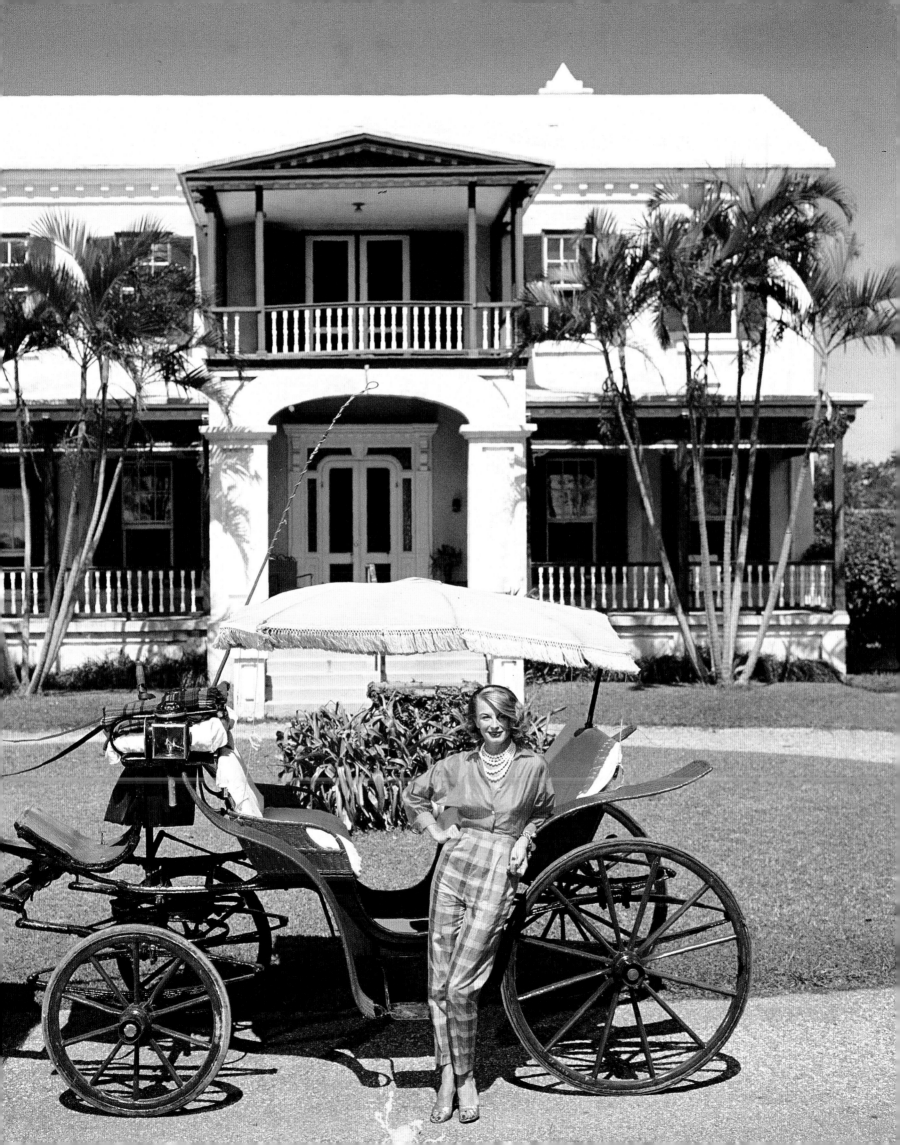

PALM BEACH

BELOW: Elizabeth Matthews, descendant of H. M. Flagler, cofounder of Palm Beach, seated in her great-grandfather's favorite chair in front of the Flagler mansion, now the Flagler Museum, 1968.

OPPOSITE: The heart of Palm Beach's gold coast as seen from a helicopter, c. 1955. In the foreground the Bath and Tennis Club, built in 1926; beyond on the left, Mar-A-Lago, the house of Marjorie Merriweather Post Close Hutton Davies May. Palm Beach, ageless, photogenic queen of America's winter resorts, is a special favorite of mine. Beyond Mar-A-Lago, in the middle distance, are some of Palm Beach's most elegant and tasteful Spanish- and Italian-style mansions, built during the boom of the 1920s. To the left, in the far distance, is the Everglades Club and golf course, and to the right, the towers of the Breakers Hotel.

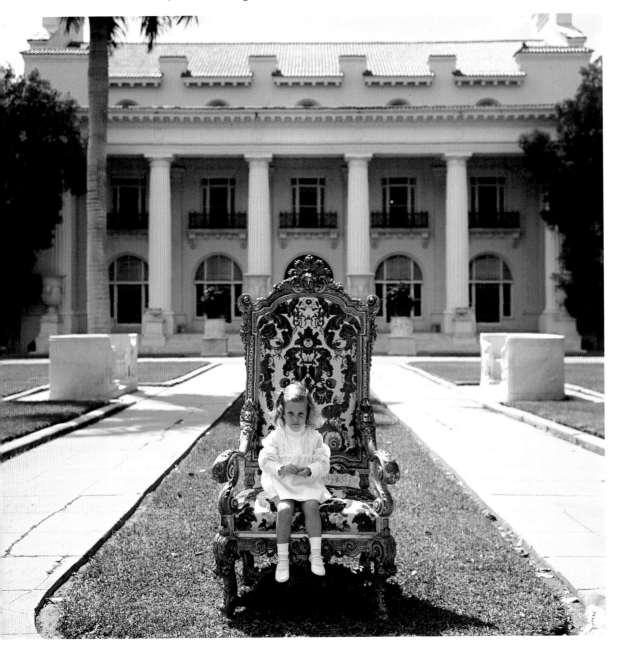

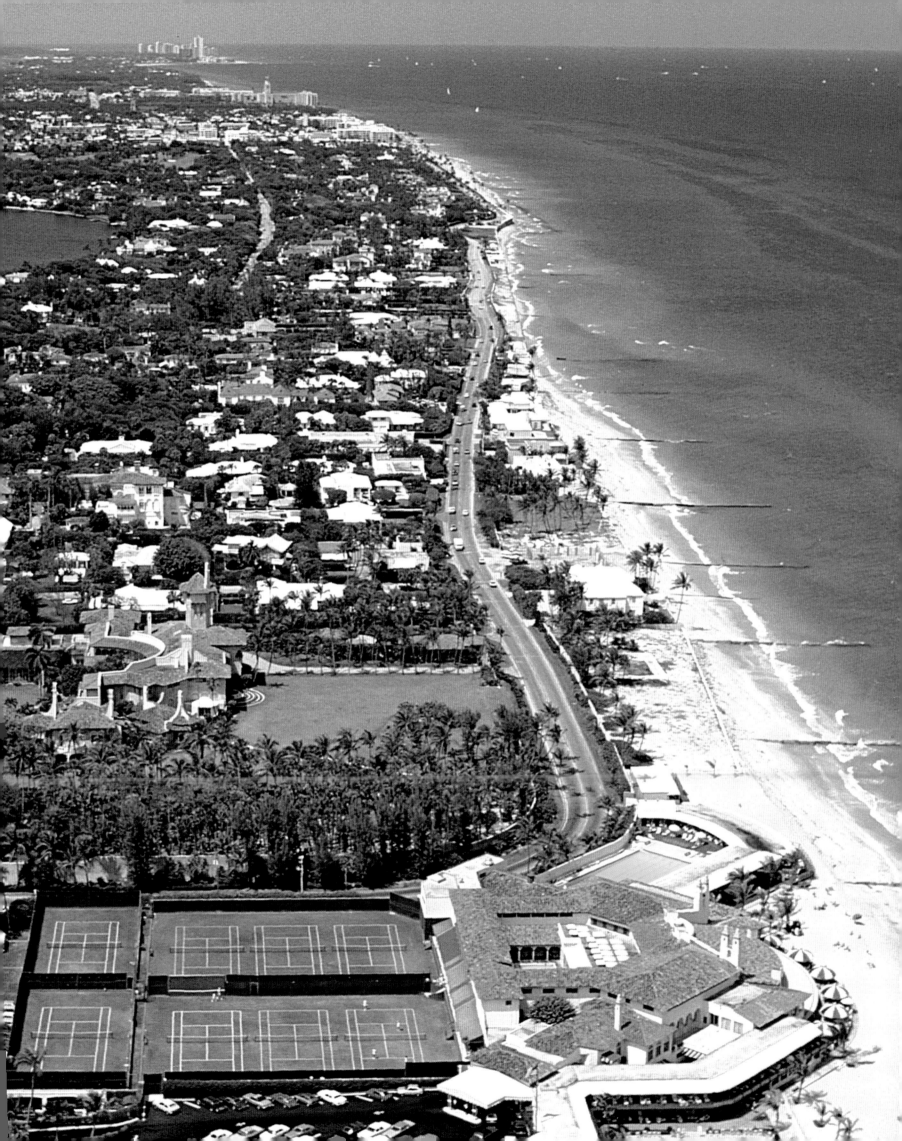

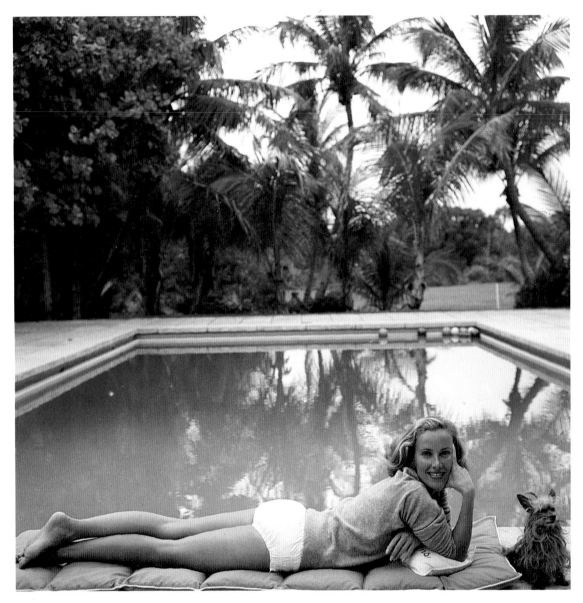

ABOVE: Alice Topping at Ned McLean's pool, Palm Beach, 1959. The dog belongs to Lorelle Hearst.

OPPOSITE: Mrs. F. C. Winston Guest ("Cee Zee") and son Alexander Michael Douglas Dudley Guest at Villa Artemis, in front of the famous Grecian temple swimming pool of her late mother-in-law, the Honorable Mrs. Frederick Guest, 1955. This is a nostalgic shot, probably one of the last taken of this pool and estate before the property was sold. I was always intrigued at how Cee Zee got her nickname. Her brother, "Budsie" Cochrane, enlightened me. While they were growing up in Boston, his older sister, Nancy, had trouble pronouncing "sister"—thus, Cee Zee.

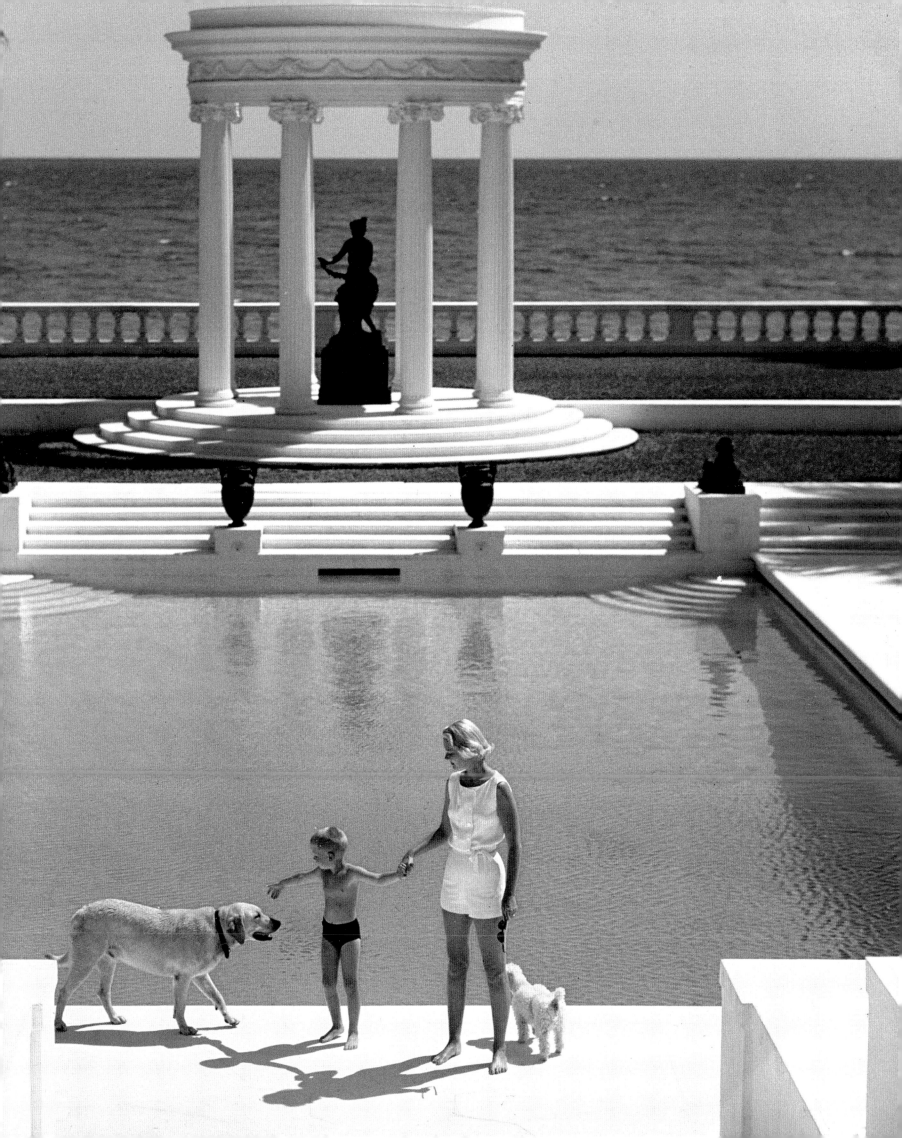

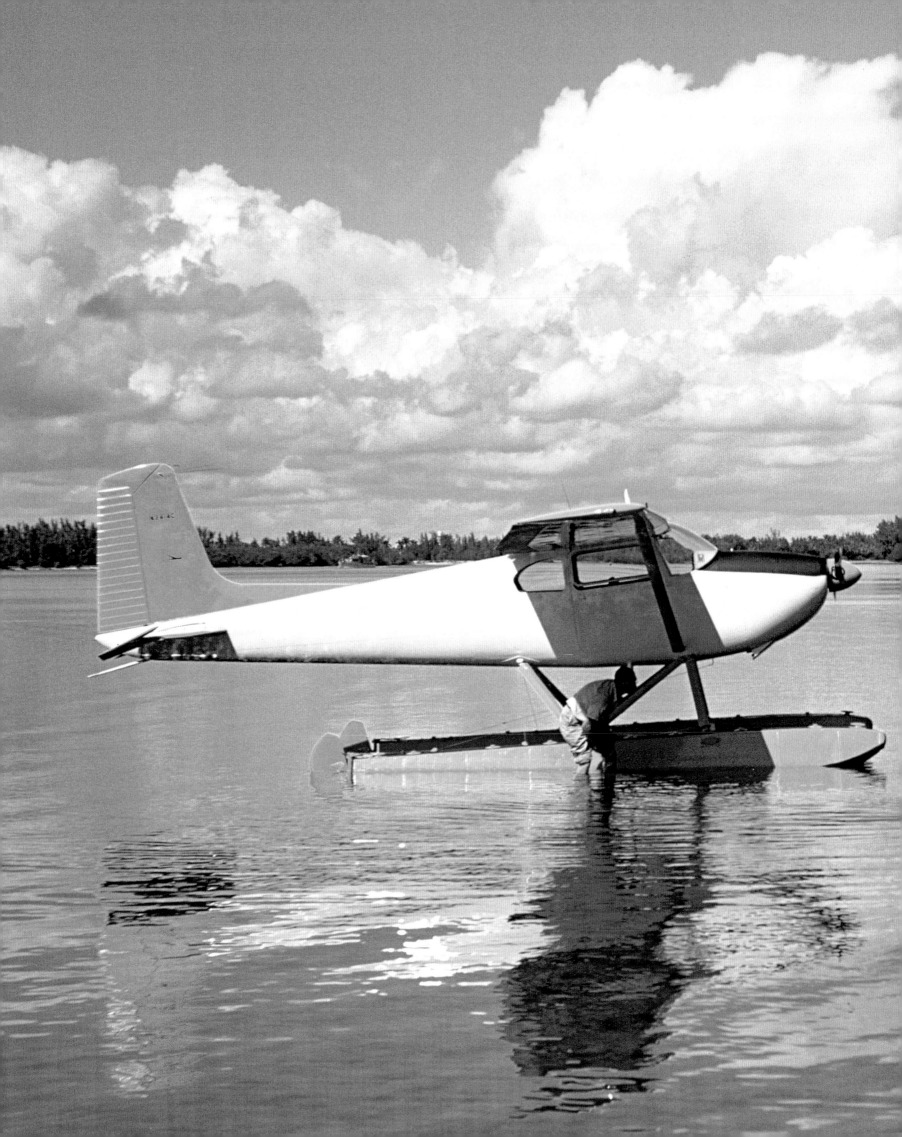

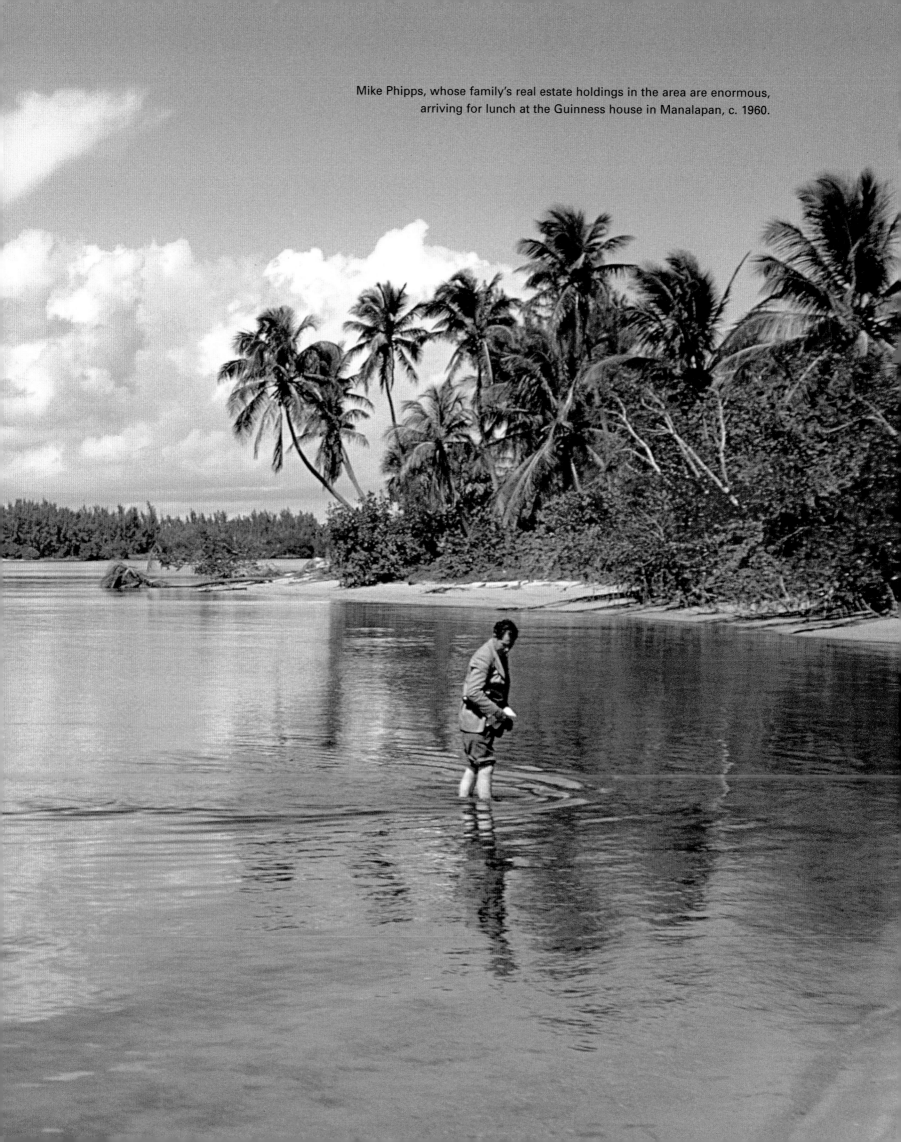

Mike Phipps, whose family's real estate holdings in the area are enormous, arriving for lunch at the Guinness house in Manalapan, c. 1960.

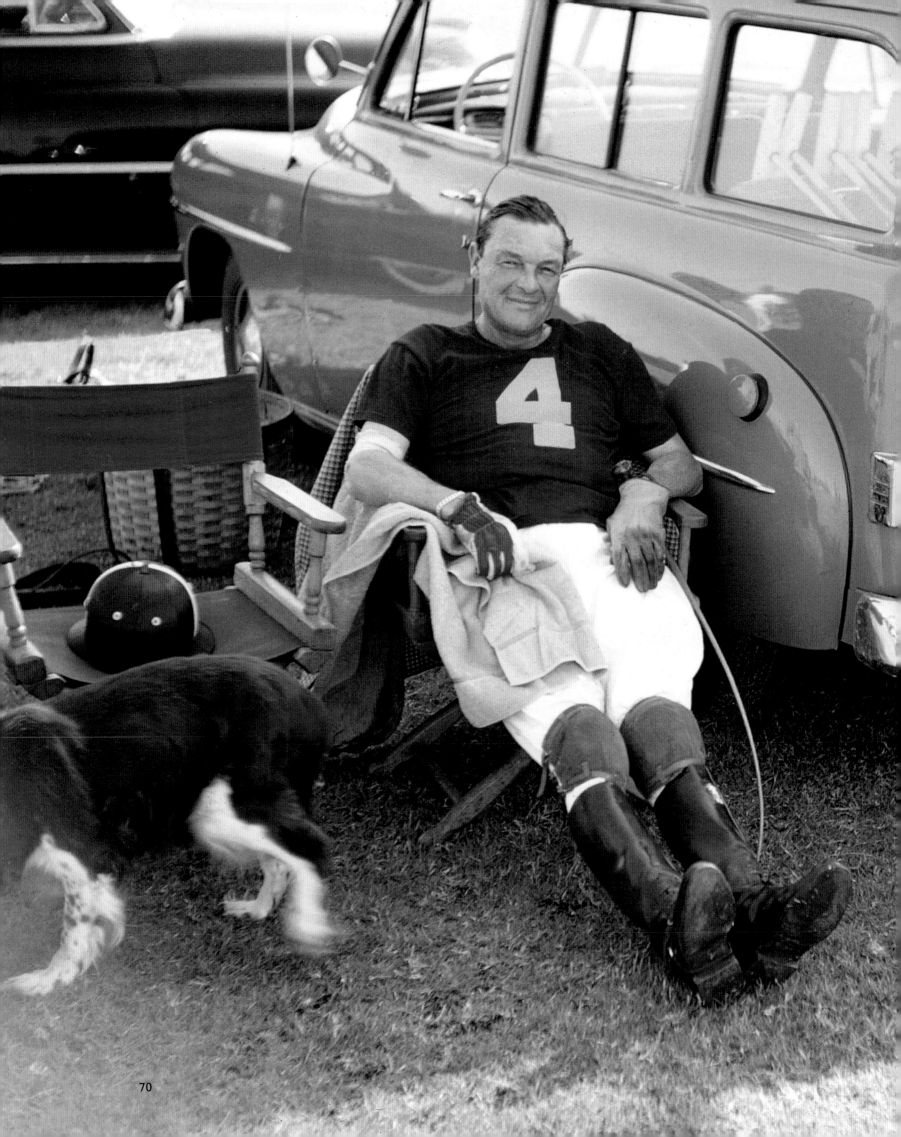

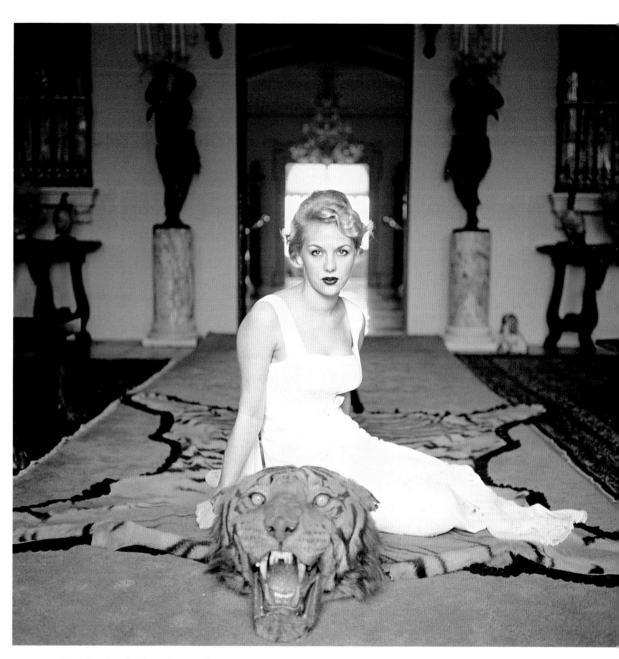

OPPOSITE: Laddie Sanford at the Gulfstream Polo Club, Delray, 1955. A member of an old and distinguished Palm Beach family, he was the great American polo player. I was fortunate to get a picture during the latter part of his career. When Ralph Lauren saw this picture he asked me to do an ad campaign based on it. He said, "Slim, rip yourself off!"

ABOVE: Mrs. George (Daphne) Cameron in the trophy room of Laddie Sanford's house in Palm Beach, 1959. She was too much for ordinary people. There are so many beautiful girls in the world, then there's one that stands out; she had something that you can't explain.

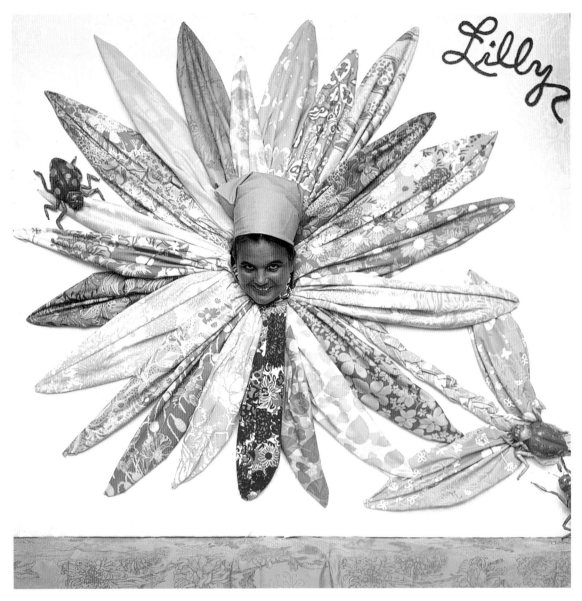

Lilly

ABOVE: Designer Lilly Pulitzer clowns around, 1968. I love this picture of Lilly because she's laughing. She is such a nice person.

OPPOSITE: The young matrons of Palm Beach, a picture I arranged for *Town & Country* with the help of Lilly Pulitzer, 1964.

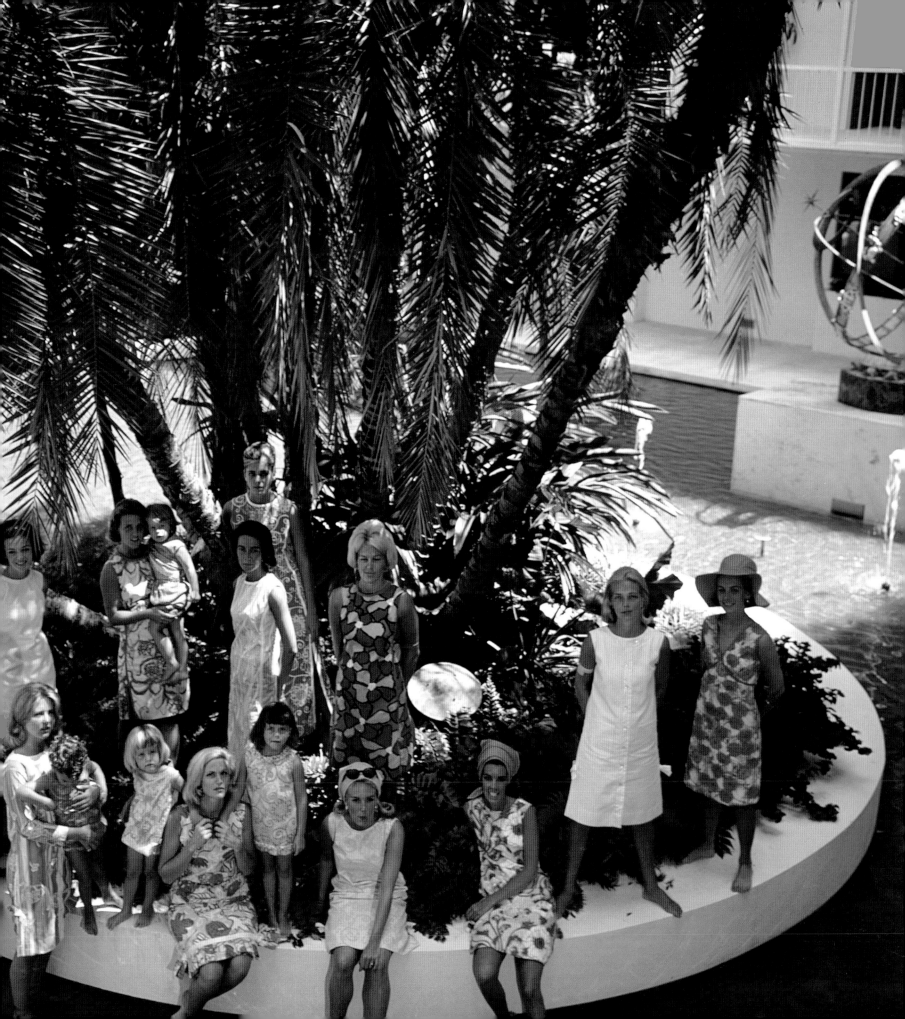

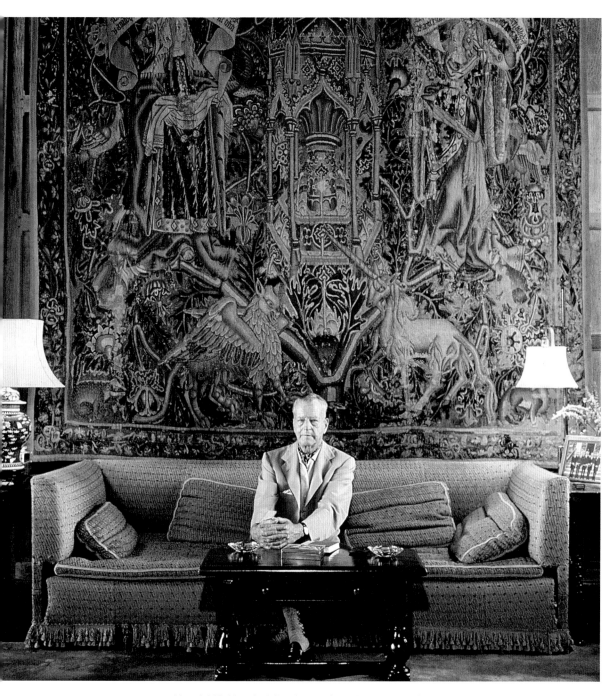

ABOVE: Harold K. Vanderbilt, dean of the Vanderbilt family, great racing skipper, defender of the America's Cup, inventor of contract bridge, in his home in Lantana, Florida, 1956.

OPPOSITE: Jim Kimberly and friend beside Lake Worth, Florida, 1968.

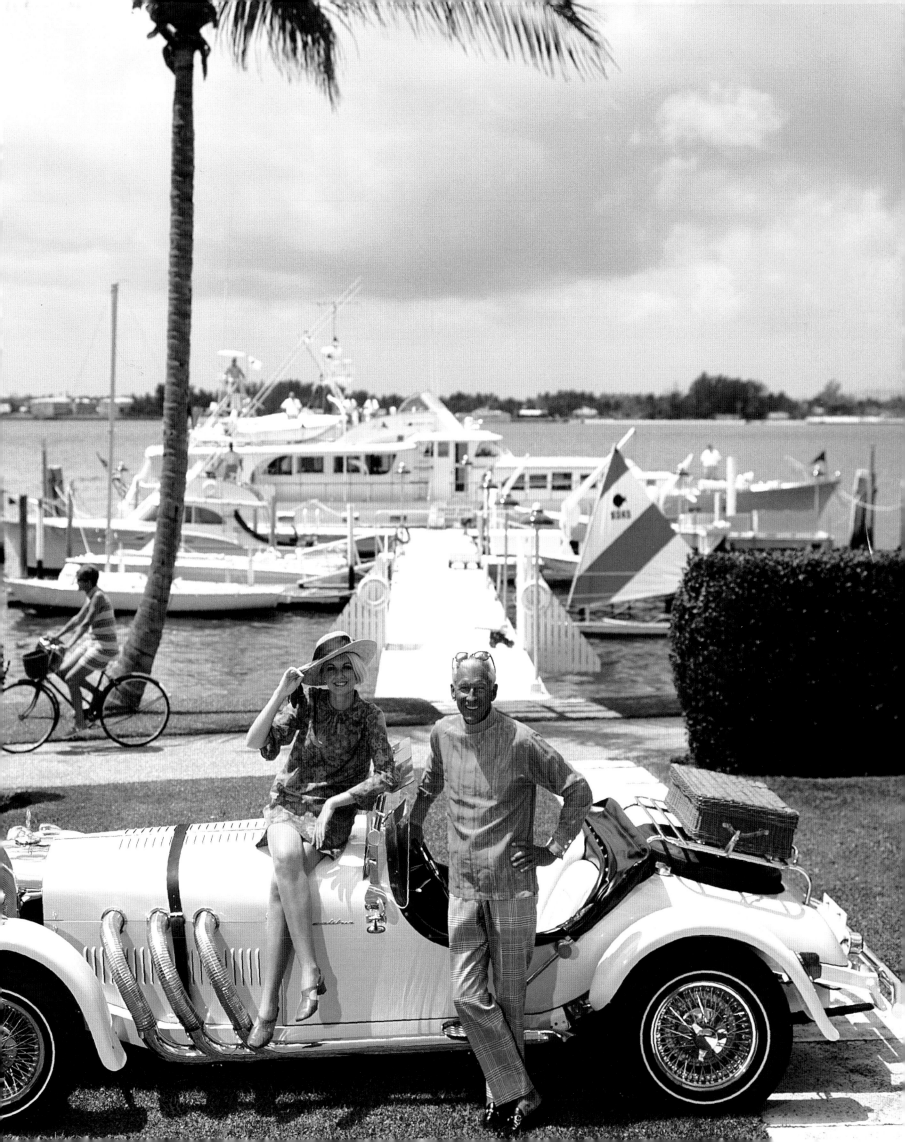

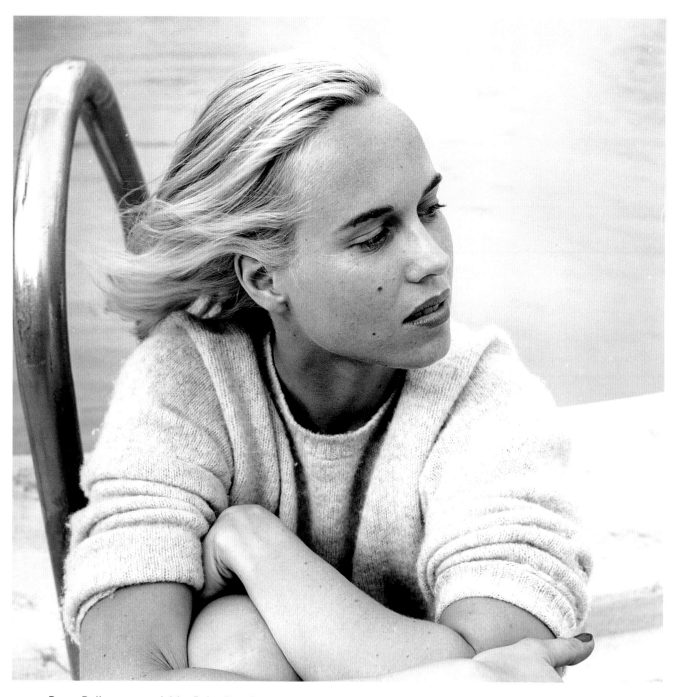

ABOVE: Patsy Pulitzer at poolside, Palm Beach, c. 1955. At the time she was Patsy Bartlett and I photographed her for a *Holiday* cover because she was quite social and sporty.

OPPOSITE: Peter Pulitzer on the patio of his home in Palm Beach, 1968. Of all the people I have photographed, three have a perpetual tan: Peter Pultizer, Palm Beach Willy Hutton, and George Hamilton.

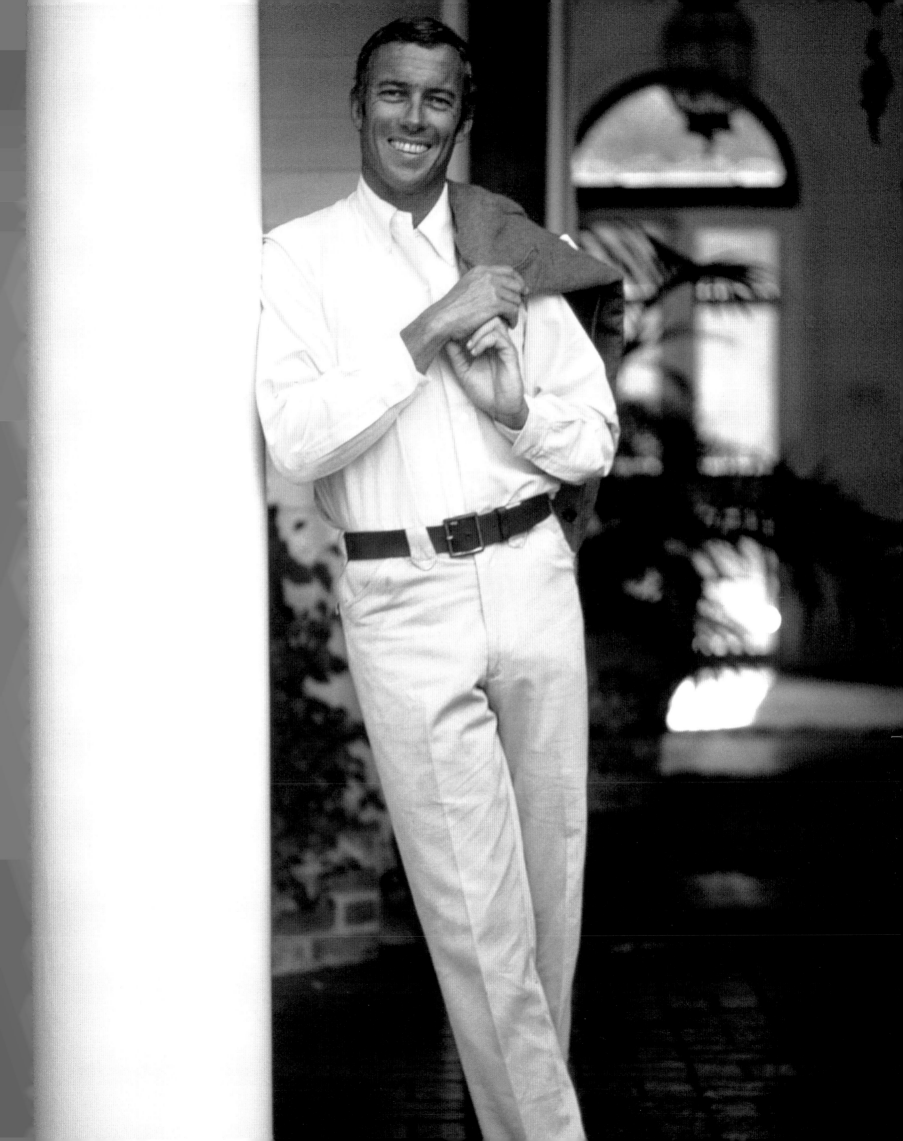

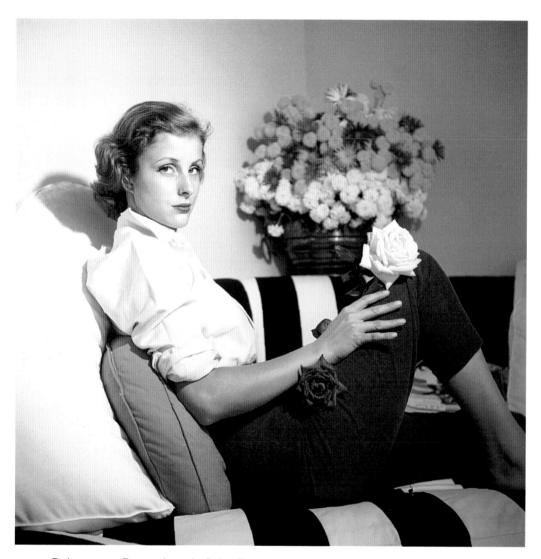

ABOVE: Dolores von Furstenberg in Palm Beach, 1955.

OPPOSITE: An elegant garden party in Miami, 1970.

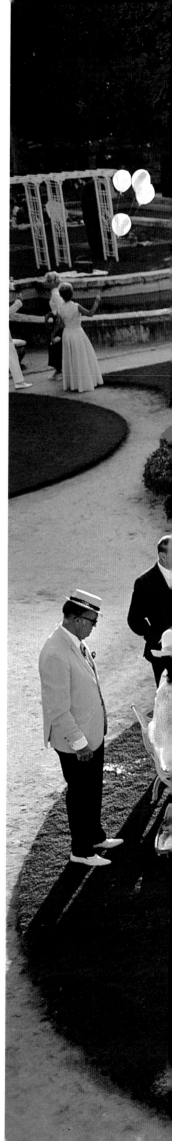

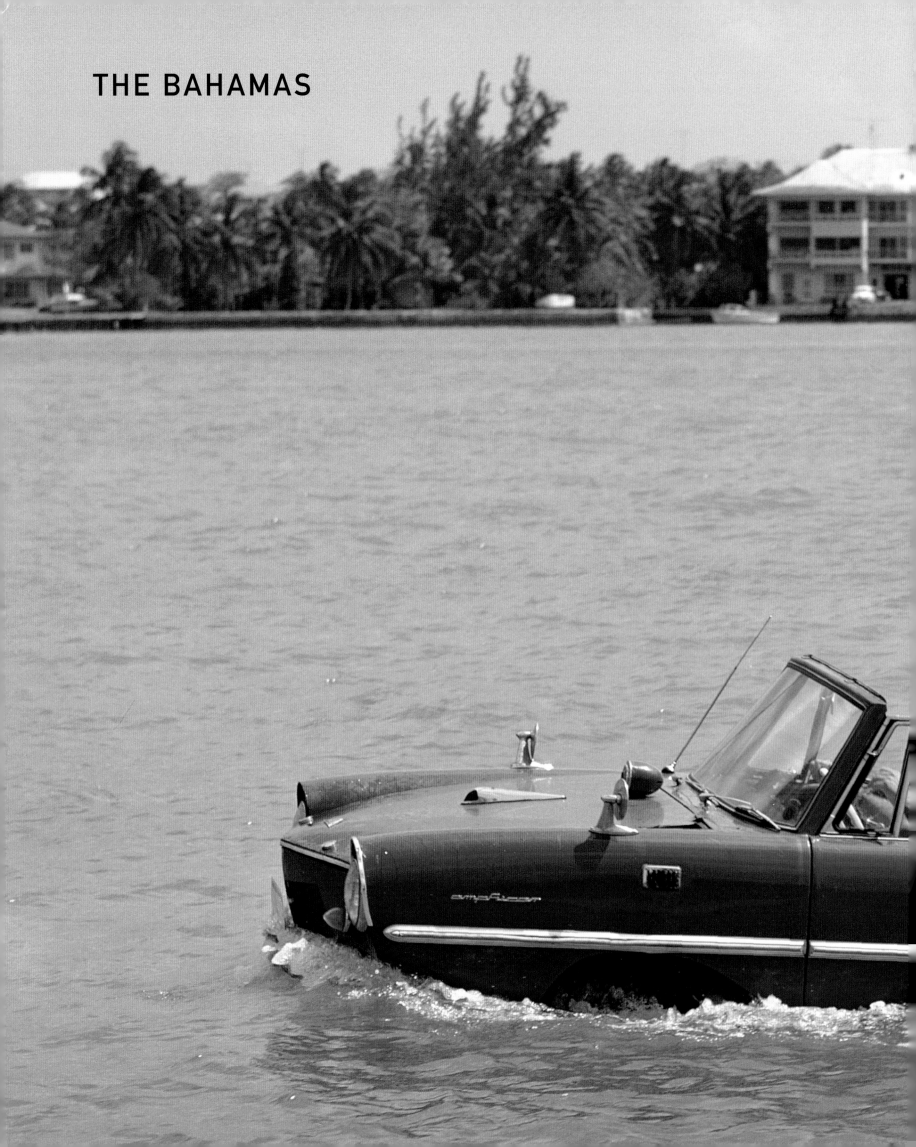

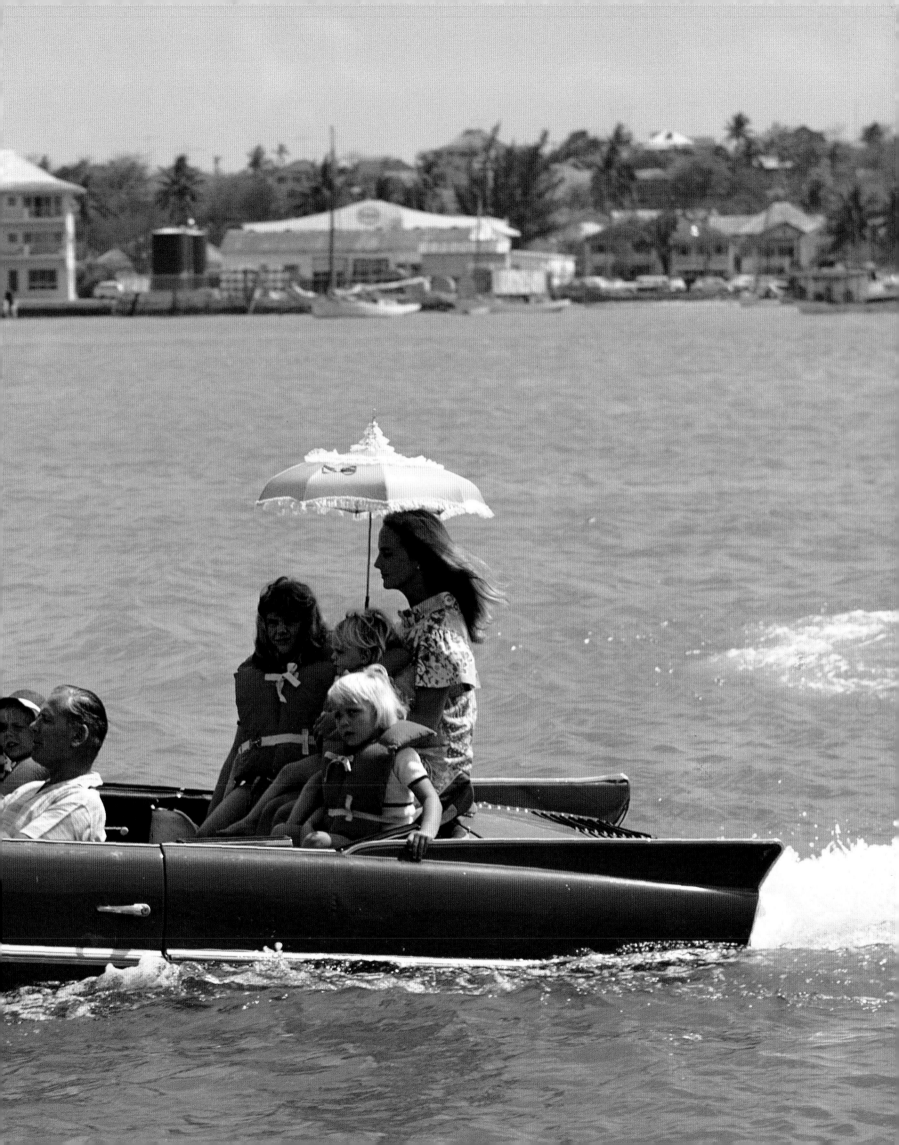

PREVIOUS PAGE: Film producer Kevin McClory and his wife, the former Bobo Segrist, and their children out for a Sunday drive, Nassau, Bahamas, c. 1967. A popular resident of the islands, and a very game guy, Kevin McClory produced the movie version of Ian Fleming's *Thunderball*. Afterward he had a number of movie props lying around, including an amphibious car, so I got this crazy idea for a shot of Kevin and his family in Nassau harbor out for a Sunday drive.

ABOVE: T. S. Eliot at Love Beach, New Providence Island, Bahamas, 1957. While doing a *Holiday* story about Nassau, I was told that T.S. Eliot had arrived on his honeymoon. I called on him at his hotel and asked if I could photograph him at a location I had in mind on the far side of the island, a place called Love Beach. All the while I was shooting I kept thinking of lines from his poem "Prufrock": "I shall wear white flannel trousers, and walk upon the beach . . ."

OPPOSITE: Eleuthera pool party, 1950s.

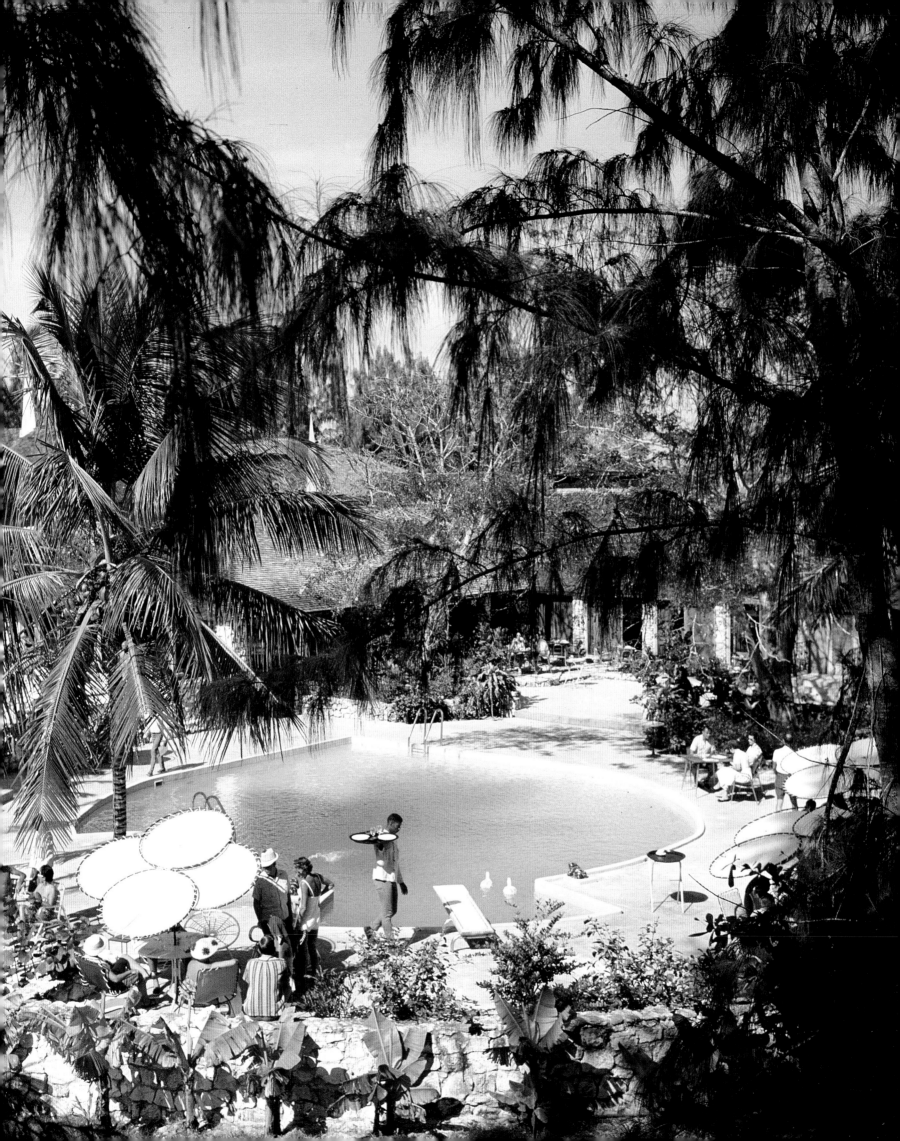

ABOVE: Marc Stanes at Lyford Cay, Bahamas, 1983.

OPPOSITE: Charles A. Dana, Jr., of New York and Connecticut, was one of the original members of the Lyford Cay Club and past chairman of the Lyford Cay Foundation, 1983.

JAMAICA

BELOW: Eva Gabor poses amid tropical blooms in a Jamaican hotel, 1954.

OPPOSITE: Mrs. William Paley at her cottage overlooking the bay at Round Hill, Jamaica, 1959. Behind her, Bill Paley aims his camera at the photographer.

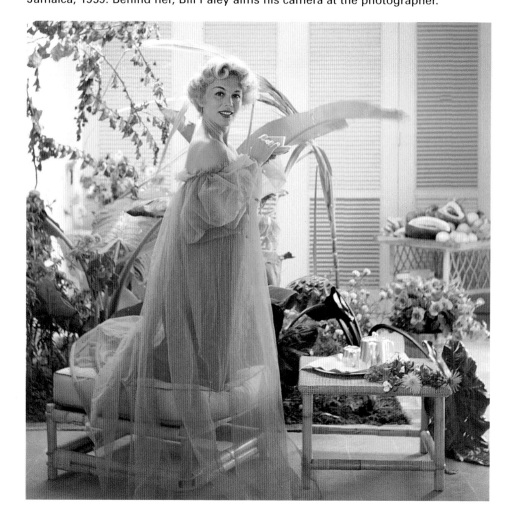

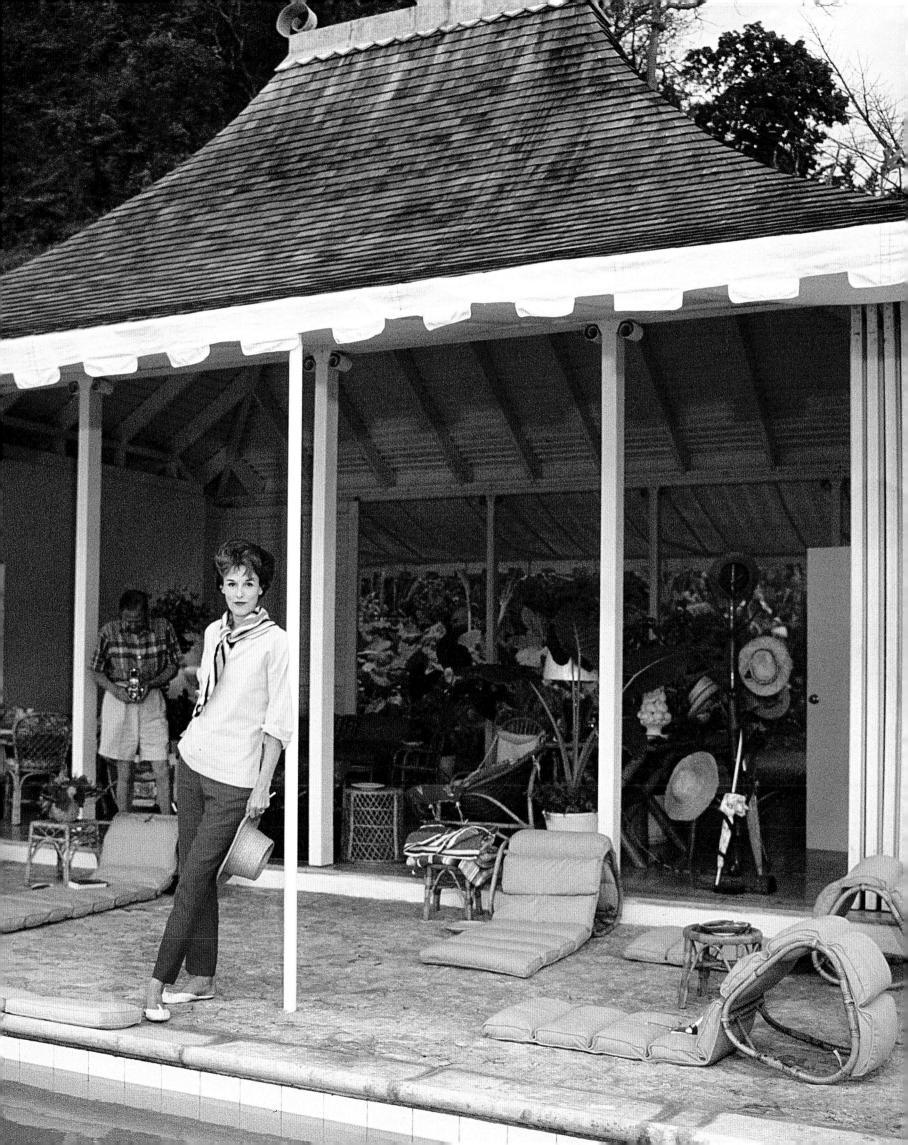

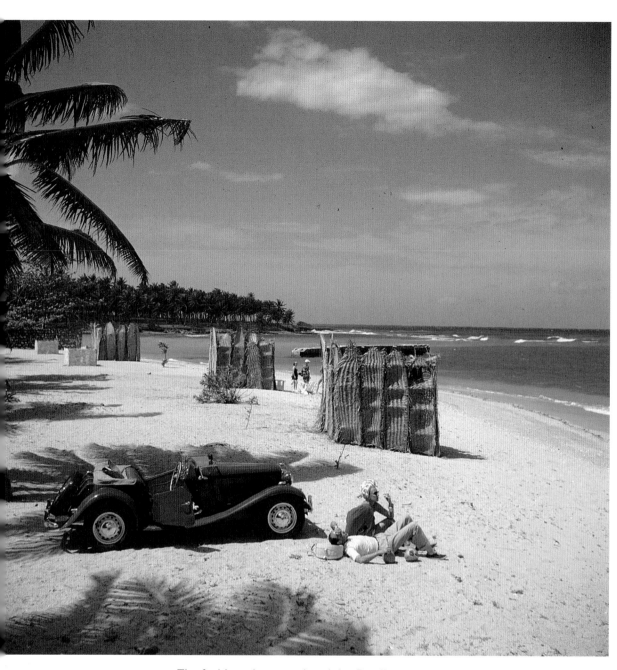

ABOVE: The fashion photographer John Rawlings on the beach at Montego Bay, Jamaica, 1950s.

OPPOSITE: Katharine Hepburn, with Irene Mayer Selznik, Montego Bay, Jamaica, 1953.

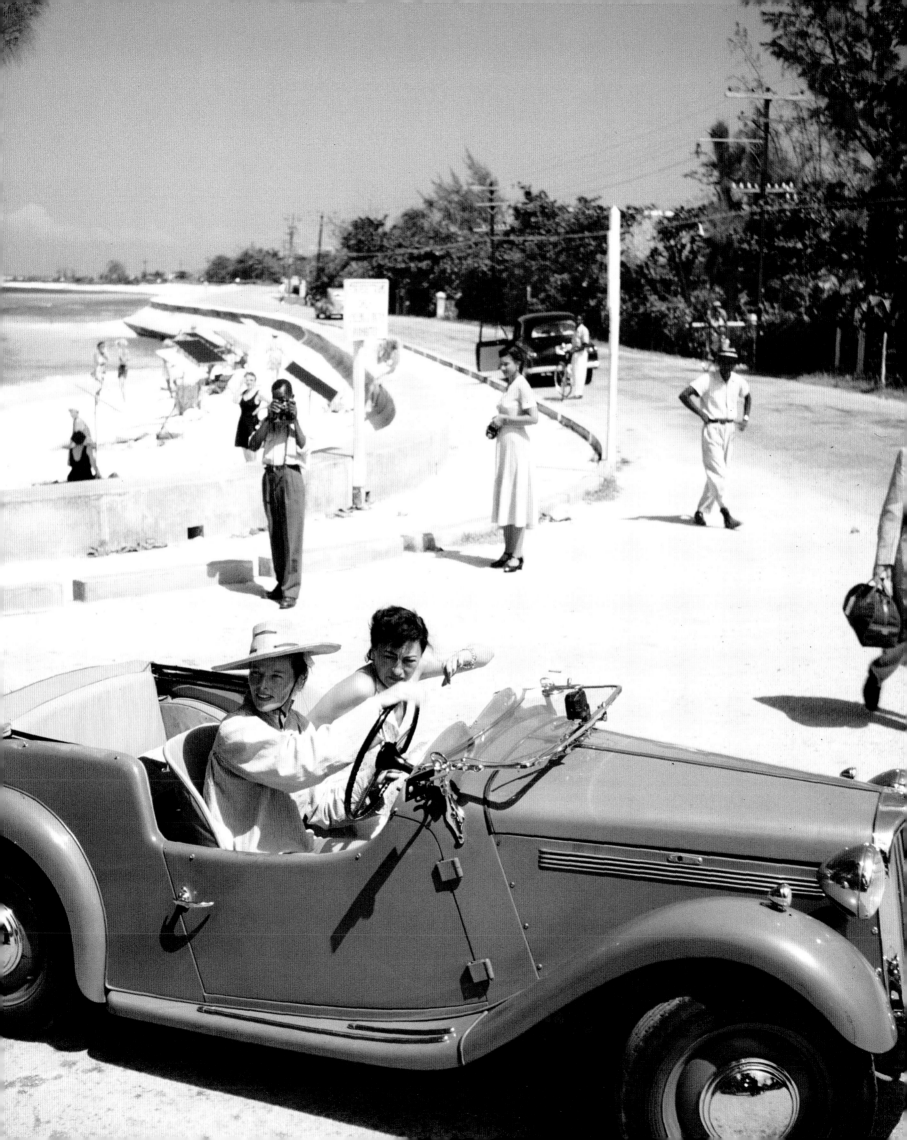

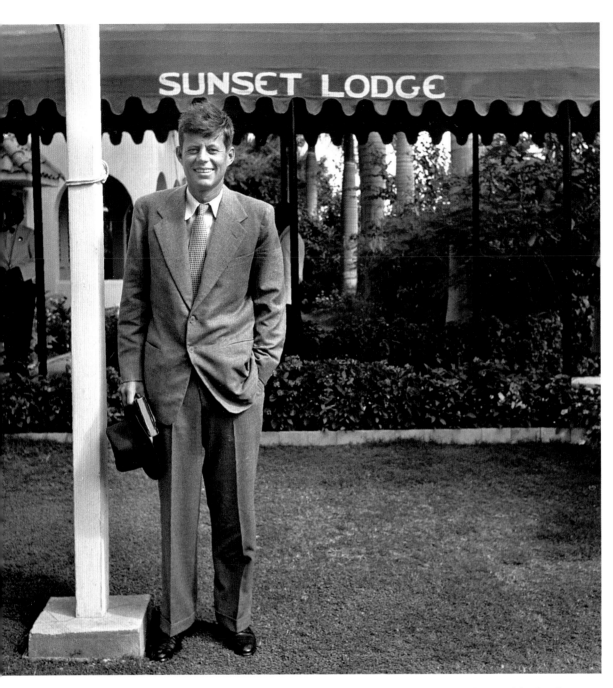

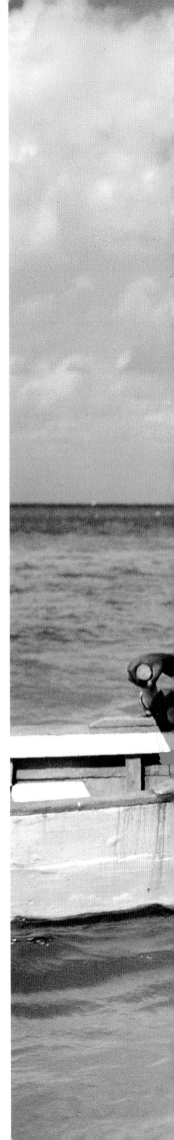

ABOVE: Democratic senator for Massachusetts, John F. Kennedy, outside the Sunset Lodge, Montego Bay, Jamaica, 1953.

OPPOSITE: Noel Coward in Jamaica, 1953.

OVERLEAF: At their family's Villa Boedecia in Haiti, Boston-born and bred Lawrence Carleton Peabody II and his son, Thomas Lawrence Claudius Peabody.

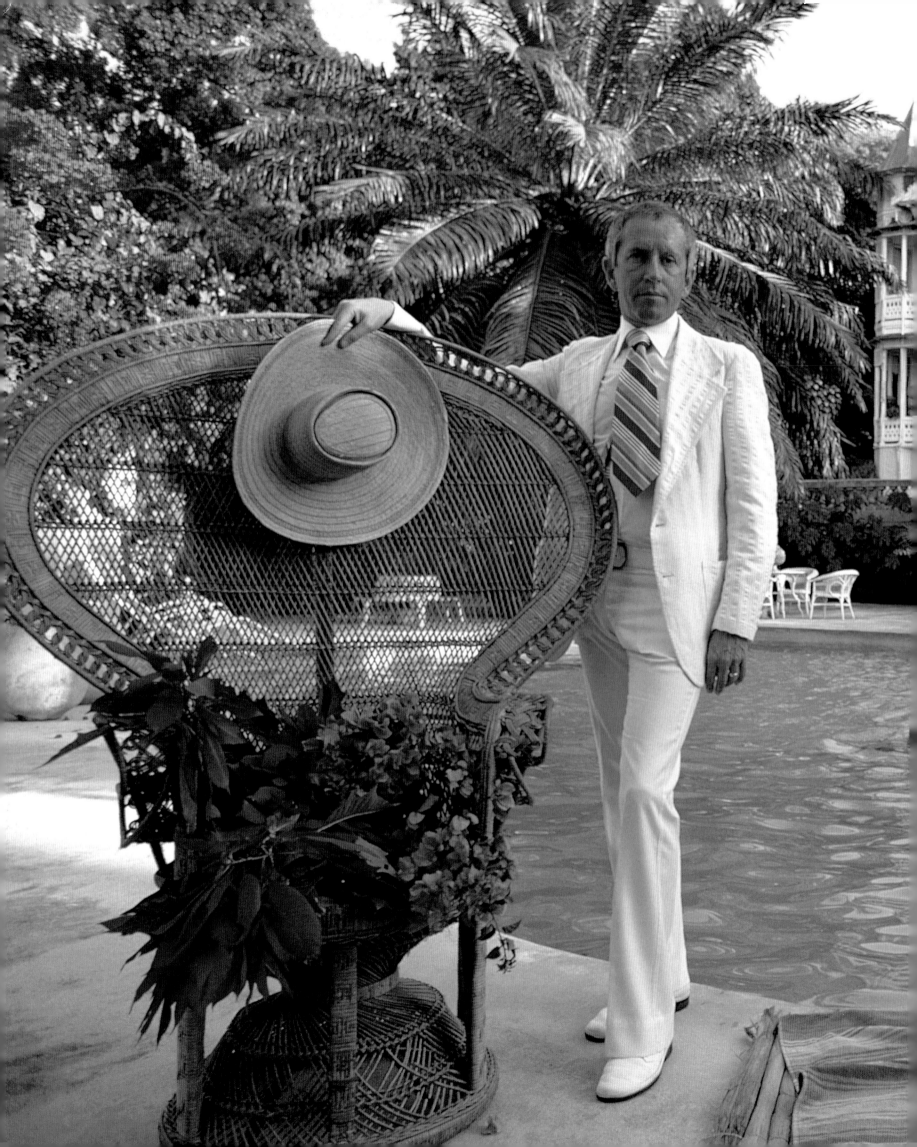

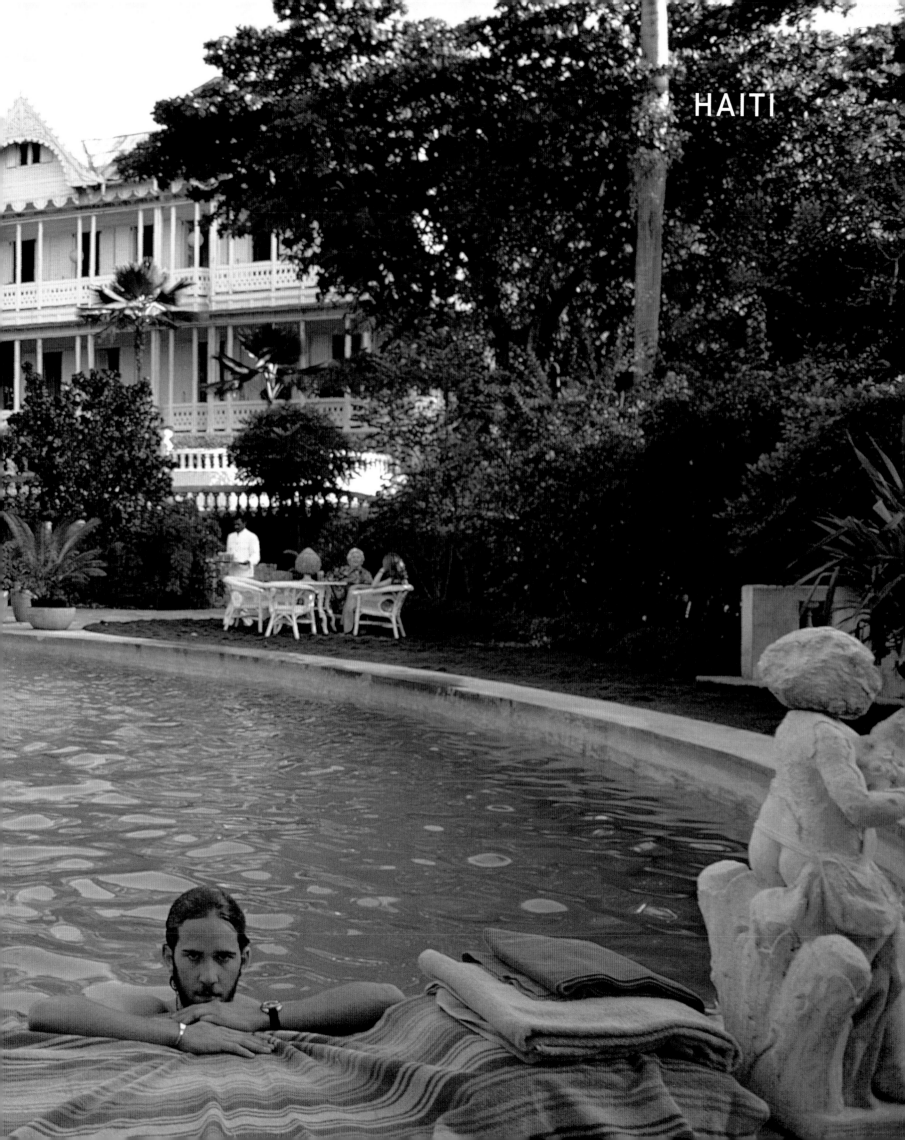

HAITI

MICHIGAN

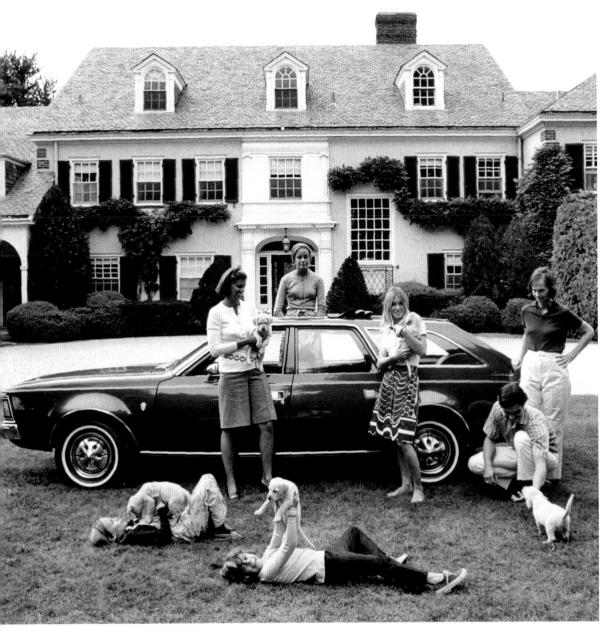

ABOVE: Mrs. Roy Chapin and family outside their Grosse Pointe, Michigan home, c. 1968.

OPPOSITE: The Ford Family: Mrs. Edsel Ford sits before the fireplace of her sixty-room home in Grosse Pointe Shores, Michigan, with her sons, left to right, Henry II, Benson, and William, and her daughter, Josephine. 1957.

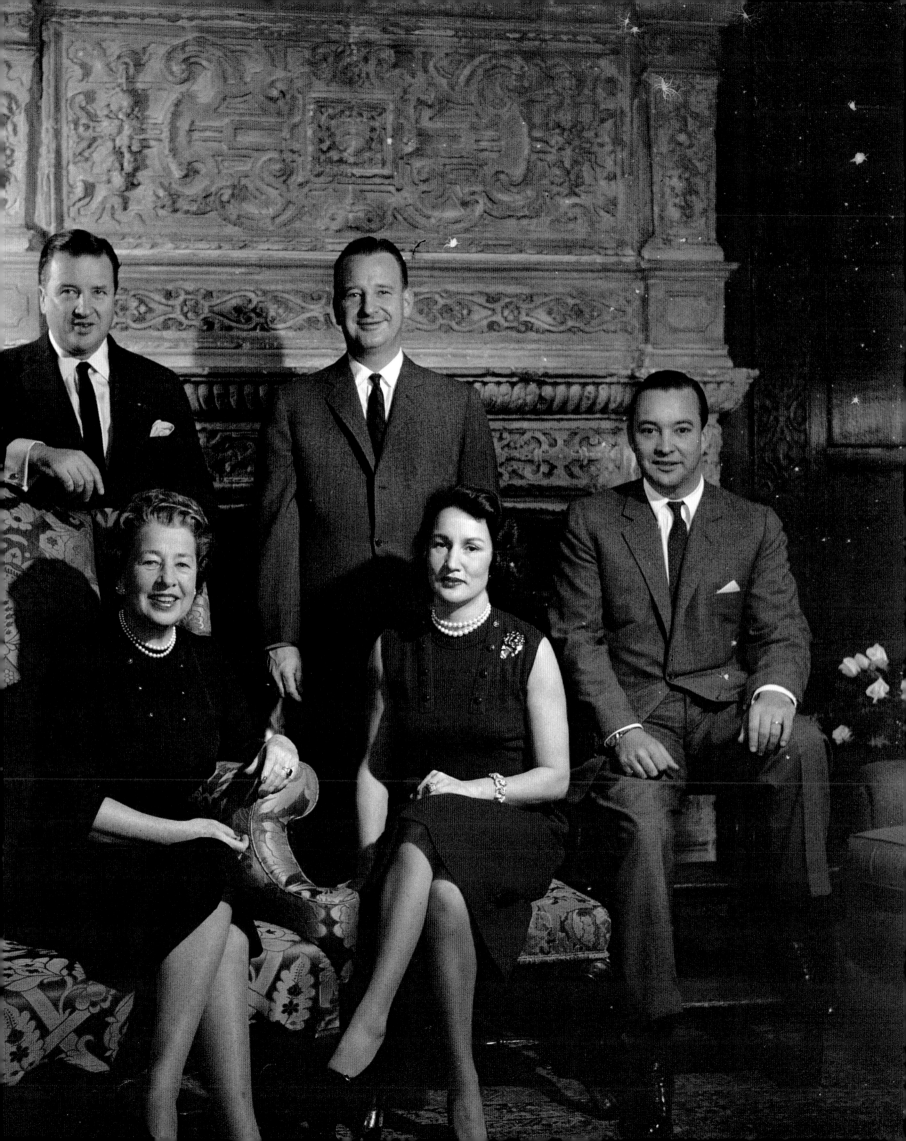

CHICAGO

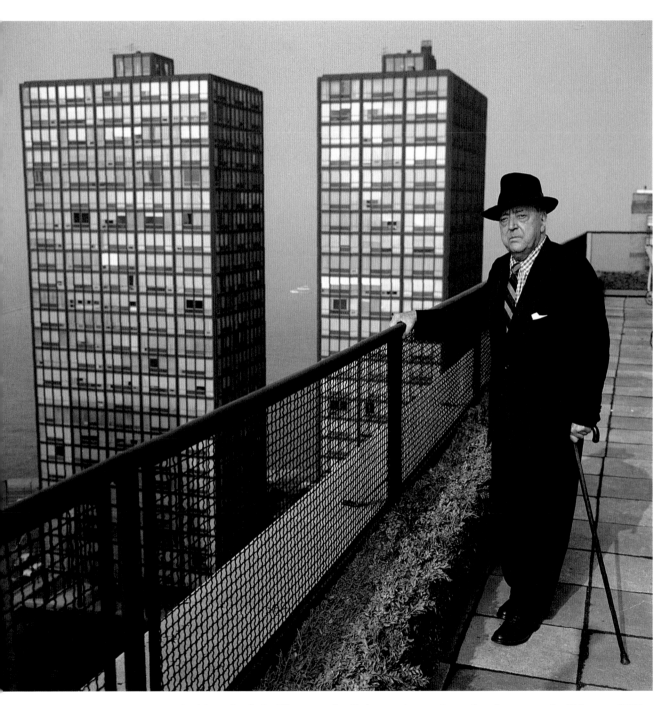

ABOVE: Architect Ludwig Mies van der Rohe on the rooftop of a skyscraper in Chicago, 1960.

OPPOSITE: Mrs. A. Watson Armour III, the former Jean Schweppe, her children and their friends, enjoying the pool on the Schweppe estate in Lake Forest, Illinois, 1957.

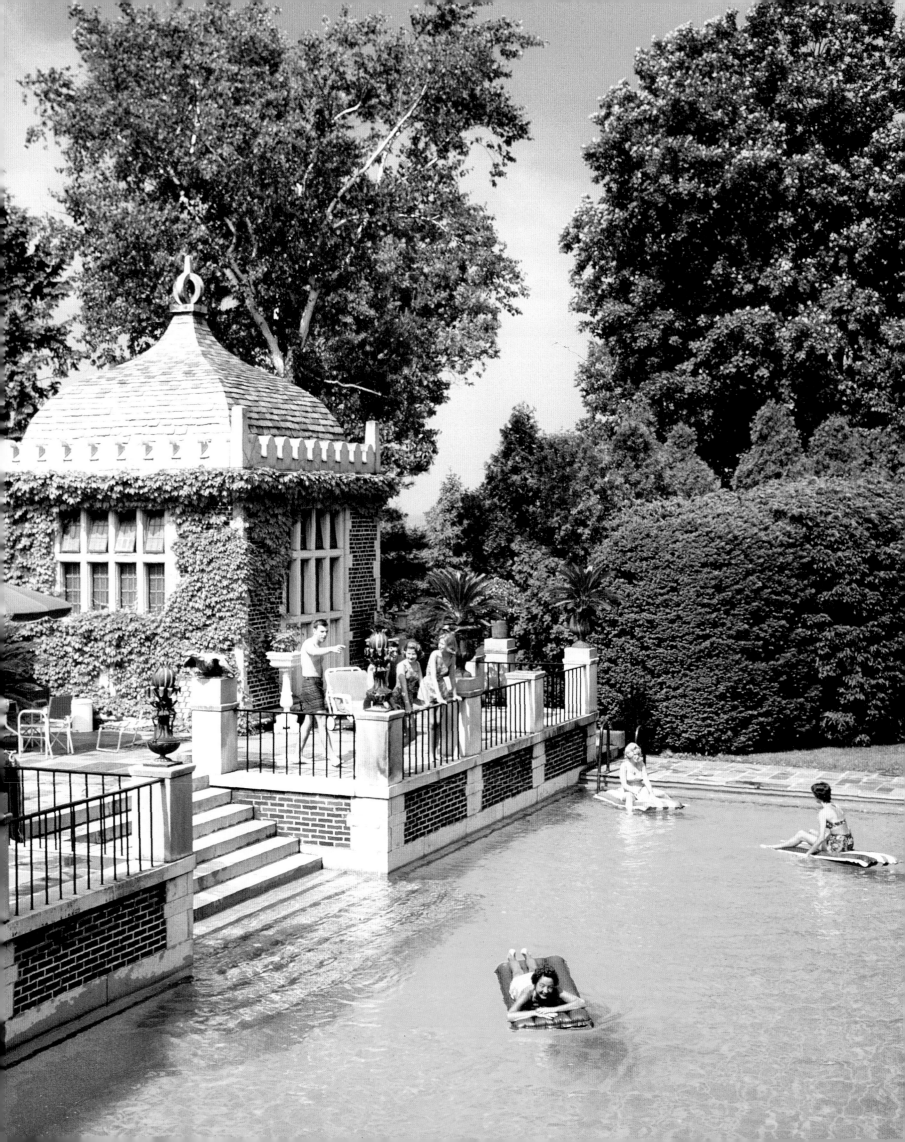

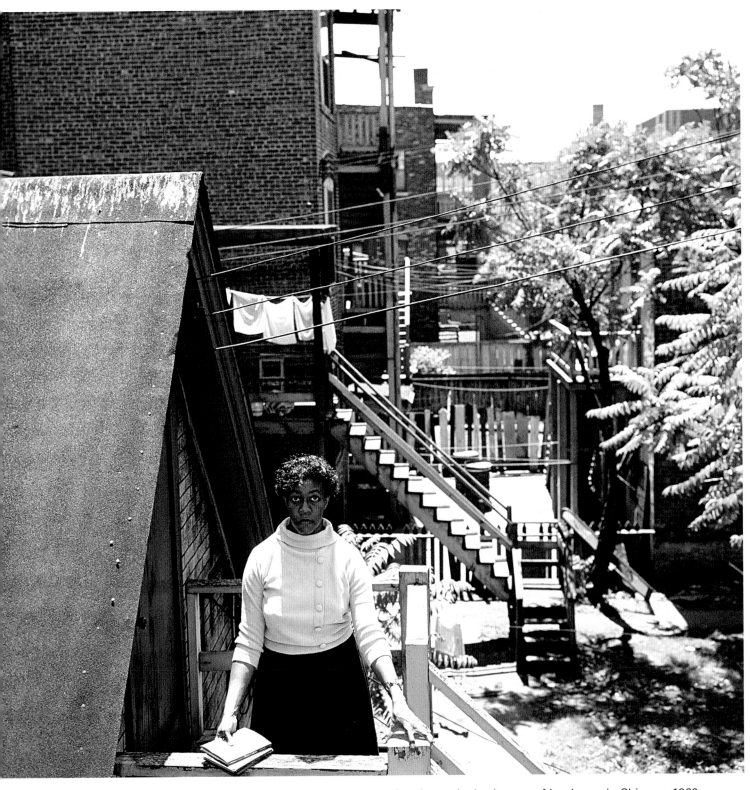

ABOVE: Pulitzer Prize-winning poet Gwendolyn Brooks on the back steps of her home in Chicago, 1960.

OPPOSITE: Carl Sandburg, 1960, Chicago's poet laureate and the Pulitzer Prize-winning biographer of Abraham Lincoln, seated at an old desk of Lincoln's in the Chicago Historical Society Museum, beneath the "rail-splitter" portrait of 1860.

OVERLEAF: Working at his typewriter while surrounded by Bunnies, publisher and founder of *Playboy* magazine Hugh Hefner at the Playboy Club in Chicago, 1960.

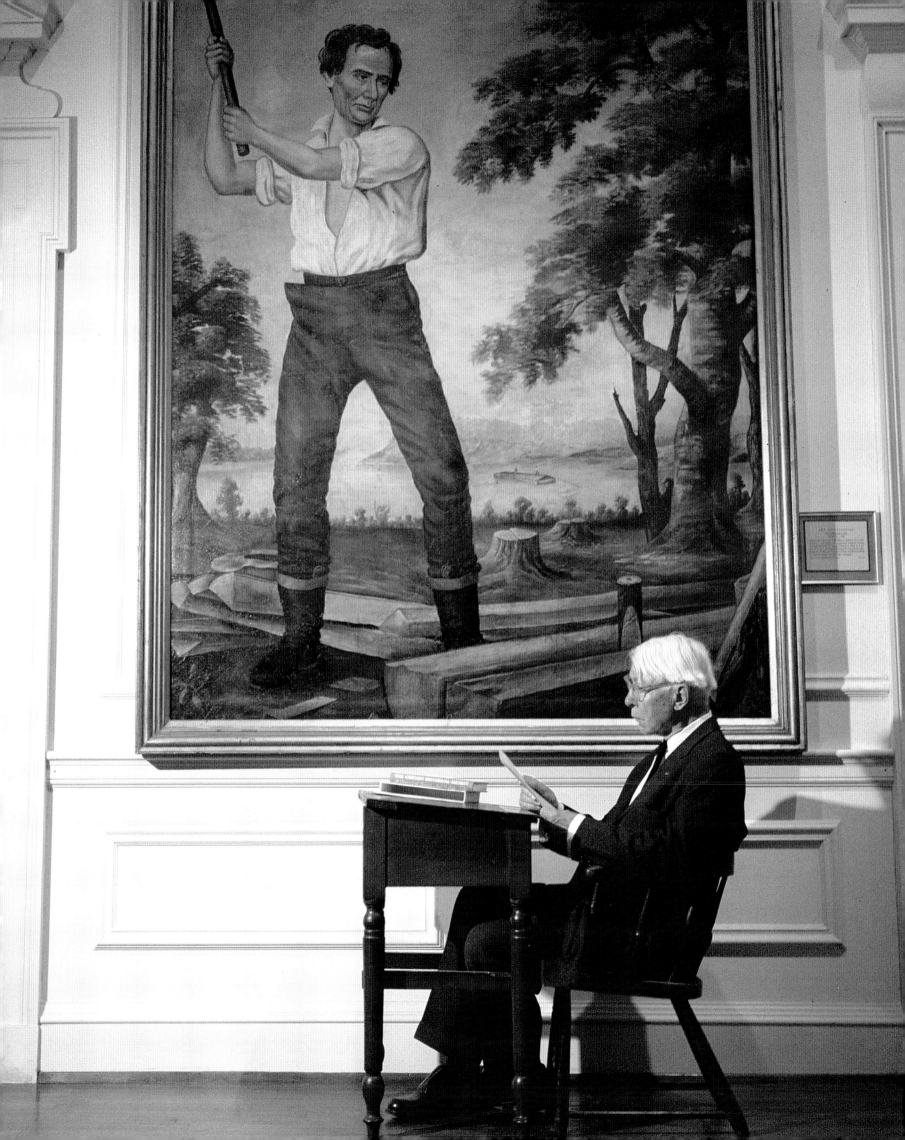

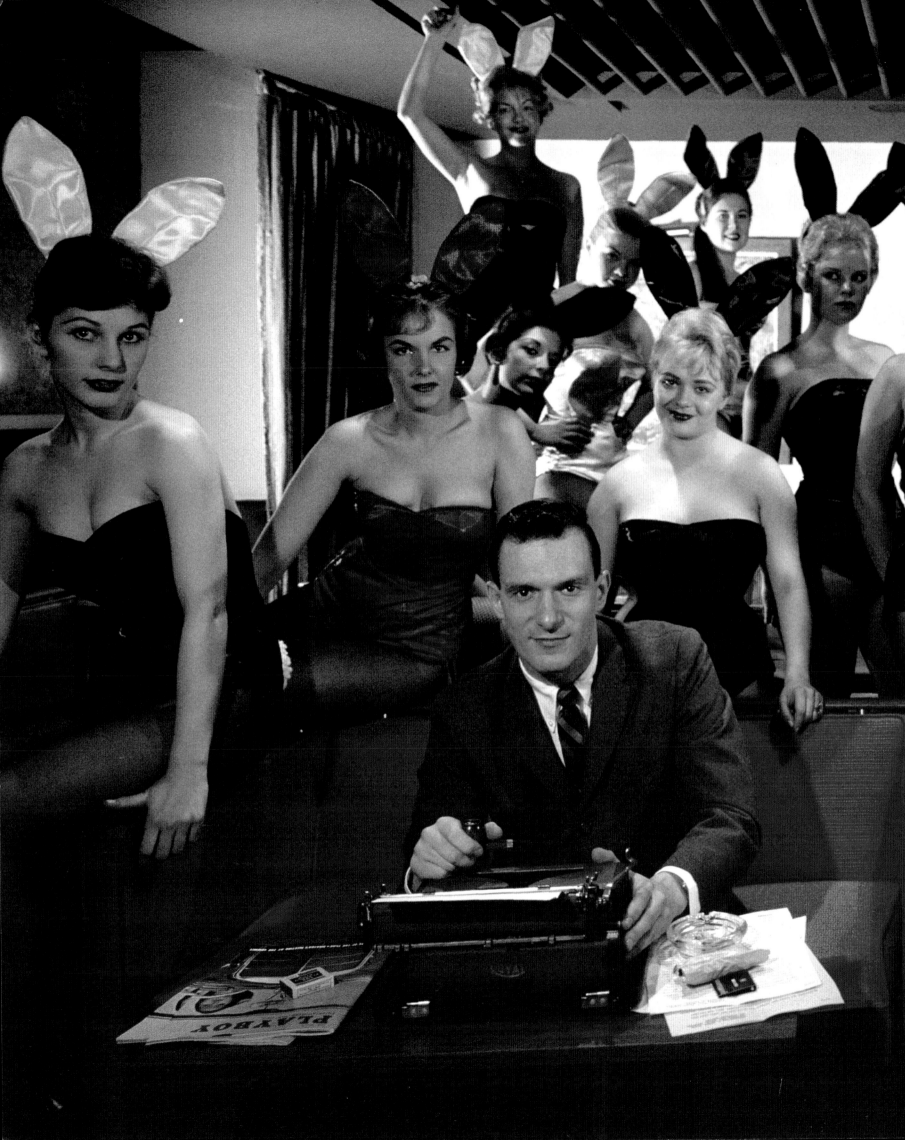

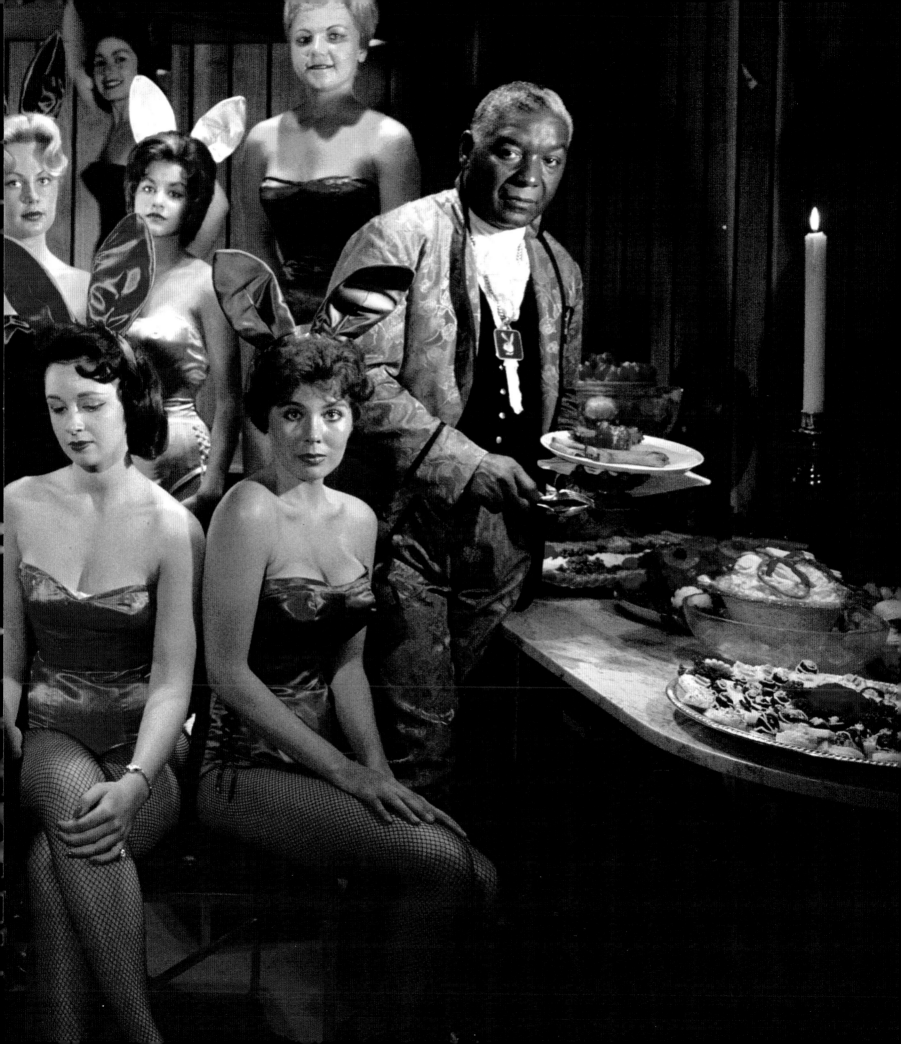

ABOVE: Mr. and Mrs. Robert J. Kleberg, Jr., with their grandniece Ida Louise Clement, at the King Ranch, Kingsville, Texas, c. 1965. The King Ranch is known all over the world; a million acres of grazing land, oil wells, and even a few towns. Edna Ferber's *Giant* was supposedly based on Kleberg.

OPPOSITE: Senator Barry Goldwater near Scottsdale, Arizona, 1967. He was a statesman, philosopher, and third-generation Arizonan. The buckboard, the background, the Western dress, and the man were completely authentic.

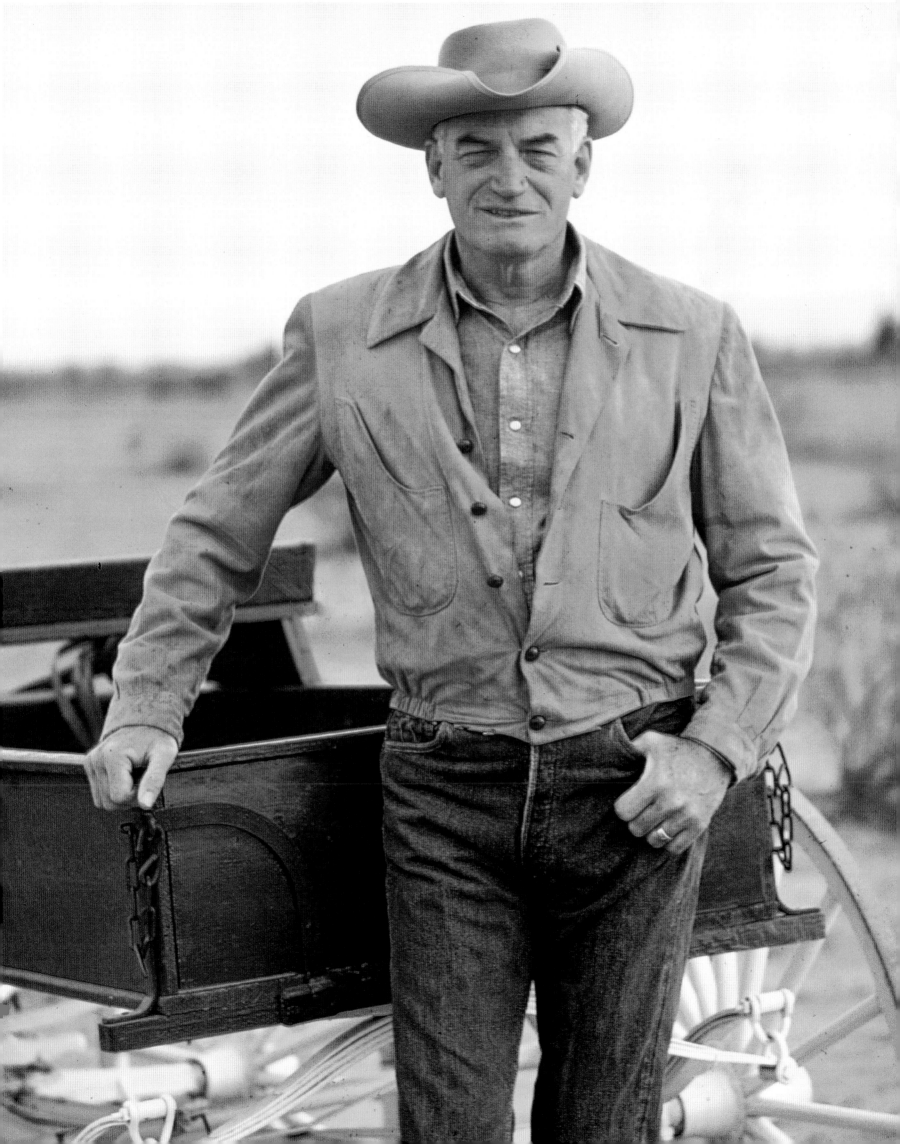

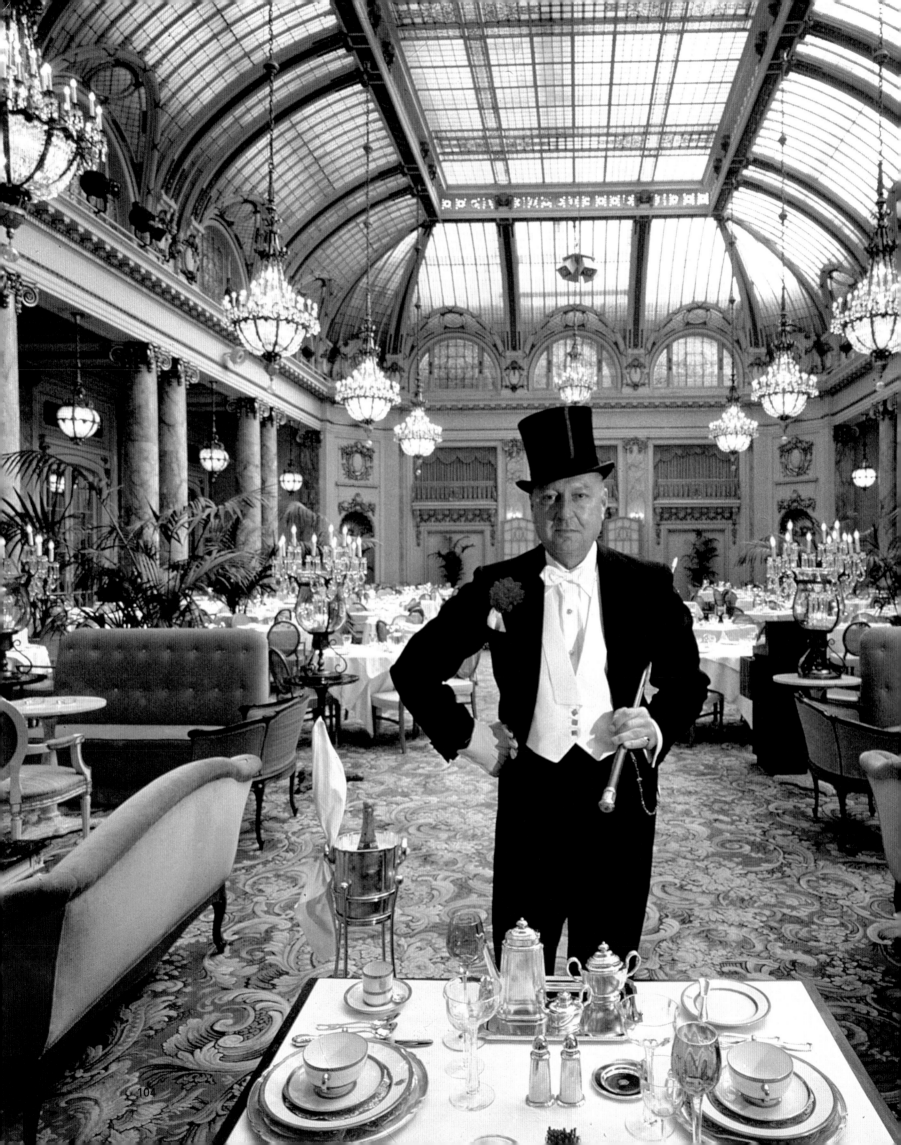

SAN FRANCISCO

OPPOSITE: Journalist Lucius Beebe beside a golden service in the Garden Court of the Palace Hotel, San Francisco, 1960. Mr. Beebe wears a watch chain of mother-lode nuggets and carries under his arm a museum-piece walking stick once presented to a Wells Fargo stage-coach driver. I worked on many stories with him and he was a photographer's delight. Clifton Fadiman once described him as a "ducal beatnik." Cleveland Amory said he was "The owner of the most publicized wardrobe east of Adolphe Menjou." He was a luscious reincarnation of the pages of his book on San Francisco's Golden Era. "I would rather," he said, "be a bright leaf on the stream of a dying civilization than a fertile seed dropped in the soil of a new era."

BELOW: Melvin M. Belli, the cantankerous and theatrical personal injury lawyer in his San Francisco office, 1960. Known as the "King of Torts," he was also the founder of the Association of Trial Lawyers of America. His many famous clients have included numerous film stars and Jack Ruby, the accused murderer of Lee Harvey Oswald.

OVERLEAF: The former George Newhall estate, its house and gardens modeled after Le Petit Trianon at Versailles, c. 1960. I was working on my first book when I ran into Robert Evans at the Excelsior Hotel in Rome. He had just finished shooting *The Great Gatsby*. When he saw this photograph in the proof sheets I had with me, he asked if I had taken it in France. I told him it was in San Francisco. Evans said, "I could have saved so much money shooting *Gatsby* if I had known about this place! We had to go all the way to Southampton to find a location."

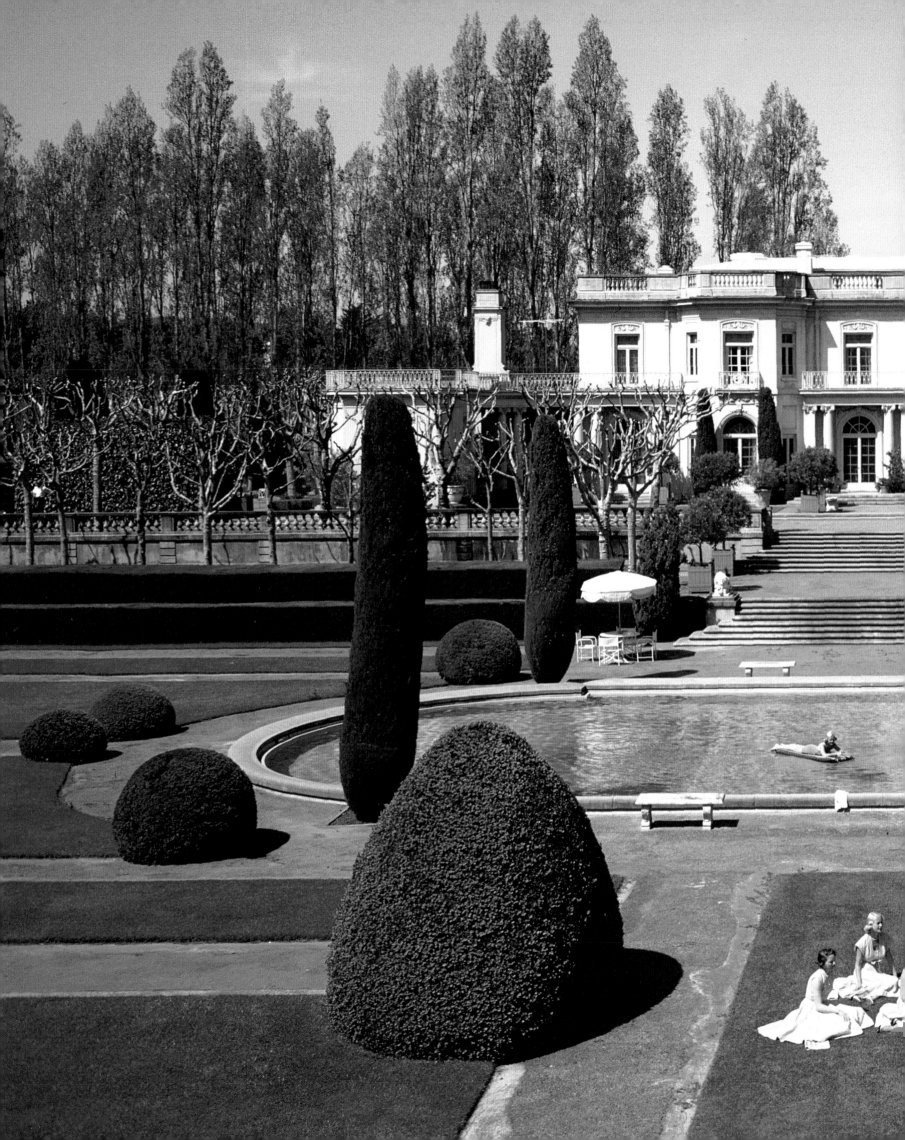

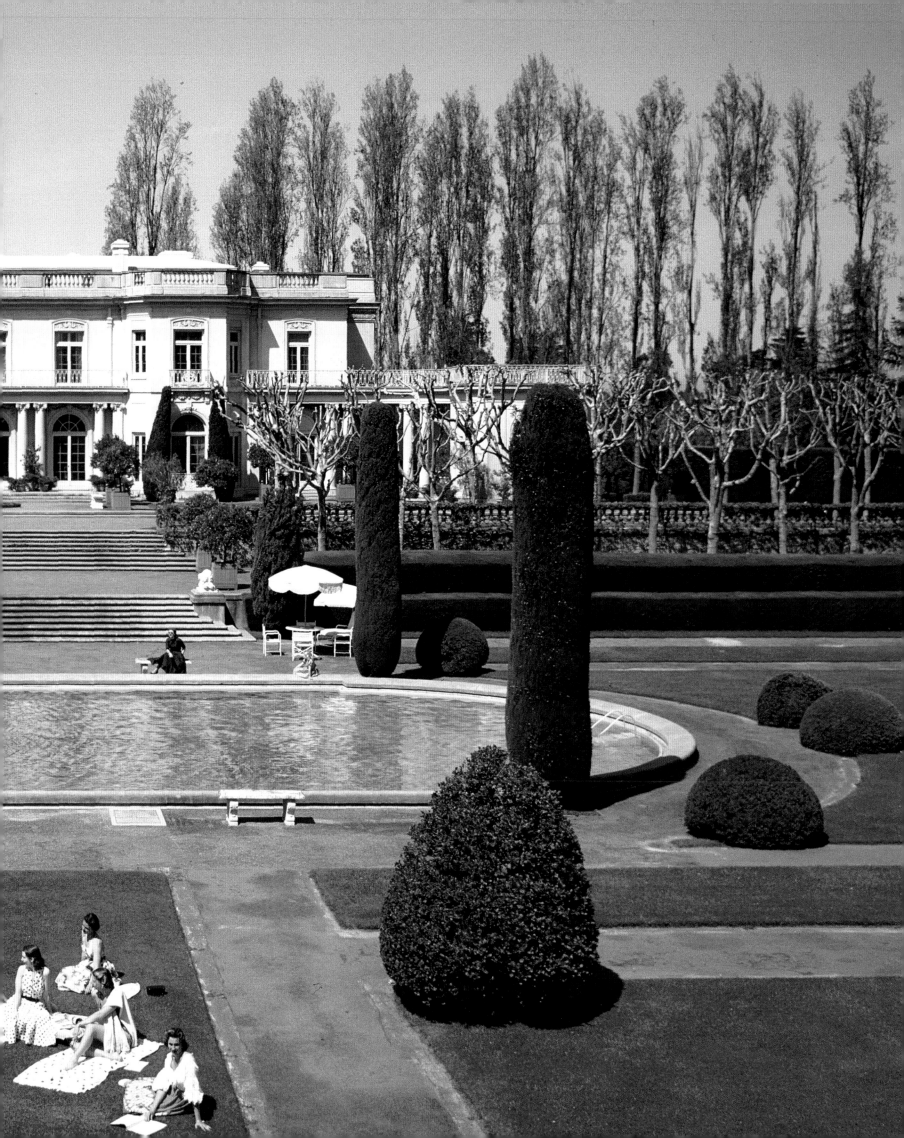

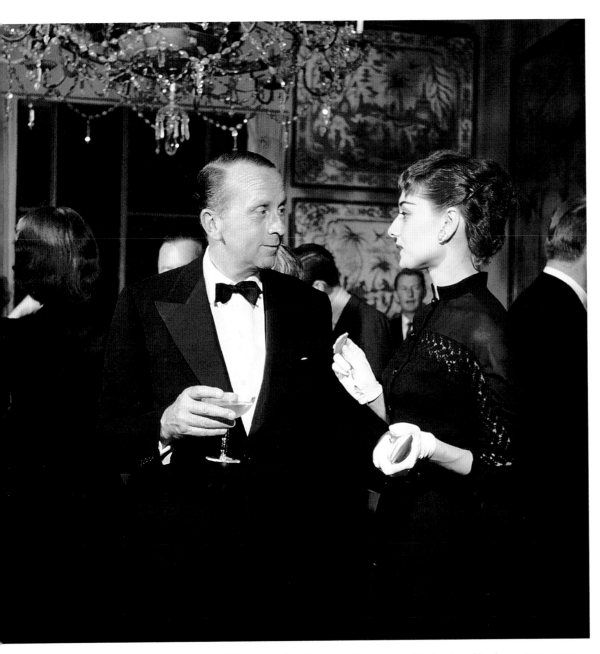

ABOVE: Whitney Warren of the Newport Warrens with Audrey Hepburn at a party he gave for her to celebrate the opening of the play *Ondine*, in which she starred. San Francisco, c. 1960.

OPPOSITE: The de Young sisters on a visit to the de Young Memorial Museum, San Francisco, c.1960. From left, Mrs. Nion Tucker, Mrs. J.O. Tobin, and Mrs. George Cameron. Their father, Meichel H. de Young, and his brother founded the *San Francisco Chronicle* in the 1860s on a borrowed twenty-dollar gold piece.

OVERLEAF: Ann and Gordon Getty and two of their four sons, Andrew and Billy, at home for Christmas, 1979.

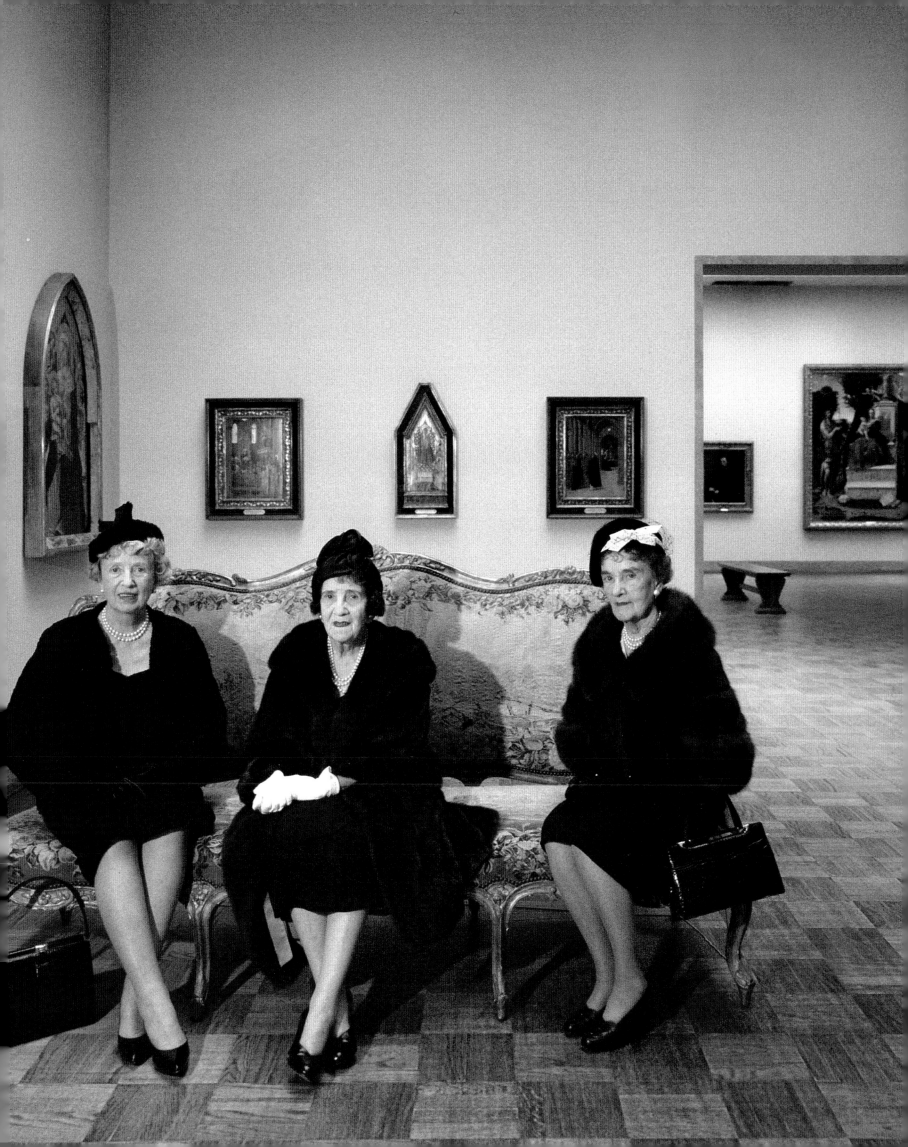

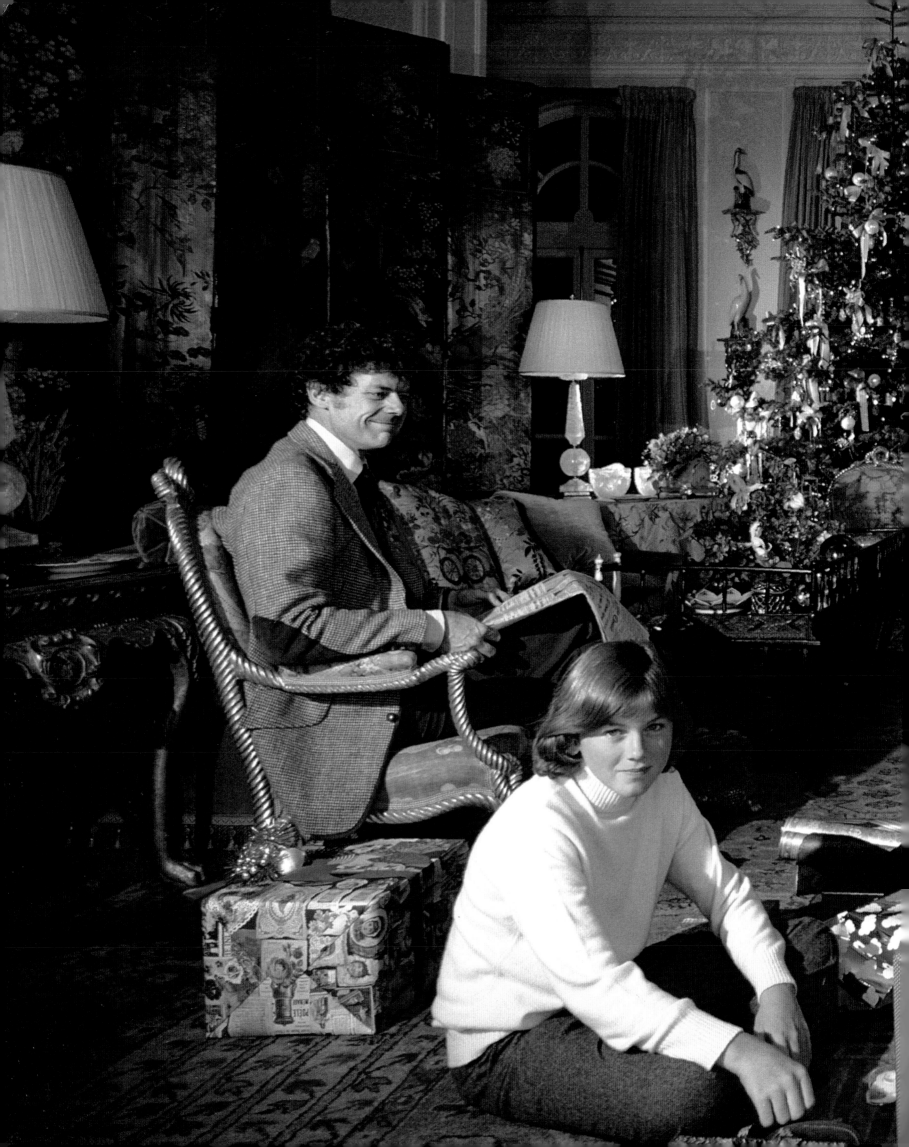

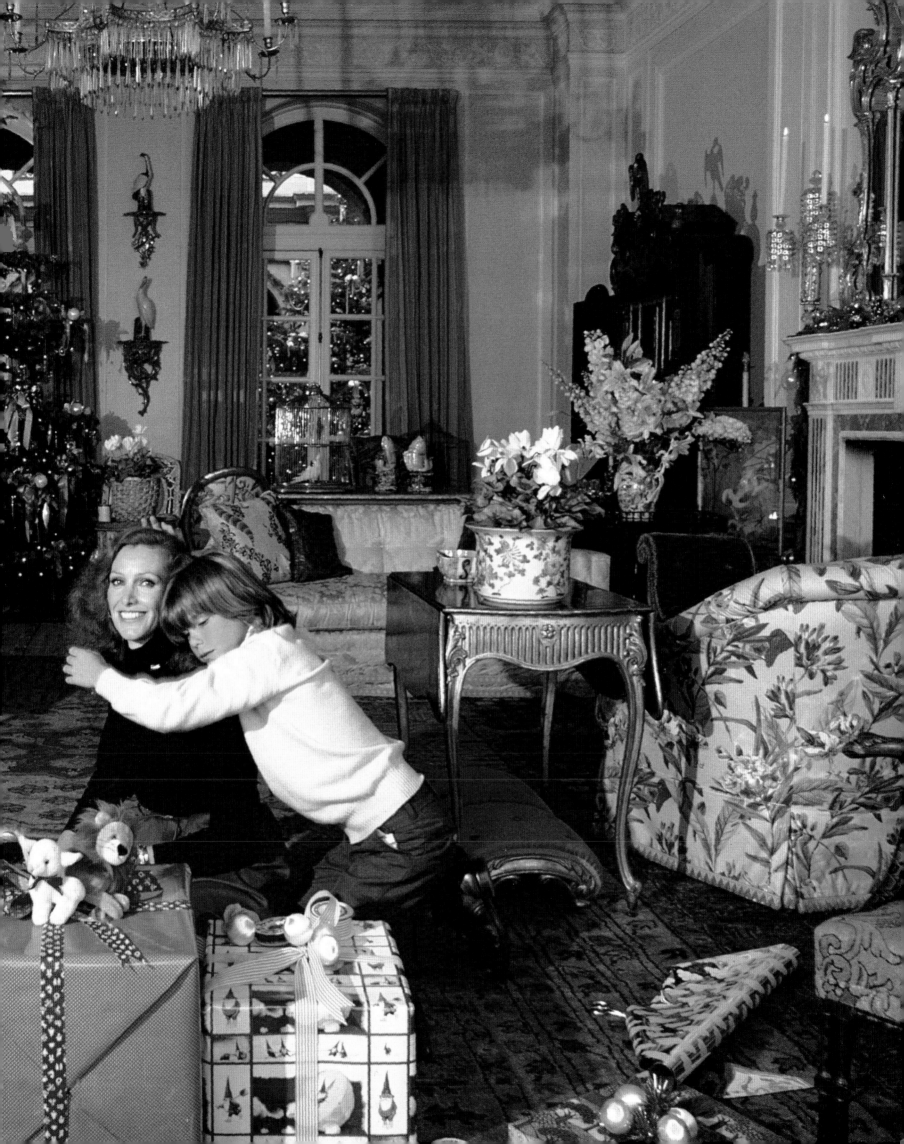

SANTA BARBARA

BELOW: Cynthia "Holly" Hollister Masek riding her horse Cocoa through a field of blooming mustard. Her ancestors were among the first settlers of Santa Barbara, c. 1976.

OPPOSITE: Santa Barbara is the West Coast rival to the East Coast's Palm Beach and Newport. Here Mr. and Mrs. J. Gordon Douglas, transplants from Newport, Rhode Island, in the formal gardens of their residence, c. 1976.

OVERLEAF: Mr. and Mrs. Alexander Saunderson in the bedroom of their home in Montecito, an opulent residential enclave of Santa Barbara, c. 1976. Mrs. Saunderson, sister of Jimmy Van Alen of Newport, had the bedroom walls painted with views of Venice by the English artist John Sander. She wanted to wake up every morning to views of her favorite city.

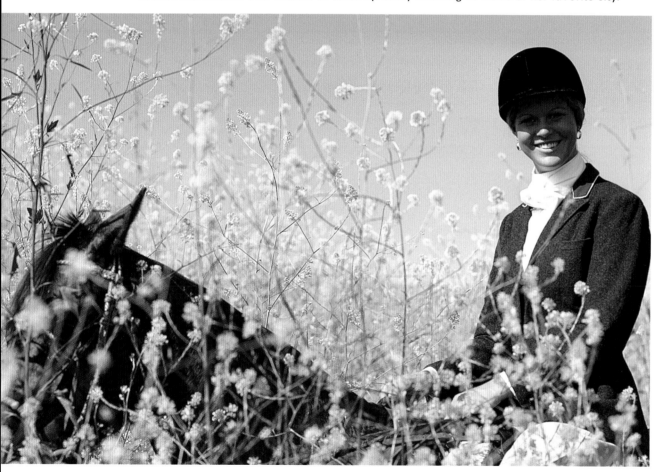

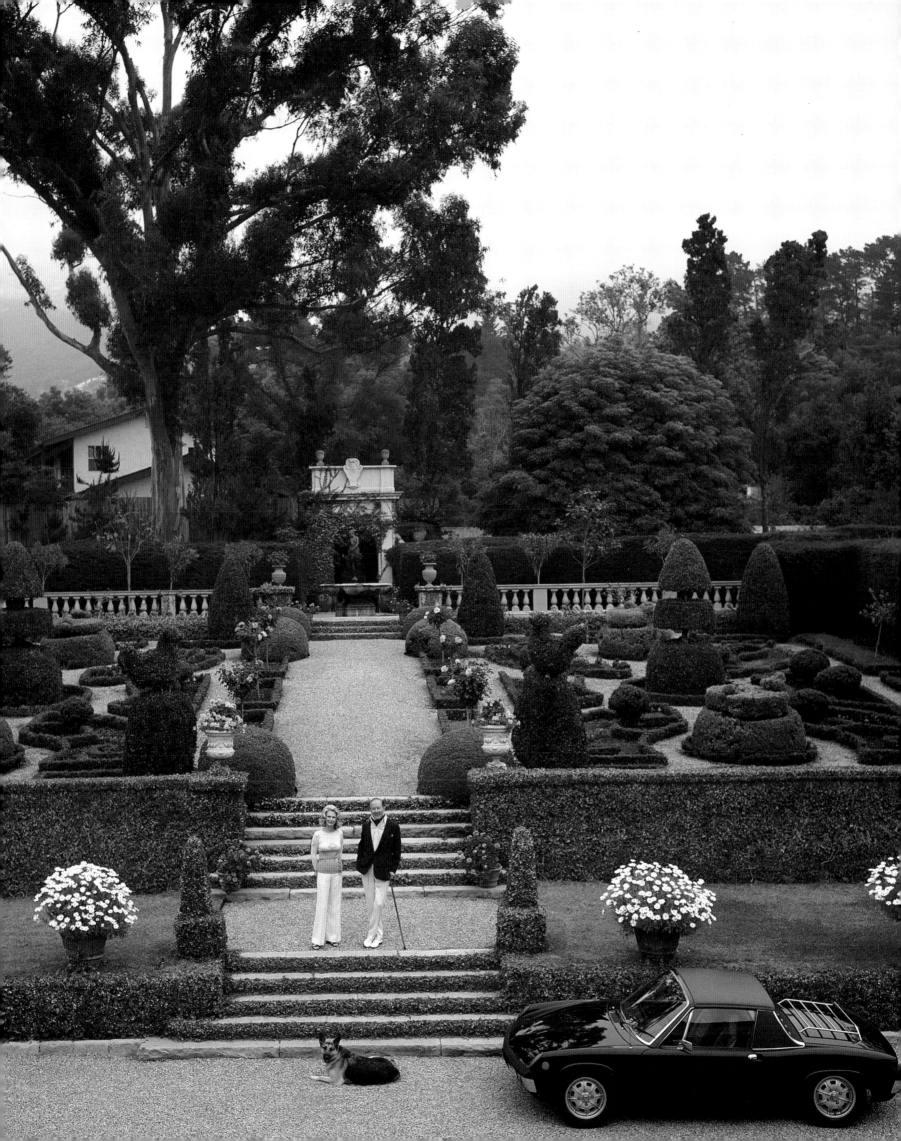

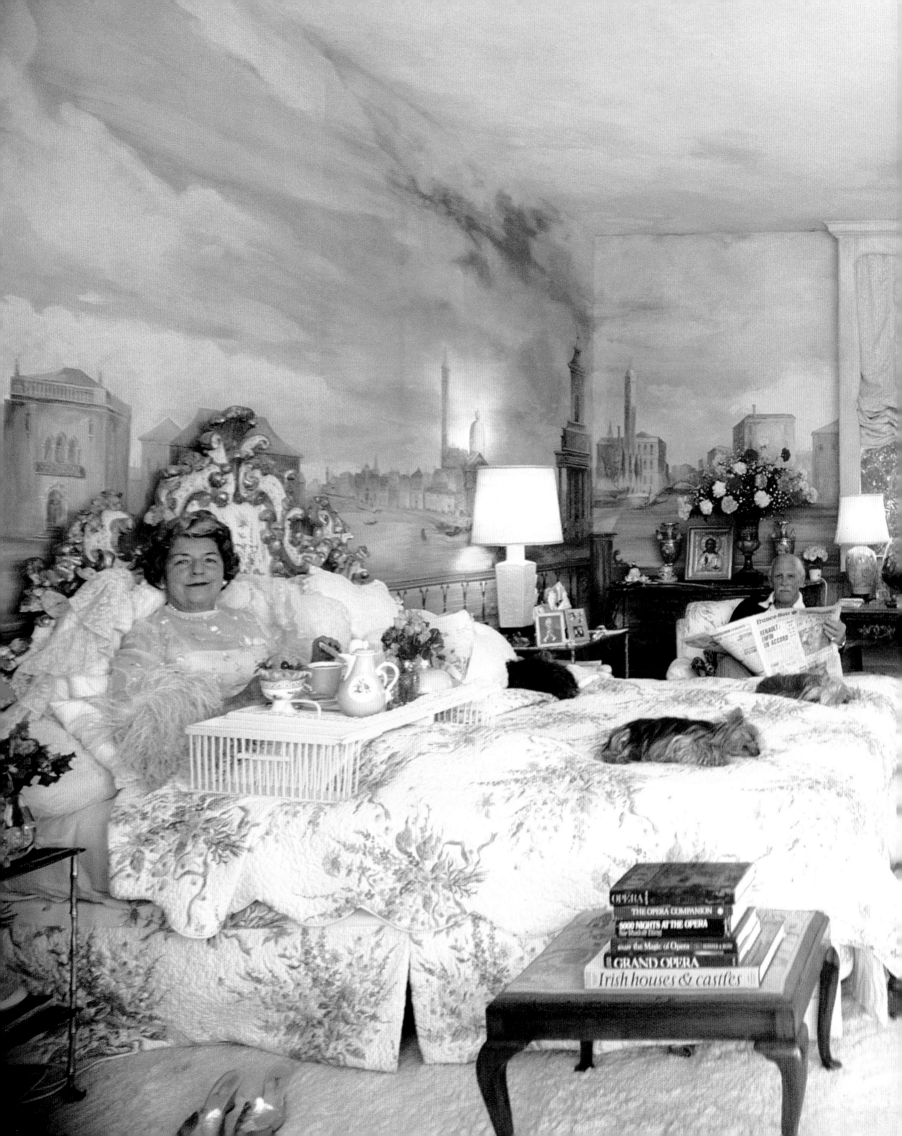

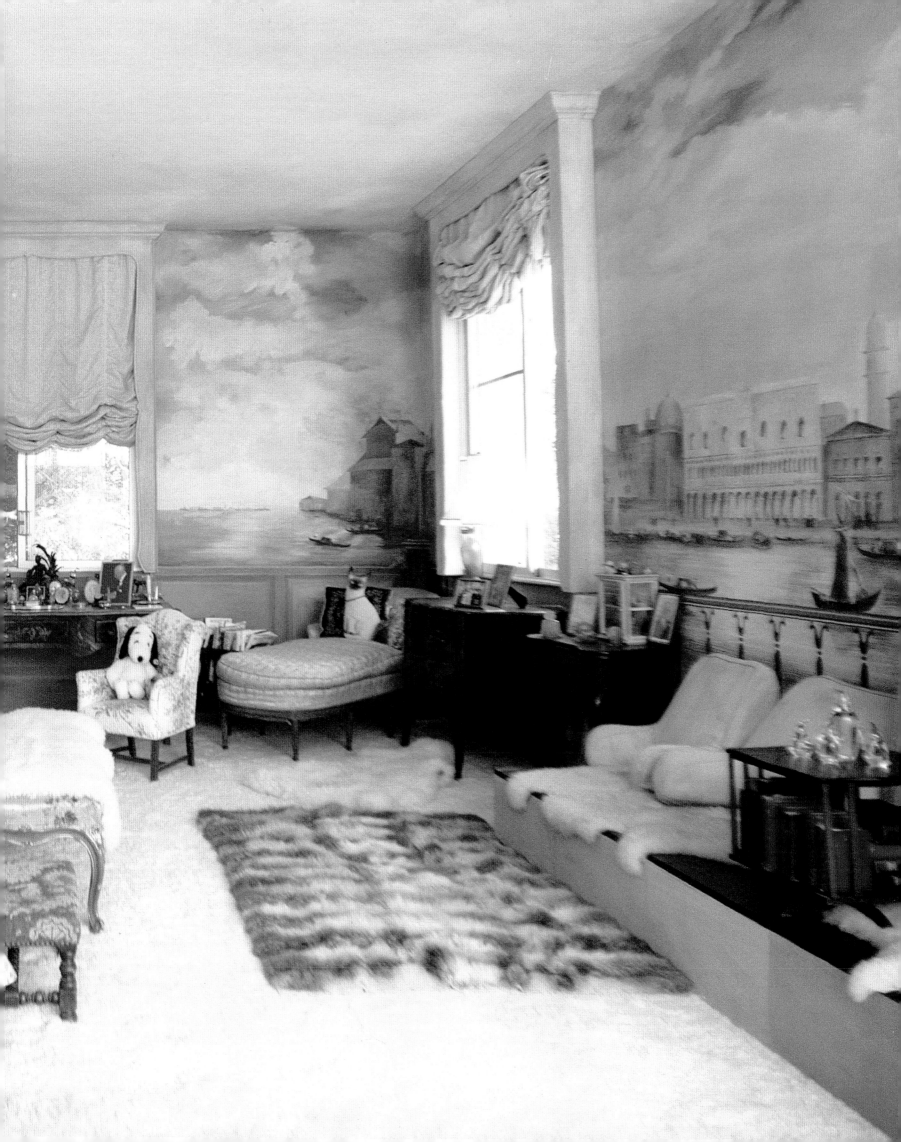

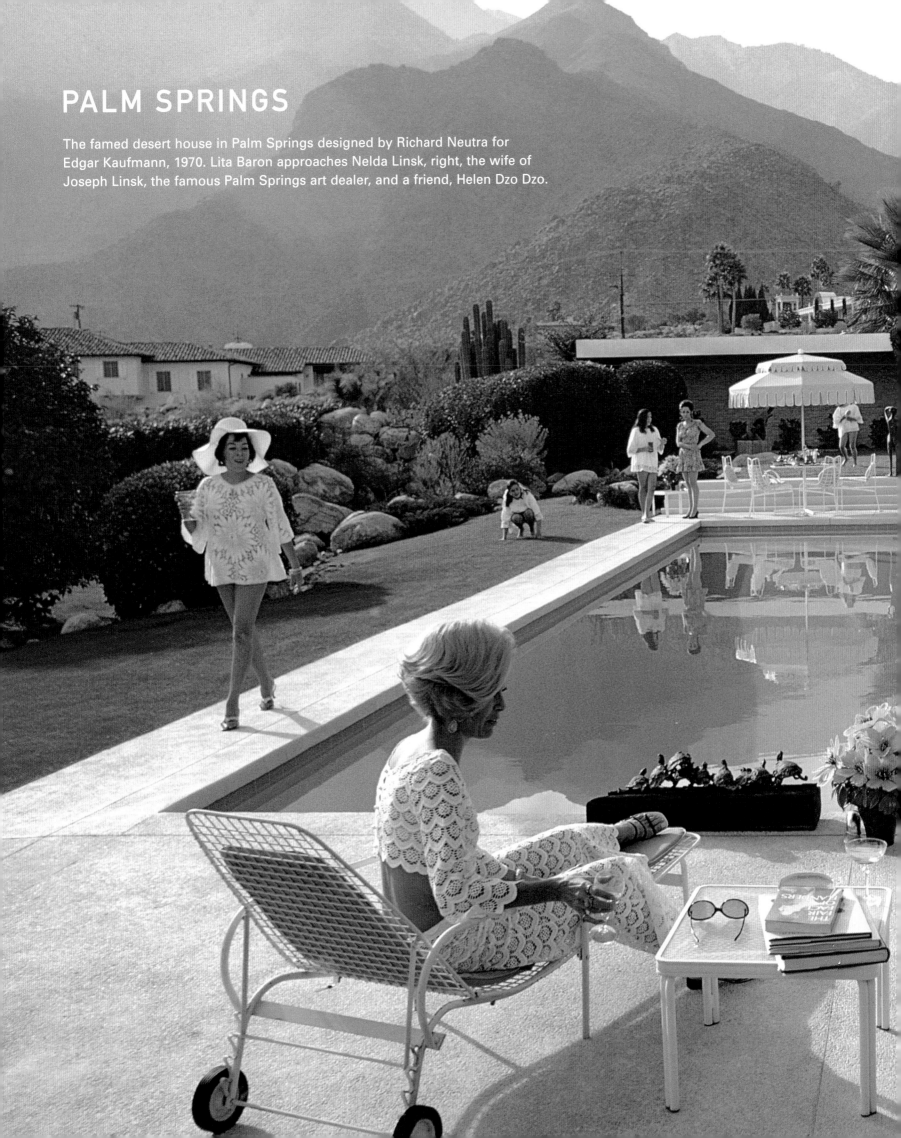

PALM SPRINGS

The famed desert house in Palm Springs designed by Richard Neutra for Edgar Kaufmann, 1970. Lita Baron approaches Nelda Linsk, right, the wife of Joseph Linsk, the famous Palm Springs art dealer, and a friend, Helen Dzo Dzo.

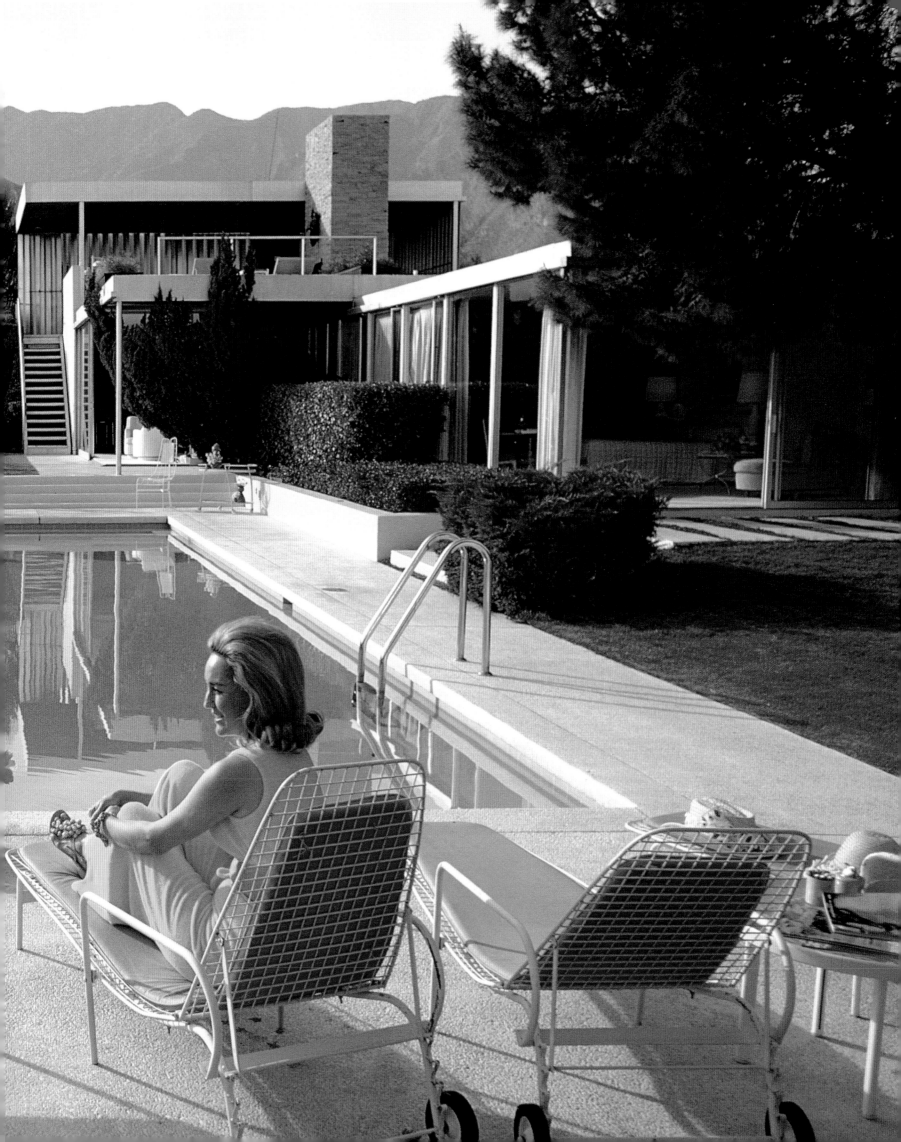

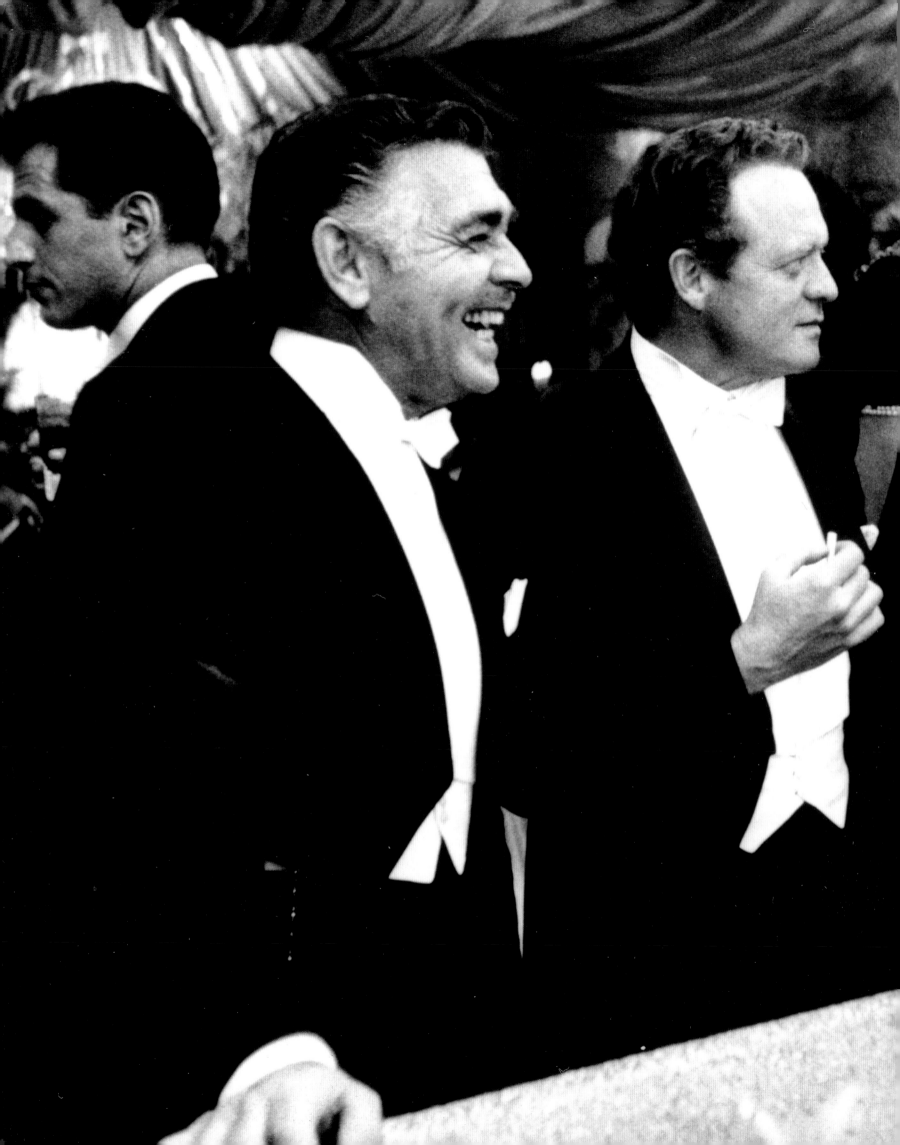

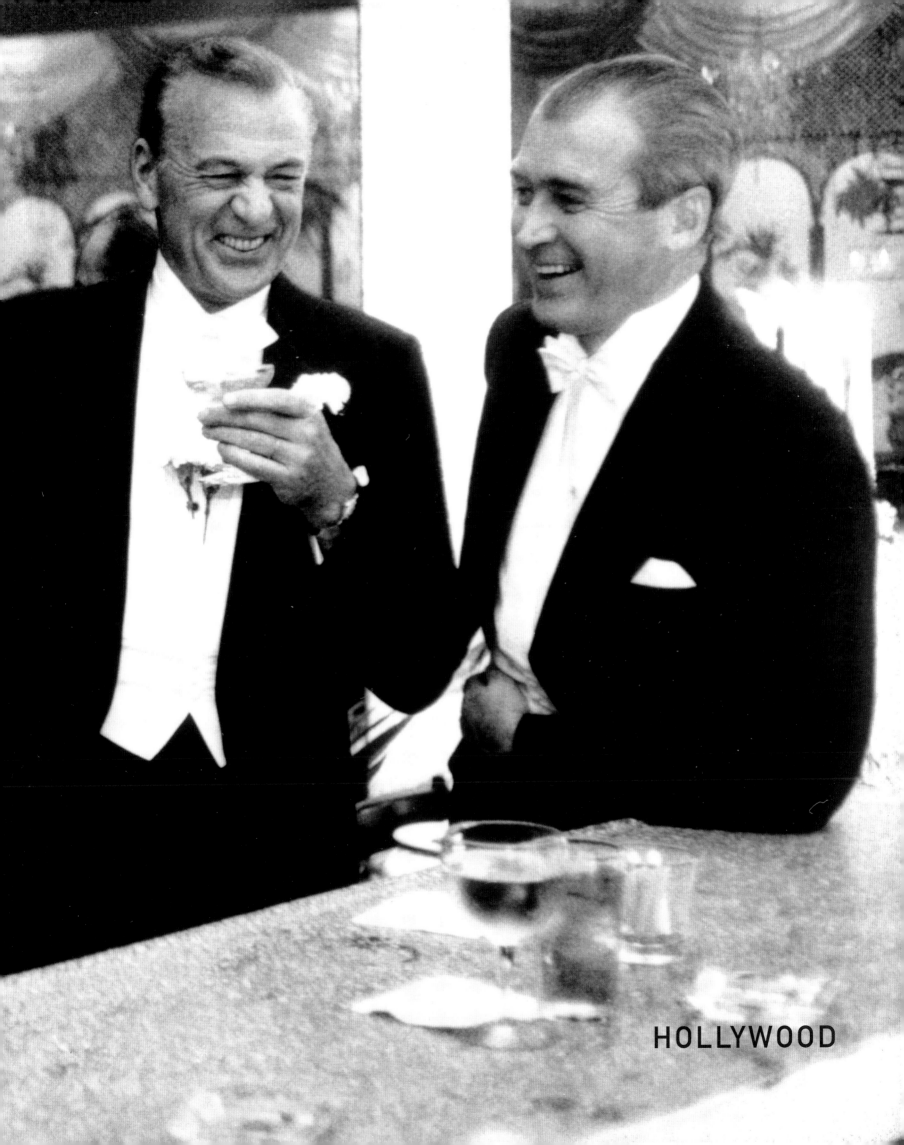

HOLLYWOOD

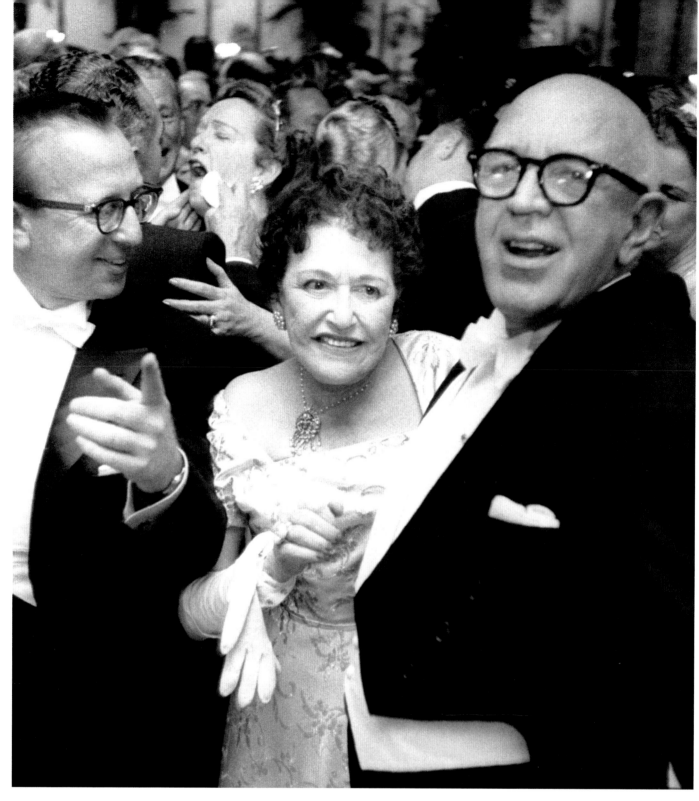

PREVIOUS PAGE: The Kings of Hollywood—Clark Gable, Van Heflin, Gary Cooper, and Jimmy Stewart—at the Crown Room of Romanoff's in Beverly Hills, New Year's Eve, 1957. Louis Auchincloss wrote of this photograph in the *Town & Country Picture Album of High Society*: "The peerless photograph, greatest of all in this volume, is that of the four great male stars—Gable, Cooper, Stewart, and Van Heflin—easily, but faultlessly clad in white tie and tails and drinking champagne at a party bar and laughing, genuinely laughing (even Cooper couldn't affect that grin) as they compose the very image of American he-men. You feel sure that they could strip off their finery and punch you in the nose the moment you got out of hand. And then go back to dazzle the ladies at the bar after their brief male recess." How do you beat that?

ABOVE: Louella Parsons at the same New Year's Eve party, Beverly Hills, 1957.

OPPOSITE: Wearing one of her trademark hats, gossip columnist Hedda Hopper in her Beverly Hills garden tending the roses named in her honor, the light-pink Hopper Rose, 1952.

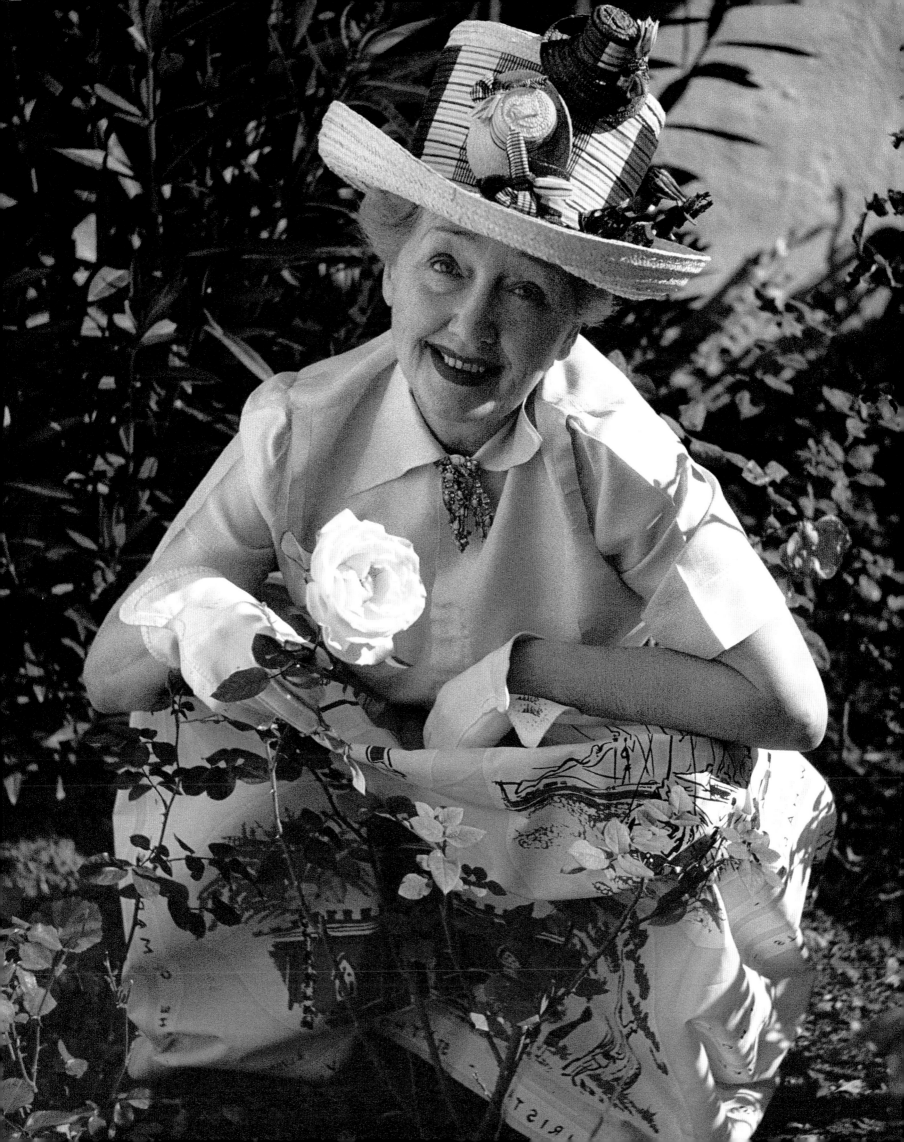

ABOVE: His Imperial Highness, Prince Michael Alexandrovitch Dmitri Obolensky Romanoff, nephew of the last of the czars of all the Russias and owner of Romanoff's Restaurant of Hollywood, chatting with Cary Grant. He was born Harry F. Gurguson in the U. S. A.

OPPOSITE: Humphrey Bogart with his wife, Lauren Bacall, and their son Stephen at home in Beverly Hills on Christmas Eve, 1951.

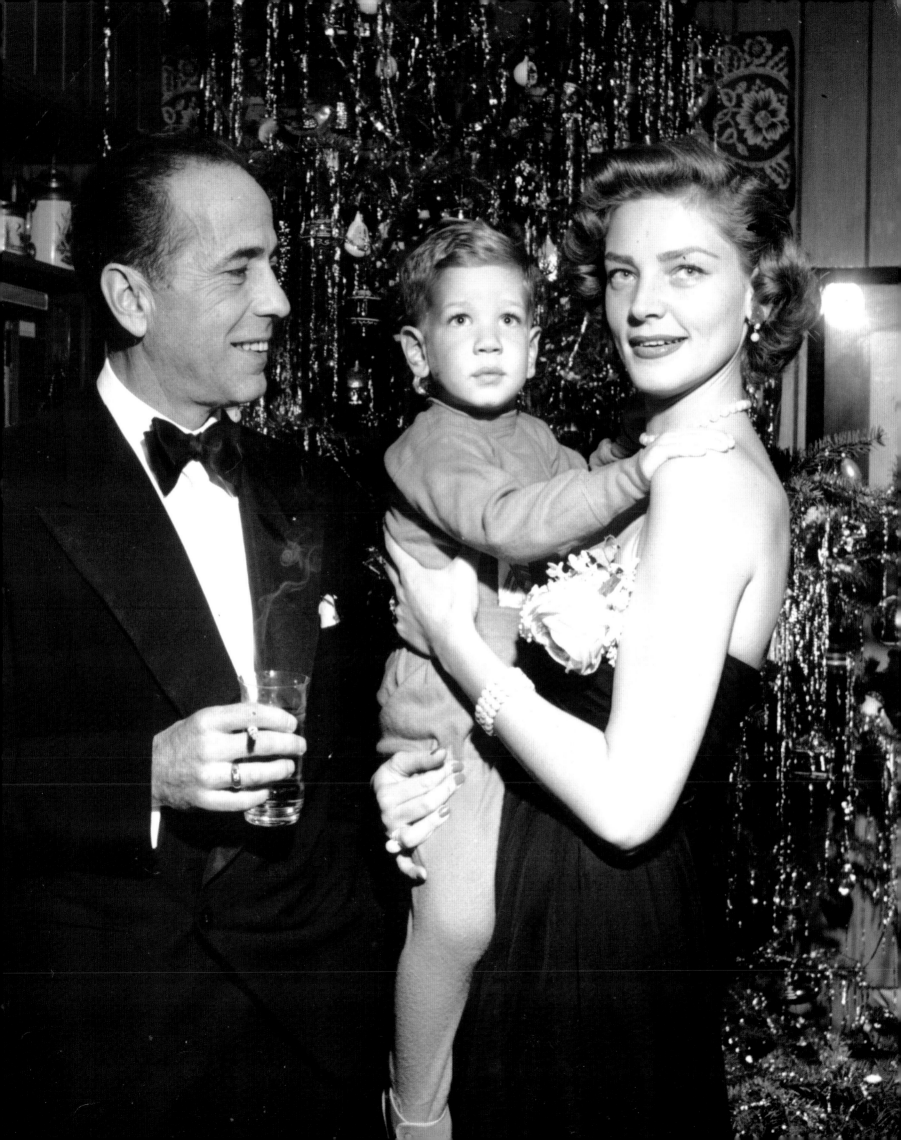

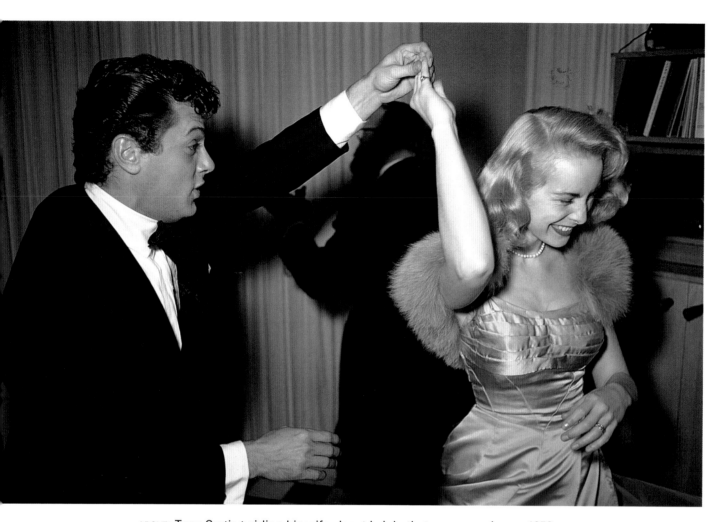

ABOVE: Tony Curtis twirling his wife, Janet Leigh, that same evening, c. 1953.

OPPOSITE: Marilyn Monroe, 1952. I photographed her as a favor for a friend, shortly after her first success in *The Asphalt Jungle*. The fan mail, the motel room, the negligée were all legitimate props for a story on Beverly Hills.

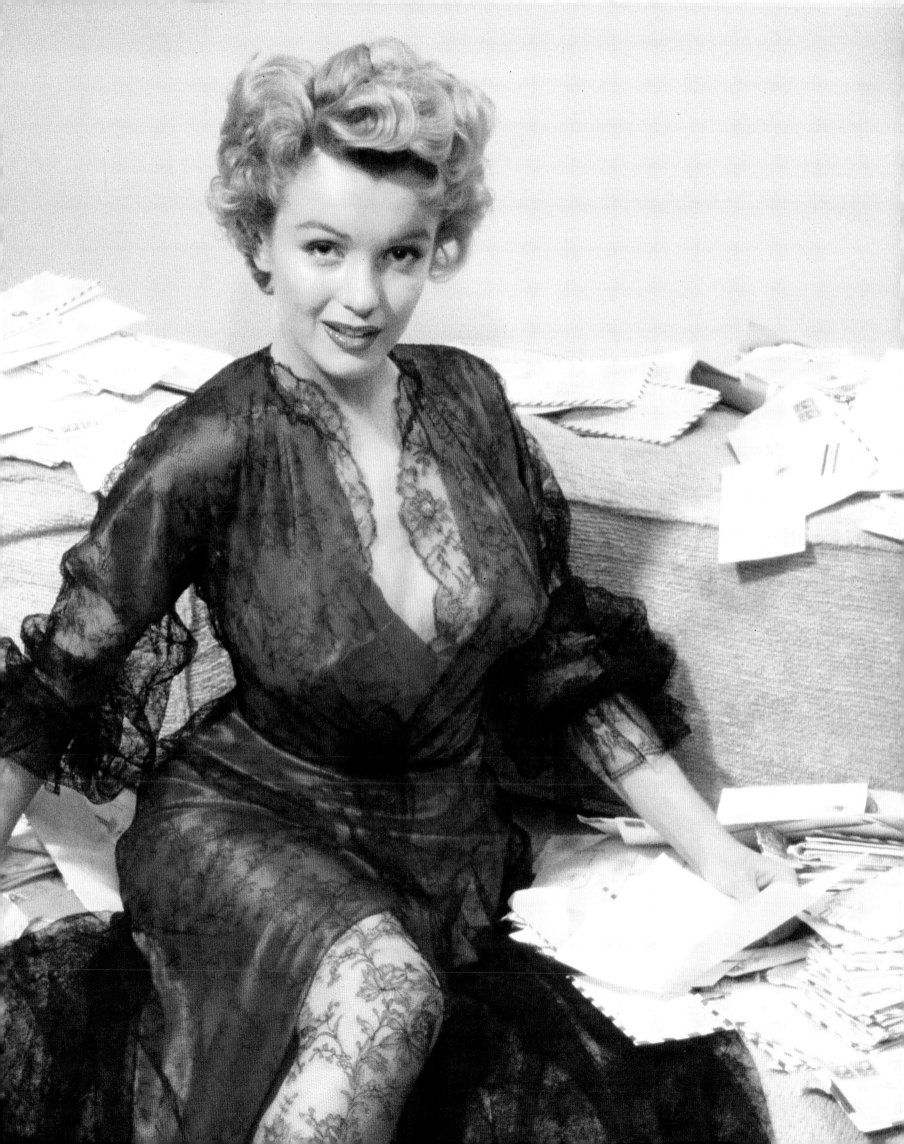

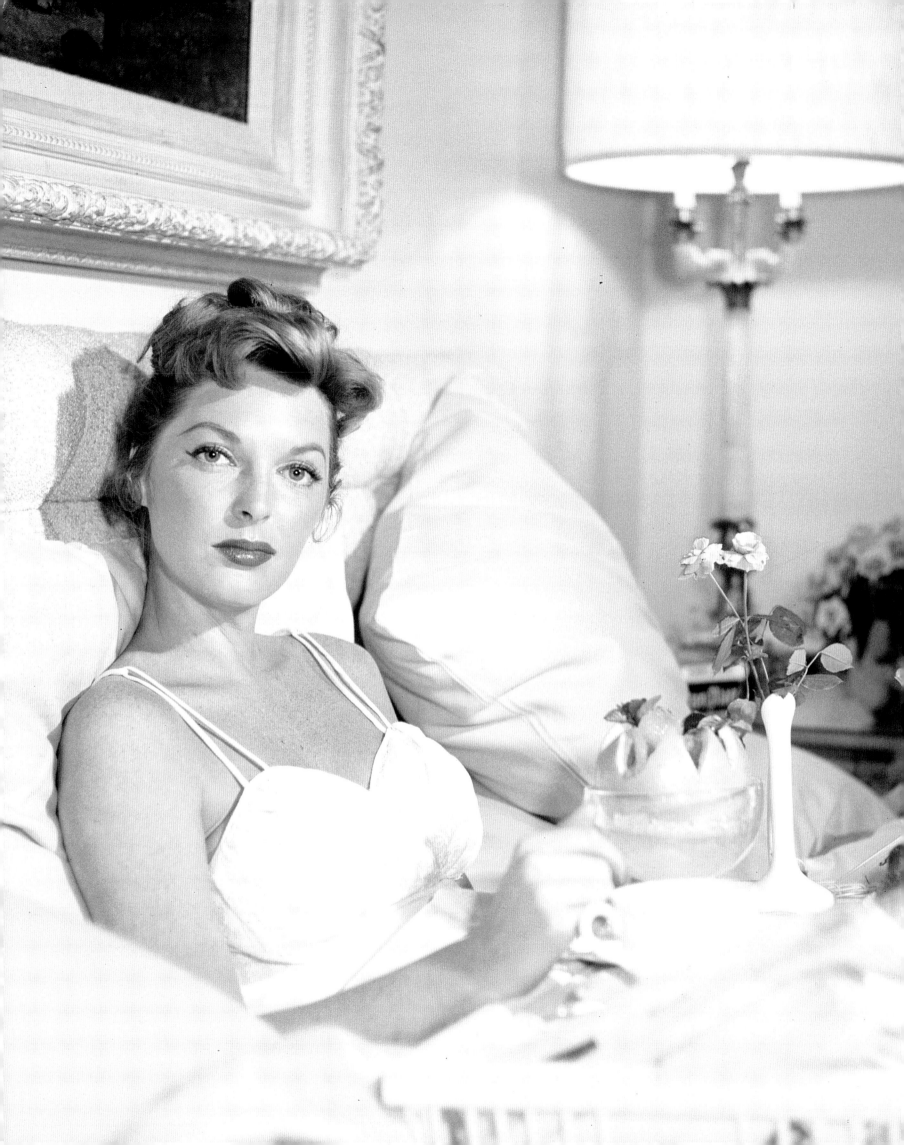

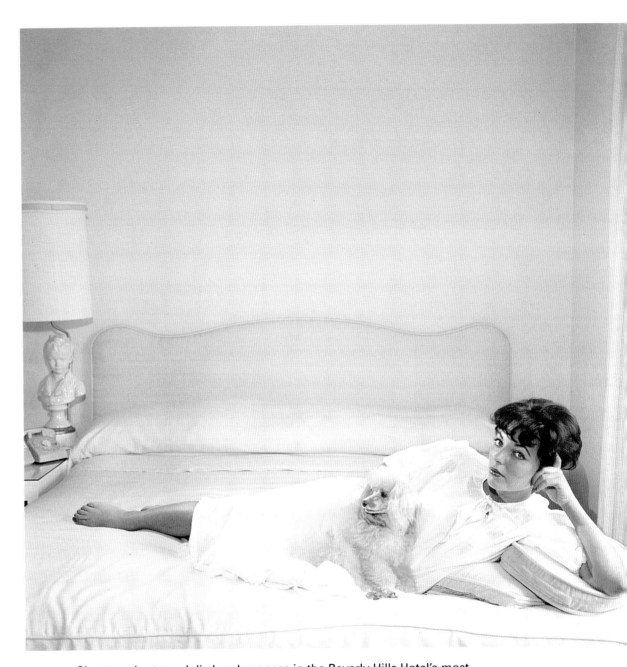

OPPOSITE: Singer and actress Julie London poses in the Beverly Hills Hotel's most elaborate bungalow.

ABOVE: Seductive in pink, Joan Collins on her pink bed with her pink poodle, c. 1955.

BEVERLY HILLS

BELOW: Jean Negulesco and his wife, Dusty, before her portrait by Noyer, c. 1950. Jean directed *Three Coins in the Fountain*.

OPPOSITE: The Beverly Hills home of interior decorator James Pendleton, later owned by Robert Evans, motion picture executive of Paramount Pictures Corporation, c. 1960.

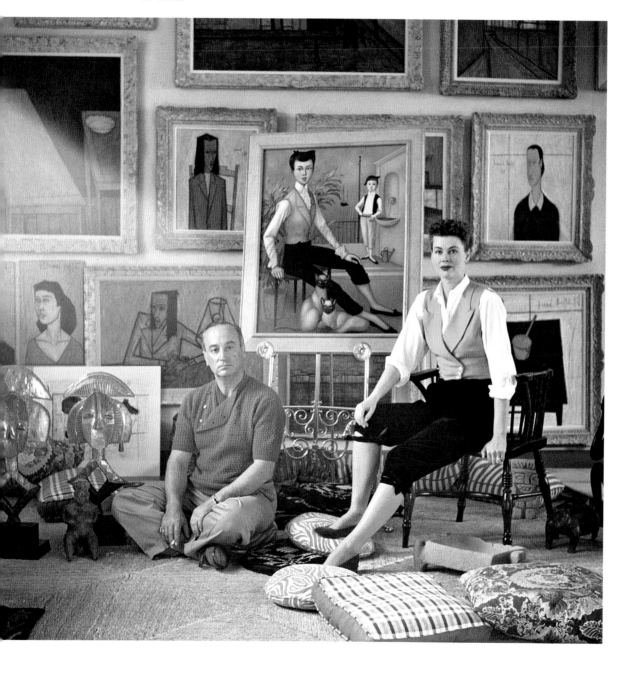

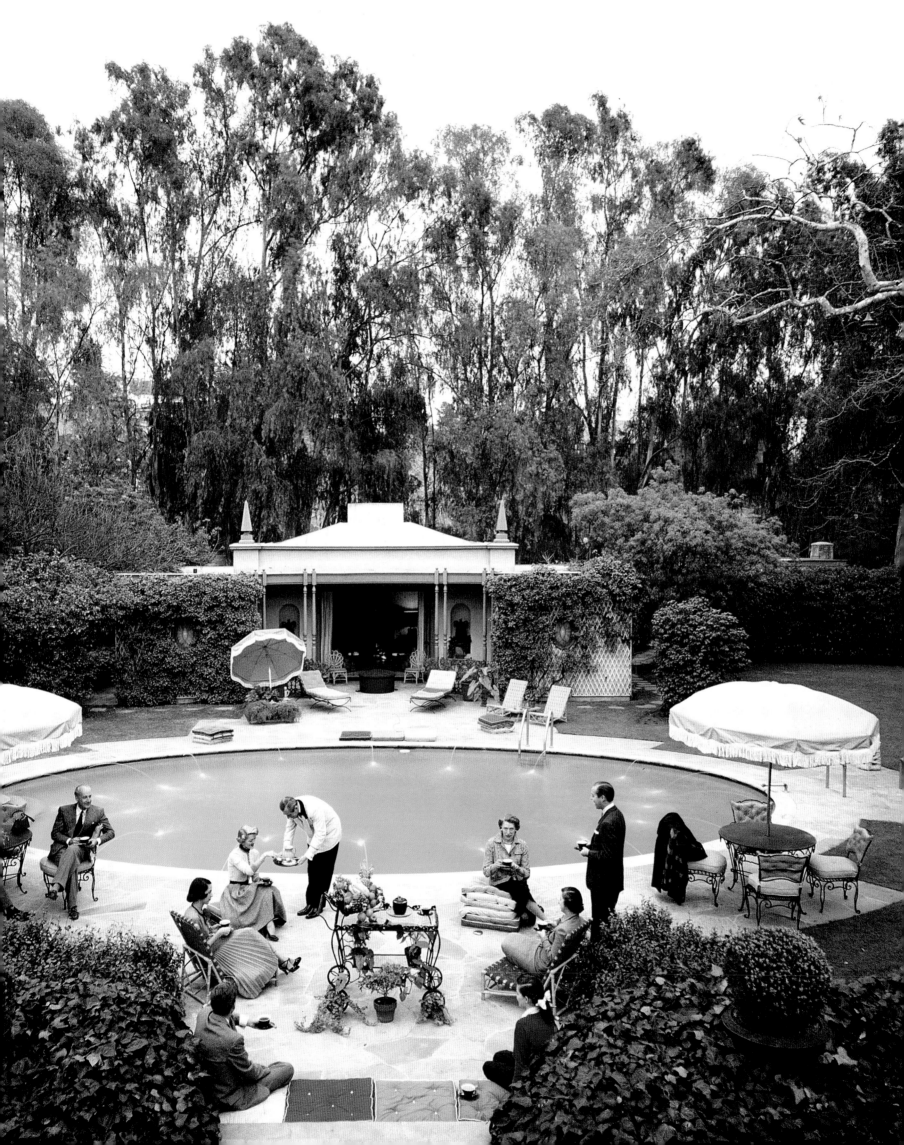

LAGUNA BEACH & PEBBLE BEACH

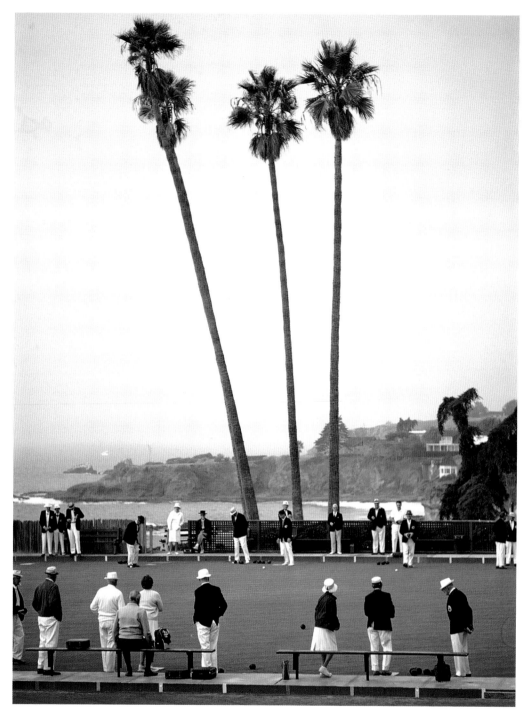

ABOVE: The Laguna Beach Lawn Bowling Club in Heisler Park, where the proper dress and rules are observed by its members and guests. Founded in 1932, the club overlooks the coves and beaches and homes of old Laguna.

OPPOSITE: At the sixteenth hole on Pebble Beach golf course, singer and film star Bing Crosby, right, and A. Thomas Taylor, 1977. At one time they had each shot a hole-in-one at the sixteenth. I took the photograph from a ten-foot ladder, because the first time I took a picture of Crosby, I had gotten down on one knee to snap the shot and Crosby said to me, "Up, up sonny boy. No up-the-nose and under-the-chin shots." While up on the ladder, I said to Crosby, "See, I learned."

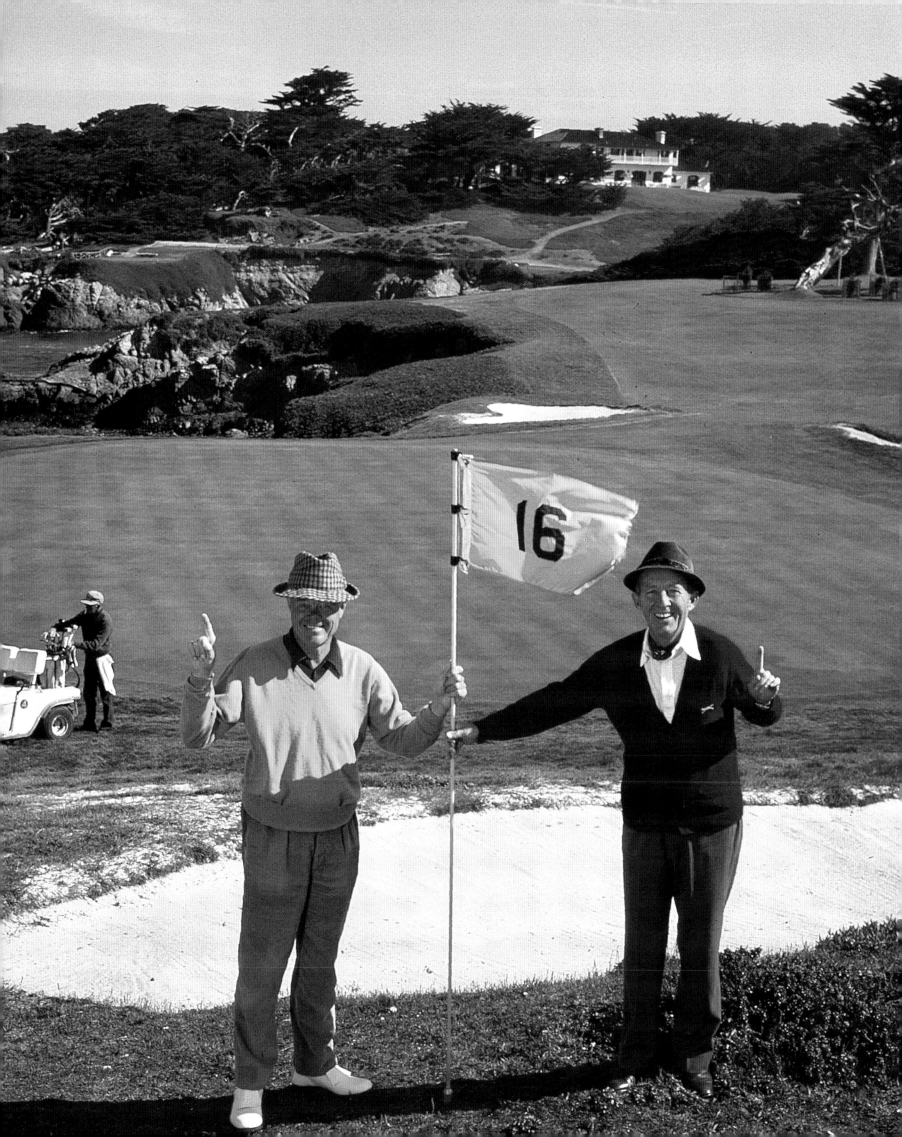

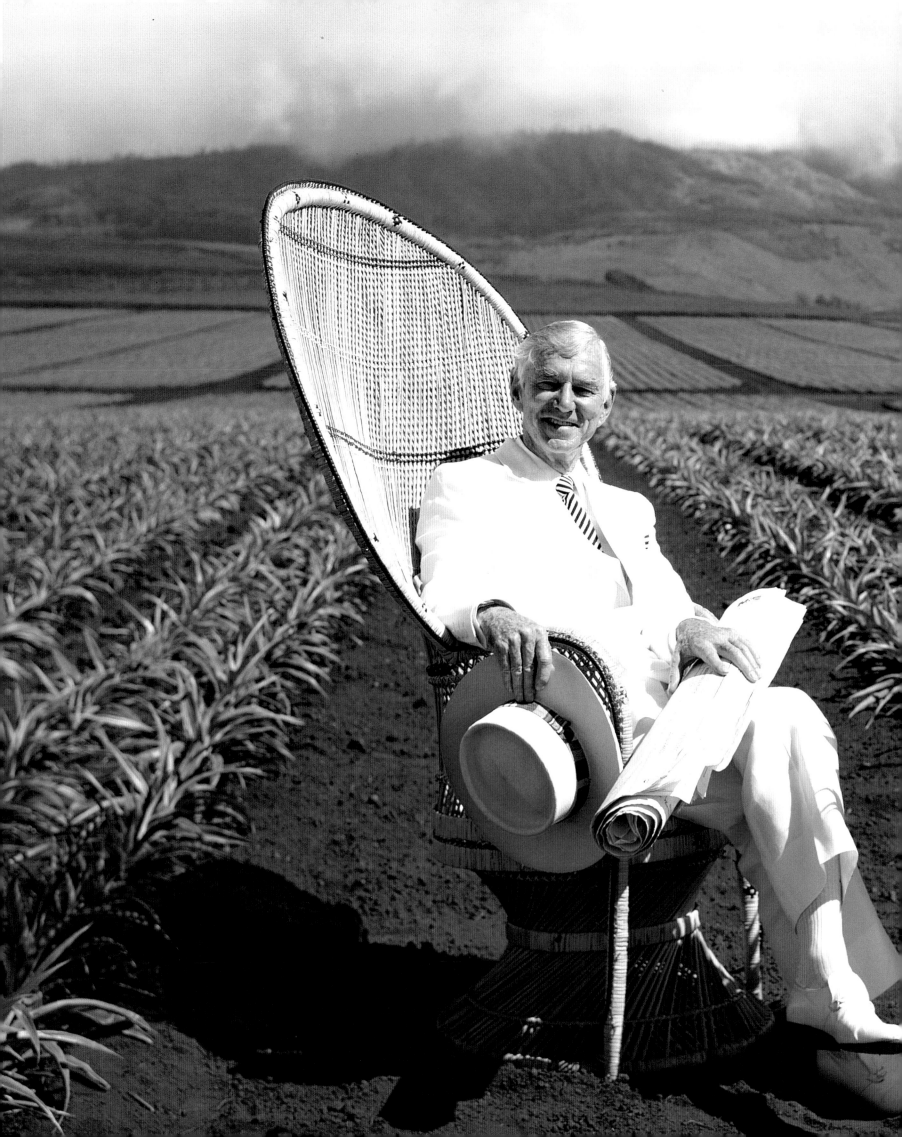

HAWAII

American entrepreneur
David Murdock relaxes on
a wicker chair on his
plantation in Lanai,
Hawaii, 1989.

133

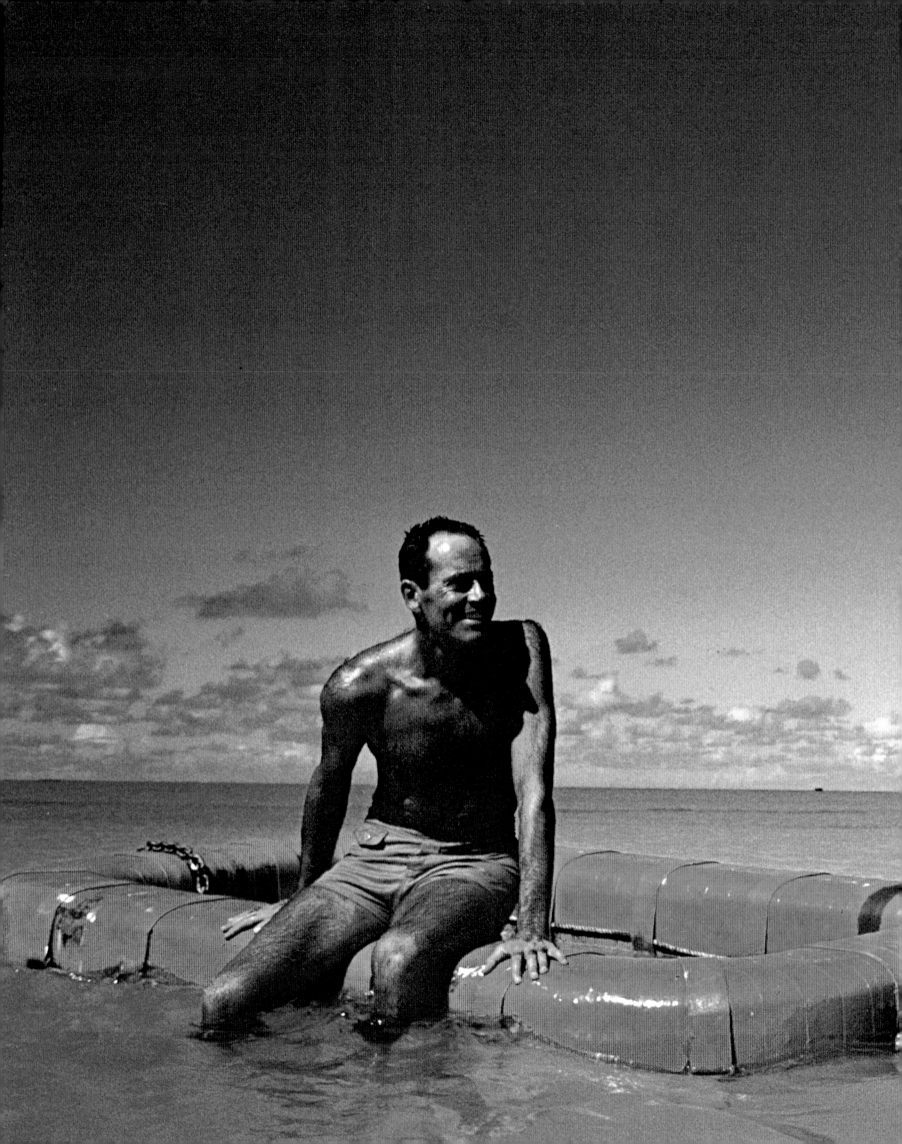

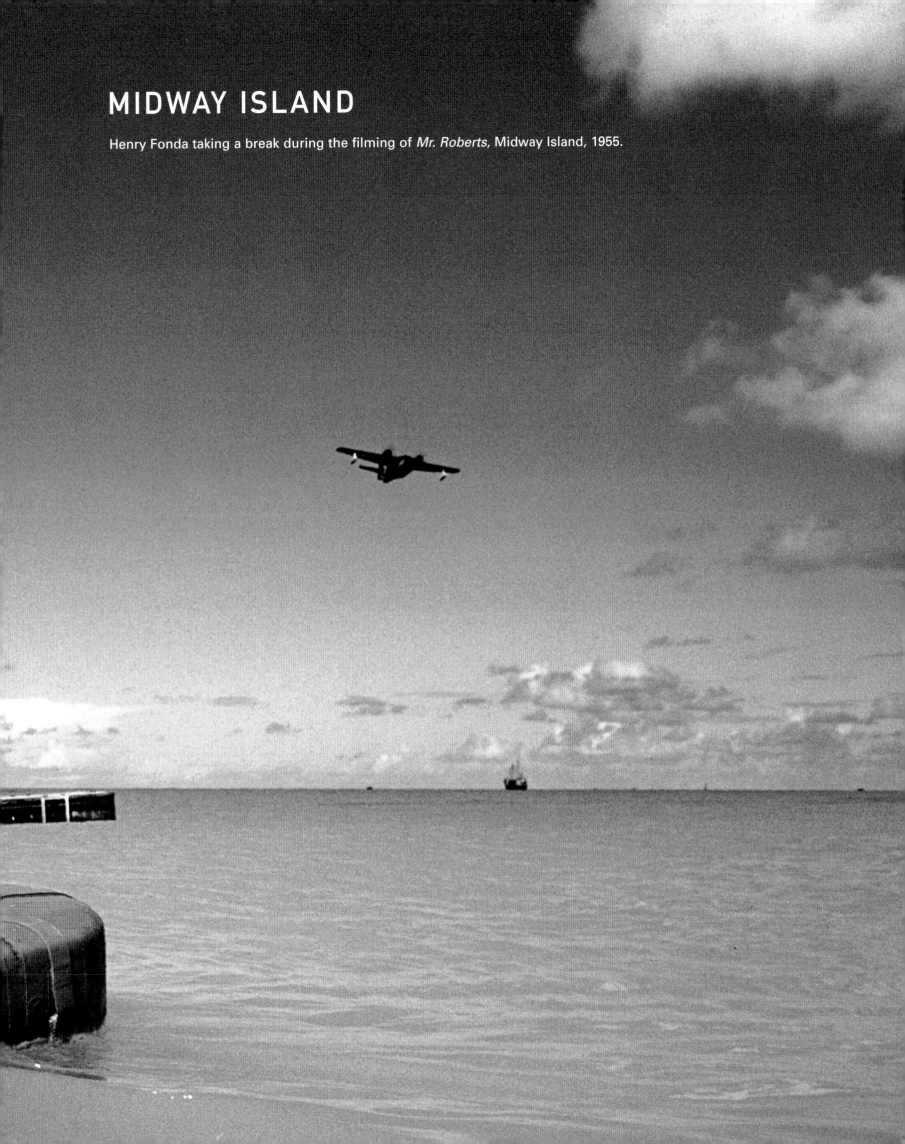

MIDWAY ISLAND

Henry Fonda taking a break during the filming of *Mr. Roberts*, Midway Island, 1955.

MEXICO

ABOVE: Teddy Stauffer, "Mr. Acapulco," with his daughter, Melinda Morgan. Teddy first arrived in Acapulco with Errol Flynn aboard Flynn's yacht "Sirocco," and has lived there since 1946. I closed my first book with this shot because it told the story of the past and the future.

OPPOSITE: Villa Nirvana, 1971, built by Oscar Obregón II, a descendant of the late Mexican president General Alvaro Obregón, in the Las Brisas area of Acapulco. Across the bay is old Acapulco.

OVERLEAF: American film director John Huston at his hideaway in Puerto Vallarta, Mexico, 1979. He bought this little bungalow when he was directing the movie *Night of the Iguana* here.

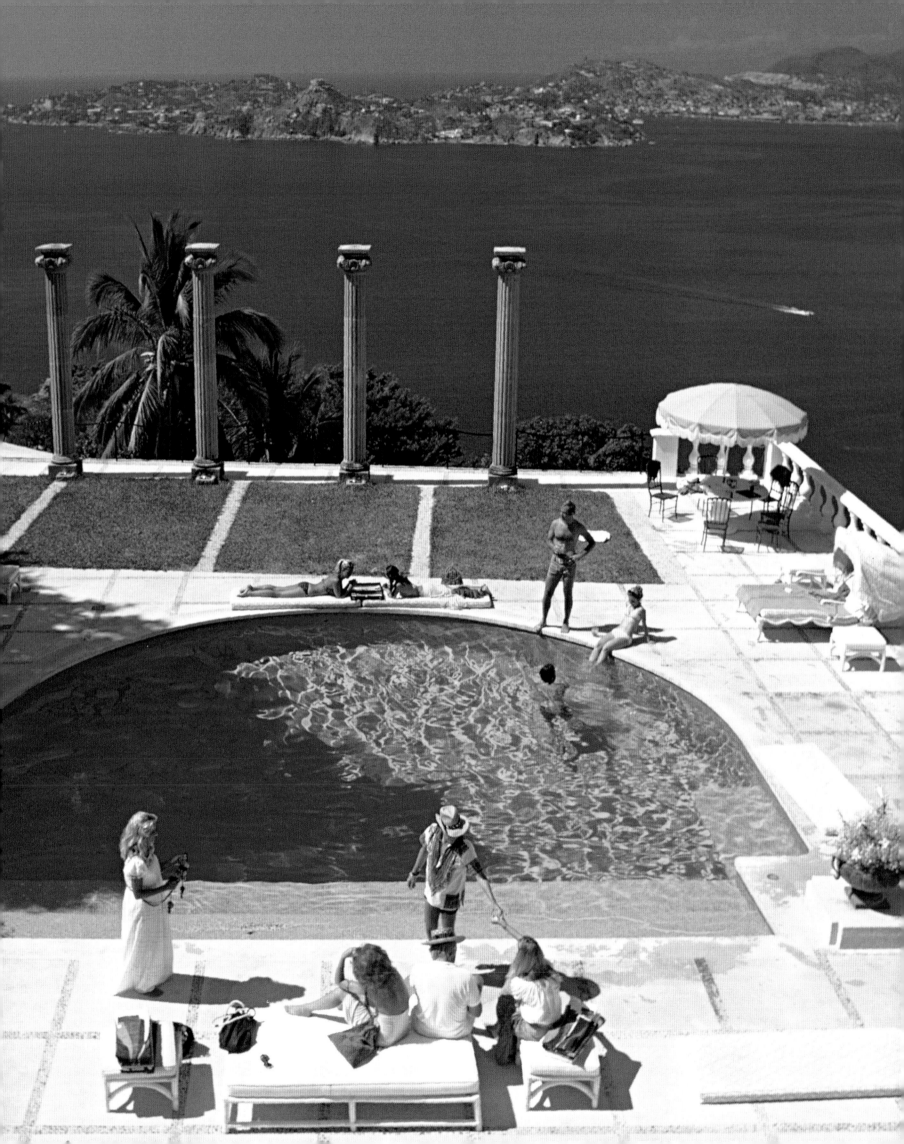

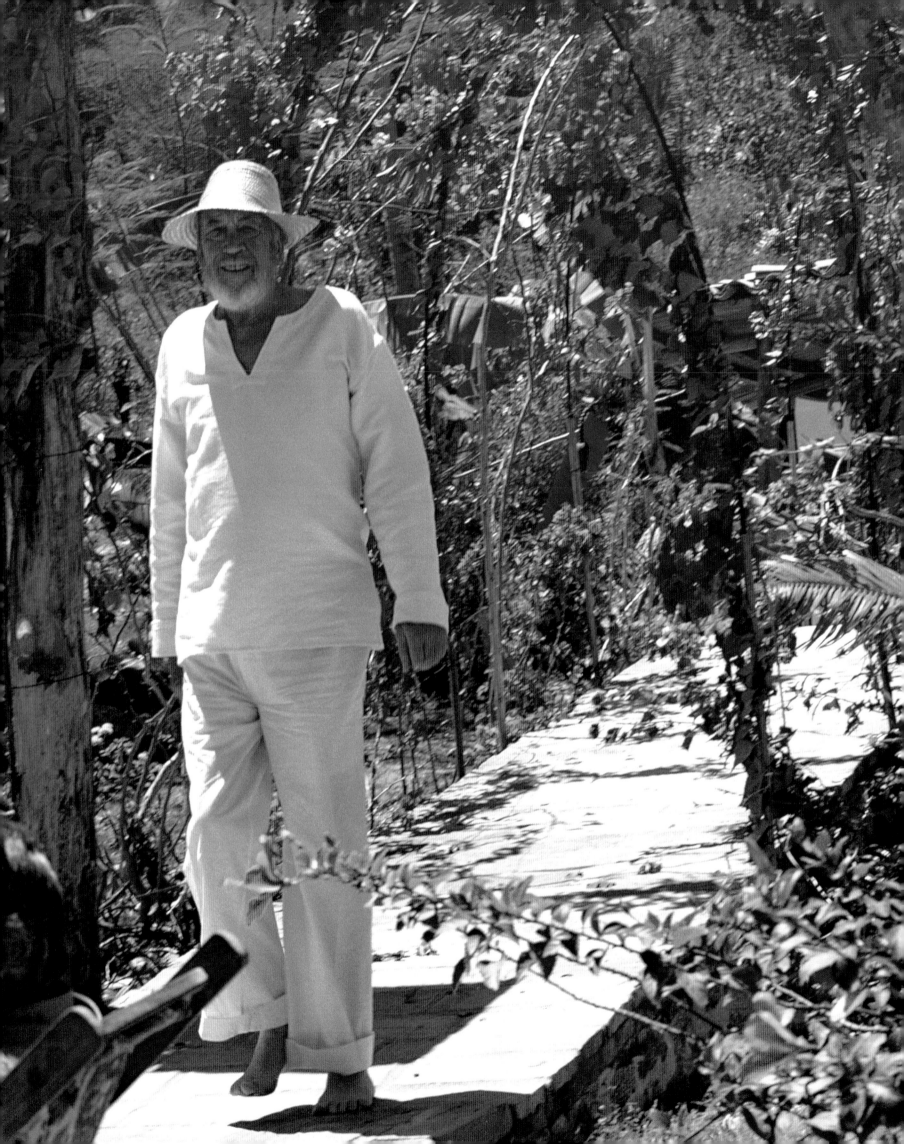

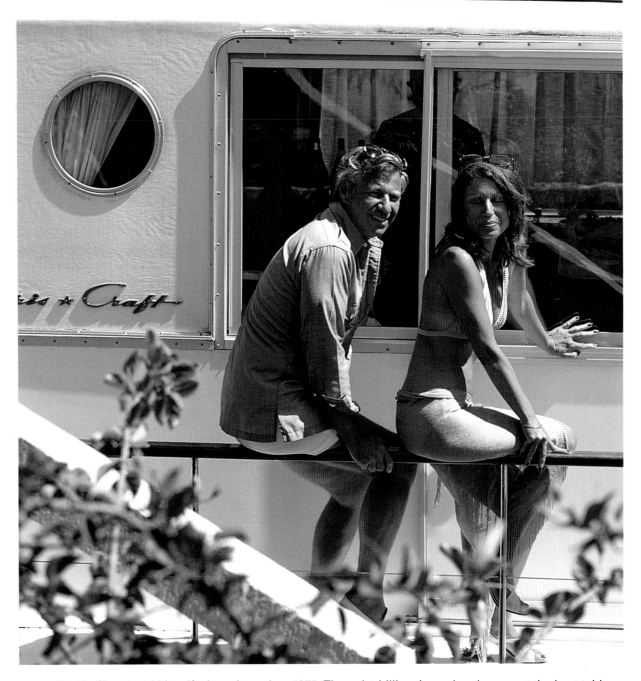

ABOVE: Herbie Siegel and his wife Ann. Acapulco, 1975. The quiet billionaires who always get the best table.

OPPOSITE: German aristocrat, model, and film star Veruschka, the Countess Vera Gottlieb von Lehndorff, standing on a balcony in Acapulco, 1966. She became a photographer of note after she quit modeling. Her glamorous life belied the tragedy of her father's execution for plotting against Hitler.

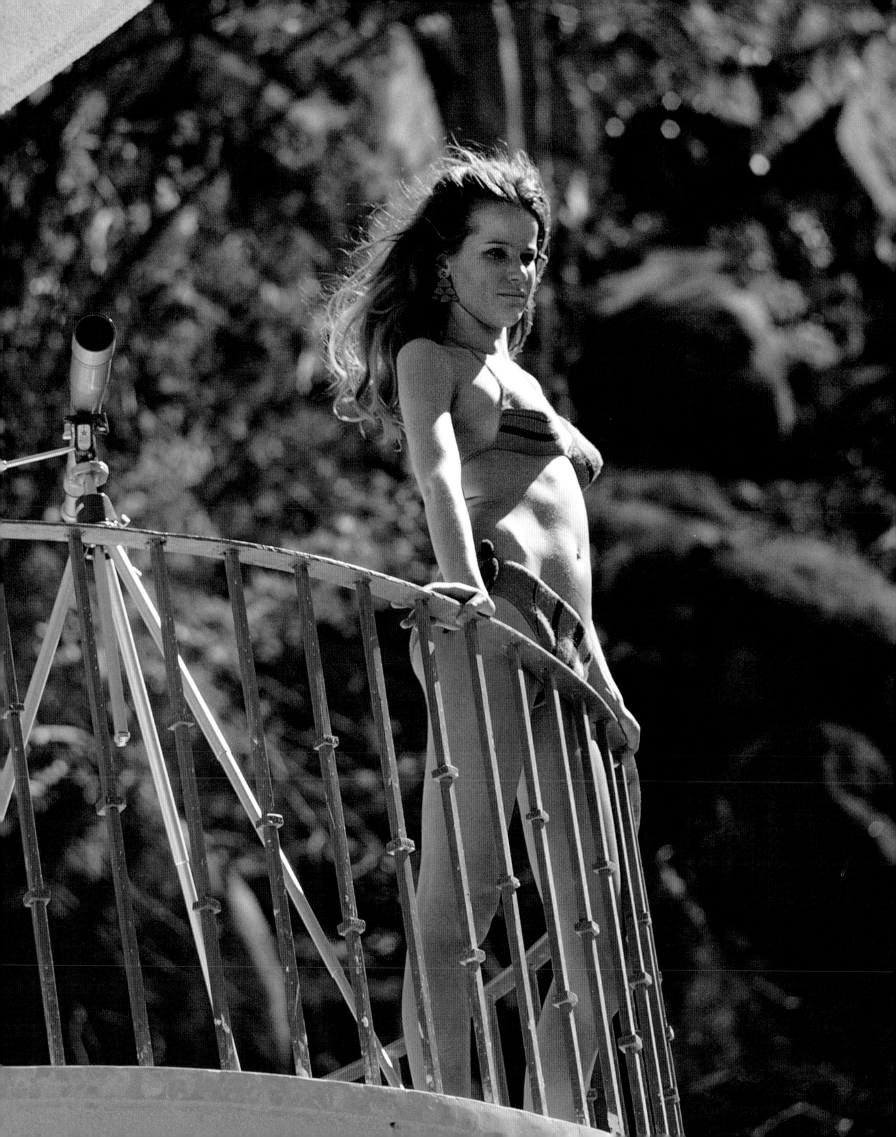

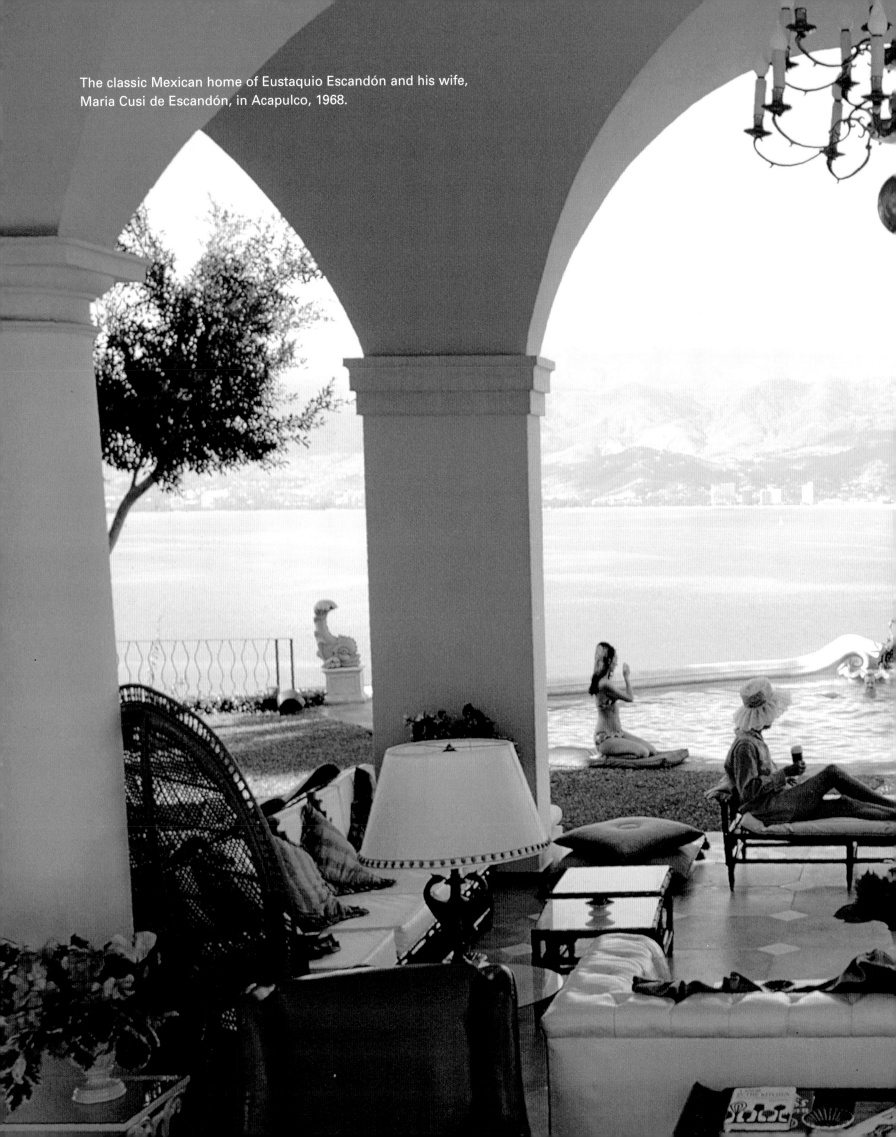

The classic Mexican home of Eustaquio Escandón and his wife,
Maria Cusi de Escandón, in Acapulco, 1968.

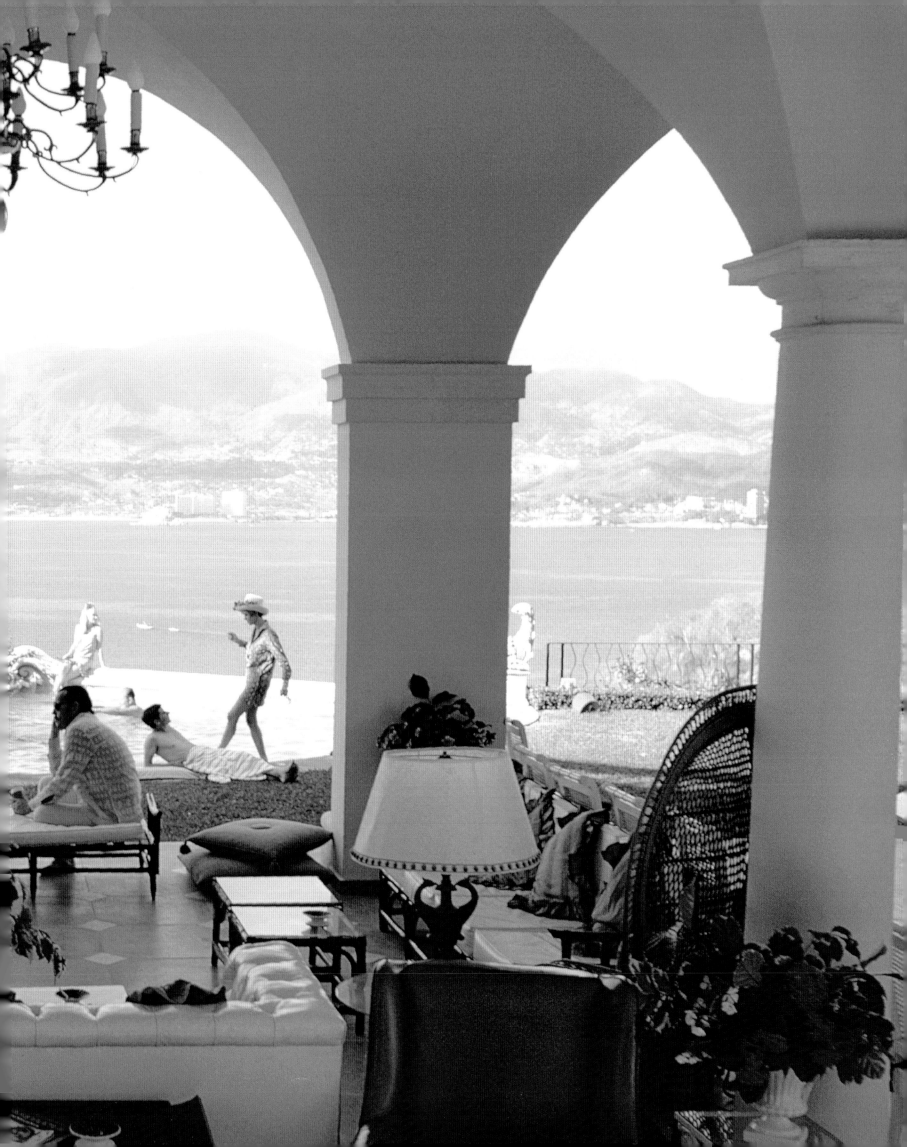

ENGLAND & WALES

BELOW: Earl Mountbatten of Burma and Lady Edwina Mountbatten walking on the grounds of Broadlands, their Hampshire home, 1958. Mountbatten was Lord of the Admiralty at that time and I was doing a story on the noble lords of England. England wanted every bit of press it could get; it was postwar and they needed tourists badly. The British Tourist Office made all the arrangements.

OPPOSITE: John Albert Edward Spencer Churchill, the 10th Duke of Marlborough, and his wife, Mary, relax on a bench on the grounds of Blenheim Palace, the family seat in Oxfordshire, 1957. Winston Churchill was born here in 1874.

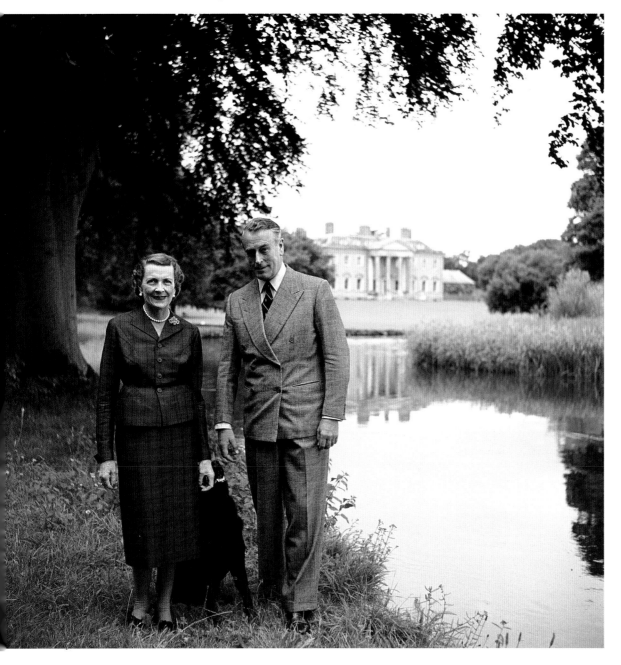

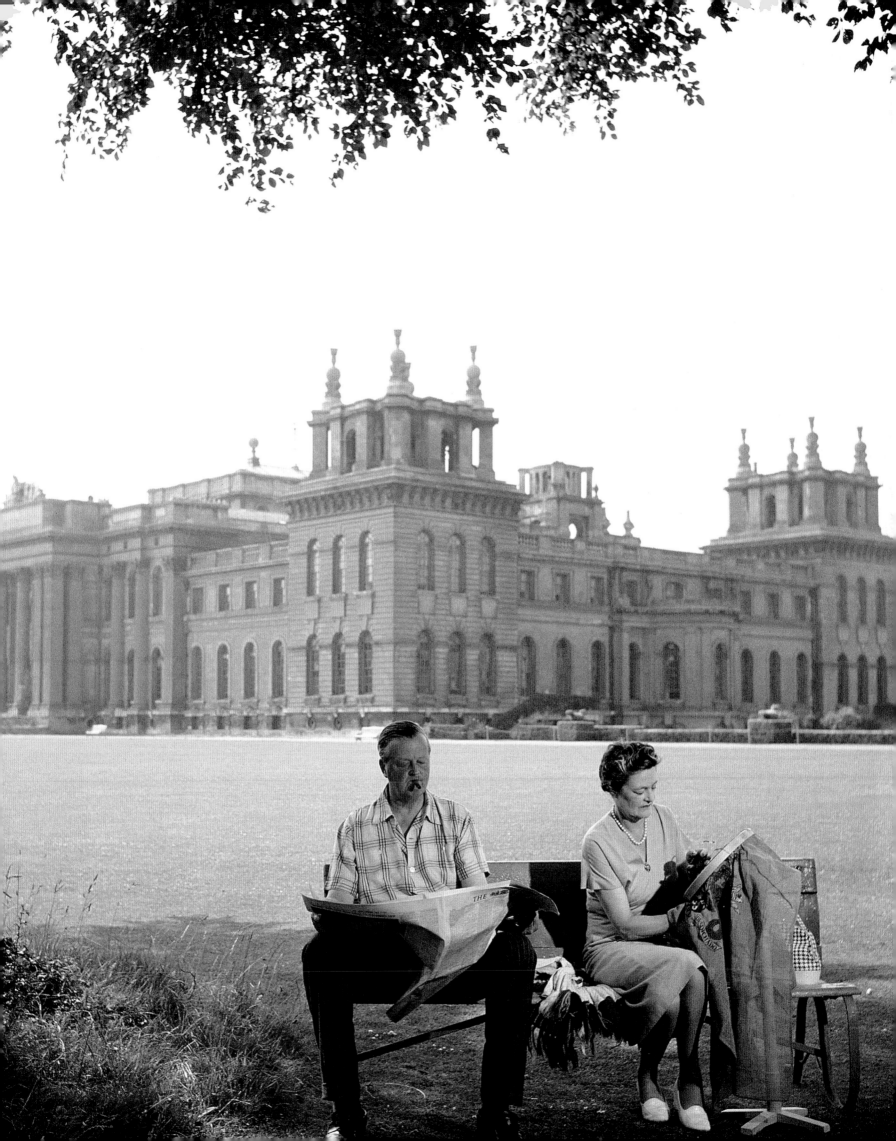

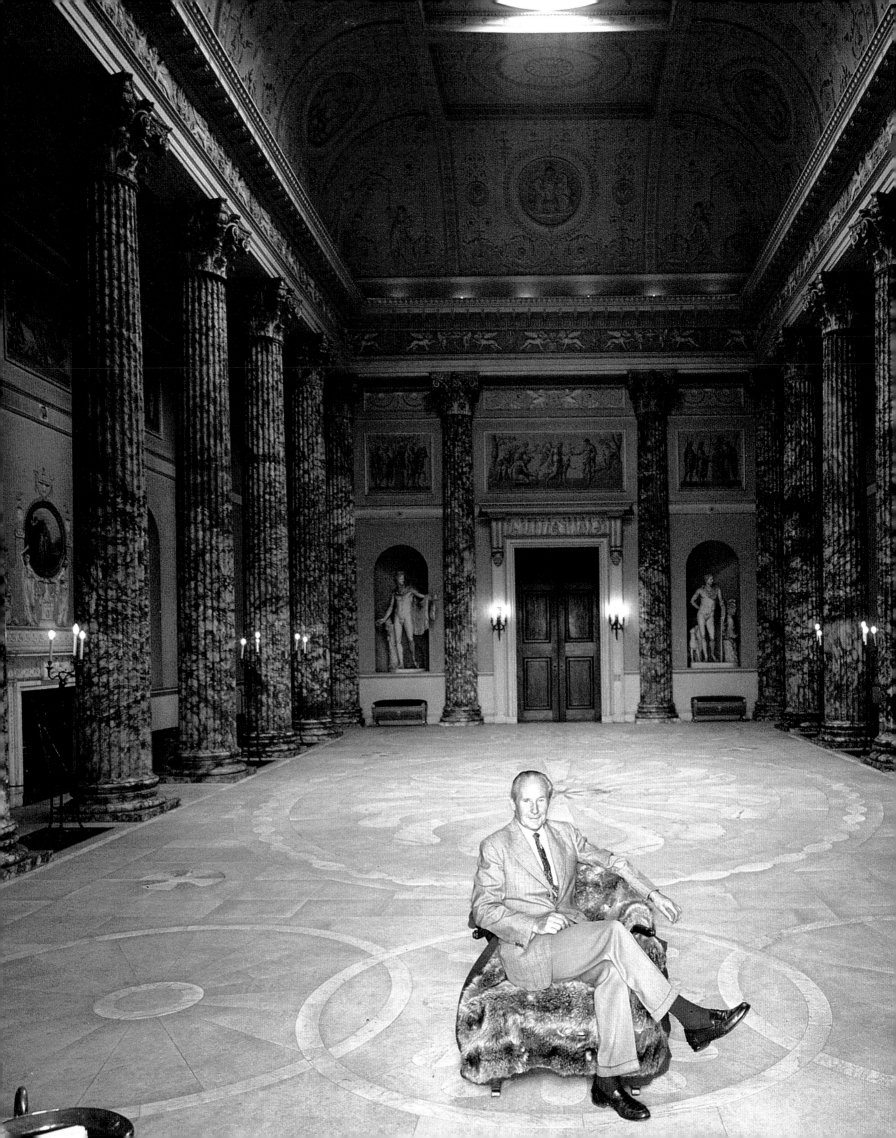

OPPOSITE: English aristocrat Viscount Scarsdale at his home, Kedleston Hall, in Derbyshire, 1957. I use a wonderful camera in these big palaces, a Hasselblad Superwide. I call the lens my Brueghel lens. It can get the ceiling, floor, and two walls. I save it just for this kind of shot. In my work I have always kept in mind the great paintings in the museums of the world. I see paintings as if I'm looking at them through a camera lens.

BELOW: The Earl of Sandwich outside his stately home in Hinching Brook, Huntingdon, 1957. At the time I was taking this picture, I asked the Earl about the origin of the sandwich. The official story is that a Lord Sandwich was so busy plotting the defense of England against the Spanish Armada that he had no time to eat a proper meal and told an aide to bring him some beef, bread, and other delicacies from Fortnum and Mason, and he put it all together into a kind of sandwich, the first sandwich. The unofficial version is that one of his ancestors was a chronic gambler. He never took time out for meals and only ate bits of bread and meat that were brought to him at the tables, thereby inventing the sandwich. Unfortunately, he gambled away much of the family fortune while doing so.

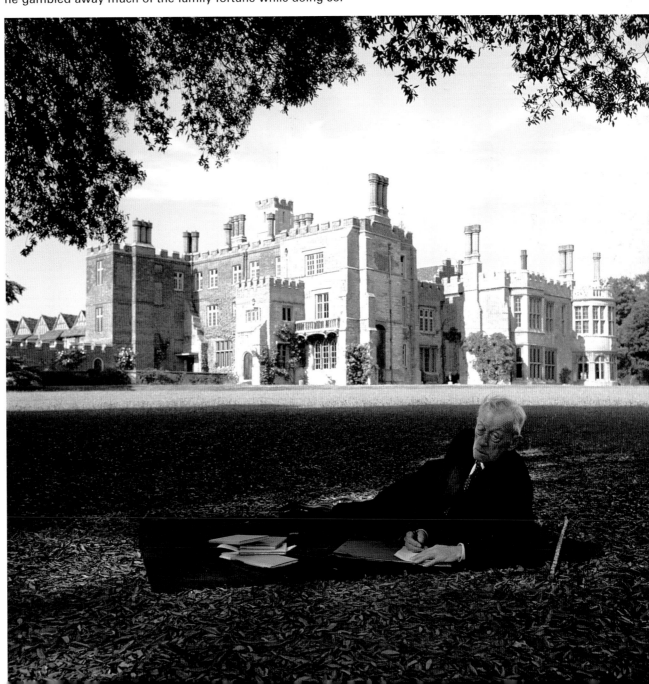

BELOW: The Honorable Timothy Jessel in London having just returned from a day at Ascot in his Jaguar, 1955. I was driving through London traffic after a day of shooting at Ascot, a big event that the Queen attends. I stopped at a light and beside me, in a sports car, was this fellow. At the next light I got his attention and asked him if I could take his photograph for an American magazine. He followed me and I took the shot in front of the Georgian house where I was staying. There he stands like any true Guardsman. He had just been at Ascot in the royal enclosure.

OPPOSITE: The youngest peer in England, seven-year-old Thomas Alexander Fermor-Hesketh, 3rd Baron and 10th Baronet Hesketh, fishing in the lake of his ancestral home, Easton Neston House in Northhamptonshire, 1957.

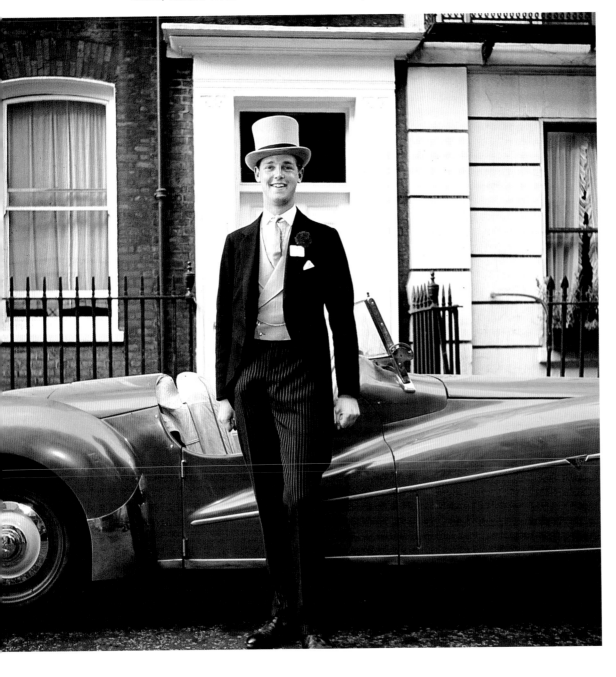

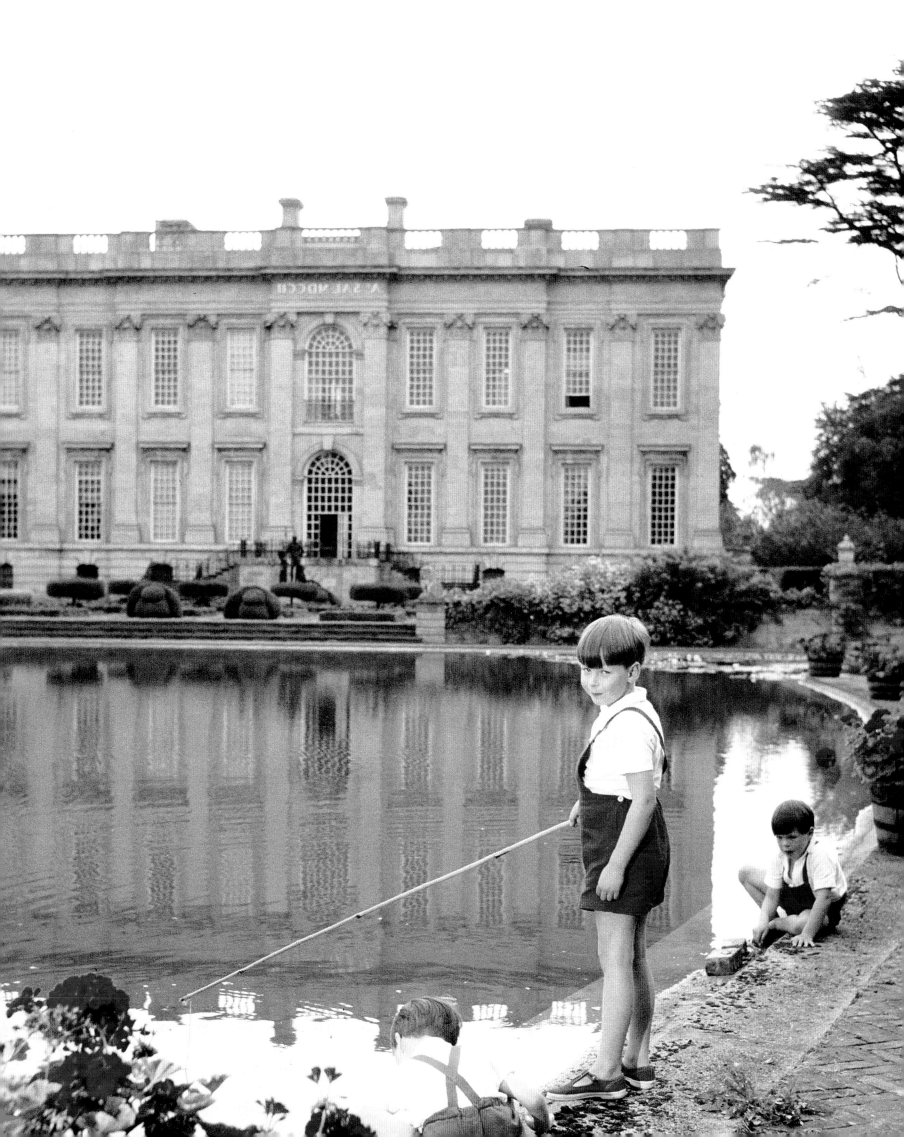

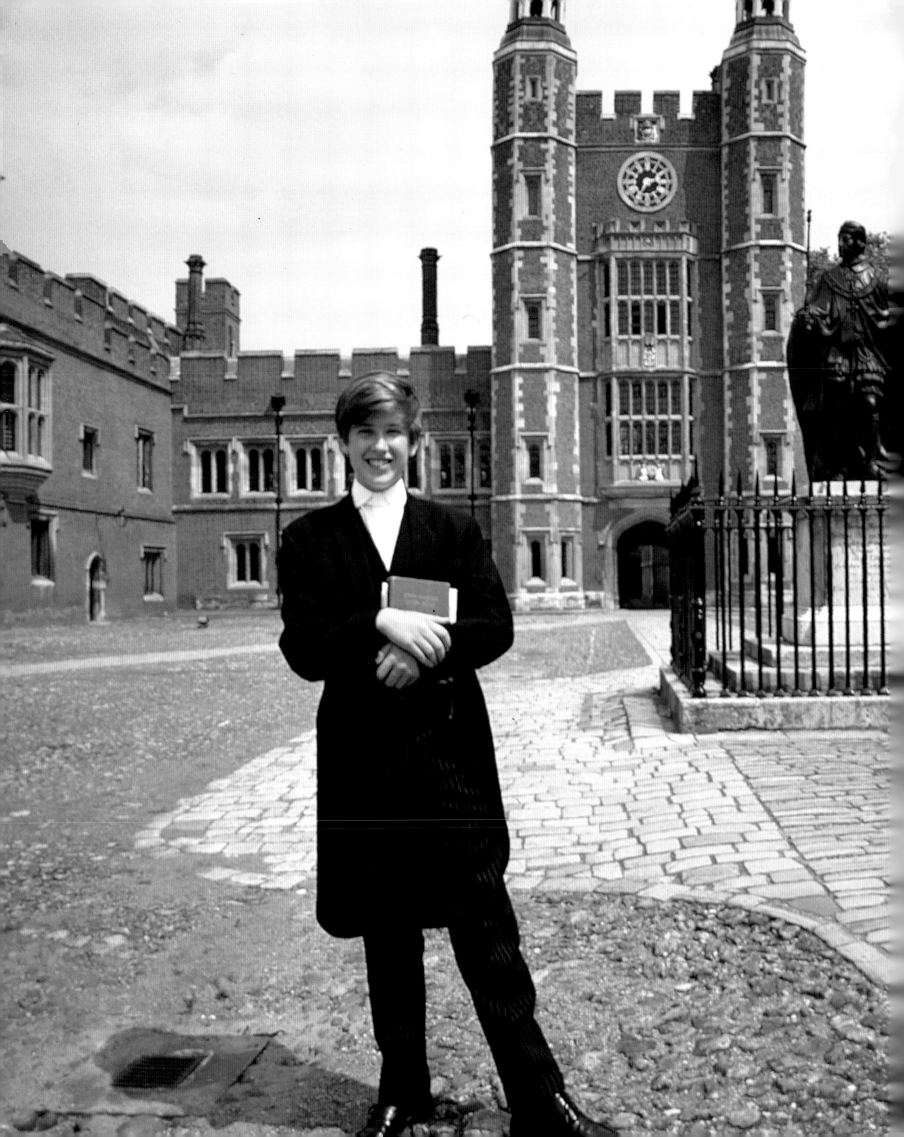

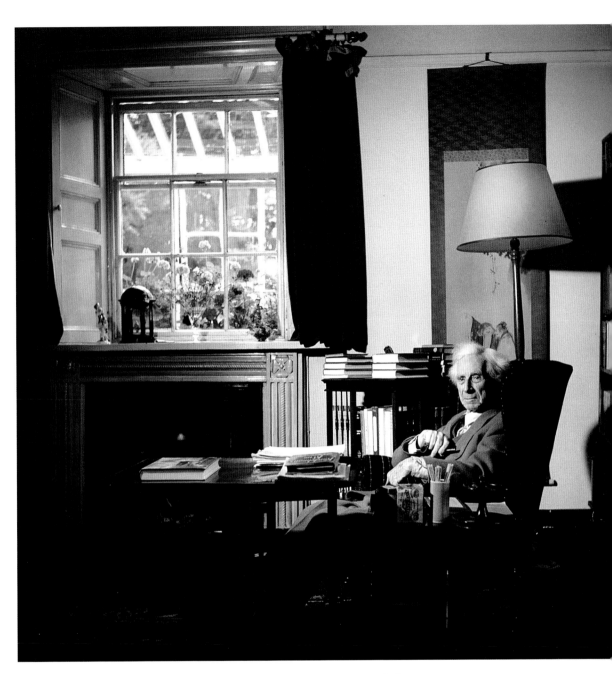

OPPOSITE: The Honorable William Stonor who will inherit the title 8th Baron Camoys, 1989. His great-great-great grandmother was Sophia Augusta Brown, whose family founded Brown University. His godfather was J. Carter Brown, the late former director of Washington's National Gallery of Art.

ABOVE: Welsh philosopher and writer Bertrand Russell at his home in Plas Penrhyn, Wales, 1957. He was associated with many causes throughout his long life, ranging from birth control to nuclear disarmament.

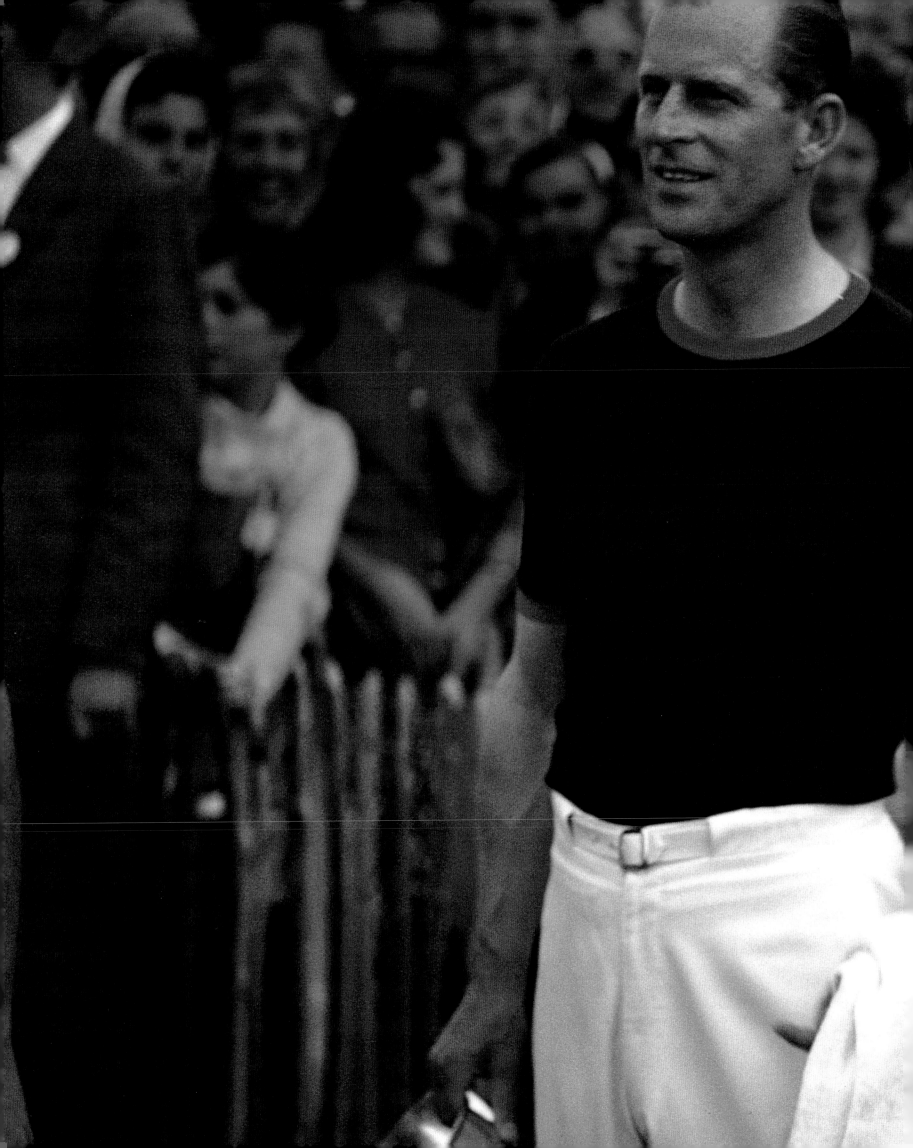

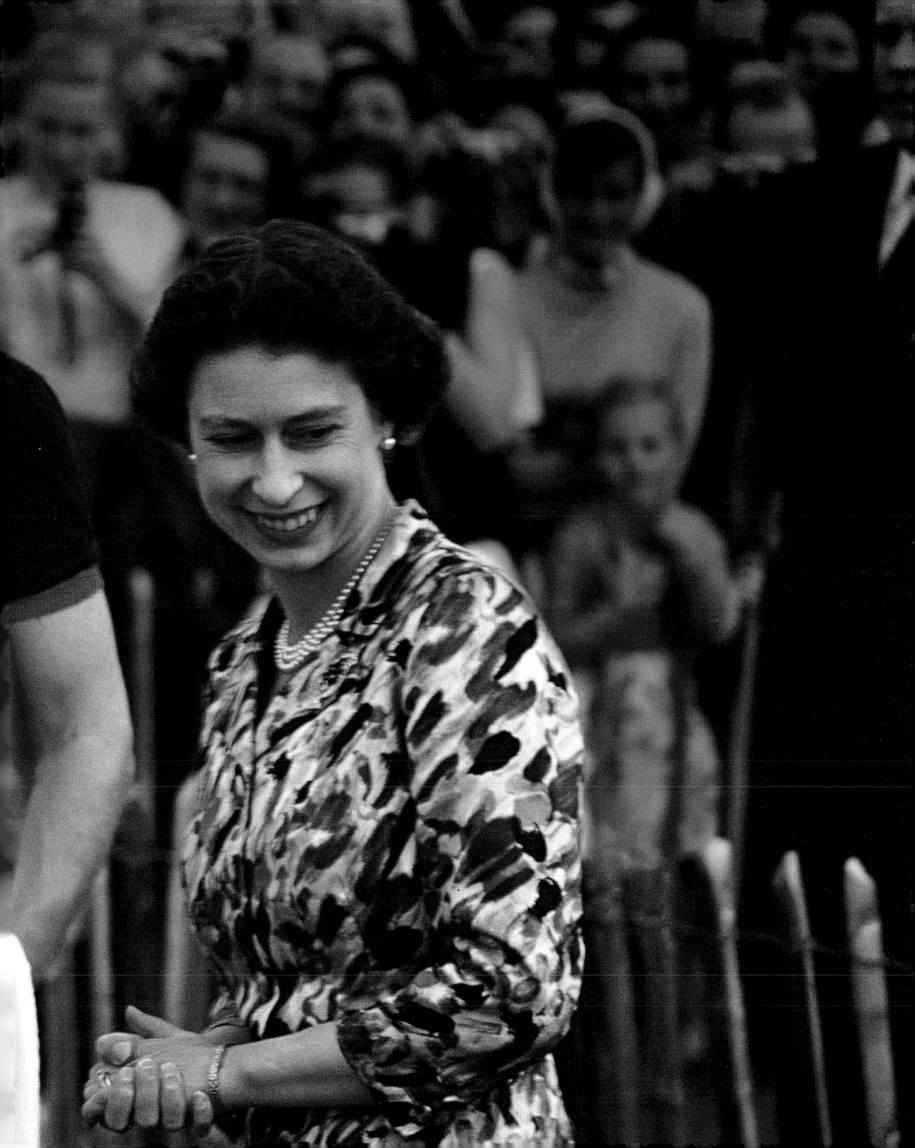

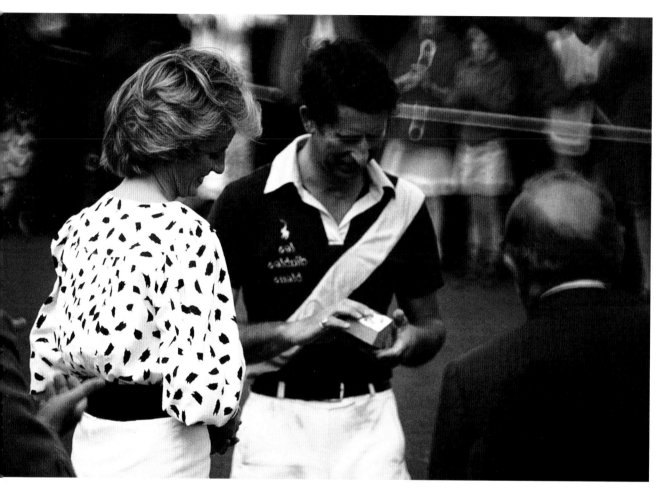

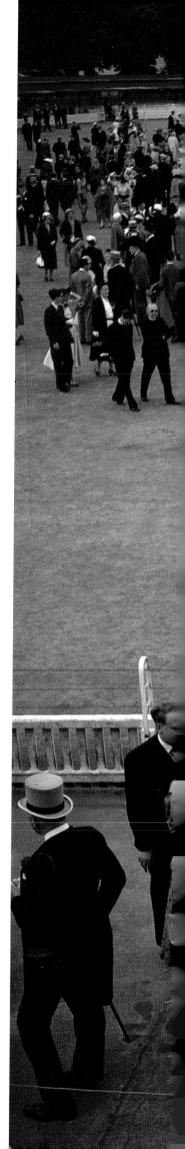

PREVIOUS PAGE: Once upon a time there was a queen and her husband, the prince. They were a handsome couple, young, and not worried about life. There were no scandals and they were widely admired . . . Prince Philip, captain of the Windsor Park Team, after his team has beaten India during the Ascot Week polo tournament, of which he was sponsor, with Queen Elizabeth, who had just presented him with the Windsor Cup for the victory, 1955.

ABOVE: Prince Charles, after playing polo for the Diables Blues at Cowdray Park in Sussex, with Princess Diana, 1985.

OPPOSITE: Lord's, the home of Britain's own game, cricket, achieves its sartorial and social pinnacle for a school event—the annual Eton-Harrow match, 1955.

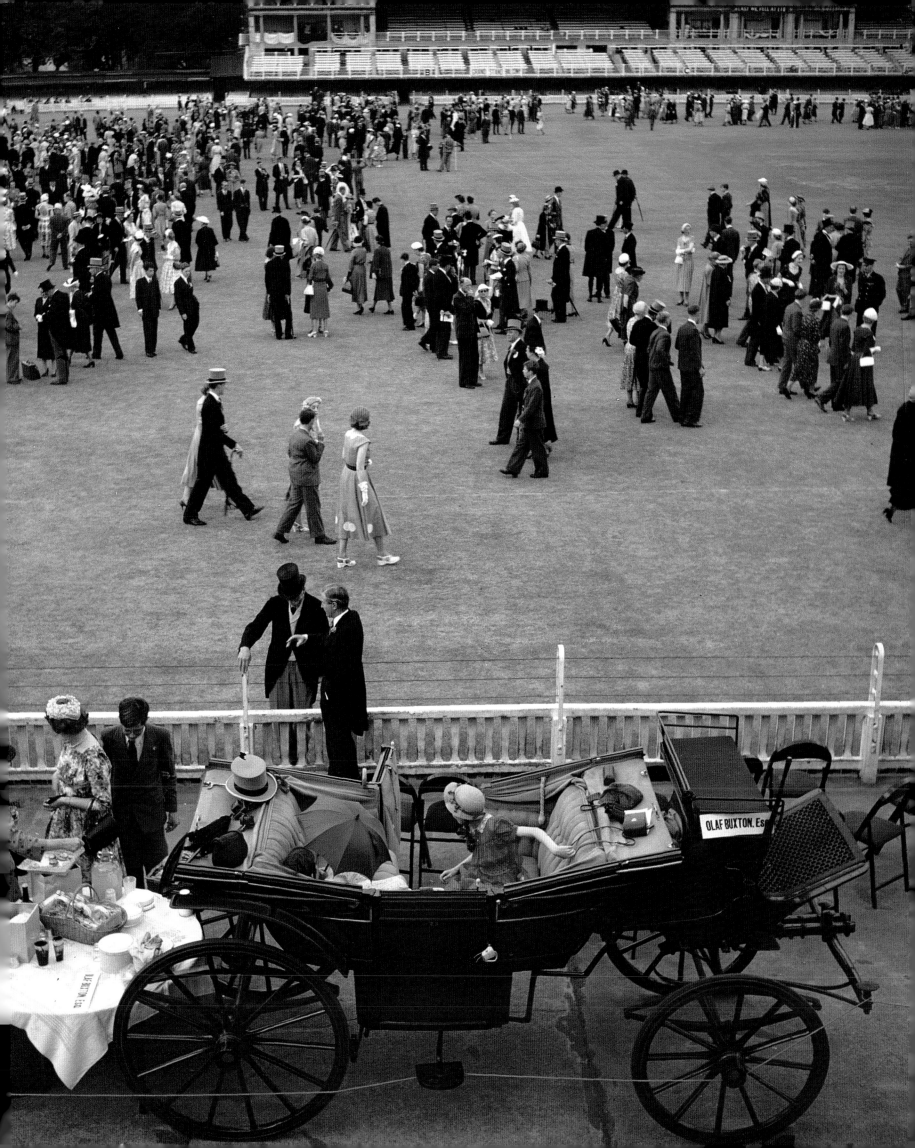

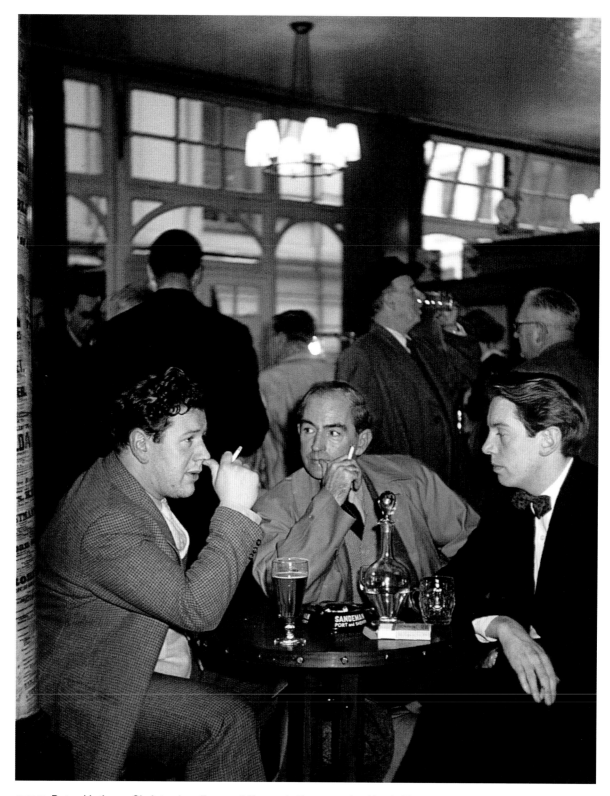

ABOVE: Peter Ustinov, Christopher Fry, and Kenneth Tynan at the Nag's Head, the actor's pub in Covent Garden, London, 1955.

OPPOSITE: Sir Laurence Olivier in Leicester Square, London, opposite the theater showing *Richard III*, in which he was playing the title role, 1955.

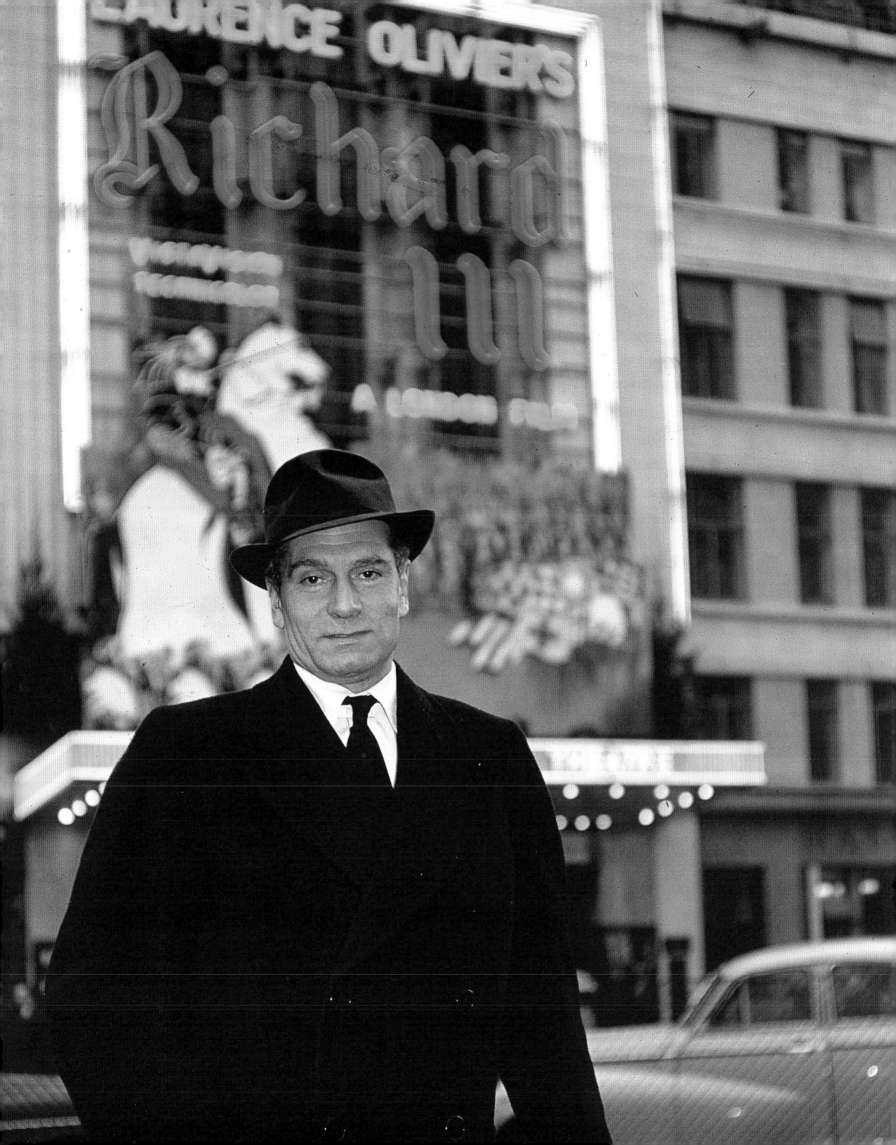

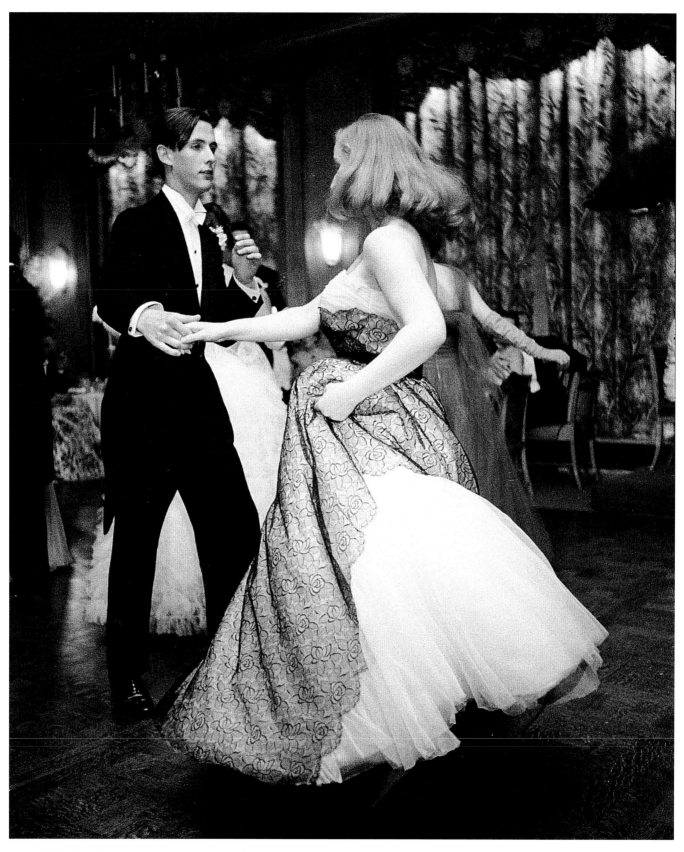

ABOVE: Miss Daphne Battine and the Hon. Charles Wilson at the Cygnets' Ball, the annual dance of a fashionable finishing school, Claridge's Hotel, London, 1955.

OPPOSITE: Mrs. Gerald Legge and the Duke of Sutherland at the Duke and Duchess of Argyll's debutante party for Miss Frances Sweeny, 1955.

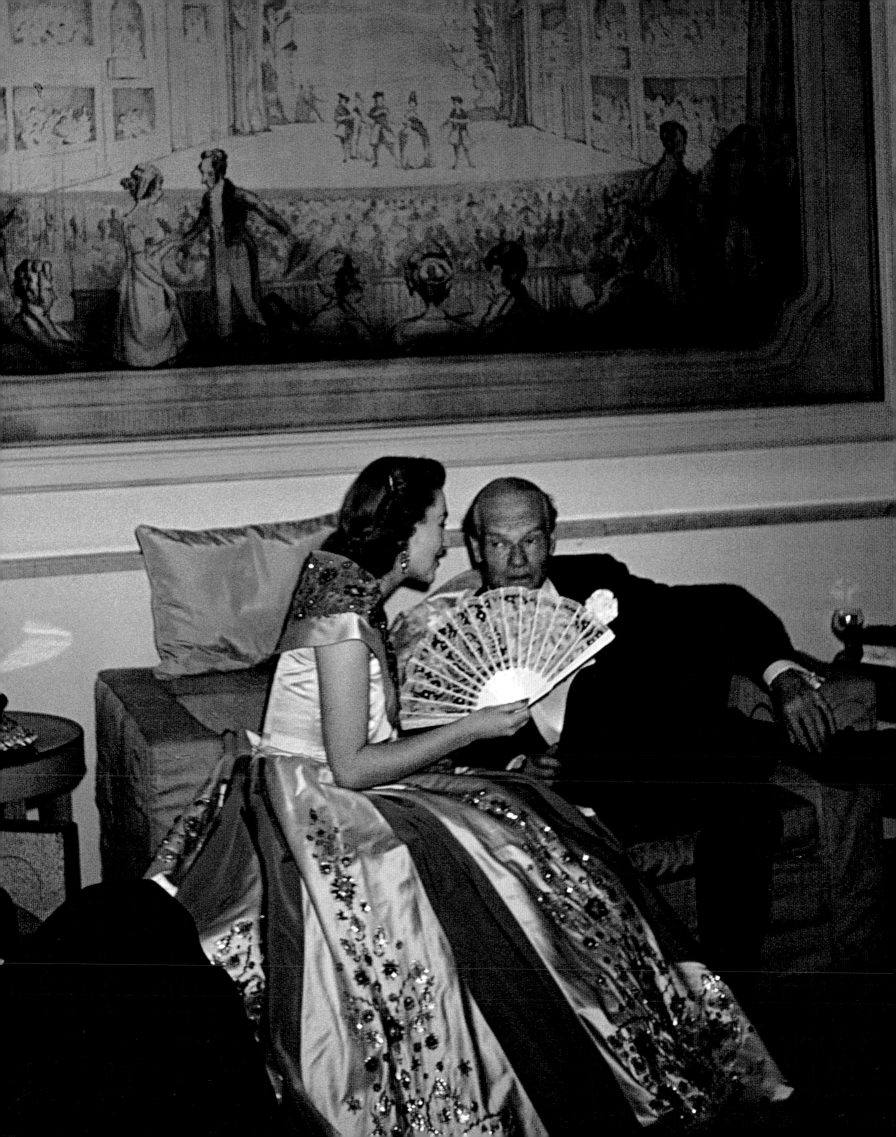

ABOVE: Film star Diana Dors, 1955. Word got out around London that we were doing a big story on London and the entertainment business for *Holiday* magazine. In the postwar era any kind of publicity was like gold, so the press agents sought me out. At the time everyone was trying to discover a new Marilyn. One of the agents told me about a film in progress starring Diana Dors. I said okay, but I know my editor and what he likes: blondes, beds, and chandeliers.

OPPOSITE: The Marquess of Cholmondeley at Kensington Palace in ceremonial uniform, 1957.

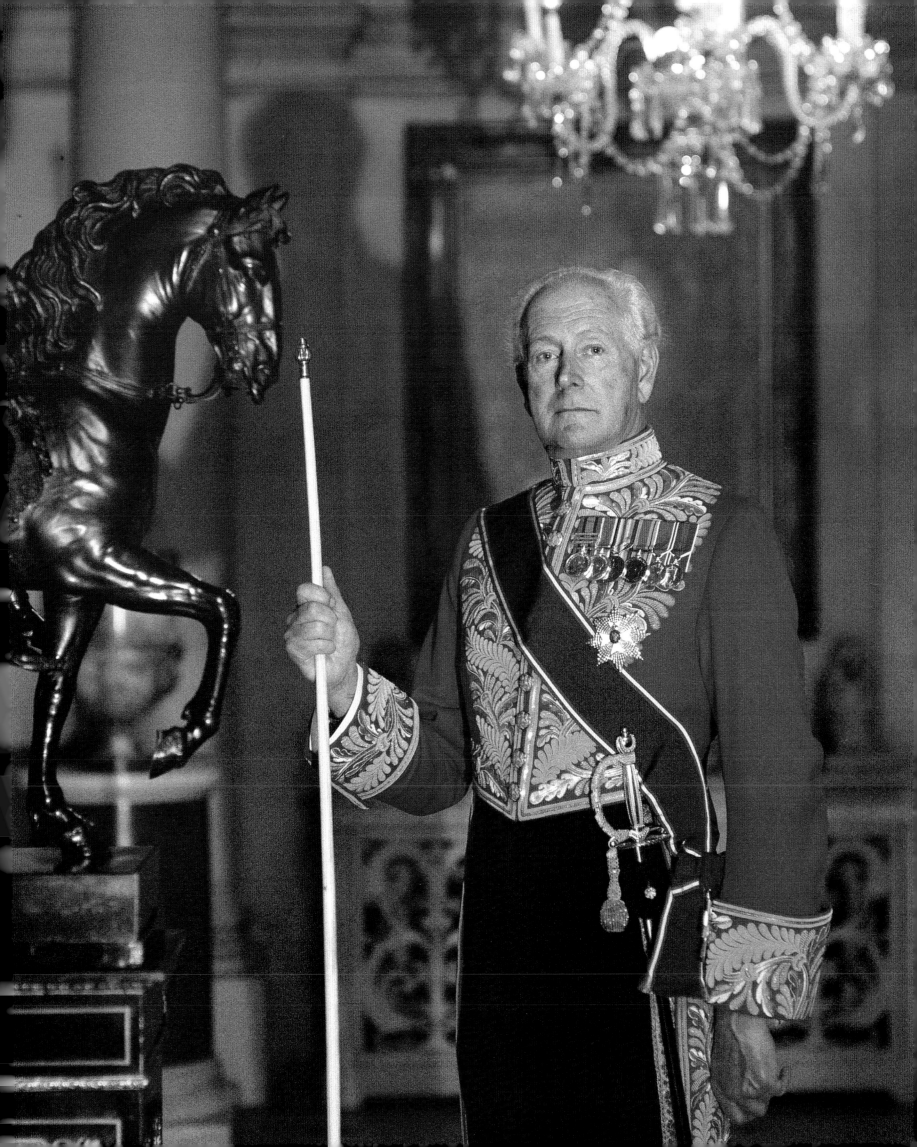

IRELAND

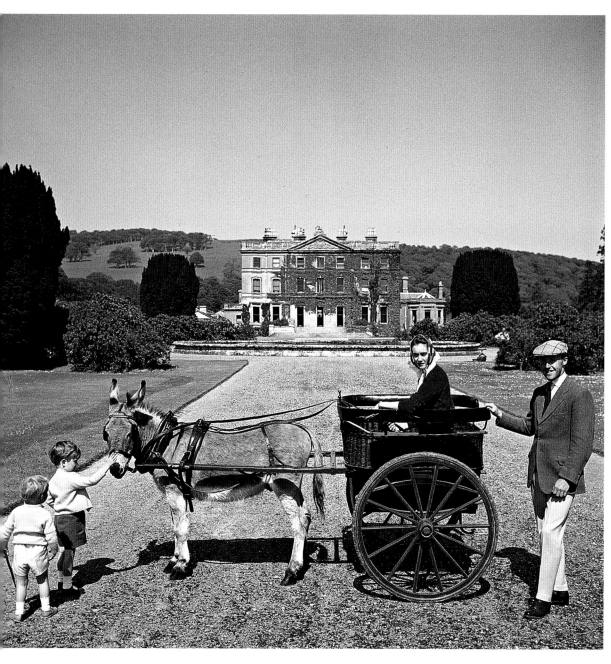

ABOVE: The Marquess and Marchioness of Waterford and their elder son, the Earl of Tyrone, on the grounds of their home, Curraghmore, in County Waterford, 1963.

OPPOSITE: Donough Edward Foster O'Brien, 16th Baron Inchiquin, is the only man in Ireland to hold a British peerage as well as an Irish chieftaincy, at Dromoland, 1963. As head of the O'Brien clan he bears the title The O'Brien of Thomond, and is a direct descendant of Brian Boru, High King of Ireland and Hammer of the Danes, whose power he broke forever at the Battle of Clontarf in 1014. Now, how does a photographer show a king of Ireland on his throne? I took a great chair from the main hall of the castle and I asked him to hold a large cane in his hand, which became his scepter. His two dogs, of course, became his court. And in the background, his castle.

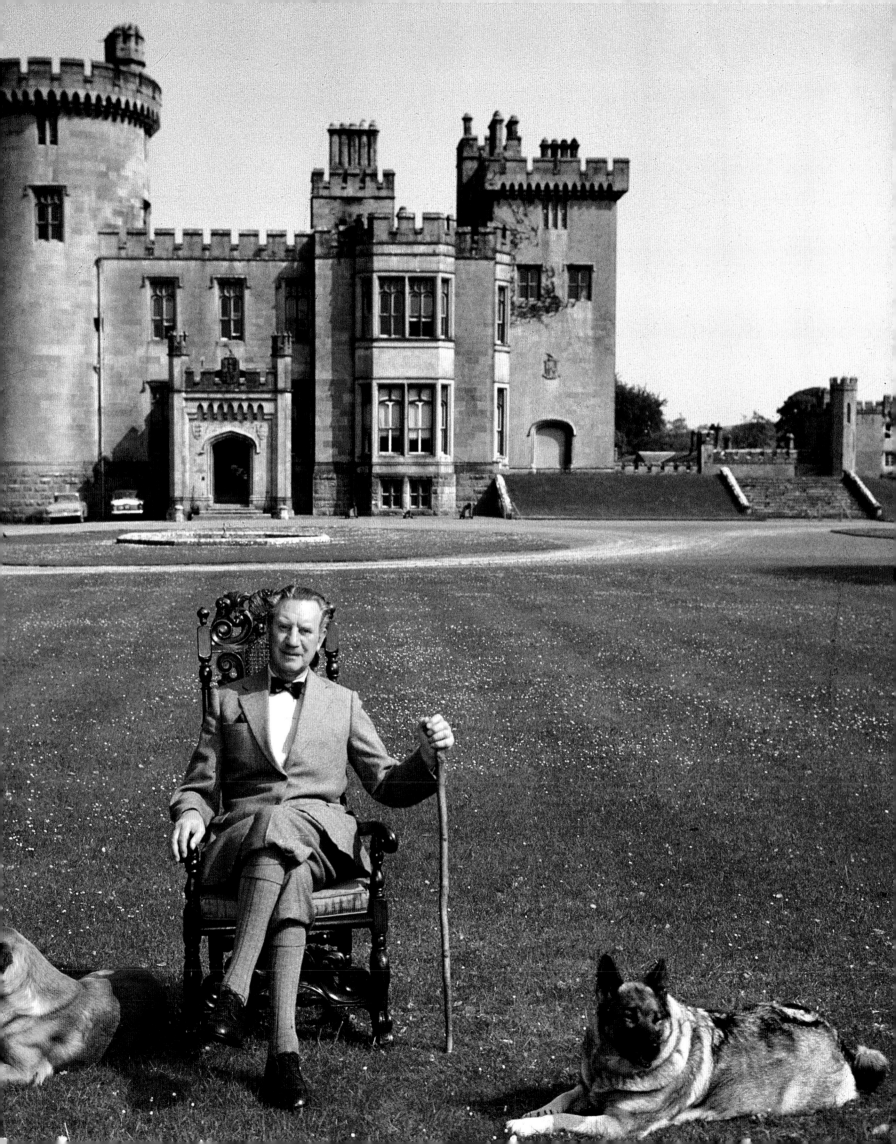

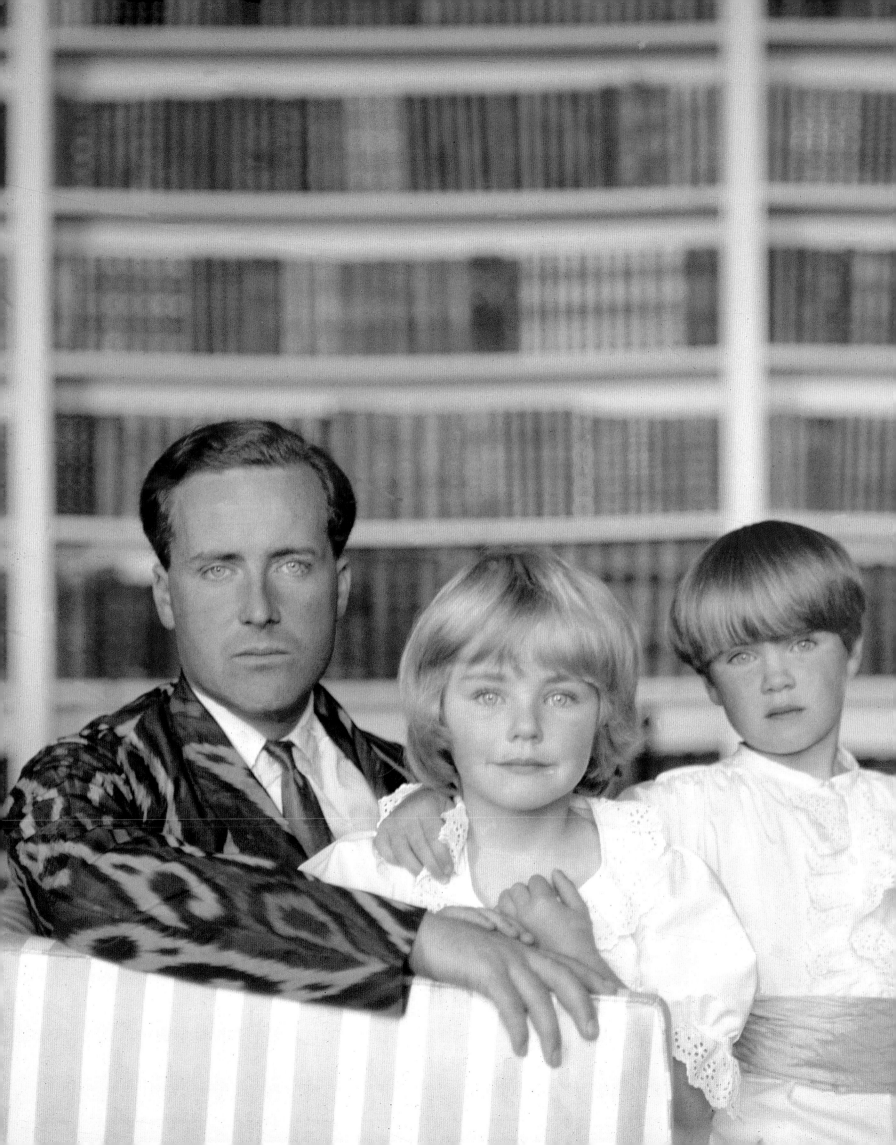

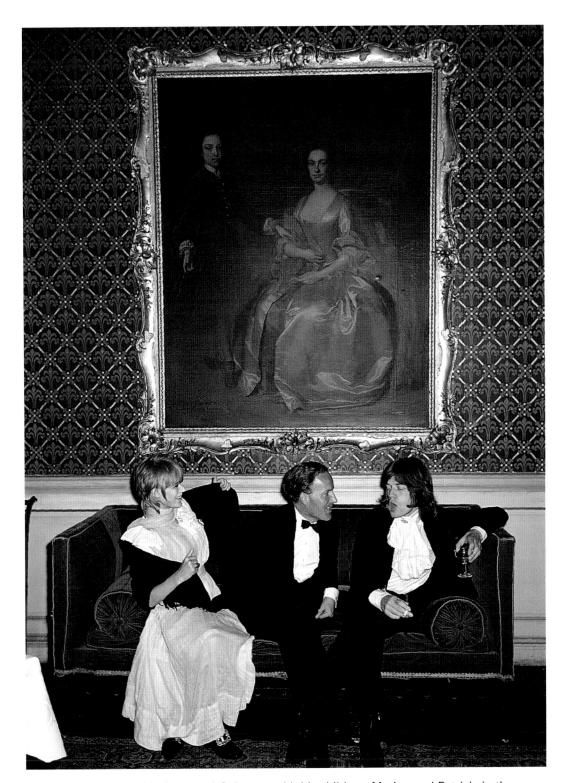

OPPOSITE: The Honorable Desmond Guinness with his children, Marina and Patrick, in the library of Leixlip Castle, County Kildare, 1963. Their mother is Princess Marie Gabrielle von Urach. Notice the famous Mitford eyes. Desmond's mother was Diana Mitford, and the Mitfords were noted for their glacial blue eyes.

ABOVE: Marianne Faithfull, the Honorable Desmond Guinness, and Mick Jagger at Castletown Mansion, Ireland, 1968. I was in Ireland on a story and the four of us went from Desmond Guinness's castle to Castletown Mansion where a big party was being given. I saw this painting in the hall, and began to pose them for a shot. Within a few minutes a local Irish press camera crew gathered around and began shooting the shot the way I had set it up. We all shot it. I spent my life setting up shots that other people used. That's life in the photography business.

The novelist Elizabeth Bowen at Bowen's Court, her ancestral home, County Cork, 1962.

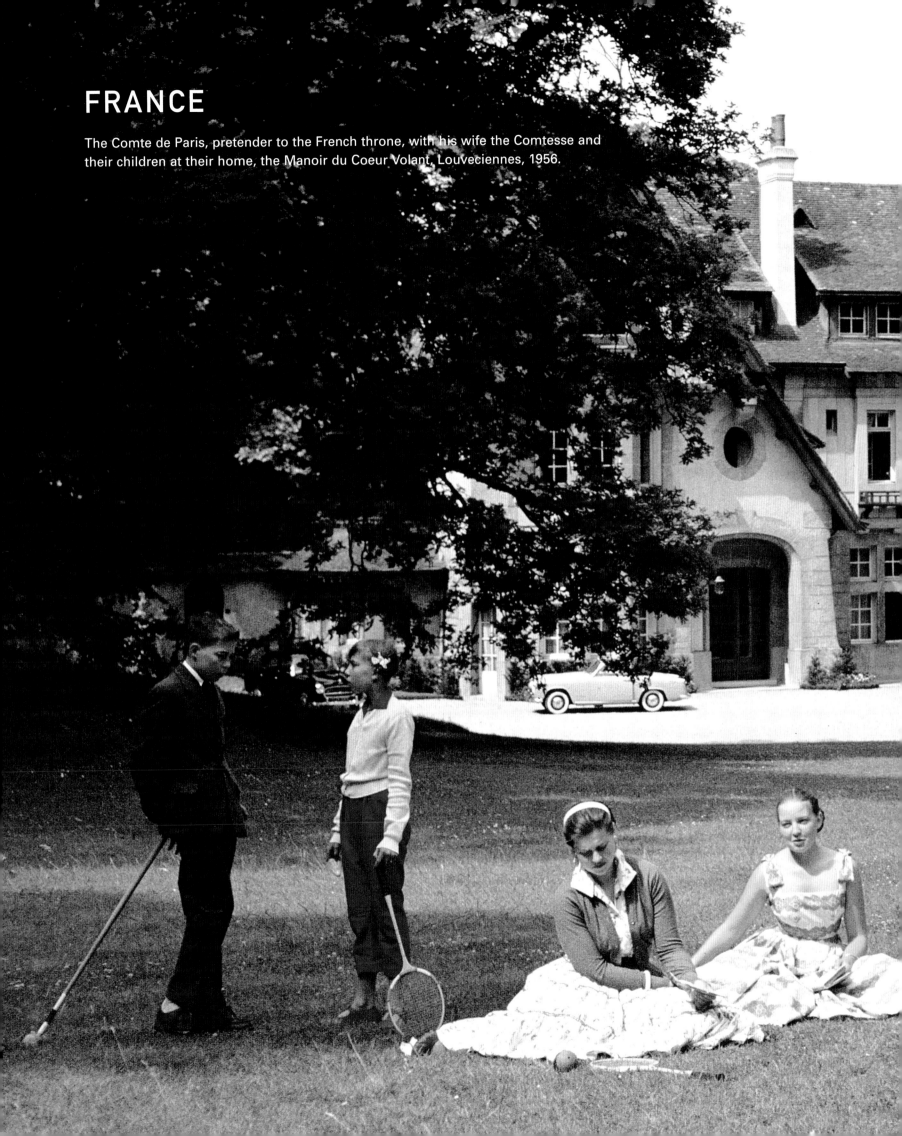

FRANCE

The Comte de Paris, pretender to the French throne, with his wife the Comtesse and their children at their home, the Manoir du Coeur Volant, Louveciennes, 1956.

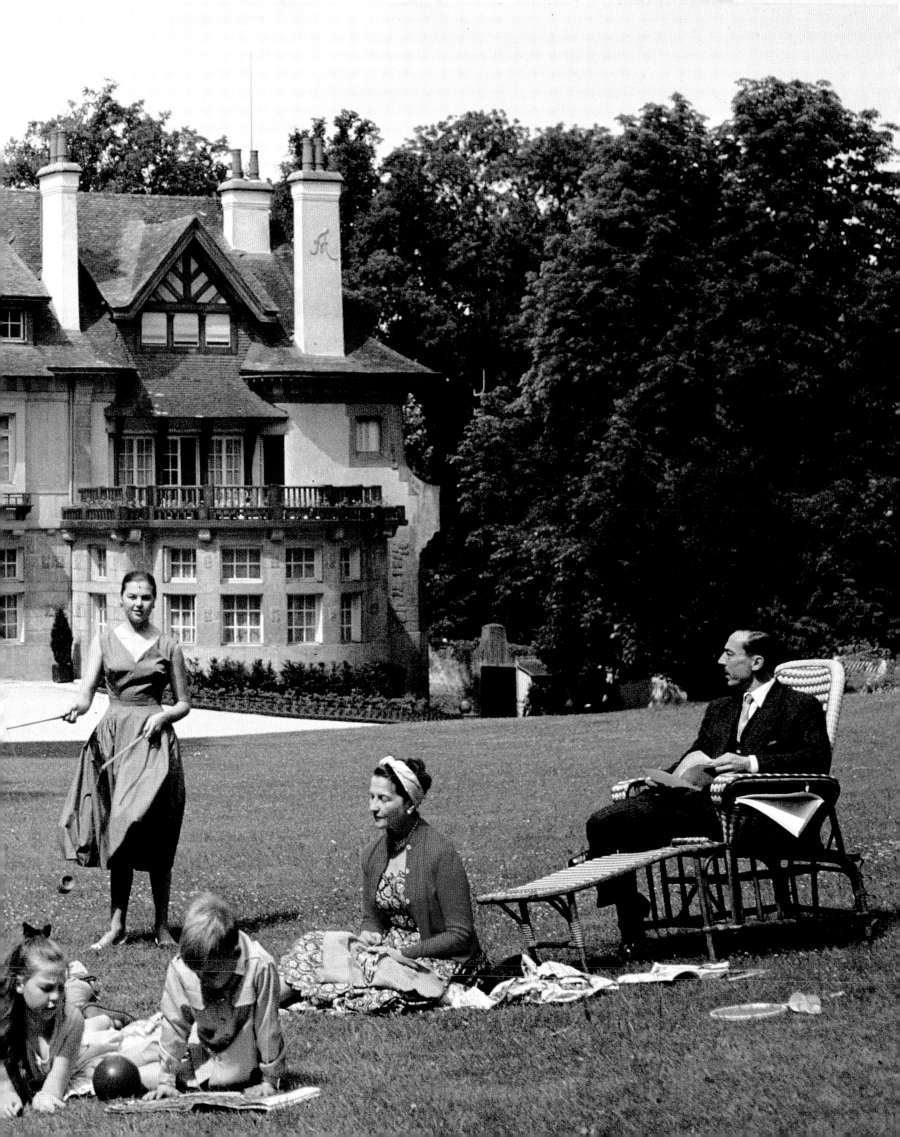

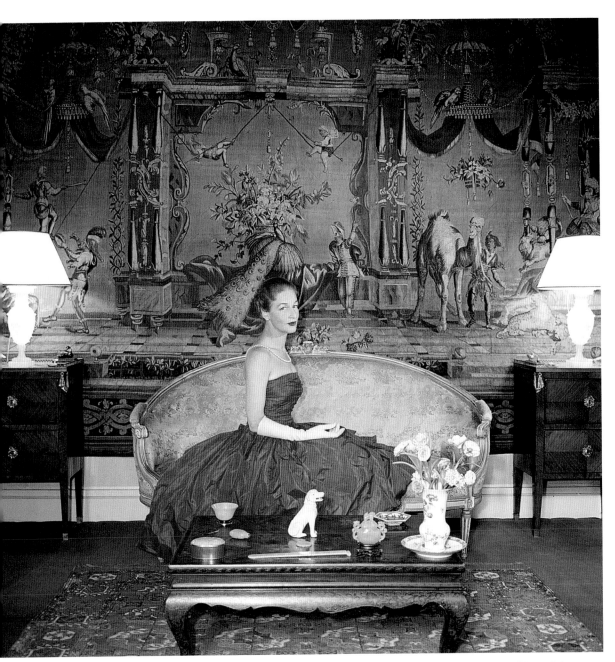

ABOVE: The Duchess of Montesquieu-Fezensac in the drawing room of her château, Neuilly, 1957. She was recognized as one of the most beautiful and best-dressed Frenchwomen of her day, but she also had a doctorate in medicine.

OPPOSITE: Madame de la Haye-Jousselin, a member of the de Noailles family, on her hunter, Gracieuse, in front of the Château de Saint-Aubin-d'Ecrosville, Normandy, 1957.

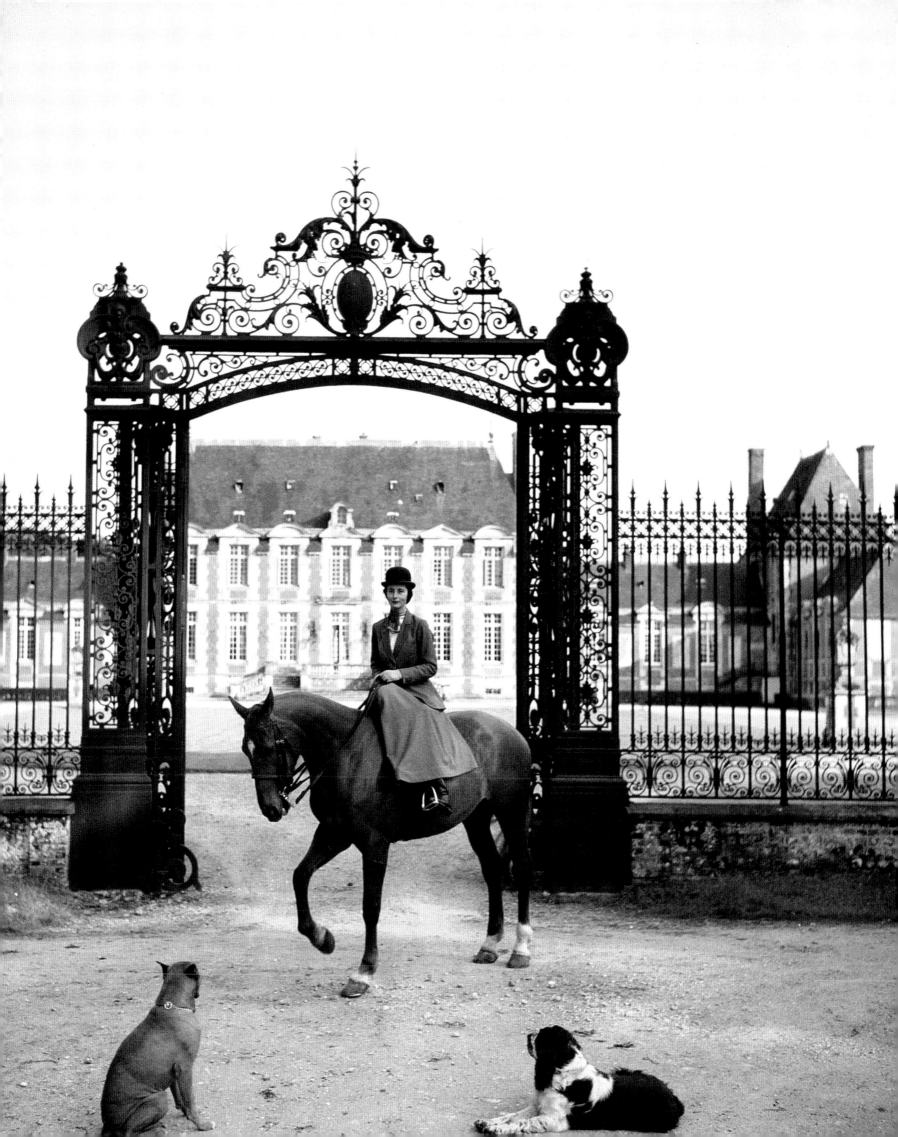

OPPOSITE: Man Ray in his Left Bank studio in Paris, 1957. Loomis Dean, the *Life* photographer, introduced me to Man Ray when I was still a kid. I saw him frequently; we always discussed photographic equipment. He taught me so many tricks that I still use—most important, keep it simple.

ABOVE: Michel, the Comte d'Arcangues, against a wall of Sèvres and Compagnie des Indes porcelains at his Château d'Arcangues, where the family has lived for eight centuries, Biarritz, 1986.

The Grande Plage, Biarritz, dominated by the Bellevue Casino and the sumptuous Hôtel du Palais, and the Bay of Biscay beyond, 1985. The court of Napoleon III transformed this Basque fishing village and sea-bathing center into a royal resort that would become known as the Beach of Kings and the Queen of Beaches.

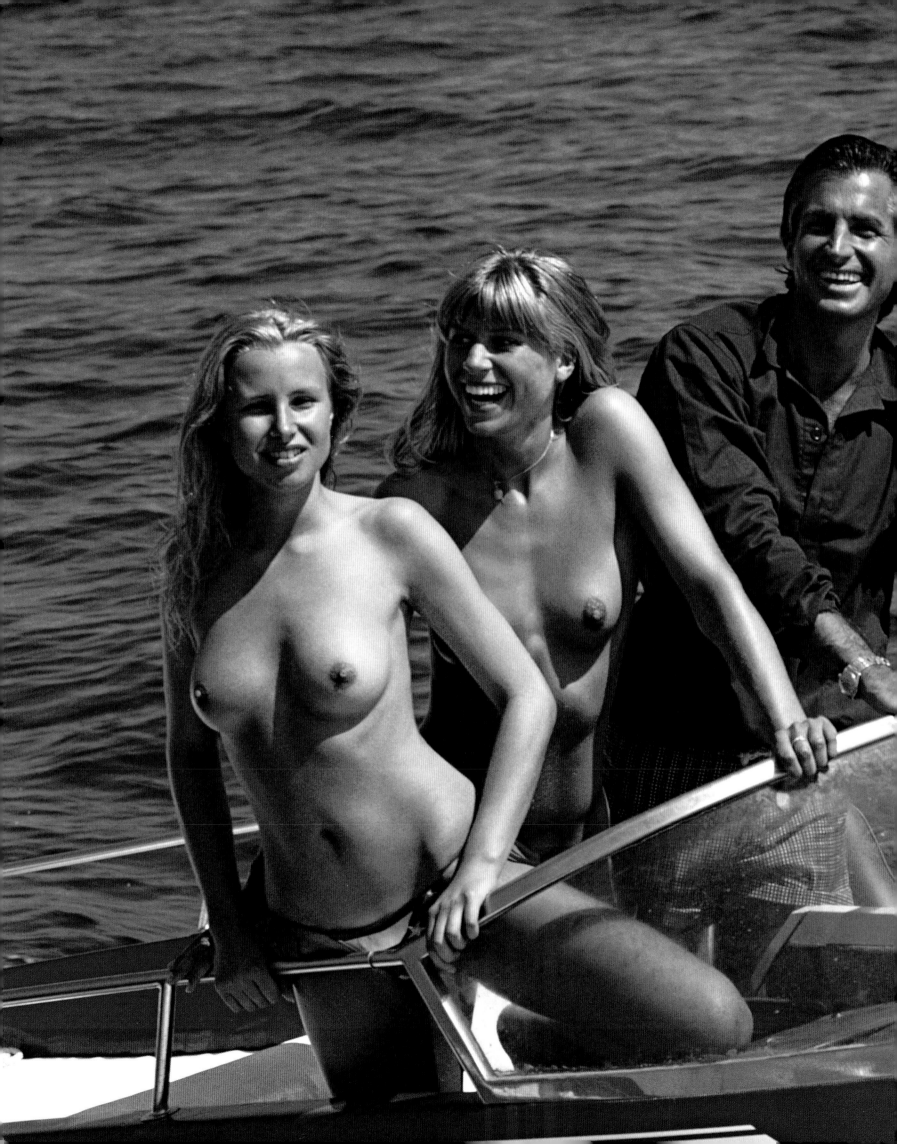

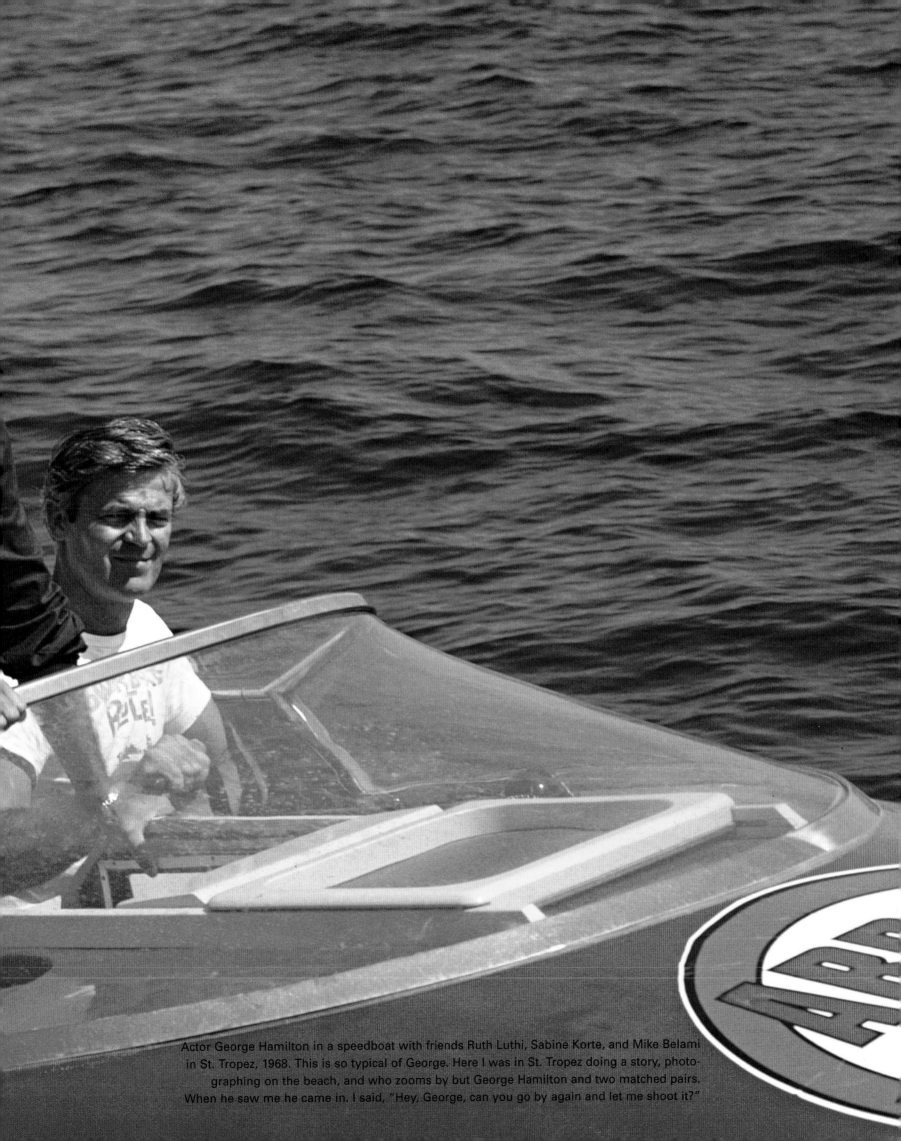

Actor George Hamilton in a speedboat with friends Ruth Luthi, Sabine Korte, and Mike Belami in St. Tropez, 1968. This is so typical of George. Here I was in St. Tropez doing a story, photographing on the beach, and who zooms by but George Hamilton and two matched pairs. When he saw me he came in. I said, "Hey, George, can you go by again and let me shoot it?"

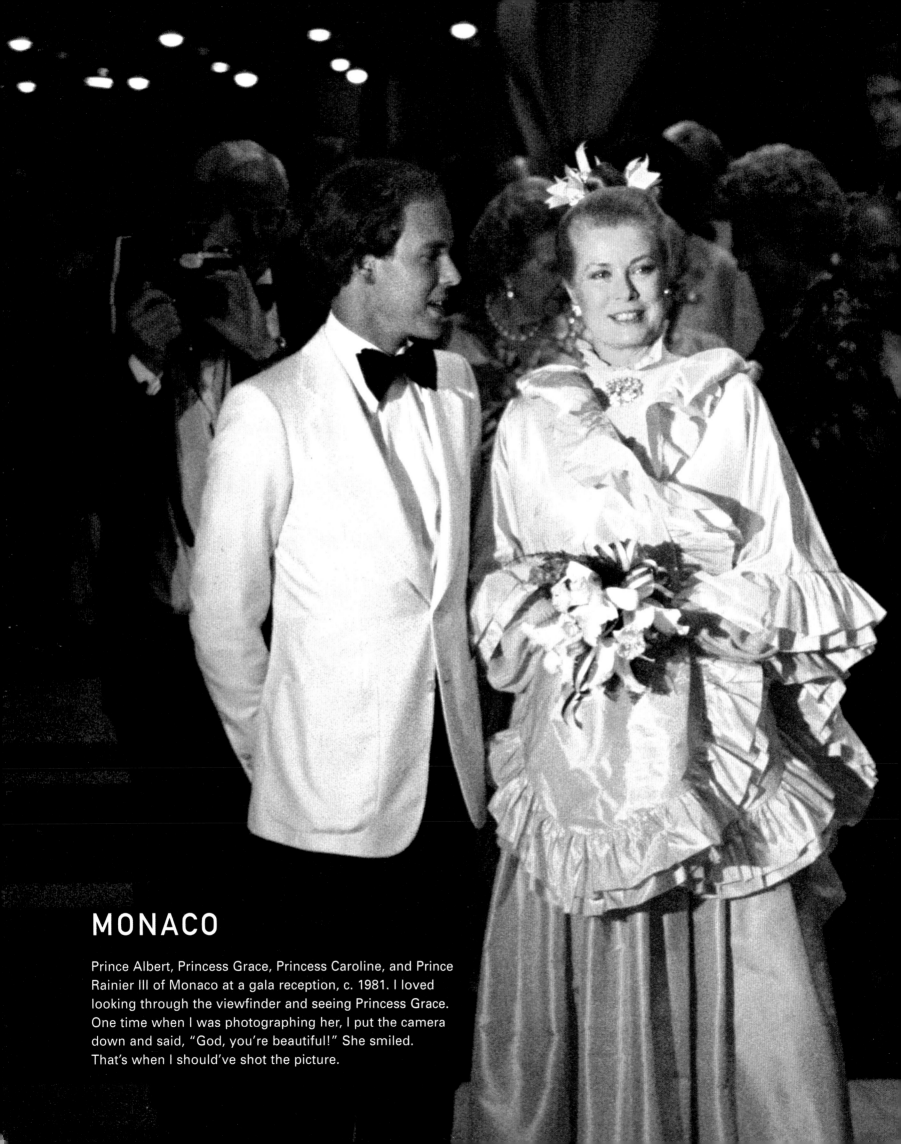

MONACO

Prince Albert, Princess Grace, Princess Caroline, and Prince
Rainier III of Monaco at a gala reception, c. 1981. I loved
looking through the viewfinder and seeing Princess Grace.
One time when I was photographing her, I put the camera
down and said, "God, you're beautiful!" She smiled.
That's when I should've shot the picture.

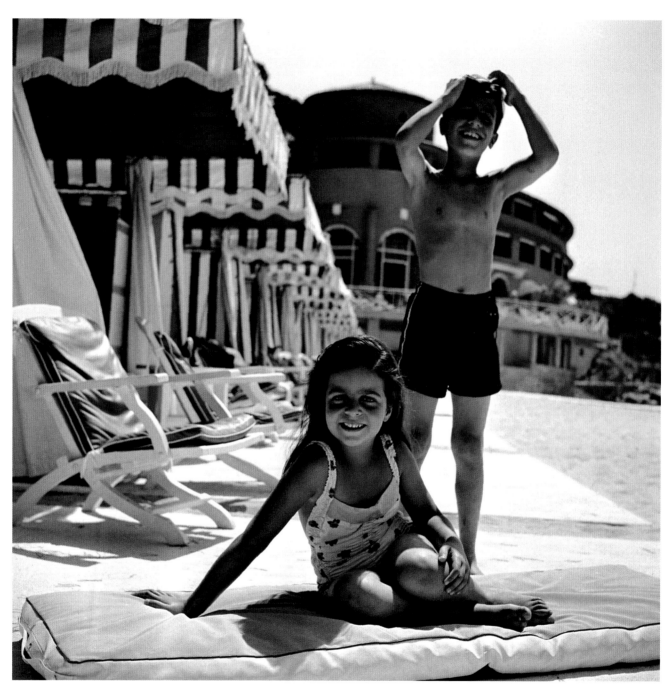

ABOVE: Christina and Alexander Onassis at the Monte Carlo Beach Club, 1958. You don't see the bodyguards, but they're there. Years later, I was seated next to Christina at a dinner party in St. Moritz. She said to me, "I'd love to be a photographer. It must be a lot of fun." I asked her if she'd like to try to take some photos at the dinner. I set the camera on automatic and she took the pictures. She wasn't bad.

OPPOSITE: A helicopter and two motor boats adorn the deck of Roy Craven's luxury yacht in the Monte Carlo harbor, 1976. Craven chats with the Prince de Polignac, a relation of Prince Rainier.

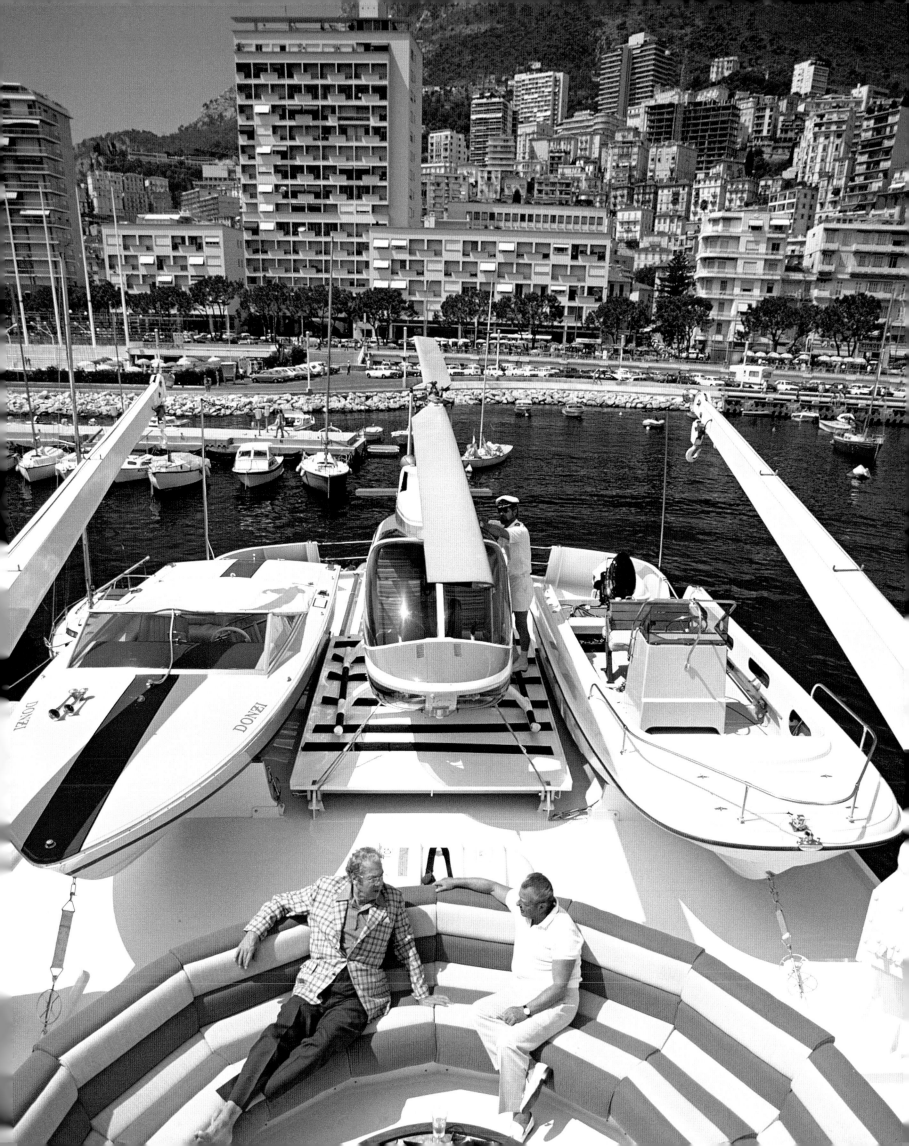

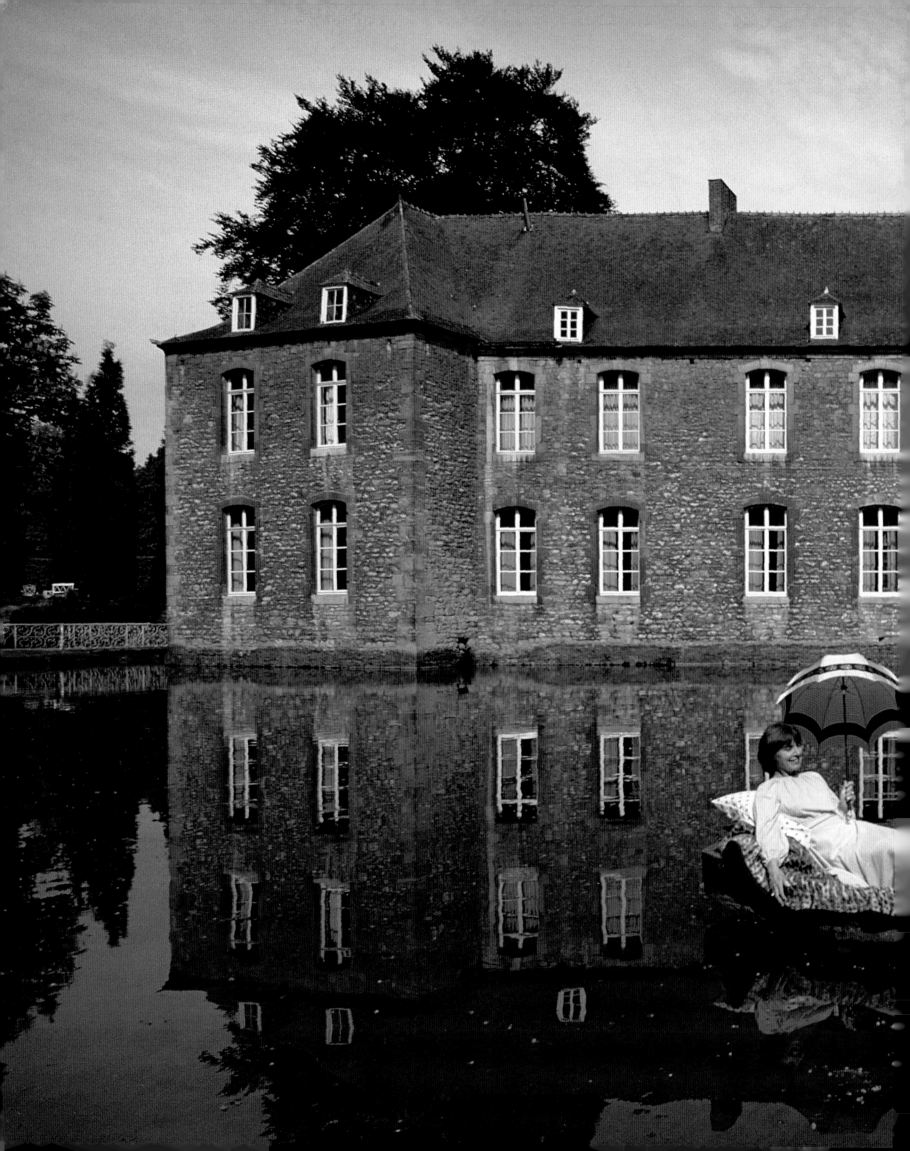

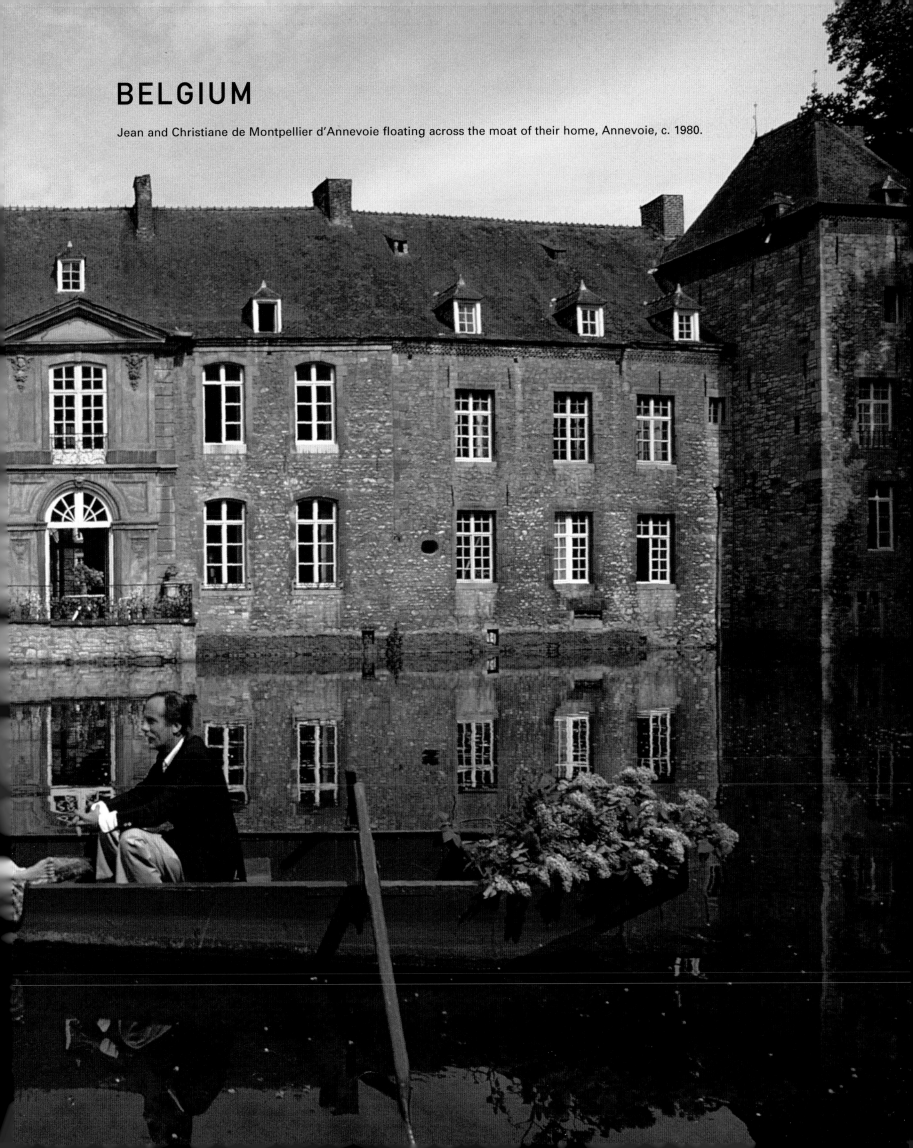

BELGIUM

Jean and Christiane de Montpellier d'Annevoie floating across the moat of their home, Annevoie, c. 1980.

SPAIN

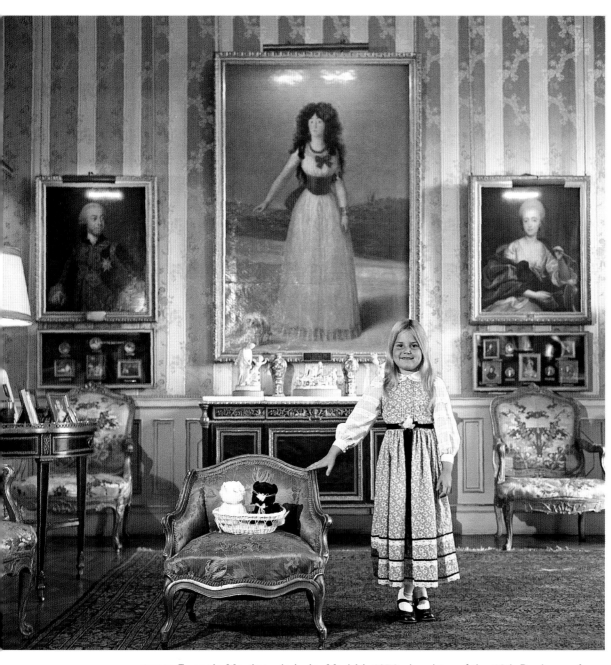

ABOVE: Eugenia Martinez de Irujo, Madrid, 1976, daughter of the 18th Duchess of Alba standing before Goya's portrait of the 13th Duchess of Alba.

OPPOSITE: The Duchess of Alba in a carriage outside the Palacio de Liria where she lives, Madrid, 1958. The Duchess has over forty titles. When she marries, her husband has to give up his name and becomes the Duke of Alba. She has a roomful of Goyas in her palace.

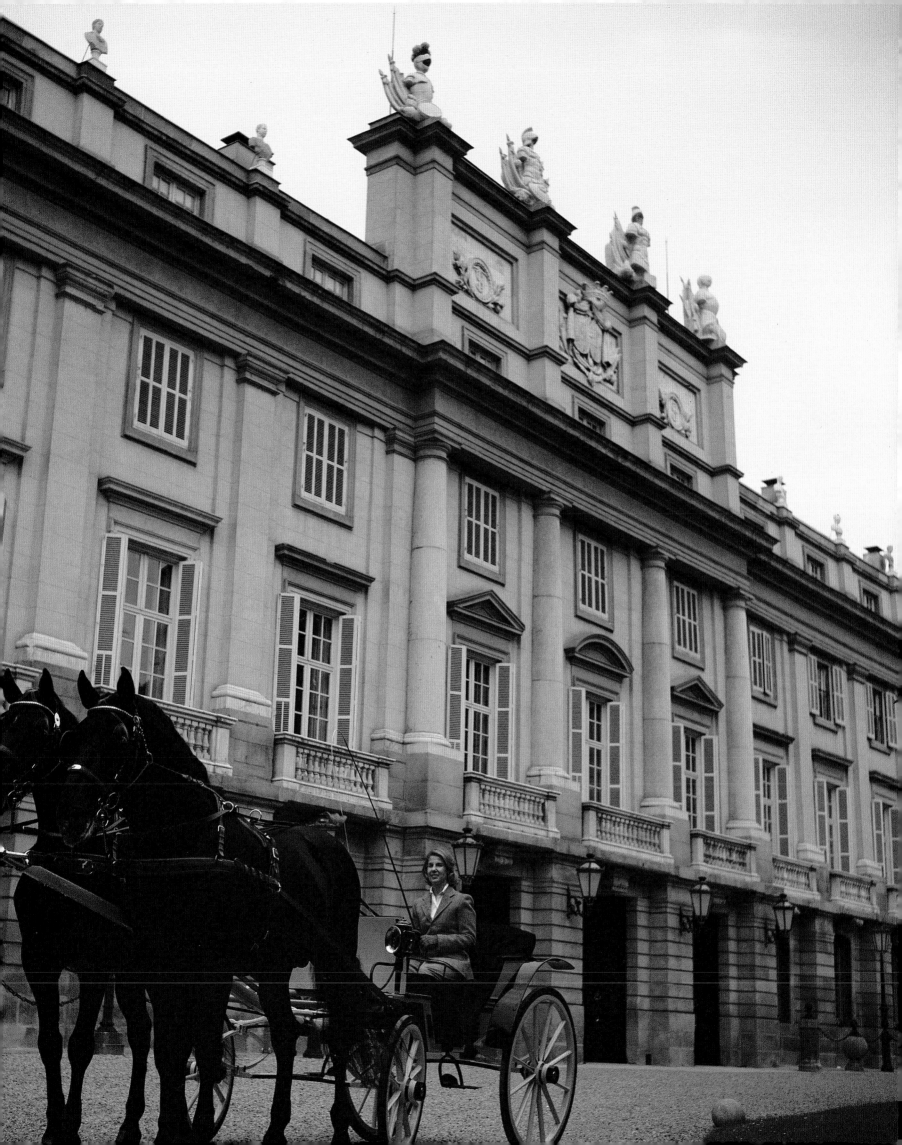

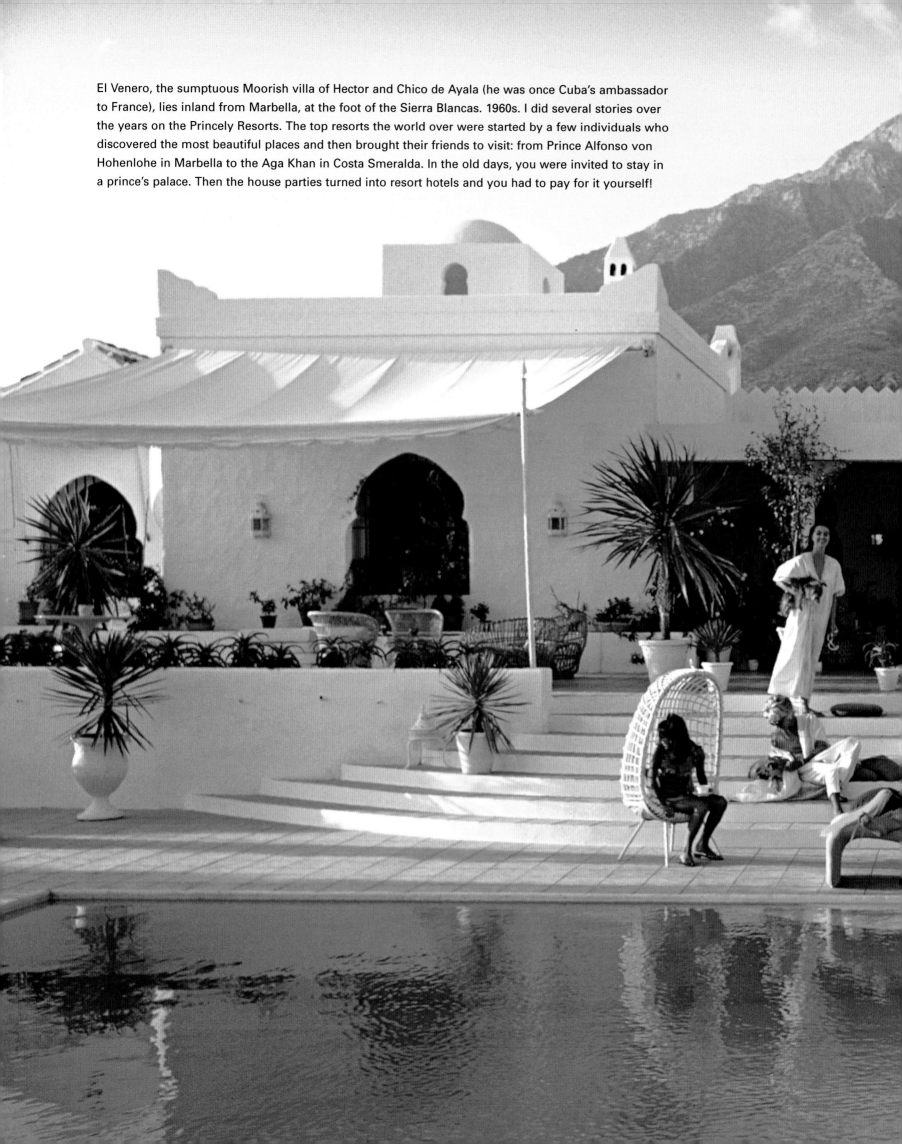

El Venero, the sumptuous Moorish villa of Hector and Chico de Ayala (he was once Cuba's ambassador to France), lies inland from Marbella, at the foot of the Sierra Blancas. 1960s. I did several stories over the years on the Princely Resorts. The top resorts the world over were started by a few individuals who discovered the most beautiful places and then brought their friends to visit: from Prince Alfonso von Hohenlohe in Marbella to the Aga Khan in Costa Smeralda. In the old days, you were invited to stay in a prince's palace. Then the house parties turned into resort hotels and you had to pay for it yourself!

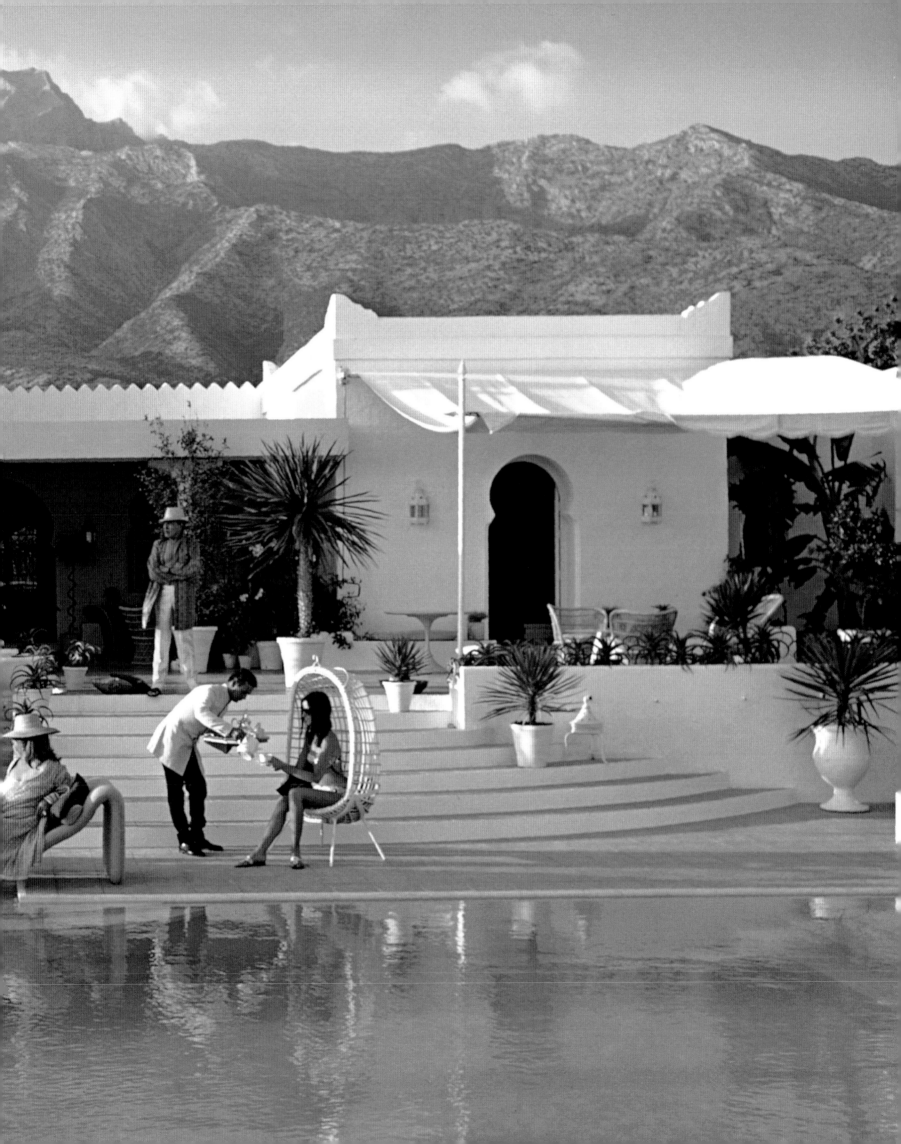

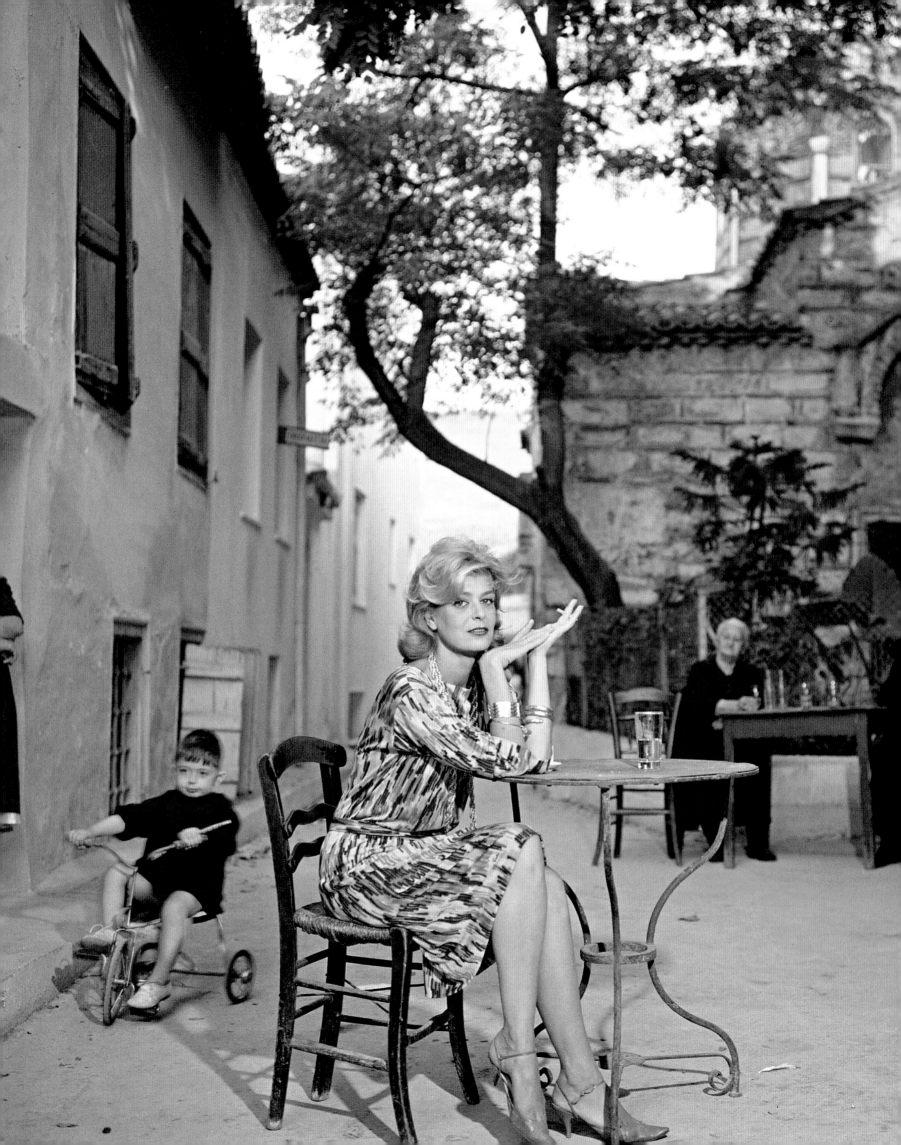

GREECE

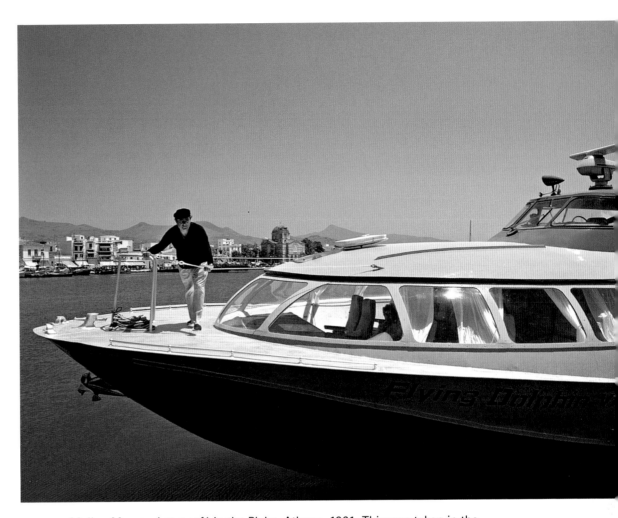

OPPOSITE: Melina Mercouri at a café in the Plaka, Athens, 1961. This was taken in the Plaka district at the foot of the Acropolis. She said to me, "Hey, do we have to have that kid in there?" Like any other movie star, she was worried that the little boy would steal the shot.

ABOVE: Ship owner George Livanos on the deck of his boat in Greece, 1978.

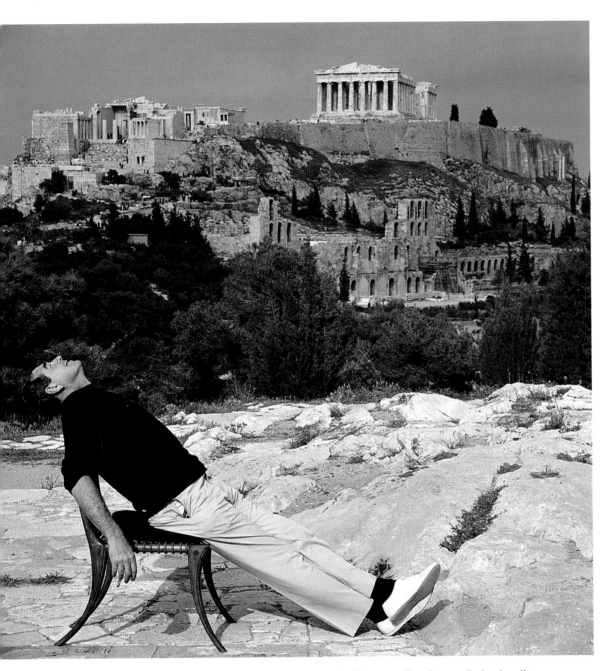

ABOVE: A funny shot for my daughter back home. The Acropolis in the distance. Athens, c. 1955.

OPPOSITE: Dimitris Kritsas, a fashionable young couturier, poses among the gleaming Doric columns of the temple to Poseidon at Sounion with models wearing his creations, 1961.

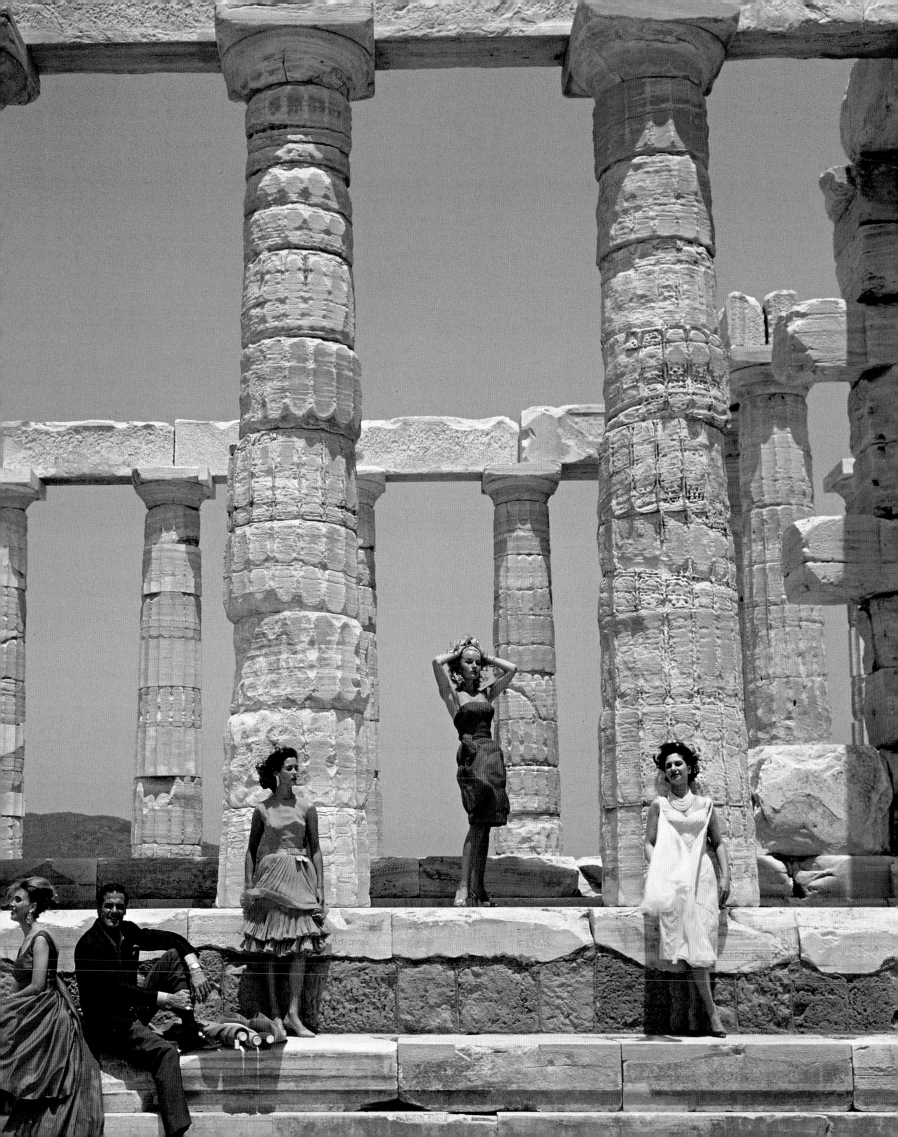

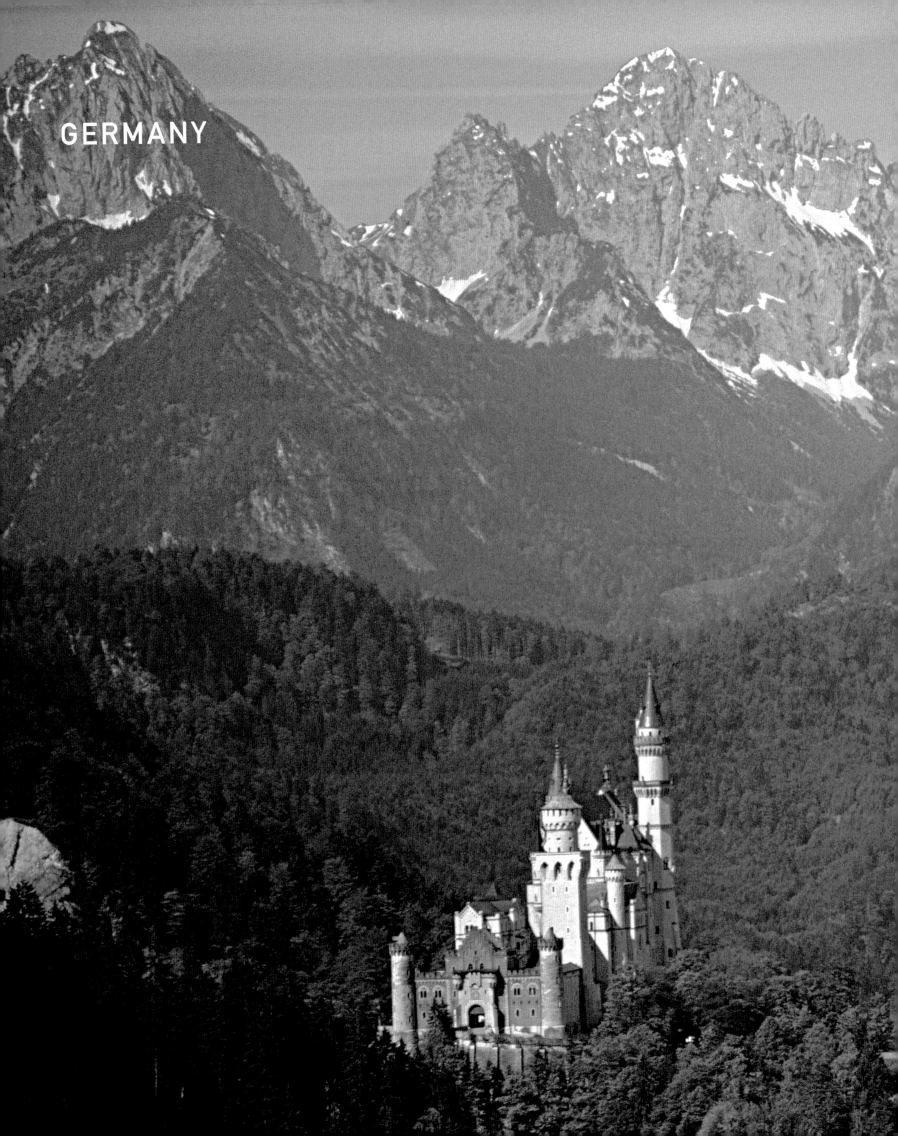

GERMANY

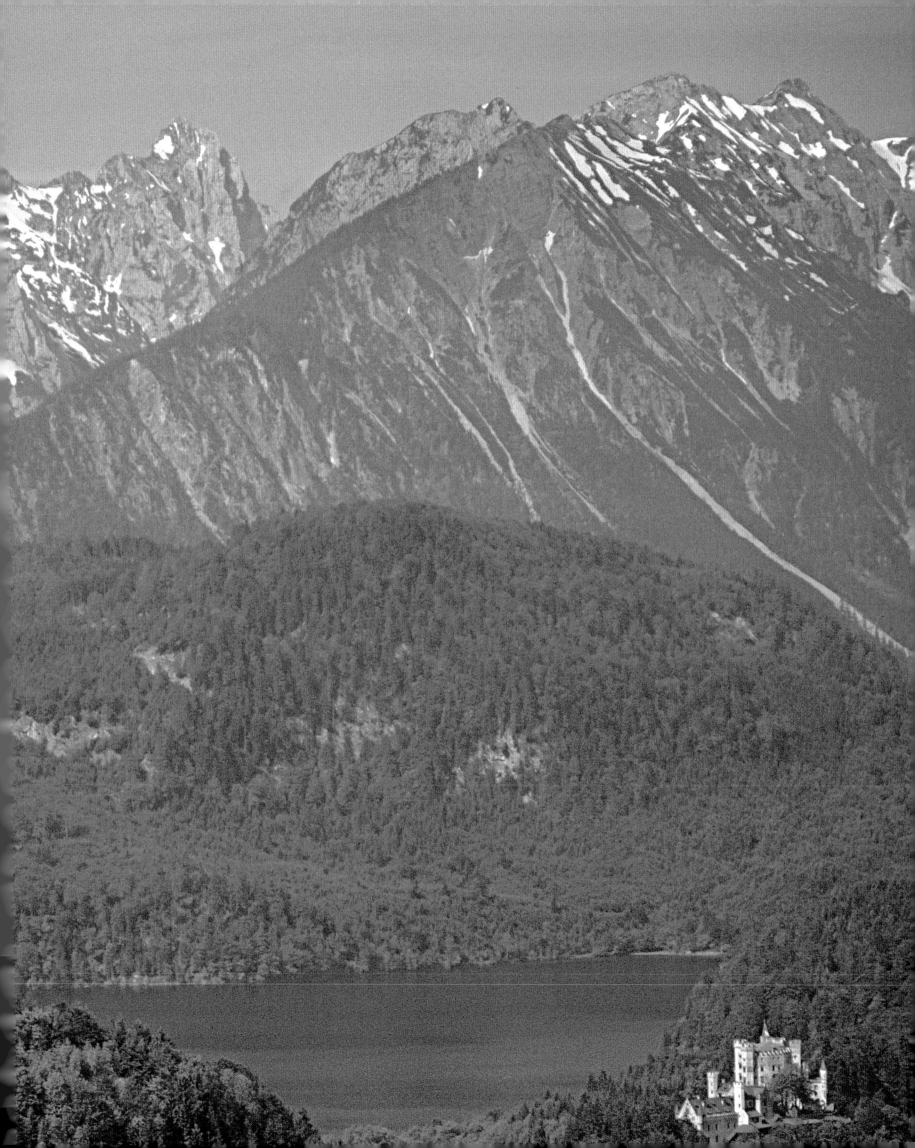

PREVIOUS PAGE: In the mountains of Bavaria are the castles of two nineteenth-century Wittelsbachs: Maximilian II, and Ludwig II. On the right is Hohenschwangau, Maximilian II's restoration of a twelfth-century schloss, and on the left is Neuschwanstein, the fairy-tale castle built by Maximilian's son, Ludwig, 1979. This is one of my favorite pictures. I had arrived late in the day and headed immediately up the mountain to see the view of Neuschwanstein. From the cable car, I first saw that there wasn't just one, but two beautiful castles. I arranged to come back first thing in the morning to get the shot from the cable car during its early morning test run. With a healthy tip, I got them to stop the car in the middle of the ascent and open the door so that I could get the shot. Everyone takes a close-up of this castle; I liked the long shot.

ABOVE: Her Serene Highness Tatiana Fürstin von Metternich-Winneburg at Schloss Johannesberg on the Rhine near Wiesbaden, 1977.

OPPOSITE: His Serene Highness Heinrich von und zu Fürstenberg with new wife, Her Serene Highness Maximiliana (Windisch-Graetz) von und zu Fürstenberg, on the grounds of their palace, Schloss Fürstenberg. The tail of the Bell Jet Ranger in which they arrived is painted in the family colors, matching the flag on the palace roof, 1977. The palace is situated near the source of the Danube.

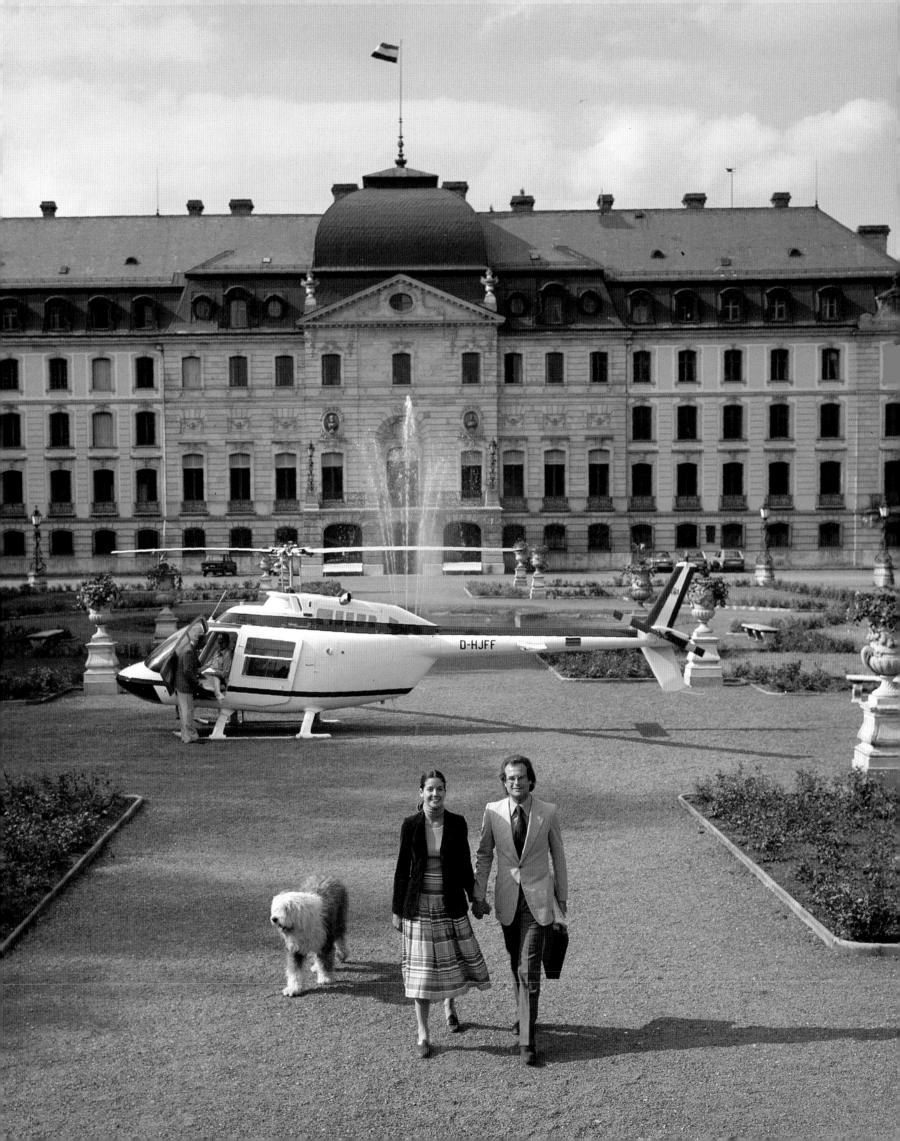

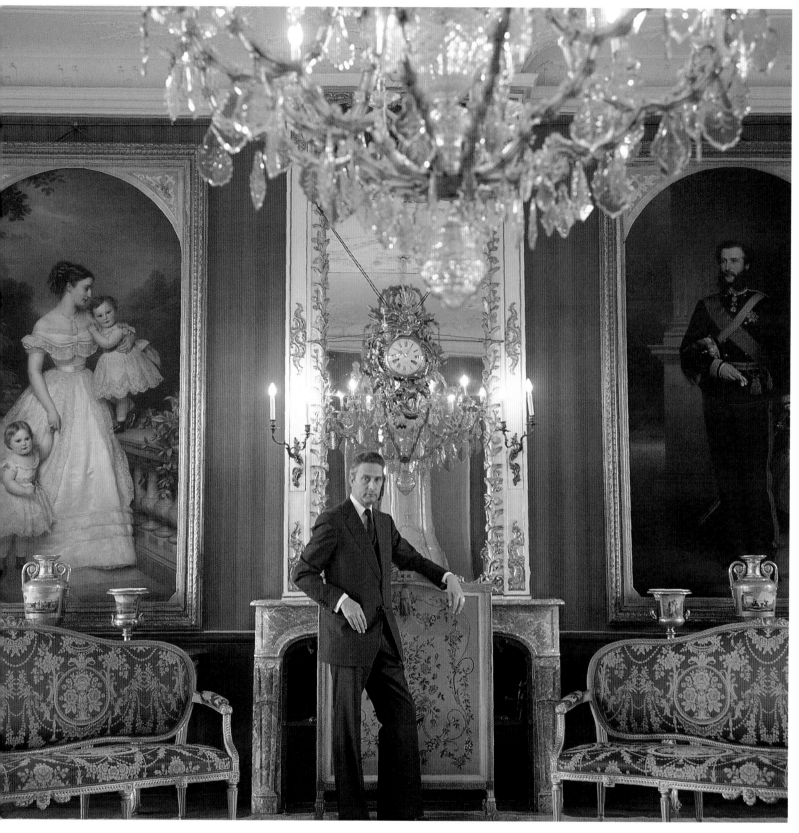

ABOVE: His Royal Highness Carl, the Duke of Württemberg in the drawing room of his family home, Burg Altshausen. To his right is a portrait of his great grandmother, Marie-Thérèse, the Archduchess of Austria, and to his left is a portrait of his great-grandfather, Duke Philipp, 1977.

OPPOSITE: German industrialist and aristocrat, His Serene Highness Johannes, Prince Thurn und Taxis, sitting in the Hall of Mirors of his palace in Regensburg awaiting his guests for an evening concert, 1977.

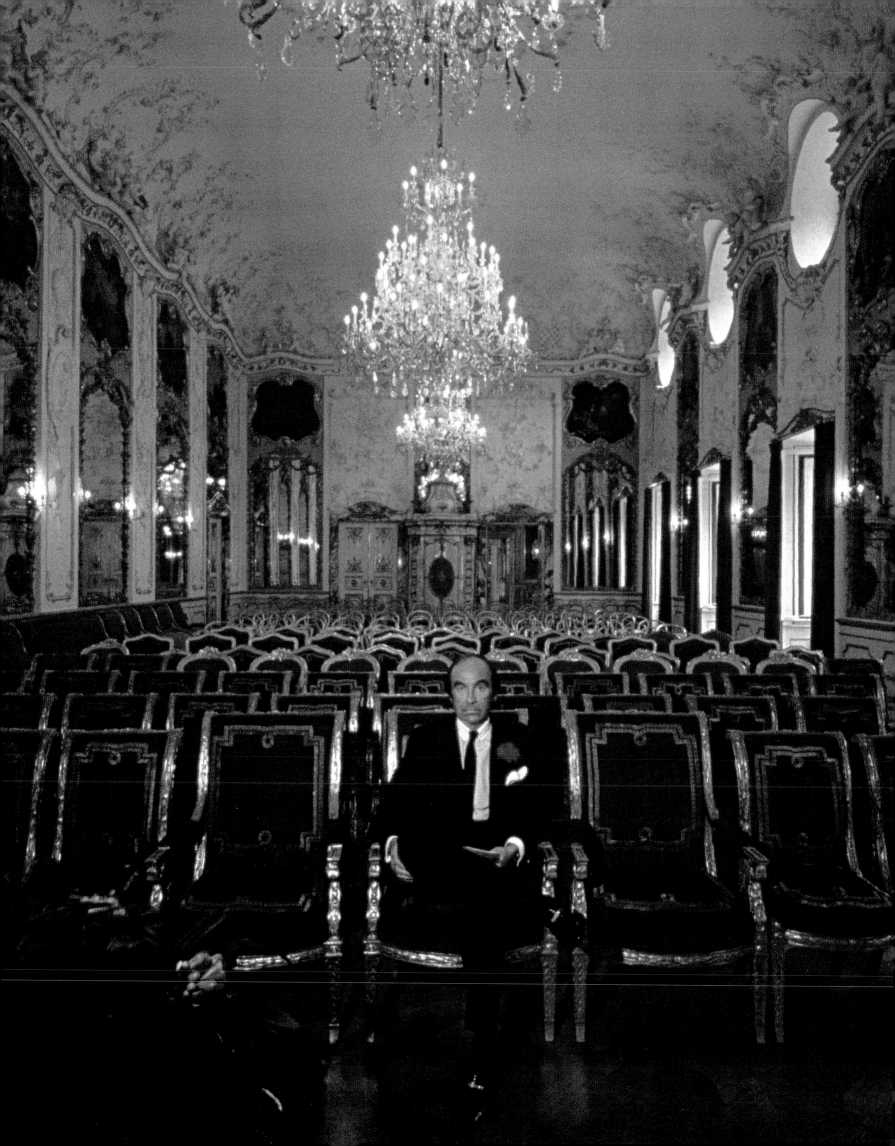

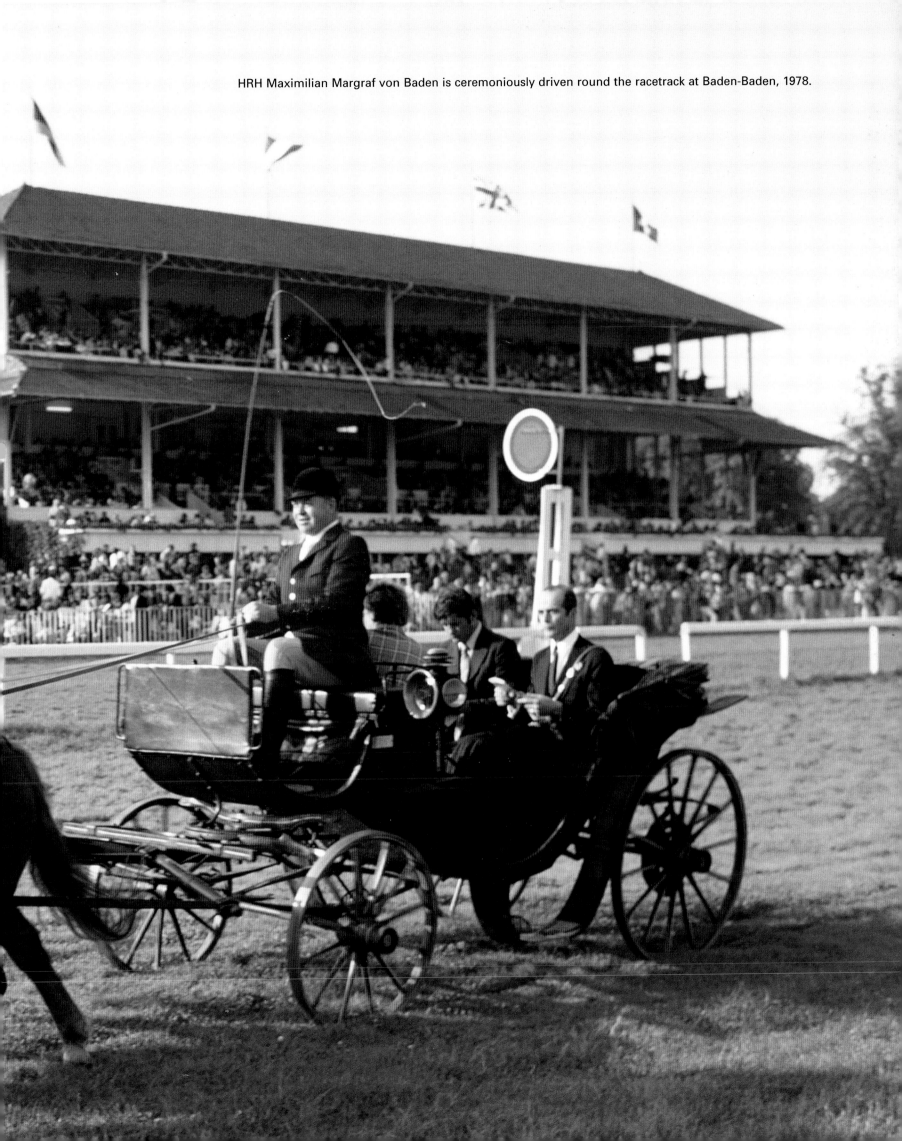

HRH Maximilian Margraf von Baden is ceremoniously driven round the racetrack at Baden-Baden, 1978.

GSTAAD

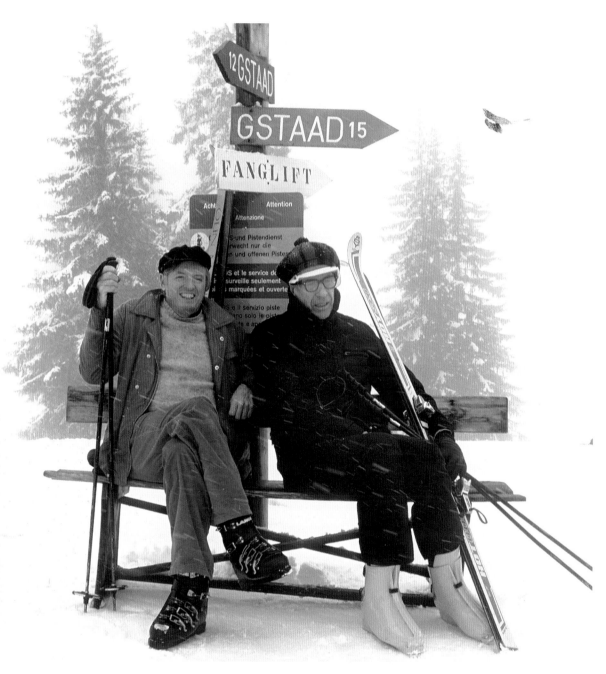

ABOVE: Political commentator William F. Buckley, Jr., and economist John Kenneth Galbraith take a break from skiing, near Gstaad, 1977. We planned to meet at this spot, but when we all got there it was snowing like crazy. They thought I wouldn't get the picture, but I did, and it became one of my most talked-about pictures.

OPPOSITE: Princess Bianca Hanau-Schaumburg at her Gstaad chalet, 1985. I've photographed Bianca three times along the golden circuit, twice in Marbella, once in Gstaad. When those photos ran in the magazine, she got two full pages each time. She never modeled a day in her life, but she was a photographer's delight. You couldn't miss with her. She was the perfect example of why I never worked with models. She was at her own home, wearing her own clothes, she did her own hair. She was just being herself.

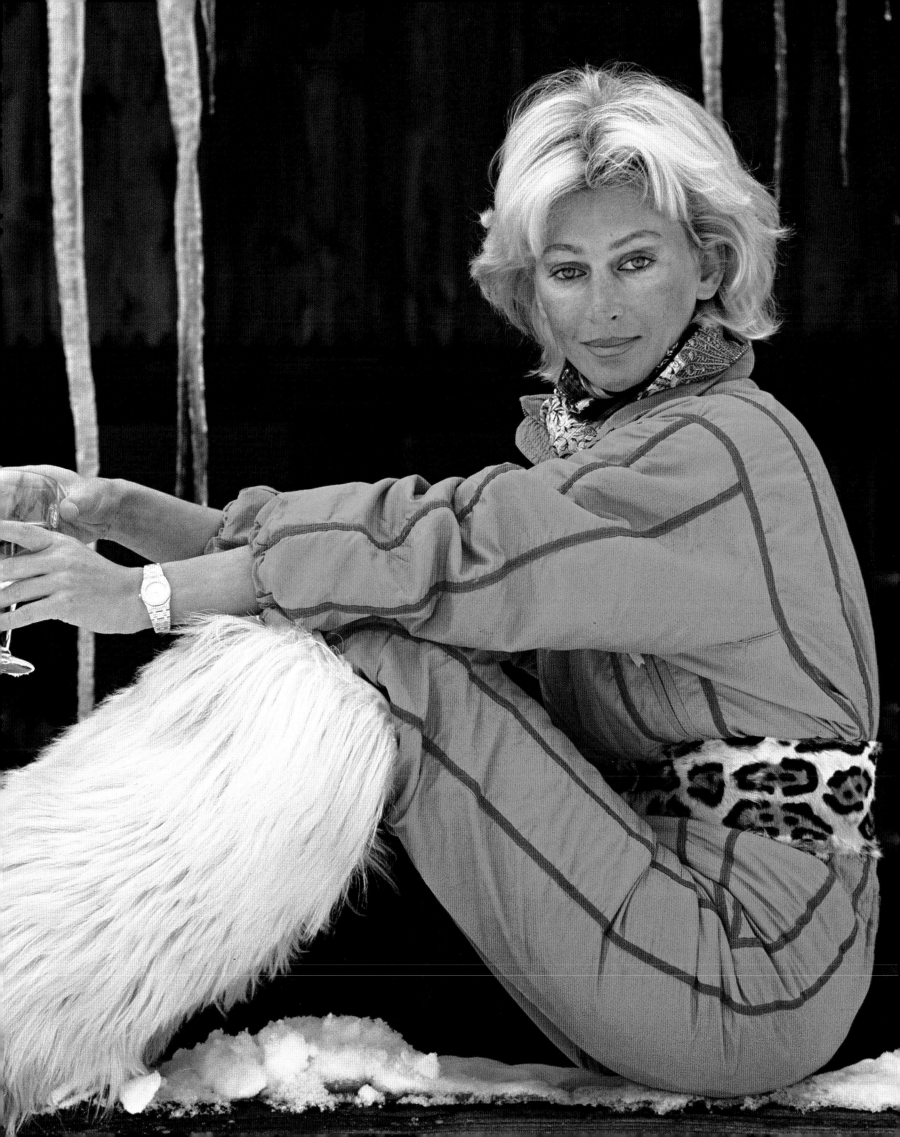

AUSTRIA

As a blue-gray fog burns off, revealing the vast green expanse of the Schonborn Palace park, everyone takes his place for the start of the day's sport. This was a shooting party set up by Hubert and Terry von Pantz. Terry was American and married to Baron Hubert von Pantz from Mittersill, Austria. 1982.

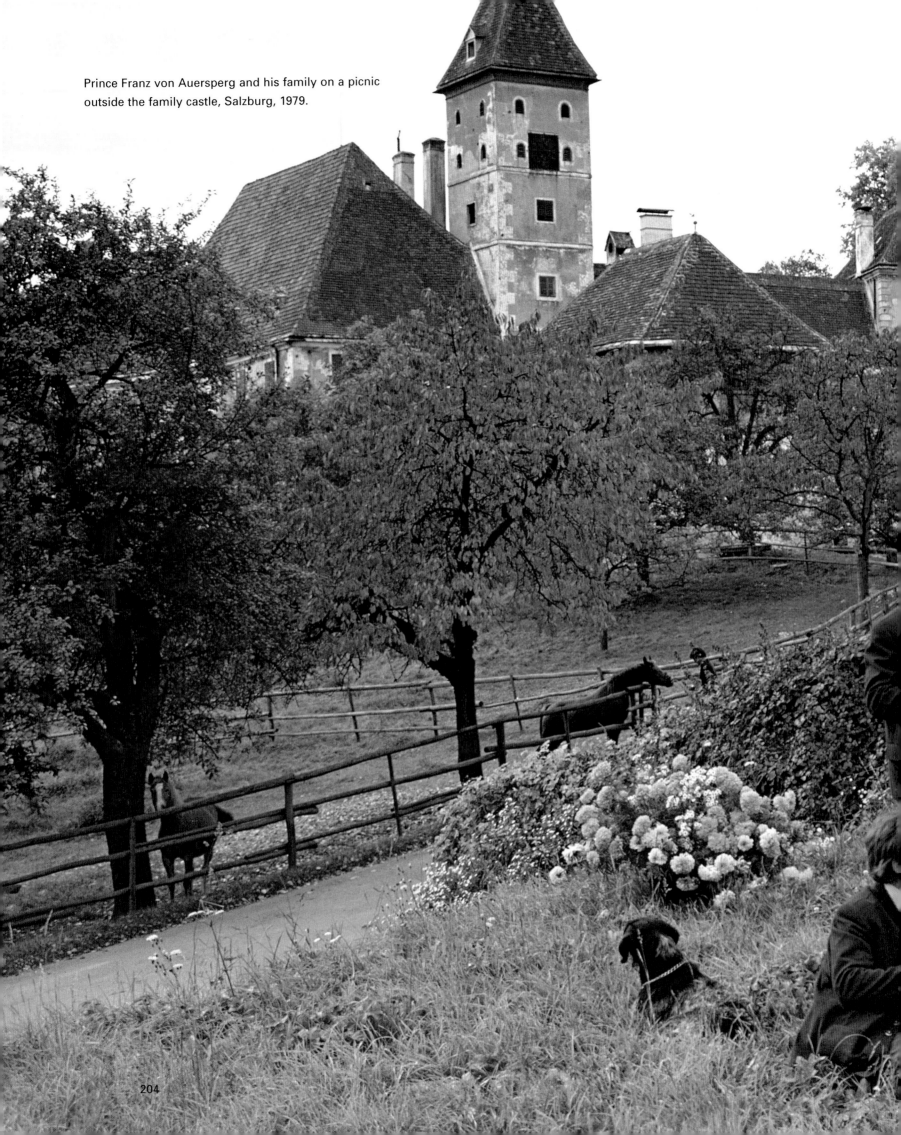

Prince Franz von Auersperg and his family on a picnic outside the family castle, Salzburg, 1979.

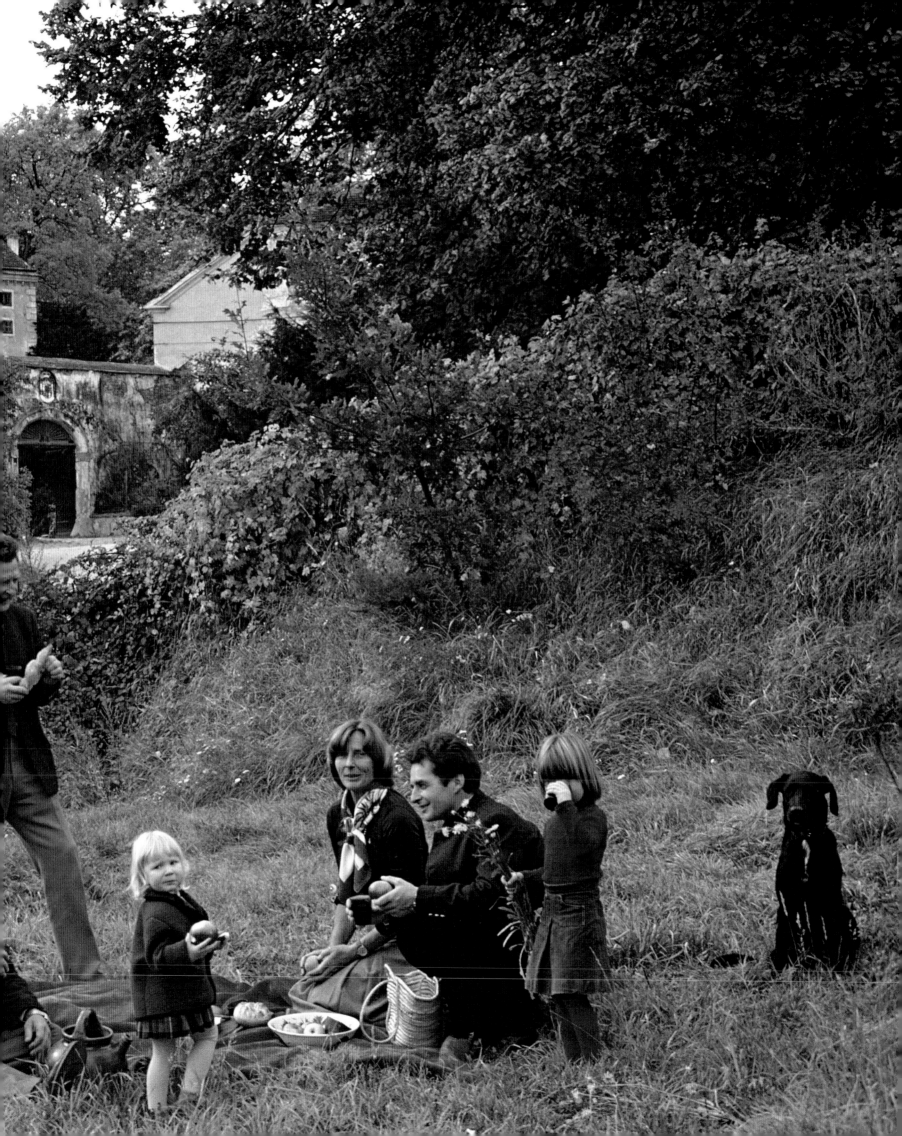

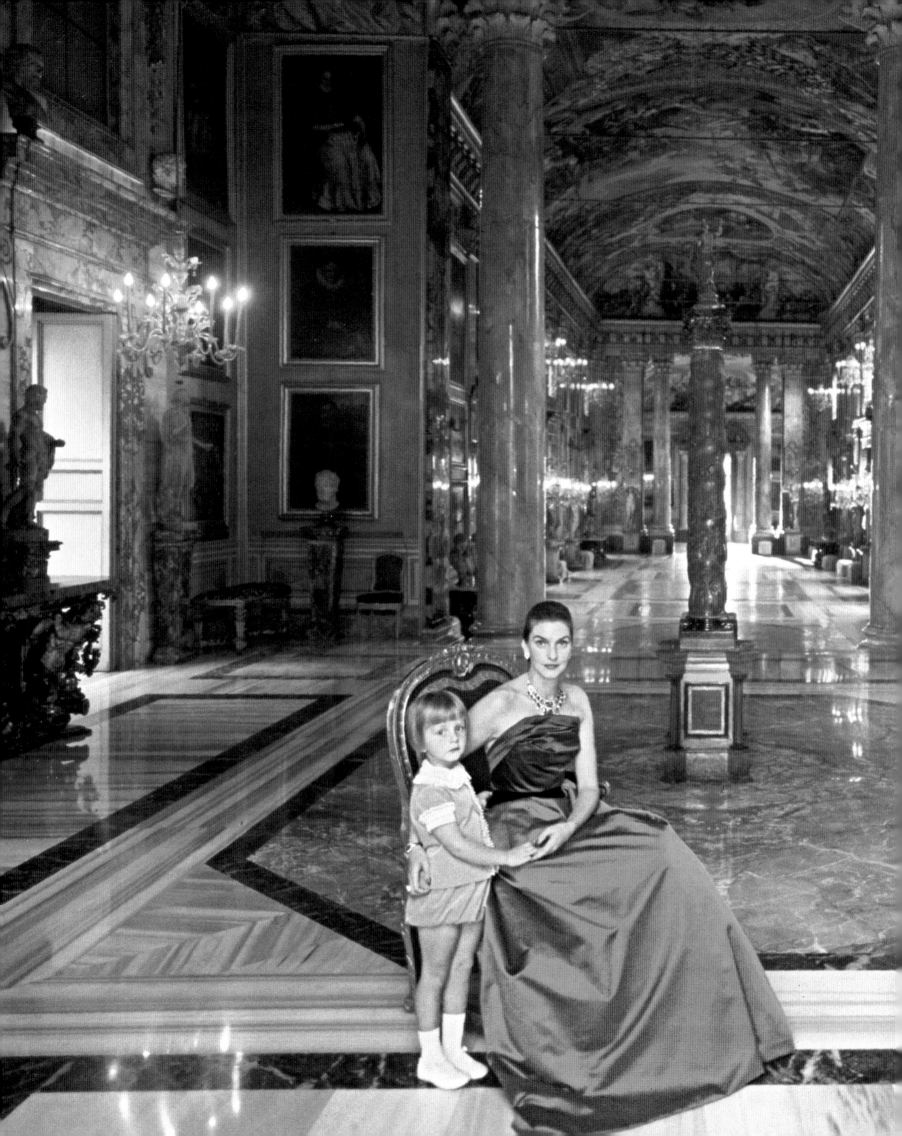

ITALY

Princess Colonna with her son
Prospero seated in the gallery of
the Palazzo Colonna. The gallery
was built to commemorate the
victory of Marcantonio Colonna,
who commanded the papal fleet
against the Turks at the battle of
Lepanto in 1571. The construction
of Palazzo Colonna was begun in
1430 by Pope Martin V, one of
three popes in the Colonna family.
Rome, 1960. I love this photo-
graph. It set the tone for the story
I did on Italy's Black Aristocracy.

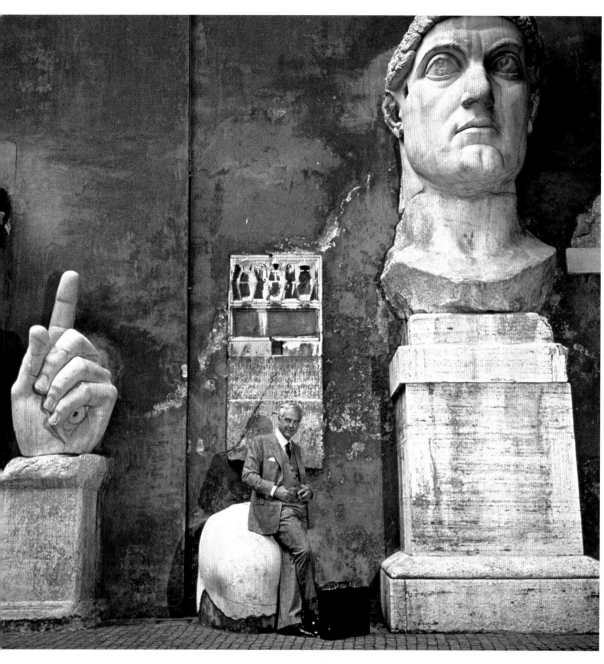

ABOVE: Aeronautical engineer Dr. Elio de Sabata sits on a fragment of the great statue of Constantine the Great in the courtyard of the Palazzo dei Conservatori, Rome, 1981.

OPPOSITE: Prince Raimondo Orsini d'Aragona stands in the ancient Roman Forum, 1981. One of my assignments was on the tailors of Rome. I just used my friends in the story. Where else to put a handsome prince—wearing an elegant suit by Savini-Brioni—but in the Forum?

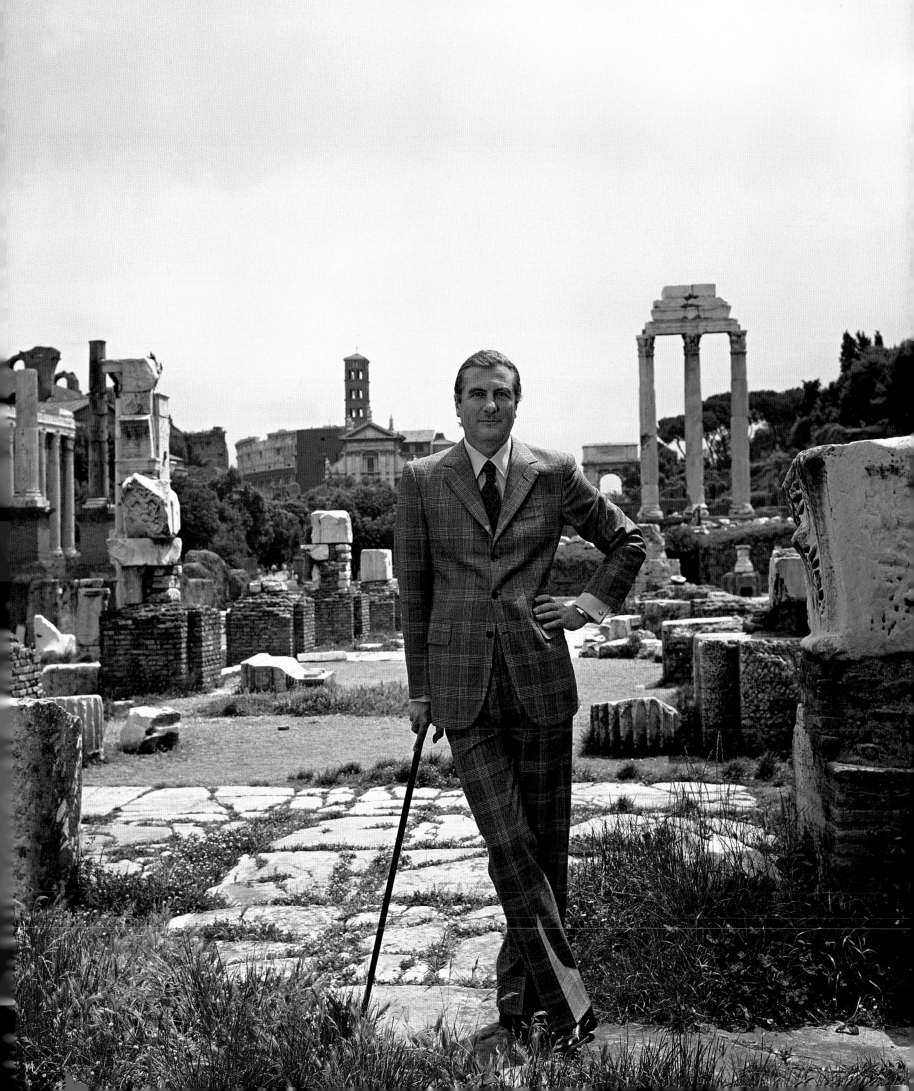

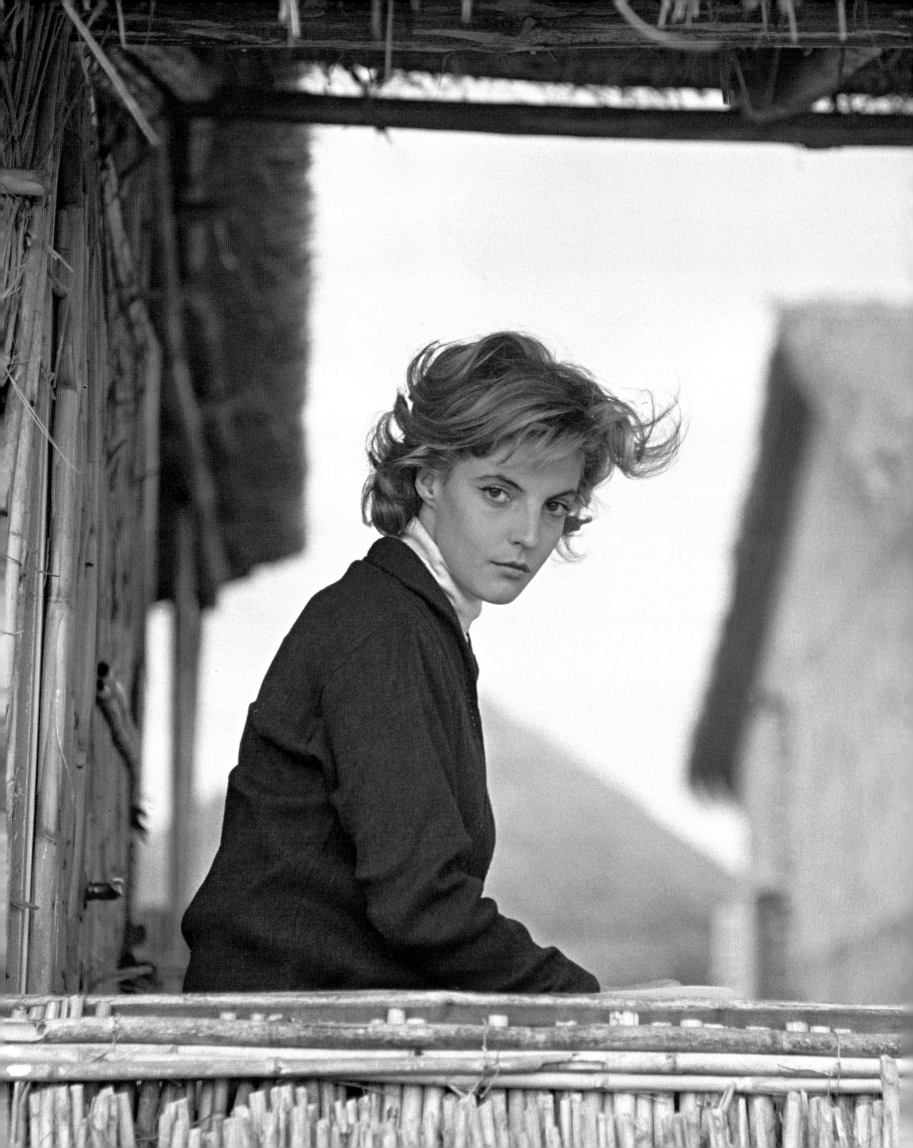

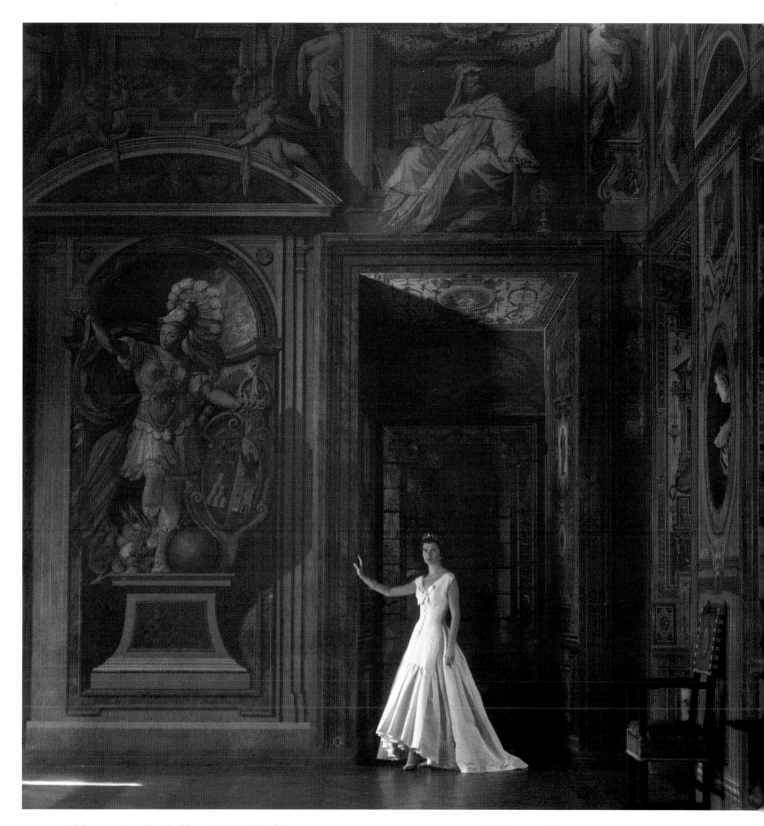

OPPOSITE: Princess Laudomia Hercolani, 1960. She was twenty or twenty-one years old. She was born a princess, the Princess del Drago, and she married a prince, Andrea Hercolani, Prince of Bologna. They were the best-looking couple in Europe. No one could touch them. Jack Kennedy, who followed my work, once rolled down the car window at the Everglades Club in Palm Beach and asked me, "Slim, that shot of the Hercolani princess in Rome, is she really that good-looking?" "Better!" I told him.

ABOVE: Donna Domitilla Ruspoli, Palazzo Ruspoli, Rome, 1960.

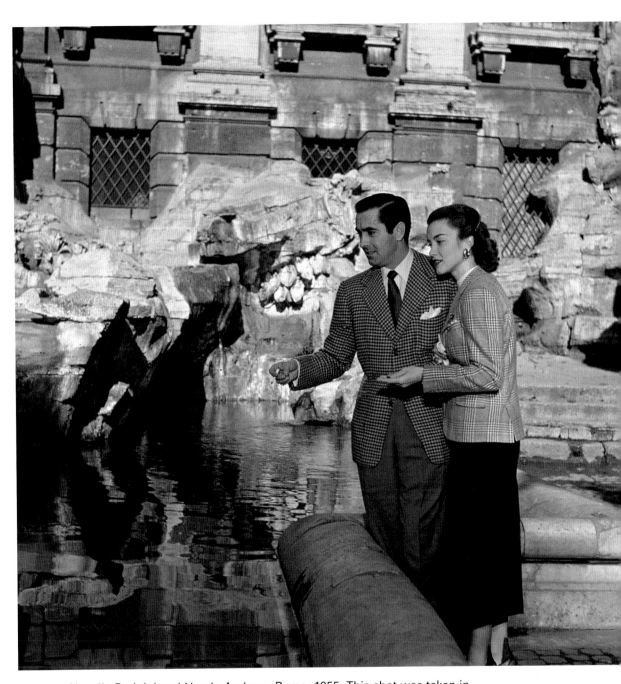

OPPOSITE: Novella Parigini and Ursula Andress, Rome, 1955. This shot was taken in Rome on the Via Margutta in a government-subsidized studio apartment. Novella was a popular young artist. Ursula was a student down for holiday from Geneva. They were friends having a wonderful time on a Roman holiday.

ABOVE: American actor Tyrone Power with his new wife, Linda Christian, the Mexican actress, tossing coins into the Trevi Fountain, Rome, 1949.

BELOW: Marchese Emilio Pucci, Florence, 1984. Philosopher, diplomat, and designer, Pucci was the originator of the silk print dresses that were the uniform of the jet-set in the 1960s. He is dressed for the parade that precedes the *Calcio in Costume*, a medieval sporting event held annually in which teams representing the various districts of the city compete.

OPPOSITE: Santa and Serena Antonelli taking tea on the terrace of their home above Via Giucciardini, Florence, 1983.

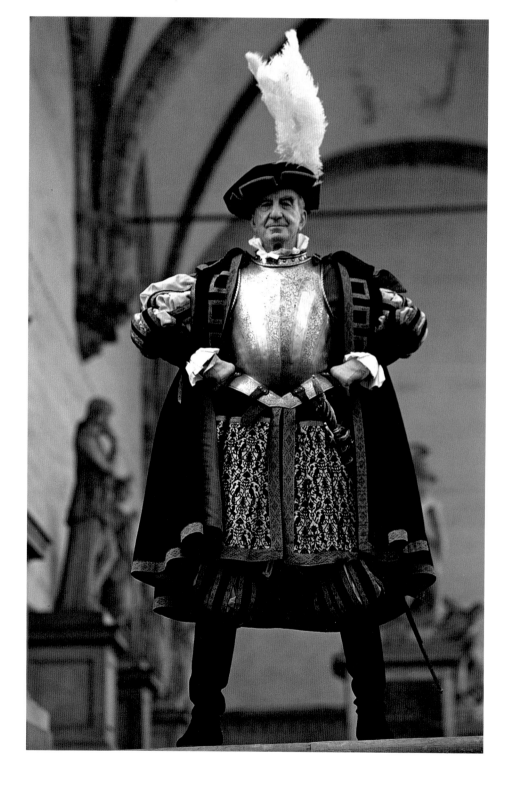

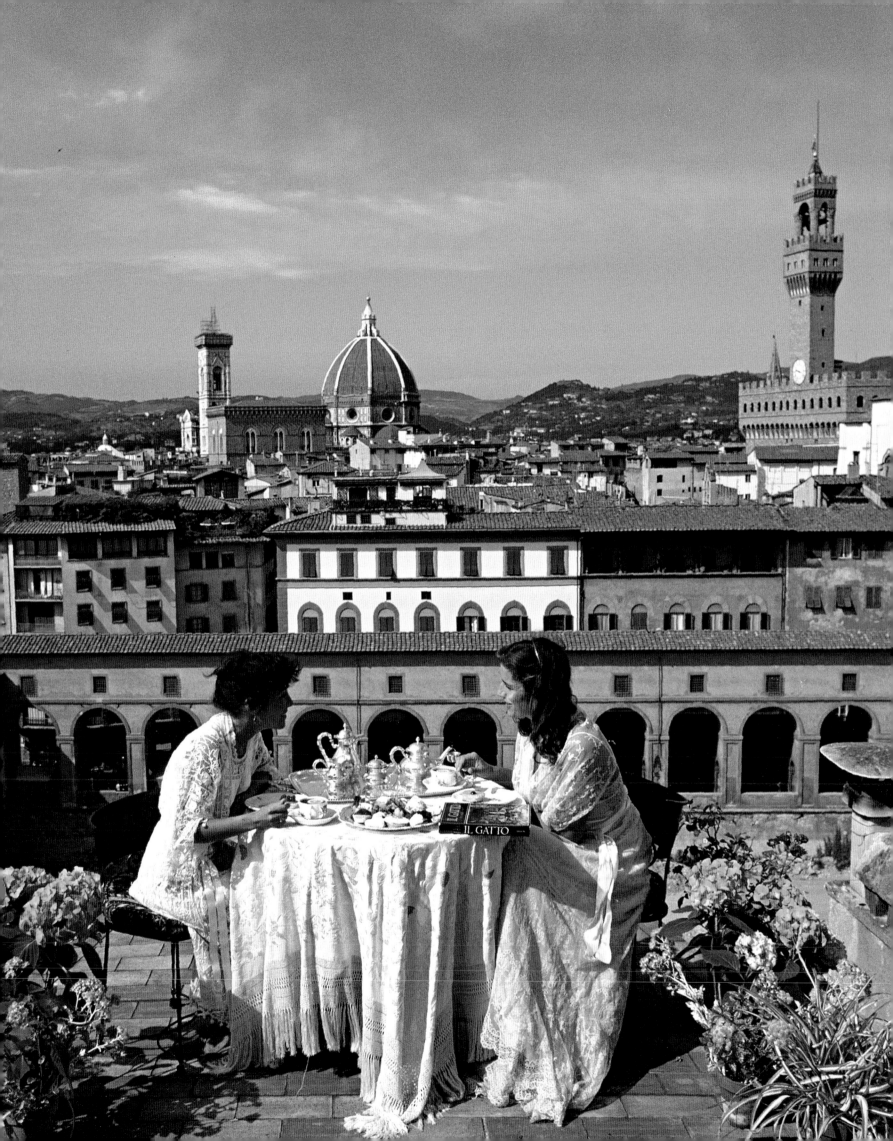

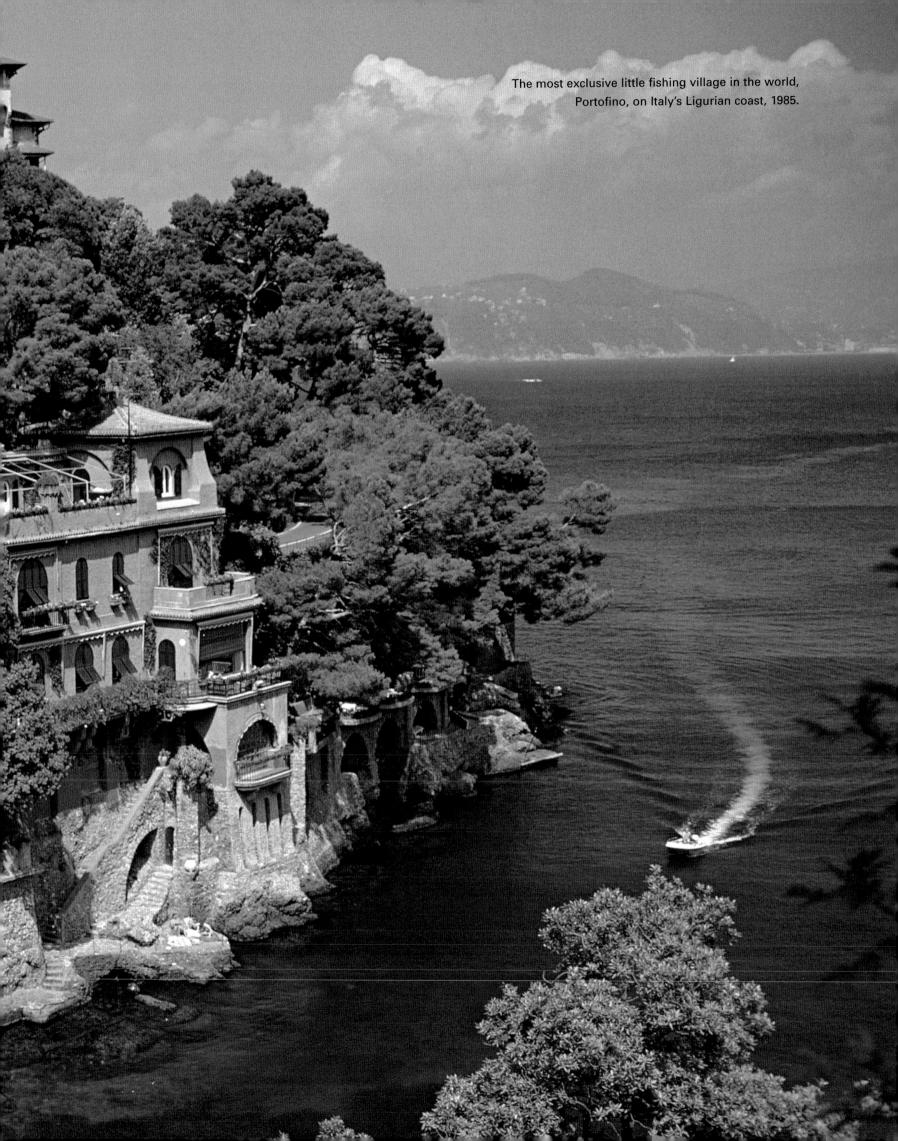

The most exclusive little fishing village in the world,
Portofino, on Italy's Ligurian coast, 1985.

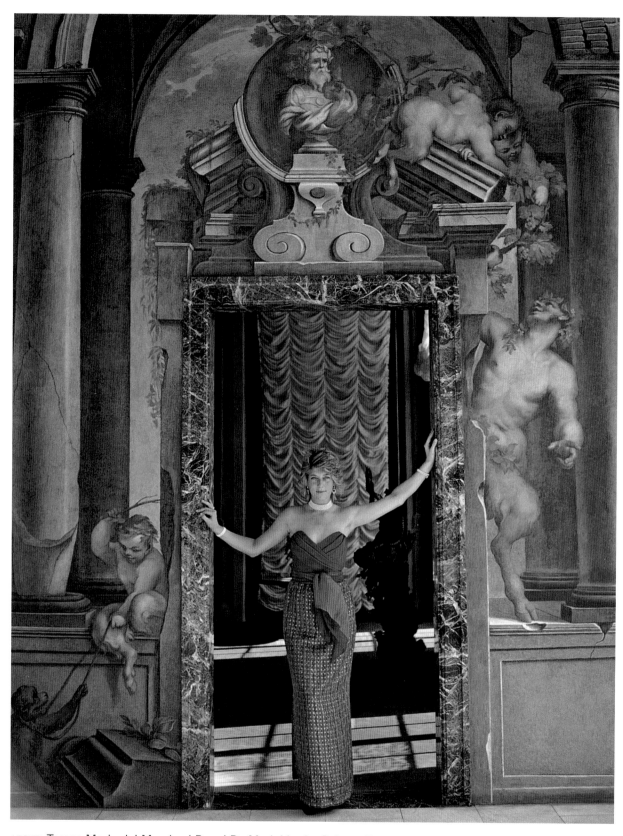

ABOVE: Teresa Maria dei Marchesi Raggi De Marini in the Palazzo Rosso, now a public museum. Genoa, 1988.

OPPOSITE: Wanda Toscanini Horowitz, the daughter of maestro Arturo Toscanini, sitting on the stage at La Scala where her father first heard the news of her birth. Milan, 1960. She was married to the pianist Vladimir Horowitz.

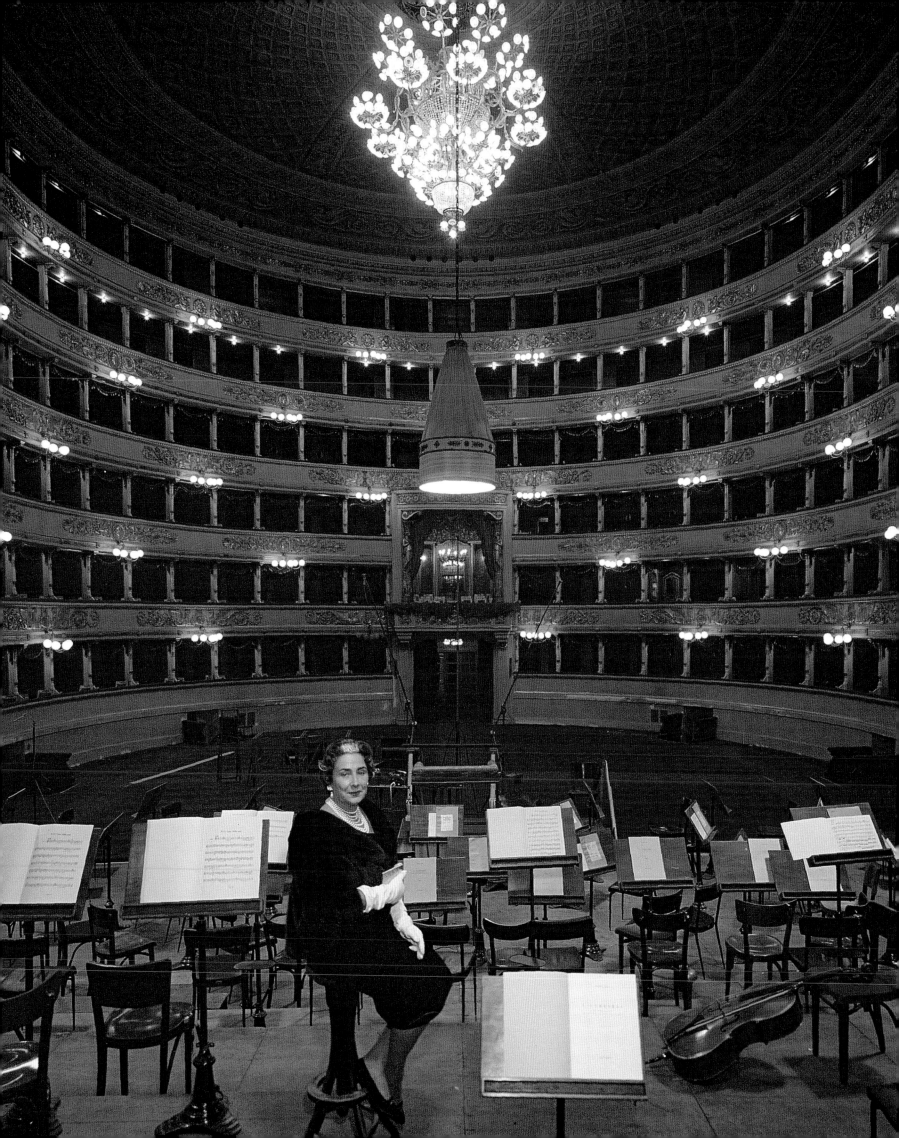

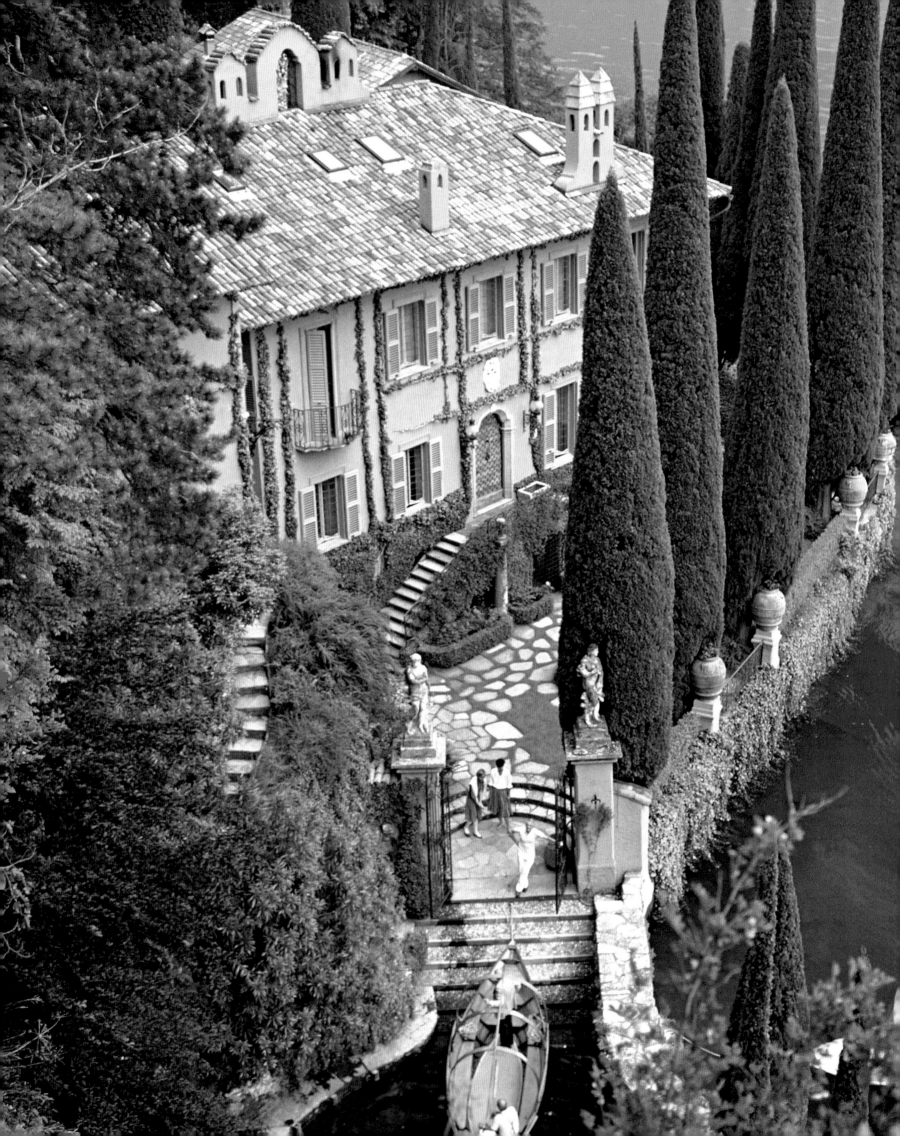

OPPOSITE: Giacomo and Stefania Montegazza welcome guests arriving by boat at their villa, La Casinella, on Lake Como, 1983.

ABOVE: Designer Gianni Versace in his home on Lake Como, 1983.

ABOVE: Art patron and collector Peggy Guggenheim in her palazzo, Venier dei Leoni, on the Grand Canal in Venice, 1980. When I arrived there to photograph her she posed herself before the nude torso of Giacometti's *Statue of a Headless Woman*. To her right is Picasso's *On the Beach* and Giacometti's *Piazza*.

OPPOSITE: American socialite and Woolworth heiress Barbara Hutton, the world's richest woman, on the Lido in Venice, 1958. I was having lunch with Countess Anna Maria Cicogna, a great hostess from an ancient Italian family, in her cabana at the Lido in Venice, when I happened to see Barbara Hutton strolling up the beach with a handsome, young Italian guy. I later approached her at her cabana and told her I was doing a story on the Lido and asked if I could take her photograph. She looked at me and said, "Why, yes, thank you. No one ever asks."

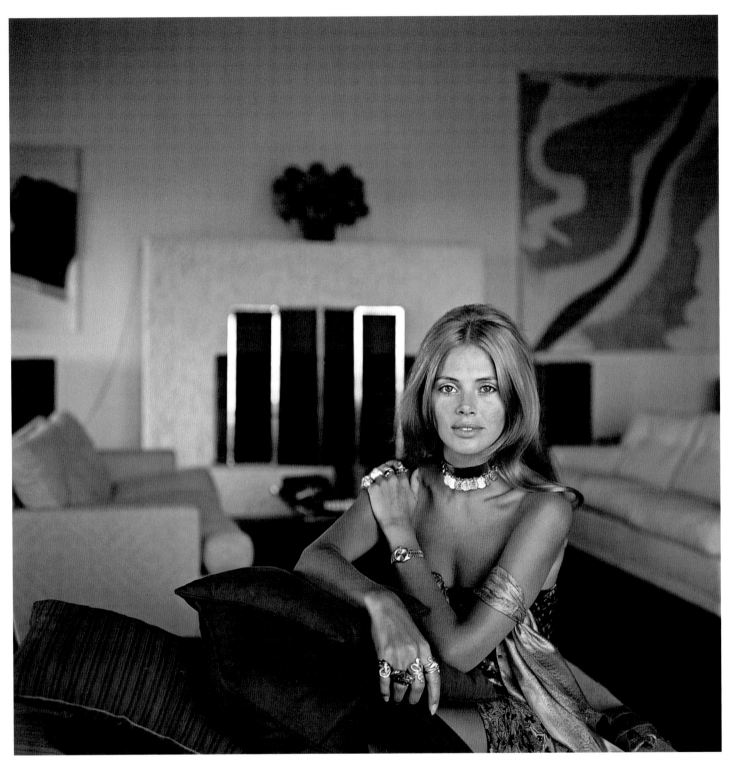

ABOVE: Actress Brit Ekland in Porto Ercole, 1969. I used to see Brit and her husband, Peter Sellers, a lot. They were great friends of the Aga Khan, so whenever I was doing any story that included the Aga Khan, they were often around.

OPPOSITE: Count Gelasio Gaetani d'Aragona Lovatelli with his daughter Iacobella, whose godfather is Juan Carlos, the King of Spain. Porto Ercole, 1987. One of my closest friends, I have known him since he was a boy. This reminds me of the time I photographed Juan Carlos' father in exile in Portugal. He said to me, "My God, you're taller than I am." I replied "Yes, Your Highness. It's a good thing it's not the old days—you would cut off my feet." He laughed and said "No, no, your head."

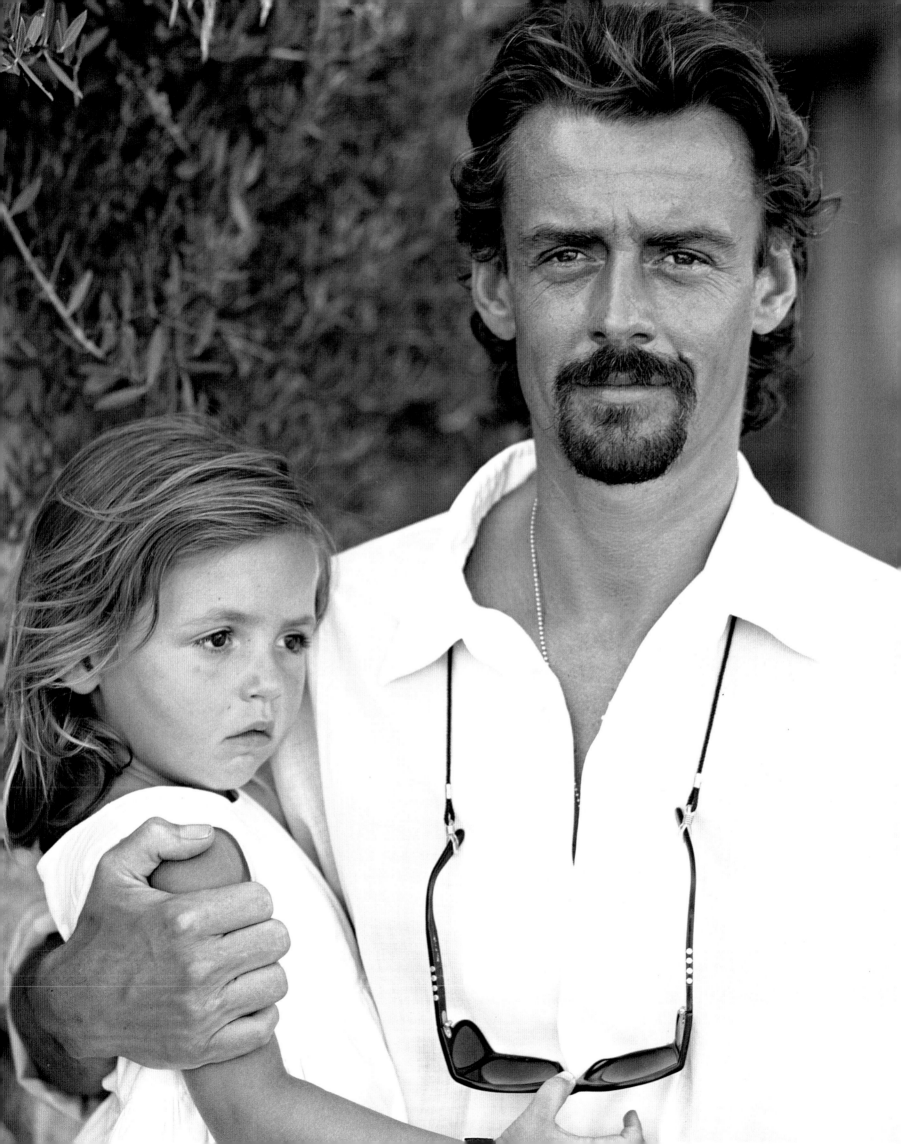

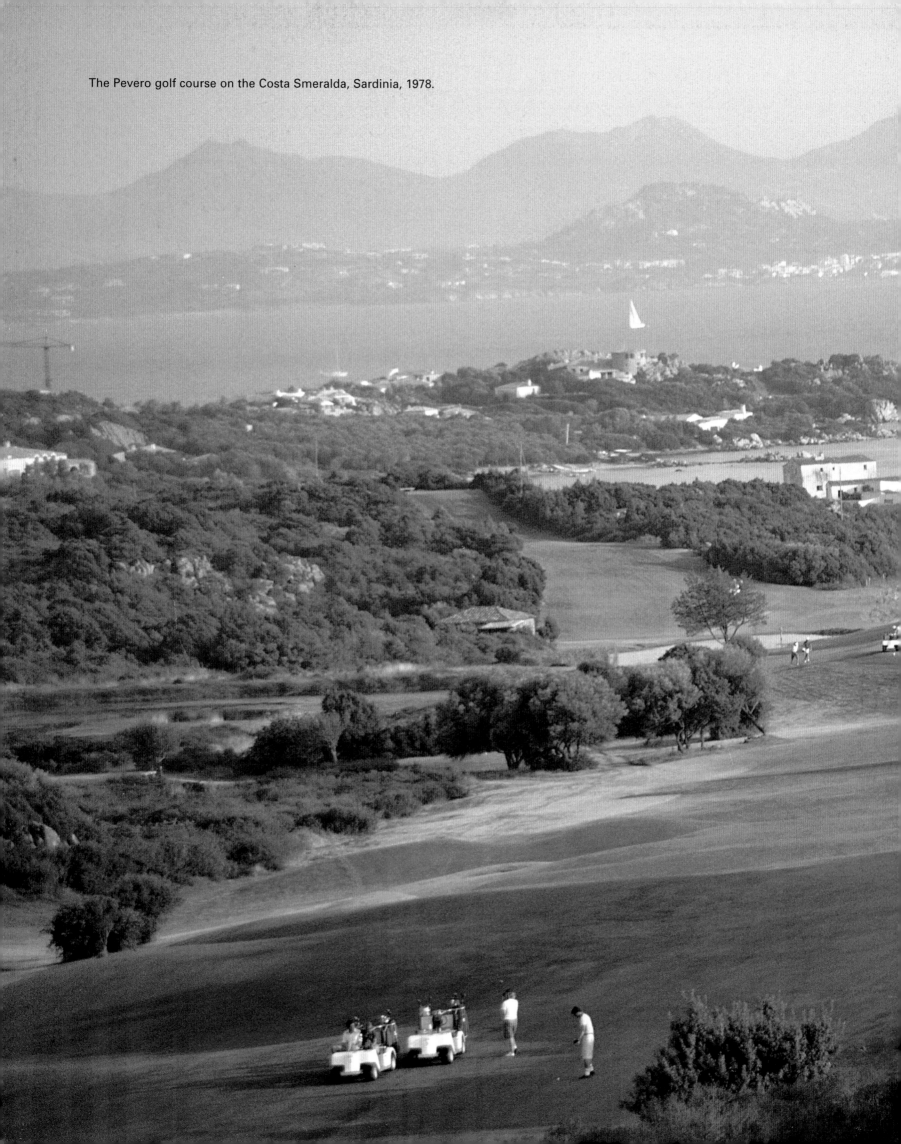

The Pevero golf course on the Costa Smeralda, Sardinia, 1978.

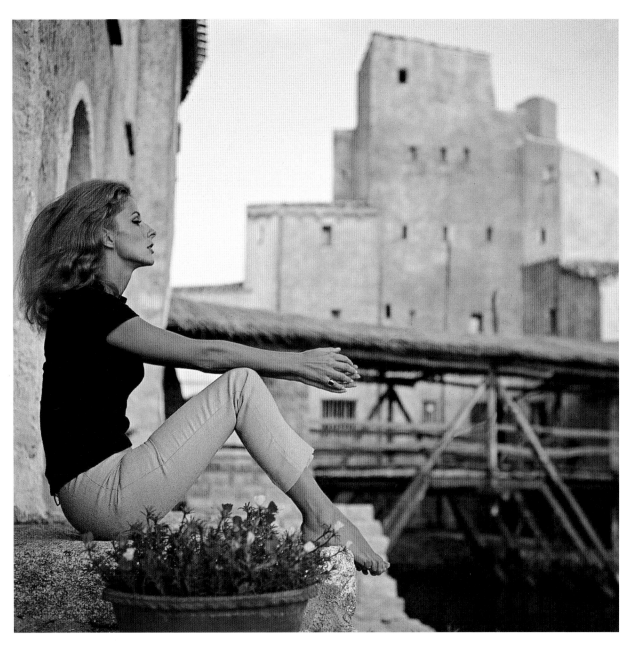

ABOVE: Dolores Guinness basking in the last rays of the sun outside the Cala di Volpe hotel on the Costa Smeralda, 1965.

OPPOSITE: The photographer Lord Lichfield - the 5th Earl of Lichfield and first cousin to Queen Elizabeth - and three Italian beauties, each a princess. Patrick's belt buckle is a self-designed Lord Lichfield monogram and he is holding a Hasselblad camera and Marina Lante della Rovere is holding him. To the left is Ines Torlonia and Signorina Gancia is reclining. It's a great life, a photographer's life without a wife. Porto Ercole, 1968.

OVERLEAF: The island of Cavallo, off the coast of Corsica, 1984.

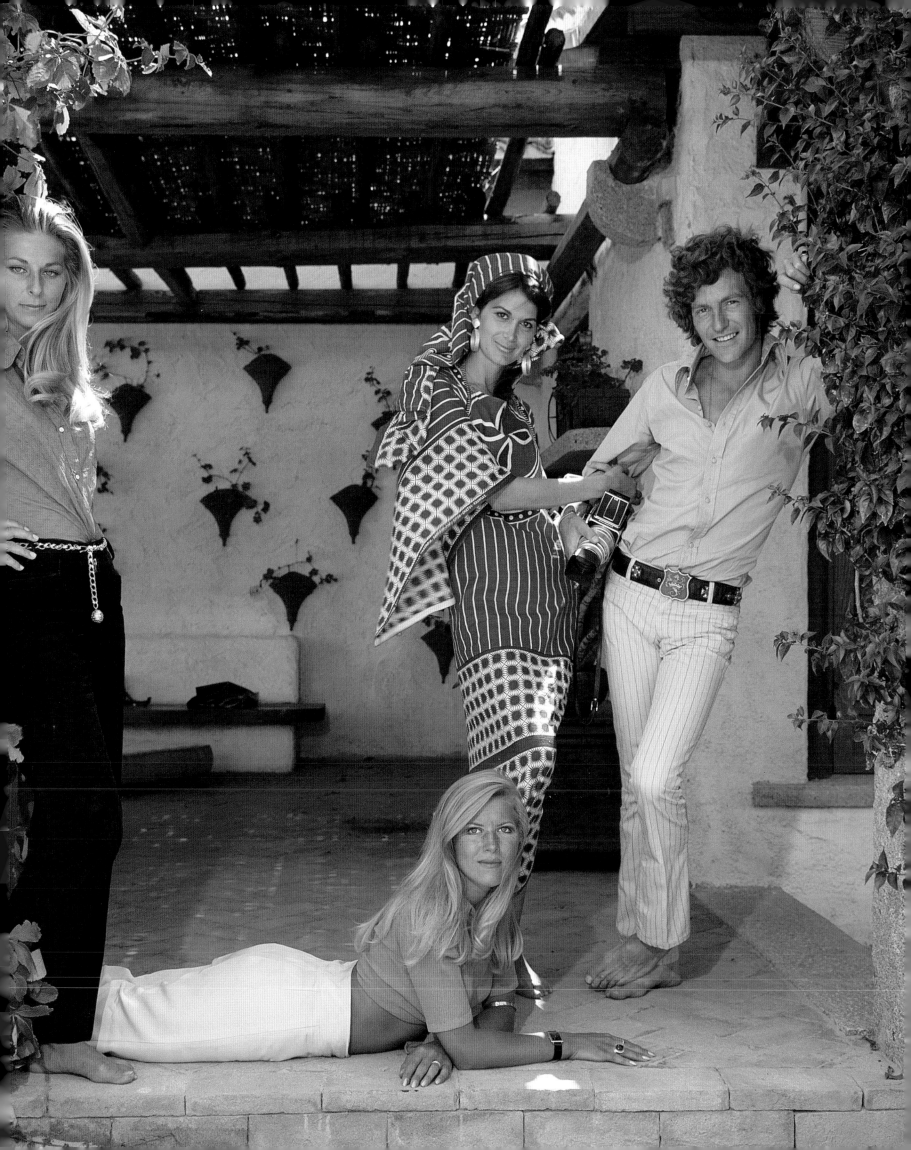

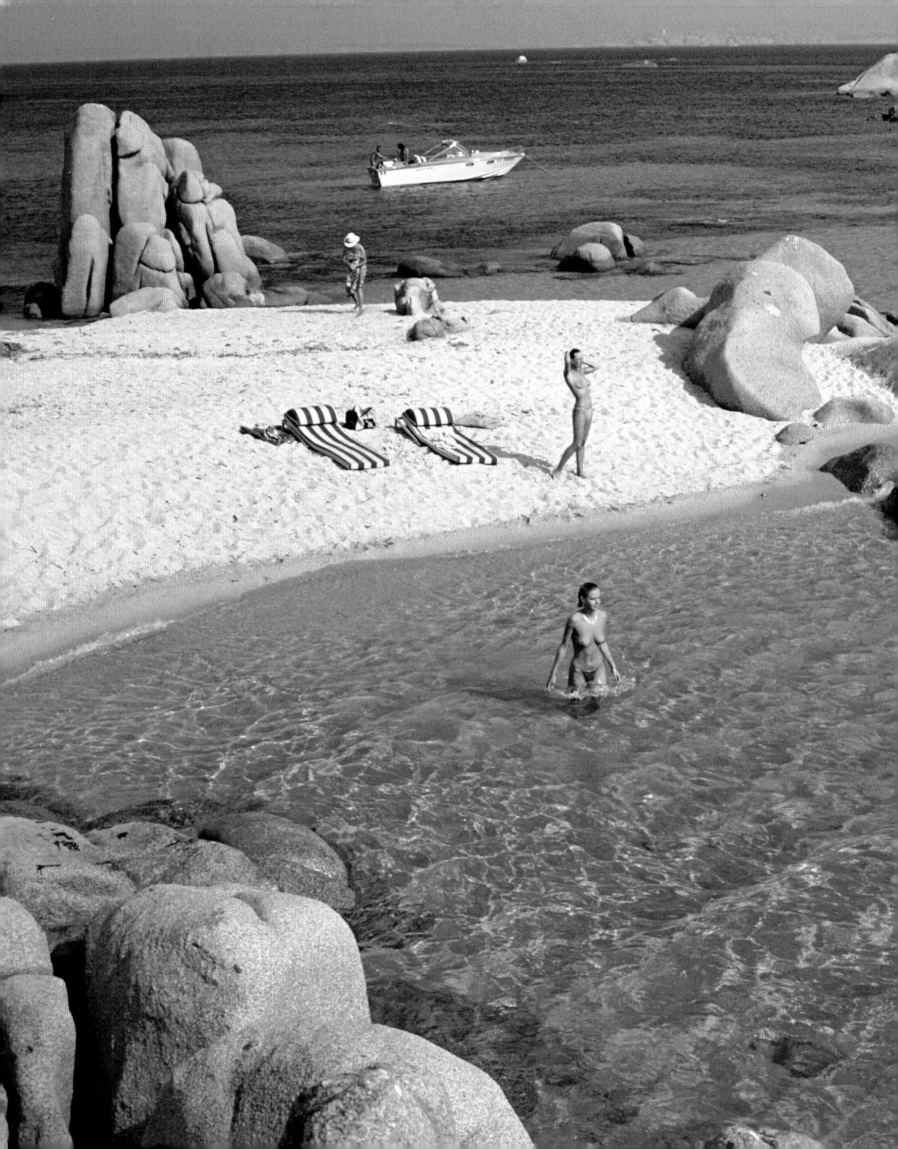

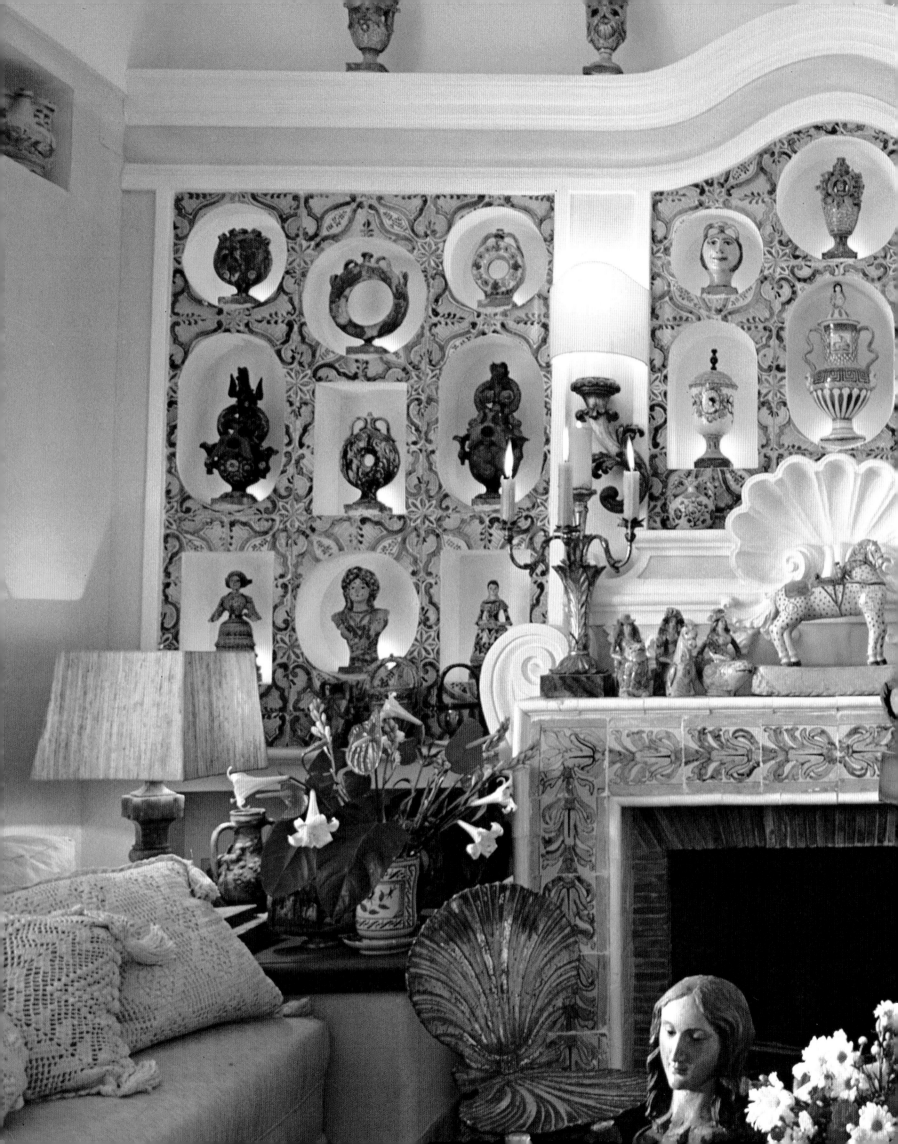

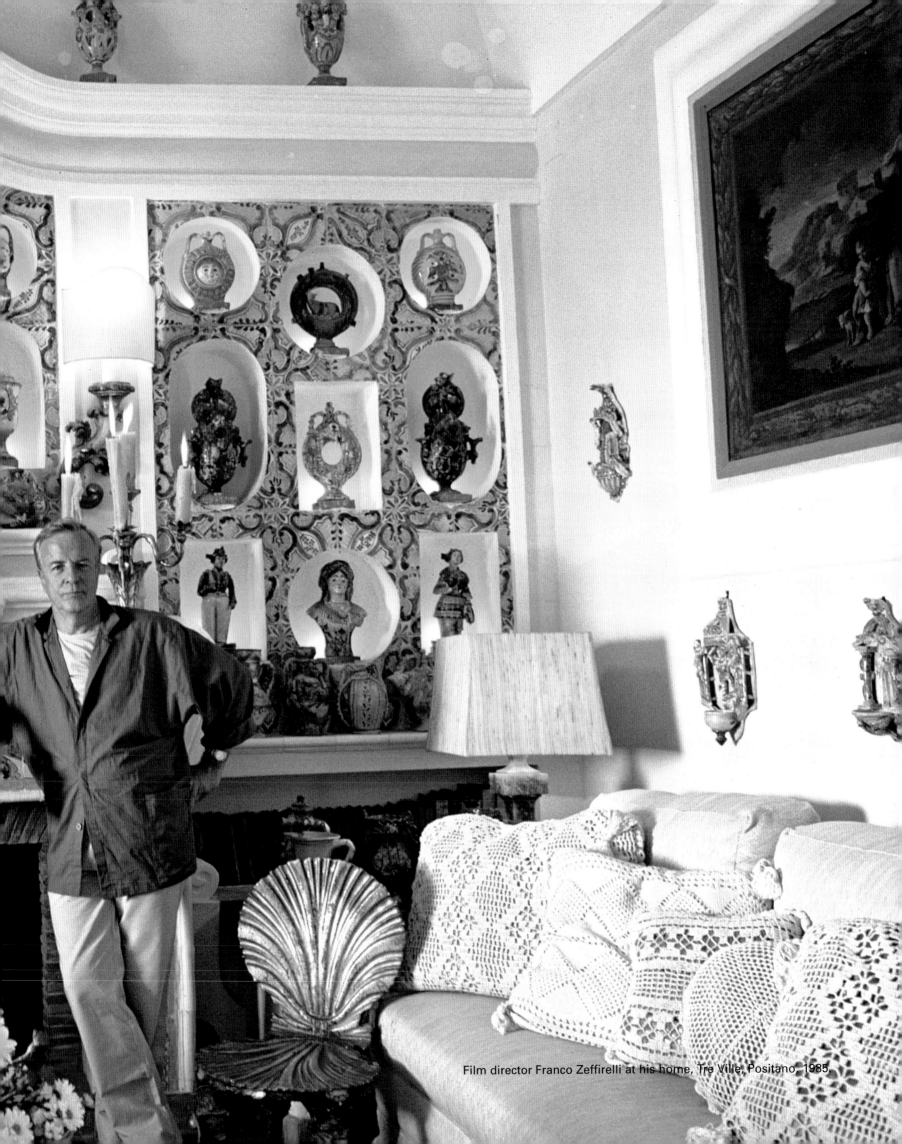

Film director Franco Zeffirelli at his home, Tre Ville, Positano, 1985.

ABOVE: Gore Vidal at his villa, La Rondinaia, high in the hills overlooking the Tyrrhenian Sea, Positano, 1979.

OPPOSITE: Elisabetta Catalano, Pamela Grupas, Charlotte Tieken (top to bottom), and Catherine Wilke (standing), Capri, 1982.

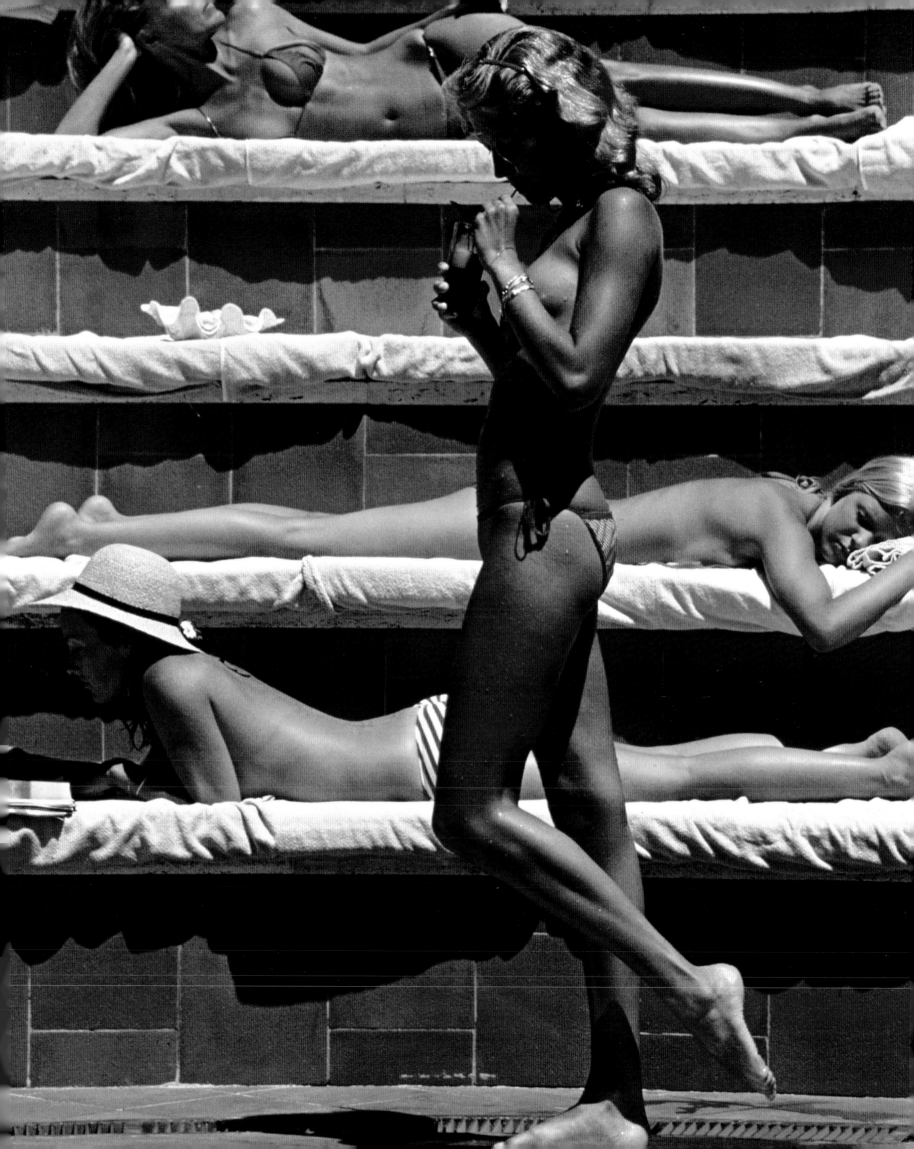

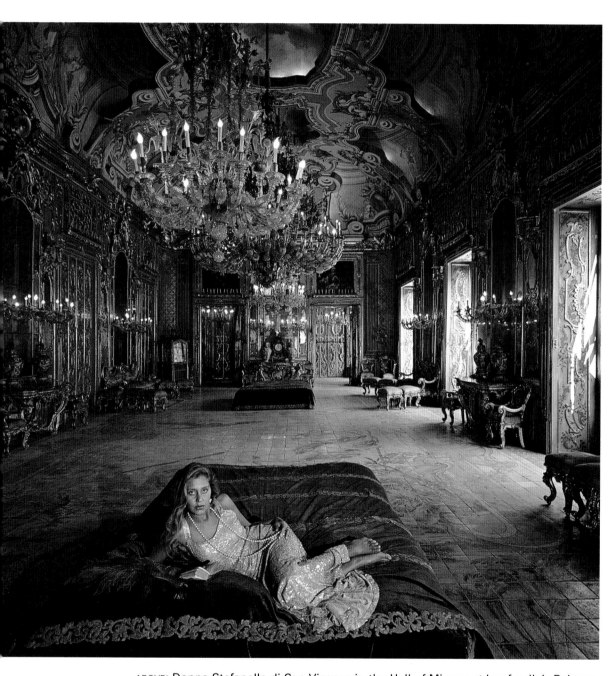

ABOVE: Donna Stefanella di San Vicenzo in the Hall of Mirrors at her family's Palazzo. The focal point of Sicilian Belle-Époque society, this eighteenth-century palazzo has been compared with Versailles. Palermo, 1984.

OPPOSITE: Donna Anna Monroy di Giampilieri in the early-Empire drawing room of the Villa Spedalotto, near Palermo, 1984.

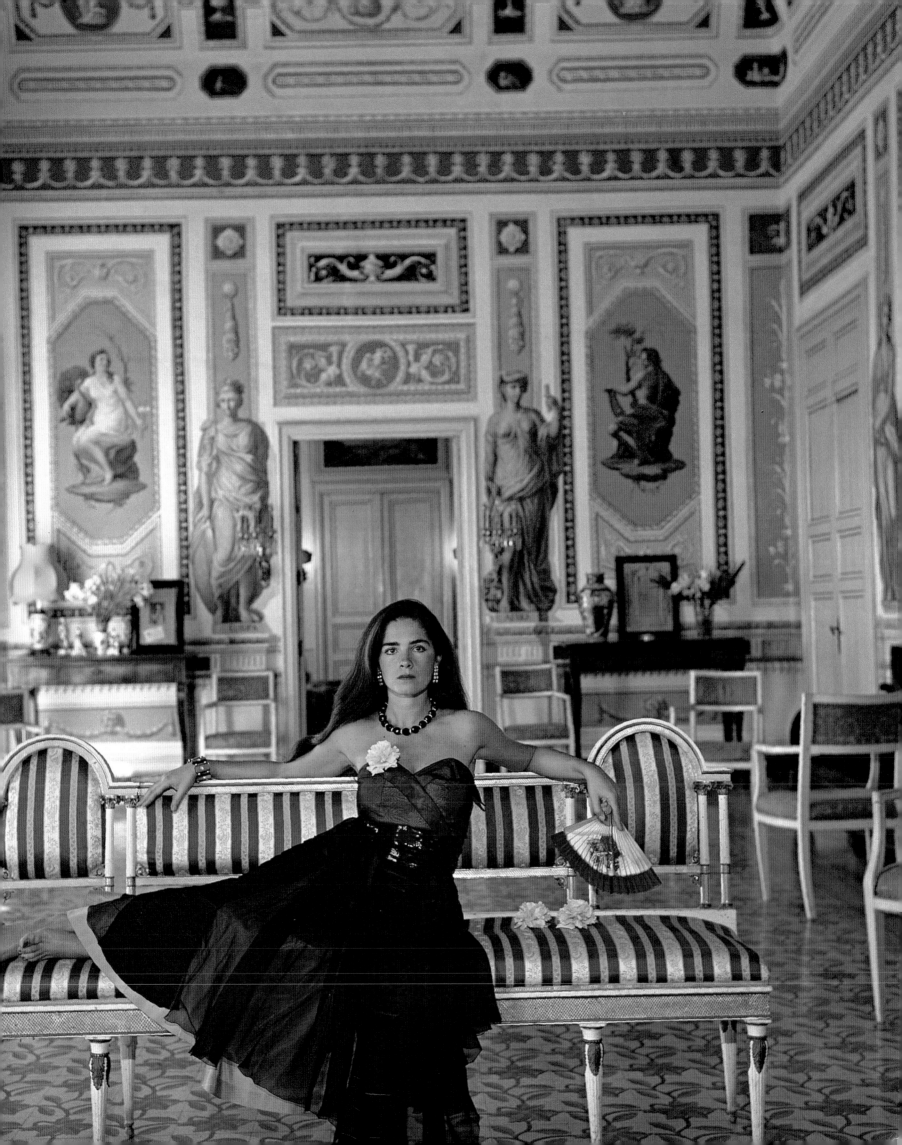

RIGHT: Gioacchino Lanza Tomasi de Lampedusa, the Duke of Palma, in the library of the palace of his adoptive father, the Prince of Lampedusa, author of the great novel about the Sicilian aristocracy, *The Leopard*. Palermo, 1984.

OVERLEAF: Prince and Princess Massimo with five of their six children in their residence, Palazzo Massimo alle Colonne, one of Rome's great Renaissance buildings, 1960. The most ancient family in Rome, the Massimo family embodies the principle that makes the Roman Black Aristocracy distinct: a link through the Middle Ages to the days of the Roman Empire. Looking at this photo, I am reminded of the story of an ancestor of the prince, a previous Prince Massimo, who was defeated during the Napoleonic Wars. After he was captured he was brought before Napoleon, who said to him, "My dear Prince, I gather that you are descended from Fabius Maximus, who led the armies of Rome against Hannibal in 217 B.C." The Prince replied, "My dear Emperor, I cannot vouch for the accuracy of that statement, but it has been a rumor in our family for a thousand years."

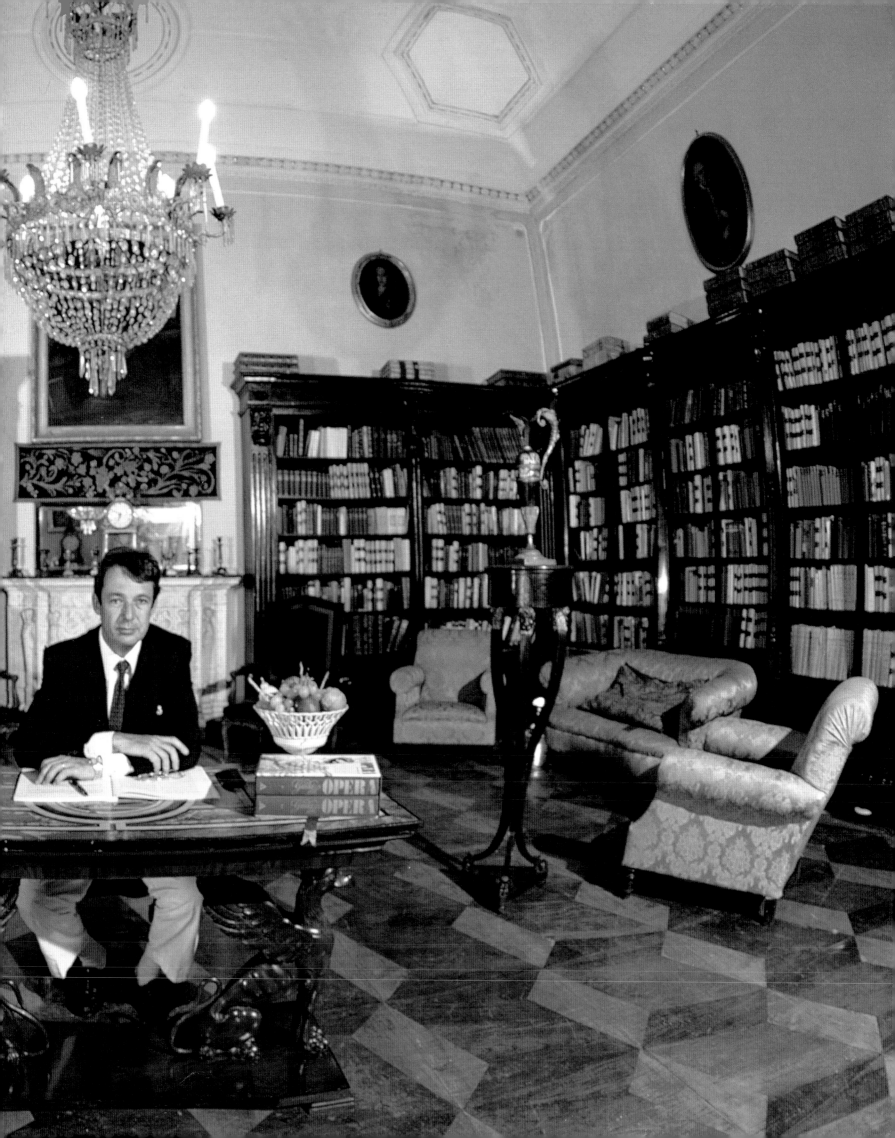

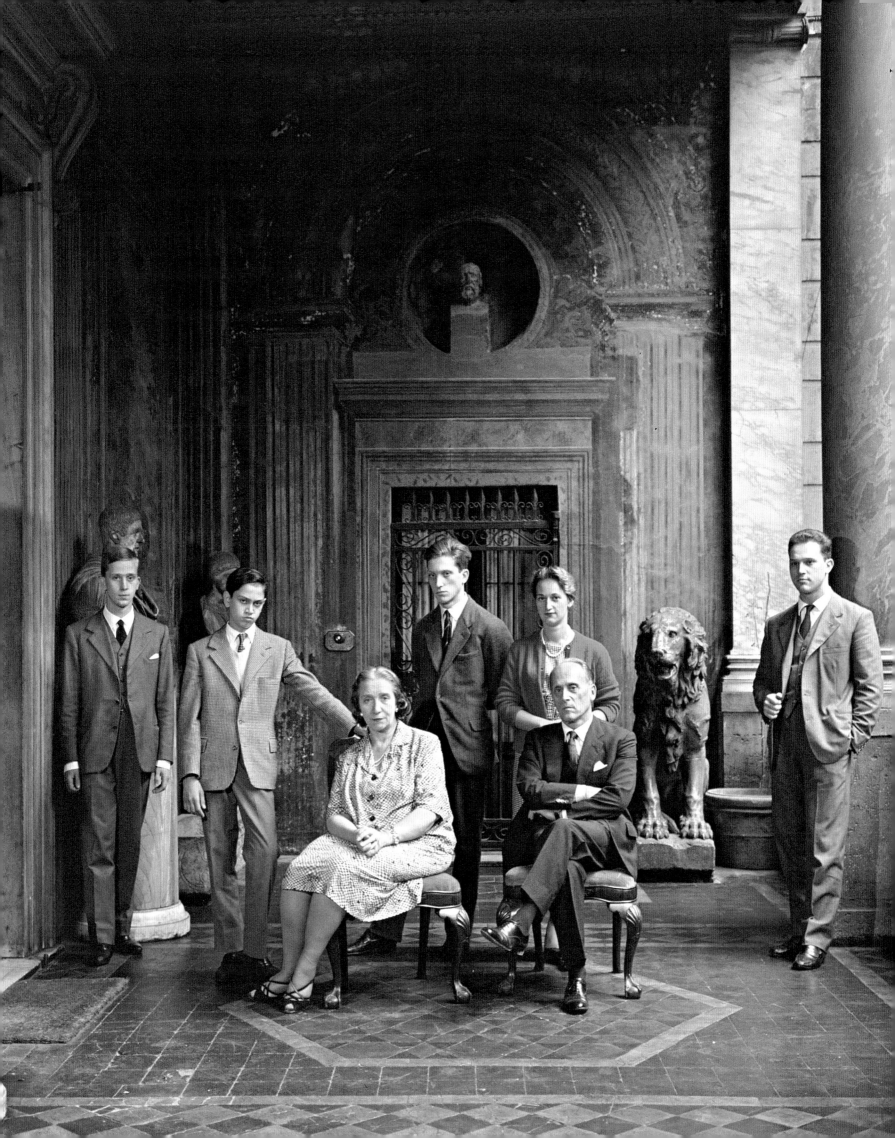